How **1999** Blew Up the Big Screen

BEST.
MOVIE.
YEAR.
EVER.

BRIAN
RAFTERY

SIMON & SCHUSTER

New York London Toronto Sydney New Delhi

Simon & Schuster
1230 Avenue of the Americas
New York, NY 10020

First Simon & Schuster hardcover edition April 2019

SIMON & SCHUSTER and colophon are registered trademarks
of Simon & Schuster, Inc.

For information about special discounts for bulk purchases,
please contact Simon & Schuster Special Sales at 1-866-506-1949
or business@simonandschuster.com.

The Simon & Schuster Speakers Bureau can bring authors to
your live event. For more information or to book an event,
contact the Simon & Schuster Speakers Bureau at 1-866-248-3049
or visit our website at www.simonspeakers.com.

Interior design by Lewelin Polanco

Manufactured in the United States of America

10 9 8 7 6 5 4 3 2 1

Library of Congress Cataloging-in-Publication Data is available.

ISBN 978-1-5011-7538-1
ISBN 978-1-5011-7540-4 (ebook)

BEST. MOVIE. YEAR. EVER.

BRIAN RAFTERY

SIMON & SCHUSTER

New York London Toronto Sydney New Delhi

Simon & Schuster
1230 Avenue of the Americas
New York, NY 10020

First Simon & Schuster hardcover edition April 2019

SIMON & SCHUSTER and colophon are registered trademarks
of Simon & Schuster, Inc.

For information about special discounts for bulk purchases,
please contact Simon & Schuster Special Sales at 1-866-506-1949
or business@simonandschuster.com.

The Simon & Schuster Speakers Bureau can bring authors to
your live event. For more information or to book an event,
contact the Simon & Schuster Speakers Bureau at 1-866-248-3049
or visit our website at www.simonspeakers.com.

Interior design by Lewelin Polanco

Manufactured in the United States of America

10 9 8 7 6 5 4 3 2 1

Library of Congress Cataloging-in-Publication Data is available.

ISBN 978-1-5011-7538-1
ISBN 978-1-5011-7540-4 (ebook)

For Bill Raftery, 1944–2018
Best dad ever

For Bill Raftery, 1944–2018
Best dad ever

CONTENTS

AUTHOR'S NOTE

This book is based upon more than 130 interviews conducted between March 2017 and January 2019. At times I also rely on archival interviews, speeches, videos, and commentary tracks. If a subject speaks in the present tense, those comments came from my own reporting. If a subject speaks in the past tense, the quotes came from an archival source.

The movies covered in *BEST. MOVIE. YEAR. EVER.* were released between January 1 and December 31, 1999, with a few exceptions. *Rushmore* and *The Thin Red Line* enjoyed limited awards-qualifying runs in December 1998 before expanding wide in early 1999. *The Virgin Suicides*, meanwhile, debuted at the Cannes Film Festival in 1999 before being released theatrically in 2000.

Finally, while *The Matrix* was credited in 1999 to writer-directors Andy and Larry Wachowski, the filmmakers in later years transitioned to Lilly and Lana Wachowski, respectively, and are referred to as such throughout the book.

AUTHOR'S NOTE

This book is based upon more than 130 interviews conducted between March 2017 and January 2019. At times I also rely on archival interviews, speeches, videos, and commentary tracks. If a subject speaks in the present tense, those comments came from my own reporting. If a subject speaks in the past tense, the quotes came from an archival source.

The movies covered in *BEST. MOVIE. YEAR. EVER.* were released between January 1 and December 31, 1999, with a few exceptions. *Rushmore* and *The Thin Red Line* enjoyed limited awards-qualifying runs in December 1998 before expanding wide in early 1999. *The Virgin Suicides*, meanwhile, debuted at the Cannes Film Festival in 1999 before being released theatrically in 2000.

Finally, while *The Matrix* was credited in 1999 to writer-directors Andy and Larry Wachowski, the filmmakers in later years transitioned to Lilly and Lana Wachowski, respectively, and are referred to as such throughout the book.

PROLOGUE

"LOSING ALL HOPE
WAS FREEDOM."

DECEMBER 31, 1999

It was New Year's Eve, and on a private beach resort in Mexico, a handful of couples had gathered to celebrate the end of the century. Brad Pitt and his then girlfriend, Jennifer Aniston, were there. So were director David Fincher and his partner, the film producer Ceán Chaffin. For the last few months, they'd watched the world react with fury to *Fight Club*, Pitt and Fincher's bruising new tale of chaos-loving alpha-maniacs. The movie was an assaultive big-budget takedown of late-nineties values with a catchphrase so recognizable—"The first rule of fight club is: You do not talk about fight club"—that Aniston had spoofed it while hosting *Saturday Night Live* that fall. But although people *had* talked about *Fight Club*, often angrily, few moviegoers had actually shown up to watch it. The film had barely earned back half its budget at the box office, making it among the biggest commercial failures of the two men's careers. By the time the group arrived in Mexico, says *Fight Club* producer Chaffin, "we were still licking our wounds."

Joining them on the getaway was Marc Gurvitz, a high-powered manager who worked with Aniston and who'd come to the island with his then fiancée. He remembers the early moments of their trip as being largely relaxed—so much so that he felt comfortable enough to prank his companions, putting fake snakes and scorpions in their beds. But Gurvitz was also a bit nervous about the decade coming to a close. Like millions of others, he'd heard the warnings: about how at midnight that night—just as the twenty-first century was grabbing a rave whistle and starting its hundred-year party—a global cataclysm would supposedly reboot civilization. Skylines would dim. Bank accounts would flatline. Things would break down. It was a save-the-date disaster with a strict deadline and a catchy name: Y2K, short for "Year 2000." "Everyone was afraid that the world was going to end," says Gurvitz. "It was pretty scary." Even *Fight Club* had picked up on that premillennial tension, its final scene consisting of a series of credit card company headquarters crumbling to the ground—a chance for society to start anew. As Pitt later recalled, the mood in 1999 was one of uncertainty: "What was going to happen?" the actor asked. "People weren't gonna go on trips, even, because they were afraid."

Pitt and his fellow vacationers had nonetheless braved it to their island resort, where they'd be hours away from the nearest city. No matter what went down when the clock struck twelve, they'd largely be on their own. As the moment drew closer, Gurvitz and the others assembled for margaritas near the beach. Just as the new year was about to arrive, though, the group was thrown into darkness. "It was *three . . . two . . . one . . .* and then all the power in the entire place went out," says Fincher. "There was nervous laughter, like, '*Y2K, ha-ha-ha!*'"

The group decided to relocate to a nearby bonfire. "All of a sudden," remembers Gurvitz, "two jeeps in the distance come out of the dark with their lights flashing." It was a team of local *federales*, many traveling in a large black vehicle with the word *policía* on it. "There were three nineteen-year-old kids with M16s in the back," says Fincher. "They came over the hill, pulled in, and got out and went running into the main lobby."

Eventually the hotel concierge emerged, saying there was a problem with the plane the group had chartered to the island, and that someone needed to come with the police. The task would fall on Gurvitz, who was confused—in the dark in every way. Before he knew it, Gurvitz's hands were being pulled behind his Hawaiian-print shirt and placed in cuffs. The federales were speaking to him in Spanish, which Gurvitz couldn't understand. But he realized they were taking him to jail. "Pitt walks up to the guys," Gurvitz recalls, "and gets in their face: 'Hey! You can't come into a resort and take an American citizen!'" Unimpressed, the officials threw Pitt to the ground. "Brad's saying, 'This is outrageous! You'll hear from my attorneys!'" says Fincher, who volunteered to go with Gurvitz.

As they pulled away from the beach, Gurvitz looked back at his party, unsure of what would happen next. "His fiancée's freaking out, in tears," Pitt said. "They're driving off with him into the pitch blackness, and he's surrounded by guys with [guns]."

Gurvitz watched as his friends grew smaller in the distance. Just as he'd feared, something had gone wrong. Something had broken down.

Oh my fucking God, he thought.

In the final months of the twentieth century, millions of Americans believed we were headed toward a reckoning—so much so, they spent what was left of the nineties gearing up for a meltdown. Some converted their homes into DIY fallout shelters, stocking them with canned chow mein, toilet paper, or three-hundred-gallon waterbeds (which they could pop open and drink from in the event of a drought). Others prepared by buying guns—*lots* of guns. Less than two weeks before the arrival of the new millennium, the FBI received 67,000 gun sale background check requests in a single day, setting a new record. Many of those applicants had no doubt become obsessed with the "millennium bug"—a data hiccup that would supposedly cause thousands of computers to simultaneously collapse, unable to recognize the changeover from 12/31/99 to 01/01/00.

The US government, along with several corporations, had spent an

estimated $100 billion combined to upgrade their machines in time. In Silicon Valley, Y2K worries were so pitched that Apple head Steve Jobs commissioned a Super Bowl ad featuring HAL, the creepily sentient computer system from Stanley Kubrick's 1968 sci-fi trip *2001: A Space Odyssey*. The commercial finds HAL speaking from the future, where he apologizes for the chaos caused by the changeover. "When the new millennium arrived," HAL says coldly, "we had no choice but to cause a global economic destruction." (The only computers to avoid the meltdown, according to HAL, were made by Apple.)

The famously private Kubrick would later call Jobs, telling him how much he had enjoyed the spot. Yet some in the tech industry didn't find the prospect of Y2K funny. There was a real fear that, no matter *what* we did to prepare, Prince's famed pop prophecy was bound to come true: "Two-thousand-zero-zero/party over/oops/out of time." "I've seen how fragile so many software systems are—how one bug can bring them down," a longtime programmer told *Wired*. He'd retreated into the California desert and built a solar-powered, fenced-off New Year's Eve hideaway (he also bought his very first gun, just in case). Others saw Y2K as a potential biblical event: in Jerry Falwell's home video *Y2K: A Christian's Survival Guide to the Millennium Bug*, available for just under $30 a pop, the smug televangelist—last seen warning his flock about the gay agenda of the Teletubbies—cautioned that Y2K could be "God's instrument to shake this nation, to humble this nation" (he also advised loading up on ammo, just in case).

Whether they were freaked out by technology or theology, many of the end-timers shared a common tut-tutting anxiety: namely, that we'd advanced a bit *too* much during the twentieth century, sacrificing our humanity in favor of ease and desire. And now retribution was due, whether it took the form of an act of God or a downloadable rapture. As one mother of three sighed in the December 31, 1999, edition of the *New York Times*, "It just seems like the end is getting closer."

If the collapse of civilization *was* upon us, the timing couldn't have been worse. In 1999, the United States was in the midst of an unexpected

comeback. The decade had begun with a recession, pivoted to a foreign war, and nearly culminated in a president's removal from office. Now, across the country, people were indulging in a wave of contagious optimism. You could see that giddiness on Wall Street, where, throughout 1999, the Dow Jones, the NASDAQ, and the New York Stock Exchange had all experienced hypercharged highs. You could sense it on the radio, where the gloom raiders who'd soundtracked so much of the decade had been replaced by teen cutie pies and *loca*-living pop stars. You could even experience it via the digital dopamine rush of the internet, which was still in utero—and still populated by weirdos—but which had the potential to make everyone smarter or richer than they'd ever imagined. In just a few years, Jeff Bezos had transformed Amazon.com from an online bookseller to an all-encompassing twenty-four-hour shopping mall (Bezos's awkwardly smiling face would be stuffed into a cardboard box for *Time*'s 1999 Person of the Year cover). And before the year was over, the recently launched movies-by-mail company Netflix would raise $30 million in funding, and introduce its first monthly DVD-rental plan.

But the surest way to feel that static-electric *zap* of possibility was to walk into a movie theater in 1999—the most unruly, influential, and unrepentantly pleasurable film year of all time.

It began with January's Sundance Film Festival debut of *The Blair Witch Project*—a jumpy, star-free vomit comet—and ended with the December deluge of *Magnolia*, the movie-ist movie of the year, featuring a 188-minute running time, a plague of frogs, and the sight of megaceleb Tom Cruise crotch thrusting his way to catharsis. In between came a collision of visions, all of them thrillingly singular: *The Matrix. The Sixth Sense. Election. Rushmore. Office Space. The Virgin Suicides. Boys Don't Cry. Run Lola Run. The Insider. Three Kings. Being John Malkovich.* Many of those films—along with *Star Wars: Episode 1—The Phantom Menace*, the most unpopular popular movie of the year, if not of all time—would break the laws of narrative, form, and even bullet-time–bending physics. In 1999, "The whole concept of 'making a movie' got

turned on its head," proclaimed writer Jeff Gordinier in a November cover story in *Entertainment Weekly*. "The year when all the old, boring rules about cinema started to crumble."

Yet for all their audacity, the movies of 1999 were also sneakily personal, luring viewers with promises of high-end thrills or movie star grandeur—only to turn the focus back on the audience, forcing them to consider all sorts of questions about identity and destiny: Who am I? Who *else* could I be? The body-bending thrills of *The Matrix*; the white-collar uprisings of *Fight Club* and *Office Space*; the self-seeking voyages of *Being John Malkovich* and *Boys Don't Cry*; the Xbox-on-ecstasy story line swaps of *Go* and *Run Lola Run*. Each was a glimpse of not just an alternate world but an alternate you—maybe even the *real* you. As exhilarating as it was to walk into a theater that year, it felt ever better to float on out, alive with a sense of potential, the end credits hinting at a new start. Maybe something *amazing* was awaiting us on the other side of 1999.

"It was a new century—the beginning of a new story," says director M. Night Shyamalan, whose spiritual shocker *The Sixth Sense* would become 1999's second-highest-grossing movie. "And it was a time for original voices. The people paying to make the movies—and the people going to the movies—all said, 'We don't need to know where we are going. We trust the filmmaker.'"

Studio executives have long lusted for the so-called four-quadrant movie—a film that appeals equally to men and women, young and old. But 1999 was a four-quadrant year: it had something for everyone. The domestic box office pulled in nearly $7.5 billion, and although some of that was fueled by franchise entries such as *Toy Story 2* and *Austin Powers: The Spy Who Shagged Me*, many of the most successful films of 1999 were complete originals: *The Matrix*, *The Sixth Sense*, *American Beauty*, *American Pie*, *Notting Hill*, and *The Blair Witch Project* all made more than $100 million, even though none was based on a comic book series, a TV show, or a real-life witch (despite what some *Blair* viewers may have believed). "One thing I learned from my farmer friends is that, every twenty or thirty years, you get a good harvest," says actor Luis

Guzmán, who appeared in *Magnolia* and *The Limey* (and who spends a good amount of time in rural Vermont). "And that's how I look at the movies from 1999."

Film dictated the conversation that year—which is impressive when you consider just how satisfyingly overstuffed 1999 was. Top-forty pop had just been reignited by MTV's *Total Request Live* and such crazy-sexy-cruel mainstays as Britney Spears, Christina Aguilera, Eminem, and Limp Bizkit's Fred Durst. And the January arrival of the mob drama *The Sopranos*—the most must-see TV show in a year that was full of them, from *The West Wing* to *Freaks and Geeks*—heralded a small-screen overthrow that would only become more pronounced in the years to come.

But in 1999, the movies were still the higher power of popular culture. You *had* to see *Fight Club*—or *American Beauty* or *Rushmore* or *Magnolia*—if for no other reason than to see what everyone else was talking about.

There'd been other years like this, of course—ones in which film took an almost teleportative leap forward, reinventing and reviving itself in front of our very eyes. In 1939, the triple-headed tornado of *The Wizard of Oz*, *Gone With the Wind*, and *Stagecoach* reimagined what big-screen storytelling could look like. The year 1967 saw the generation-defining (and generation-dividing) debuts of *Bonnie and Clyde* and *The Graduate*, while a decade later came *Star Wars*, *Annie Hall*, and *Eraserhead*—a trio of films that are still being ripped off and riffed upon today. Even a relatively shallow season like 1985, which occurred smack in the middle of the escapist Reagan era, could find room for sneak-attack thrills such as *Brazil*, *After Hours*, and *Desperately Seeking Susan*. Pretty much *every* movie year is a good one, even if you have to do some searching to find the masterworks or minimovements.

But in 1999, sixty years after Dorothy dropped a house into Oz, a group of filmmakers started their own Technicolor riot, one that took place right on the fault line of two centuries, and drew power and

inspiration from both. Many of the directors, writers, and executives from that year were de facto film scholars—some educated at NYU or USC, some by VHS—and their movies shared a reverence for what had come before. It wasn't hard to connect *The Matrix*'s reality-revealing red pill to *Oz*'s yellow brick road; or the fax-and-mouse games of *The Insider* to the hush-hush muckraking of *All the President's Men*; or the adrift suburban teens of *The Virgin Suicides* to the ones in *Sixteen Candles*.

"We may be through with the past, but the past ain't through with us," is the oft spoken mantra of *Magnolia*, and the past was everywhere you looked in 1999—as if all of those previous cinematic epochs had been compressed, burned onto a zip drive, and passed around from one filmmaker to the next. The movies that loomed largest over 1999 were the ones produced between 1967 and 1979—a period that saw an unparalleled, and today unthinkable, combination of high-IQ thrillers, confrontational comedies, and existentially troubled dramas. For many late-nineties directors, the so-called Easy Riders, Raging Bulls filmmakers—named after Peter Biskind's myth-making 1998 book— were the big screen's own greatest generation, executing wild ideas with big-studio backing. "They were movies that dealt with the texture of real life," says director Alison Maclean, whose 1999 druggie travelogue *Jesus' Son* was influenced by such rough-and-tumble seventies pictures as *The Long Goodbye* and *The Panic in Needle Park*. "There's a soulfulness to those films, and a sense of spiritual crisis—of something being broken."

Decades later, that unvarnished, unfulfilled sense of purpose-driven *ennui* crept back into movie theaters. Sometimes the links between the movies of 1999 and the films of the Nixon/Carter years were atmospheric: the Gulf War–set *Three Kings* echoed such combative black comedies as *M*A*S*H* and *Catch-22*, while the doomed heartland romance in *Boys Don't Cry* recalled the one in *Badlands*. Other times, the filmmakers had consciously sought to forge connections with the past. Pedro Almodóvar's Oscar-winning *All About My Mother*—a vibrant heartbreaker about love and theater—was inspired by John Cassavetes's 1977 drama

Opening Night. Before shooting *Magnolia*, writer-director Paul Thomas Anderson held cast and crew screenings of the 1976 tragicomedy *Network* for inspiration. And no movie seduced quite as many filmmakers as 1967's *The Graduate*, the quintessential tale of rudderless youth that informed everything from *Fight Club* to *Rushmore* to *American Pie*.

But that reverence toward film's history was matched by a desire to fuck around with its future. Everything was up for grabs in 1999—visually, narratively, thematically. The old "It's like movie X meets movie Y" descriptors simply didn't compute anymore. "I remember looking at that lineup in '99 and thinking, 'Name me any year between 1967 and 1975 that had more really original young filmmakers tapping into the zeitgeist,'" says *Fight Club*'s Edward Norton. "I would stack that year up against any other." Adds Sam Mendes, whose suburban nightmare debut, *American Beauty*, earned Academy Awards for Best Director and Best Picture: "It's astonishing how many different genres were being redefined. Is *The Sixth Sense* a horror movie, a thriller, or a ghost story? What is *Fight Club*? What is *Being John Malkovich*? Even *American Beauty*—is it a coming-of-age tale or a fantasy? Something was definitely shifting."

It wasn't just genres that were evolving in 1999. Storytelling itself was in the middle of a mutation. Aided by quick-moving digital editing machines and cheap video cameras, filmmakers ripped up and remixed the century-old rules of cinema, screwing with time, perspective, and expectations. Movies such as the madcap *Go* or Steven Soderbergh's crisp neo-noir *The Limey* treated traditional story beats like Tetris blocks, stacking them atop or snugging them around one another—or letting them fall, just to see what form they might take. And *The Matrix* and *The Phantom Menace* used immersive digital effects to render entire artificial worlds, which could then be altered with a computer; it was almost as if the filmmakers could actually reach right into the frame and reorder their onscreen universe.

Audience members—who'd spent the nineties retraining their brains to absorb everything from reality TV to *Resident Evil* to pixel-dusted webcam videos—were willing to play along, even if they

didn't always know what they were getting into. "The entire narrative structure of movies exploded," notes Lisa Schwarzbaum, an *Entertainment Weekly* film critic from 1991 to 2013. "You could tell stories in pieces, or backward. You could be lost at the beginning, or you could repeat things, or you could have people flying around the Matrix."

At times the movies of 1999 felt like part of some mass insurrection, one overseen by three overlapping generations of idiosyncratic filmmakers. "These are very eclectic, interesting directors, who have all stood the test of 'Do you have anything really to say?'" notes Fincher, who refers to his peers as "precocious, inspired lunatics." "*Speed* was one of the biggest movies that had ever been made at that time—but was [director] Jan de Bont a voice? No. These directors we're talking about all have something that stains what they do."

Some of the Class of '99—including *Eyes Wide Shut*'s Stanley Kubrick and *The Thin Red Line*'s Terrence Malick—were returning to moviemaking for the first time in decades. Others, such as Michael Mann (*The Insider*), had been revered as sly, stylish troublemakers since at least the eighties. Then there were the upstarts who'd begun their careers in the world of lower-budget indies: Wes Anderson (*Rushmore*), the Wachowskis (*The Matrix*), and Alexander Payne (*Election*), among several others. In 1999, they'd all be joined by such nü-brat debutantes as Sofia Coppola, Spike Jonze, and Kimberly Peirce. "We were de facto *not* the establishment," Peirce says of her contemporaries. "A bunch of us were reacting to the bigger and more actiony movies of the nineties, saying, 'That's not how I think—but I have *this* story that I really love, one that's smaller and weirder.'"

Nearly all the filmmakers of 1999 opted to tell stories that were similarly personal (even if they weren't always quite so small-scale). And they often subverted the expectations of their own fans. Few would have guessed, for example, that *Magnolia*'s Paul Thomas Anderson would follow his sweaty porn-biz odyssey *Boogie Nights* with a sober drama about cancer and interconnectivity. Nor would anyone have predicted that David Lynch—who'd spent the decade making such provocations as *Twin Peaks: Fire Walk with Me*—would close out the

nineties with a film like *The Straight Story*, a G-rated, Disney-released tale of an elderly man traveling cross-country on a tractor to visit his ailing brother. If the writers and directors of 1999 shared one unspoken trait, it was the ambition to make something no one had seen before. "Young and older generations came together in this exploratory way," says *Run Lola Run* writer-director Tom Tykwer. "There was this beautiful competition between experimental filmmaking and the so-called established filmmaking. But they were also giving each other fire and enthusiasm."

And they were doing so in a year in which some people were penciling the apocalypse on their calendar, just in case. "There was so much going on about Y2K, and so much talk about computers going haywire, that it even reached down to the people who thought it was total malarkey," says *The Straight Story* cowriter and editor Mary Sweeney. "It was the end of a very dramatic decade."

While the nineties would later be revised by some as a sort of pre-9/11 paradise, the period had in fact been marked by social and political tumult: the beating of Rodney King, the battle over Anita Hill, and terrorist attacks like the bombing in Oklahoma City. By the time 1999 arrived, it felt like *anything* could happen. "People forget how much anxiety there was," says Norton. "It was the anxiety of Gen-X entering adulthood, and it had real collateral. It's expressed in *Magnolia*, it's expressed in *Fight Club*, and it's expressed in *Being John Malkovich*: that anxiety about being asked to enter a world that seemed a little bit uninviting."

But it's Norton's *Fight Club* character—an unnamed solace seeker who dramatically reboots his own life—who discovers the hidden promise of this new era of uncertainty: "Losing all hope was freedom," he says, and many of the filmmakers and performers from the 1999 movies could relate. Thrown together at the end of the century, and at the height of their industry's pop-culture powers, they'd been liberated from constraints of budget and technology—and sometimes even the wishes of their bosses—to make whatever movie they wanted, *however* they wanted. "Maybe it was the rush of everyone thinking about the

end of the world," says Rick Famuyiwa, the writer-director of the 1999 comedy-drama *The Wood*. "We felt we had to get our voices heard before we all disappeared."

And so, as the clocks drew closer to midnight on New Year's Eve and the Y2K buzzkillers waited it out from their homemade bunkers, the rest of the world prepared to party into a new age. At the White House, President Bill Clinton and First Lady Hillary Clinton hosted a massive gala, as well as a musical concert emceed by Will Smith, he of the recent kinda hit "Will 2K" ("What's gonna happen/Don't nobody know/We'll see when the clock hits twelve-oh-oh"). In Manhattan, nearly a million ball watchers showed up in Times Square—the home of MTV's studios, where No Doubt's Gwen Stefani would play R.E.M.'s hyperwordy "It's the End of the World as We Know It (And I Feel Fine)," aided by a grip holding up cue cards.

Meanwhile, at smaller get-togethers across the country, revelers stuck close to friends and family, waiting to make sure the millennium went off without a hitch. Brendan Fraser, star of 1999's summer hit *The Mummy*, was in his newly finished home in rainy Los Angeles, watching *Tonight Show* host Jay Leno fend off the downpour on live television, "looking like a wet cat who was really annoyed," Fraser says. Shyamalan—no stranger to surprise endings—sat in his Pennsylvania home, keeping an eye on his newborn daughter. Sofia Coppola and her husband, *Being John Malkovich* director Spike Jonze, gathered for a decadent get-together at her parents' estate in Napa Valley, California. "If it was the end of the world," she says, "we were going to do it in style." And *The Matrix*'s Joe Pantoliano was at a neighbor's house in suburban Connecticut, hanging in the laundry room with actor Chazz Palminteri. Pantoliano had stockpiled some valuables for the millennium, just in case. "I'd bought $10,000 worth of silver coins and hid them above the refrigerator," he says. "If there was any validity to Y2K, I thought I could buy milk and gas and tools."

Not all of the celebrants that night were quite as concerned about

the centennial changeover. Fraser remembers that by December 31, end-times hoopla had gotten so out of hand it was hard to take it seriously: "There'll be giraffes on fire charging down the street! ATM machines are going to spit cash everywhere!" he jokingly remembers of the warnings.

Yet with an uncertain new decade now closer than ever, it was hard to put such concerns completely out of mind. That night in Los Angeles, Reese Witherspoon, the twenty-three-year-old star of *Election* and *Cruel Intentions*, was at a party in Los Angeles, just months after giving birth to her first child. At one point during the festivities, her *Cruel Intentions* costar (and then husband) Ryan Phillippe took a photo of Witherspoon posing underneath a giant Y2K sign, her hands covering her head. "We were all terrified," she says.

Meanwhile in Mexico, Marc Gurvitz was heading down a long, darkened road. Fincher, riding with him, noticed the lights had suddenly gone back on at the resort, and asked the gun-toting officials to allow Gurvitz to return to make a phone call. Reluctantly, the driver agreed.

Soon the vehicle was pulling up at the beach—which is where Pitt and the rest of the revelers were waiting. "They've all got jeroboams of champagne, and Brad's wearing this ridiculous gold-sequinned little party hat," remembers Fincher. The whole thing had been a setup: the power outage, the arrest, even Pitt's tussling with the federales ("Daniel Day-Lewis would have been awed," Fincher says of the actor's performance). After being subjected to Gurvitz's own practical jokes for days, Fincher and Pitt—the space-monkeys behind *Fight Club*—had decided to take their revenge, coordinating the stunt with the help of the locals. "It was as harsh as it could be and not be cruel," says Fincher, still chuckling at the ruse decades later. "Listen, if we could have had gunfire with blanks, we'd have done it, but it was a last-minute thing." Even Gurvitz eventually laughed, "after I cleaned up my pants," he says. "It was like Fincher choreographed a movie. That's how sick these fucking guys are."

As midnight arrived across the world, millions felt the same way as Gurvitz: They'd been pranked. The meltdown of Y2K never arrived.

Computers kept humming; planes remained airborne; bank accounts survived. "Just a whimper, not a bang," says Fraser.

Y2K was its own kind of phantom menace. We'd spent so much time wondering what the twenty-first century might look like, most of us failed to notice that it had already shown up. And if you wanted to see it, all you had to do was go to the movies.

WINTER

There won't be any accidental survivors. Hell starts January 1, 2000, when the lights go out. . . . The euro, the new currency for most of Europe, got off to a strong start yesterday. . . . *My loneliness is killing me (and I)/I must confess I still believe (still believe).* . . . **MONICA LEWINSKY RETURNS TO WASHINGTON TO GIVE DEPOSITION** . . . *What happened to Gary Cooper? The strong, silent type. That was an American. He wasn't in touch with his feelings. He just did what he had to do.* . . . *A scrub is a guy that can't get no love from me.* . . . "So we tell the Americans as people," bin Laden said softly, "and we tell the mothers of soldiers and American mothers in general that if they value their lives and the lives of their children . . ." . . . *I think Ross knows about me and Monica.* . . . **CLINTON ACQUITTED DECISIVELY: NO MAJORITY FOR EITHER CHARGE** . . . *Welcome to* The Daily Show. *Craig Kilborn is on assignment in Kuala Lumpur. I'm Jon Stewart.* . . . In an upset, "Shakespeare in Love" was selected Best Picture tonight at the 71st annual Academy Awards, defeating Steven Spielberg's "Saving Private Ryan," the favorite. . . . **JOE DIMAGGIO, YANKEE CLIPPER, DIES AT 84** . . . Polls show that the public is ambivalent about a Gore Presidency. . . . *Hi! My name is (what?)/My name is (who?)/My name is (chika-chika) Slim Shady.*

1

"I'M SCARED TO CLOSE MY EYES. I'M SCARED TO OPEN THEM."

THE BLAIR WITCH PROJECT

In the late nineties, when reporters asked Robert Redford about the crazed ascent of his long-running Sundance Film Festival, the actor-director-producer's response was part boast, part warning: "It's gotten to be a monster."

Over the course of the decade, Redford's tucked-away moviegoing retreat had been transformed into a high-altitude hunting ground. Thanks in part to Sundance discoveries such as *Hoop Dreams* and *Reservoir Dogs*, the upscale mountain town of Park City, Utah, was overrun each January with hit-snuffling studios, all looking to bag bragging rights for the next big thing. Leading them was Miramax, the New York City indie powerhouse cofounded by Harvey and Bob Weinstein. Decades later, the brothers and their empire would be undone after numerous accusations of sexual abuse and rape were lodged against Harvey Weinstein, driving him out of Hollywood. But in the nineties, the Miramax founders were everywhere—a pair of Queens-born goons

with decent taste and halitotic personalities. Miramax had incited the modern indie film riot back in 1989, when it purchased writer-director Steven Soderbergh's debut, *sex, lies, and videotape*, for $1 million, not long after the film's Sundance premiere. It was a daring price to pay for a conversational, quietly creeping drama about sweat-flecked yuppies who voice their lustiest confessions on camera.

Yet *sex* became a surprise box-office hit, and several new small-scale studios were launched in its wake, hoping to capture some of *sex*'s independently spirited audience. For the next several years, executives would scour Sundance's screening rooms, where they'd divine such future art house sensations as *Crumb* and *Welcome to the Dollhouse*. They'd also eyeball younger filmmakers, some of whom would be plucked from Sundance and given a chance to direct a (slightly) bigger-budgeted feature for one of the newly emerging mini-major studios, like Fox Searchlight and Sony Pictures Classics. "We called them 'Indiewood,'" says Sarah Price, coproducer of the 1999 documentary *American Movie*, about a defiantly DIY horror director trying to complete his opus. "You could make one or two features independently, go to Sundance, and then get offered an Indiewood feature—everybody was going down that track."

But as the decade went on, the nineties indie film surge began to turn into a slog. In Park City, thin oxygen levels and unreliable buzz whisperers prompted buyers to overspend on underperforming titles such as 1996's *The Spitfire Grill*, a mawkish rural drama that was scooped up for a ludicrous $10 million. The movie would play in theaters for little more than a month—just one of countless big-deal Sundance films to evaporate upon reaching normal altitude. There were too many *enh*-inducing movies being produced and purchased for too much money, and not enough moviegoers to watch them all. "With so many art films out there, they're killing each other," Harvey Weinstein said at the time. "The goose that once laid the golden eggs is slitting its own throat."

Miramax, though, had laid many of those eggs itself. In 1993, the

studio that had once been a conferrer of downtown indie cool was bought by Disney in a deal estimated at between $60 million and $80 million. The extra capital and clout allowed Miramax to inject nervy hits such as *Sling Blade* and most notably *Pulp Fiction* into the mainstream. *Pulp Fiction* represented the Miramax apex: released in the fall of 1994, Quentin Tarantino's chatty crime caper made more than $100 million and earned seven Academy Award nominations. Yet the triumph of films such as *Pulp Fiction*—as well as later Miramax hits such as *Trainspotting* and *Velvet Goldmine*—tended to obscure some of the snoozy dramas and slack Gen-X romances that clotted the studio's roster. By decade's end, the company was slipping into a semirespectable middle age, investing in pricey Oscar winners such as *The English Patient* and *Shakespeare in Love*, while casually throwing millions at Sundance films they'd sometimes barely bother to release.

As Miramax chased awards and higher box-office rewards, so, too, did its competitors. For the American indie movement, *Pulp Fiction* was a mushroom cloud–laying motherfucker: after its success, studios wanted their smaller-budgeted movies to have outsized impacts. "Earlier in the decade, exhibitors understood we needed word of mouth, and we could nurture a film along through many, many weekends," says Allison Anders, the writer-director of such acclaimed nineties indies as *Gas Food Lodging*. "Once *Pulp Fiction* happened, forget it. Everybody wanted that big opening weekend, and they wanted all the stars."

Indie distributors also wanted prestige, which often came in the form of polite dramedies (*The Brothers McMullen*), heartbreaking tales of triumph (*Shine*), or cheery comedies (*The Full Monty*). They were the kinds of films that could play for months in upscale markets, hopefully gaining awards traction along the way. The popular definition of "independent movie" was changing. Instead of the cheap acts of insurrection that had spurred the movement in the early nineties, such as *Clerks* and *El Mariachi*, many of the new indies were glossy, classy, and thoroughly nana-pleasing. By the time Sundance 1999 rolled around, there was a

well-worn playbook for turning a low-budget movie into a middlebrow success, one that Miramax had helped create: find a *slightly* outsidery tale of uplift with a famous face or two; hype up its festival cred and underdog charm; roll it out delicately across the country.

Then a bunch of kids went and got lost in the woods, and the rules changed all over again.

One night in the fall of 1991, horror fans Daniel Myrick and Eduardo Sánchez found themselves at a theater on the campus of University of Central Florida, taking in a screening of *Freddy's Dead: The Final Nightmare*. The film pitted the once terrifying Freddy Krueger against the likes of Roseanne Barr and Tom Arnold. "We were film students, and it was a free movie—we would never turn that down," says Sánchez. Afterward, the two men held a post-screening postmortem on the state of the horror genre. "We were like, 'What the hell happened to scary movies?'" Sánchez remembers. "*The Exorcist, Jaws, The Shining, The Changeling*—these movies had all creeped us out as kids." Sánchez and Myrick went on to discuss the pseudodocumentaries and TV shows they'd seen growing up, such as *The Legend of Boggy Creek*, a 1972 film that purported to document a Bigfoot-like creature in rural Arkansas, and the Leonard Nimoy–hosted series *In Search of . . .* , which chronicled such phenomena as UFOs and ESP. What if, they wondered, they used the fake documentary format of *Boggy Creek* to make a movie as legitimately frightening as *Jaws*? "We were reacting to a lot of the CGI'd fare that was coming out at the time," Myrick says, "and we wanted to make something authentic."

Myrick and Sánchez soon came up with a legend of their own, about a group of documentarians who'd ventured into the woods, looking for some mythic evil—only to become lost forever, their fates captured in the rolls of film they left behind. It was an idea that was still on their minds years later, after both men had graduated. One night, in Orlando, Myrick mentioned the lost-in-the-woods legend while out for drinks

with fellow UCF alum Gregg Hale. "The hackle on the back of my neck went up," Hale remembers. "I said, 'I want to produce this.' And I'd never produced anything in my life, except for stuff in film school."

Working with Sánchez, the team developed a brief teaser, which they hoped would lure investors. Leaning heavily on the docu-investigation style of *In Search of. . .*, their video used black-and-white photographs, nineteenth-century drawings, and starchy narration to tell the story of an ancient horror in the woods of Maryland, dubbed the Blair Witch, who was rumored to be responsible for countless deaths. The nearly ten-minute-long video was an expertly concocted con—proof of how well the filmmakers had studied the teasing narratives and mock gravitas of modern nonfiction storytelling. Now they just needed enough money to turn their short into a feature film. Surely *someone* would be interested in funding them. After all, it was the nineties. Everybody wanted to be in the indie business.

By then, the UCF team—which included Myrick, Sánchez, Hale, and fellow alumni Robin Cowie and Michael Monello—had rechristened themselves Haxan Films, after an early-twenties faux documentary about witchcraft. Beginning in the fall of 1996, they set out to meet with potential investors, with the aim of raising $350,000, which Haxan figured would be enough to pay for a crew, catering, and other comforts. Hale assembled rooms of dentists and doctors, hoping to convince them to chip in $50,000 apiece. "We'd get ten people in a room, and present the tape as if it was real," says Hale. "They'd all be freaking out, and we'd say 'Got you! It's a fake.'" The response was one of the first signs that their found-footage ruse worked. But, as Hale soon learned, no one wanted to hand over tens of thousands of dollars for what appeared to be, at best, a startlingly effective prank.

Not long afterward, the filmmakers learned that John Pierson was heading to Orlando. Pierson, then in his early forties, was a well-known indie movie connector and connoisseur who'd helped nurture the careers of Spike Lee and Kevin Smith, among other upstart filmmakers. "John had a crazy-ass record of being cool to indie filmmakers," says

Sánchez. "And he always knew how to back up talent." Pierson was coming to town to cover a local festival for an episode of *Split Screen*, an indie-culture TV series he was hosting and producing for the recently launched Independent Film Channel. Myrick helped out with filming and, as the shoot was winding down, handed Pierson a copy of their teaser. Pierson had screened nearly 550 full-length features in 1995 alone; watching the Haxan team's ten-minute short would be easy. Afterward, he called up Myrick and asked if the Blair Witch story was real. It was an encouraging sign for the filmmakers, especially as Pierson hailed from Maryland. "I *shouldn't* have been fooled by it," he says. "But that shows how much I suspended my disbelief."

Pierson offered the team $5,000 to air the footage on *Split Screen* and another $5,000 to shoot a follow-up segment. Combined with money that the members had scrapped together themselves, Haxan now had about $22,000 to put into their movie. At a time when some more polished, studio-backed indies were being made for seven figures, the *Blair Witch* budget was a throwback to the self-funded indies of the early nineties, when filmmakers like Richard Linklater (*Slacker*) and Robert Rodriguez (*El Mariachi*) maxed out credit cards and borrowed whatever they could to get their movie made.

Haxan's limited finances wouldn't allow for caterers or big crews. But it would give the filmmakers the chance to incorporate a new narrative element they were folding into their tiny horror tale. It had been inspired by Hale's four-year stint in the army, during which time he'd enrolled in a survival program called SERE (short for Survival, Evasion, Resistance, and Escape). "It was terrifying," Hale says. "They dump you in the woods for four or five days and chase you, so you don't get any sleep. Then everybody was captured and taken to a fake POW camp." Hale figured the Haxan team could adopt that approach to create "a narrative obstacle course in the woods," he says. "We'd run the actors through it, and by the end, when they reach the house, they'd be all fucked up. And they could use all of that in their acting."

It was an ingenious and potentially dangerous way to make their movie. And it raised a new challenge for the filmmakers: Where do

you find a bunch of young actors crazy and desperate enough to throw themselves into the woods for a week-long experiment?

The answer was obvious: go to New York City.

Every Wednesday night right before midnight, Heather Donahue would rush down to her local newsstand, waiting for the latest issues of the theater tabloid *Back Stage* to go on sale. "As soon as that thing was un-wrapped, I was on it," says Donahue, who'd scour the audition listings and open-call notices from around the city. In 1997, the actor spotted a particularly strange ad for a film. The part required a knack for impro-visation and an ability to work under difficult conditions. "Everybody around me said, 'This sounds horrible,'" recalls Donahue. "I was like, 'Sign me up.'"

Donahue, who hailed from outside Philadelphia, didn't have many screen credits to her name; her biggest role had been a TV commercial for Psychic Friends Network. But the twenty-four-year-old had spent the past few years in New York City, studying improv and working in experimental theater. Such skills made her especially qualified for the strange audition, which featured a sign-in sheet with a warning:

> *You are about to read for the most demanding and unpleasant project of your career. If you are cast, we are going to drag you into the woods for seven days of hell. 168 hours of real-time im-provisational torment. We're not kidding. If you're not serious about your craft, then you're wasting your time and ours.*

It was Donahue's first glimpse of just how intense *The Blair Witch Project* would become. Before being ushered into a room with the two directors, Donahue was given a synopsis of the character she'd be try-ing out for: a headstrong documentarian who leads a team of filmmak-ers into the woods. Myrick and Sánchez began the audition without so much as a greeting. "I walked in, and they said something like 'We're the parole board. You threw your kid in a Dumpster. Why should we

let you out?'" remembers Donahue. "I looked them in the eye and said, 'I don't think you *should* let me out.' Then I just shut up. I thought the ability to make a bold, unlikable choice was the only way the movie was going to work. And if I had one skill, it was not giving a shit about being unlikable."

Donahue would spend months auditioning for the film, part of a casting process that, thanks to the team's slow-moving fund-raising efforts, would take more than a year to complete. During that time, Sánchez would occasionally hear from Joshua Leonard, a self-described "hippie-rocker kid" and videographer who'd missed the first round of auditions but was eager for a chance to play *Blair Witch*'s cameraman. At the time, Leonard says, "I didn't have a laser focus about being an actor. I was twenty-one, stoned, and living in New York." But at least Leonard knew his way around a camera—a crucial job requirement.

The *Blair Witch* directors began sorting prospective actors into groups of three to see how well they played off one another. Eventually, Donahue and Leonard were teamed with Michael C. Williams, twenty-four, who'd recently relocated from upstate New York, where he'd studied theater and practiced improvisation. He'd just picked up copies of his résumé and some head shots when he spotted the *Back Stage* notice for *Blair Witch*. "It had two things I loved: improvisation and camping," says the actor, who, like his castmates, underwent several callbacks before finally being hired to play the *Blair Witch* crew's soundman.

Now that the *Blair Witch* participants were finally in place, the movie's on-camera stars would maintain their offscreen names: Heather, Joshua, and Michael would become "Heather," "Josh," and "Mike." All three actors had been recruited in large part for their improv skills, but they weren't going into the woods without a plan. The Haxan team had come up with a thirty-five-page director's outline—"a script without dialogue, full of situations," says Sánchez—that would serve as a bible during the shoot, which would last a little more than a week. Plot details would be relayed to the cast in the form of brief notes, which the actors would pick up throughout filming. "Sometimes they'd be very

specific, like 'Tell Josh this,'" says Sánchez, "and sometimes they were just 'You're in a bad mood,'" or 'Holy shit, what have you gotten yourself into?'"

It was a question the *Blair Witch* cast and crew members would be asking themselves soon enough. In October 1997, the Haxan team and its stars assembled for production in Maryland, where Sánchez had a townhouse that doubled as a production base. "The area was riddled with folklore," says Myrick. "There's a lot in the soil and a lot of history you can draw from. And the woods are very barren and spooky and still."

Using Hale's survival school training, the filmmakers had set up their "narrative obstacle course," which would test the cast members' endurance without killing anyone (hopefully). The actors were equipped with a GPS device that would lead them to white crates with orange flags sticking out. That's where Donahue, Leonard, and Williams could drop off their recordings and pick up story notes for the rest of the day. The campers were also given code words—such as "bulldozer" or "taco"—to use if they needed to break the scene and get assistance from the filmmakers, who were often right nearby, wearing camouflage and communicating with each other via walkie-talkies. "We'll take care of you as a person," Hale told them before shooting. "You take care of yourself as a character."

The *Blair Witch* trio had been given a mix of new and old technology to play with, including a 16mm film camera, a DAT machine, and a $500 Sony Hi8 camcorder (the last bit of gear would be returned to Circuit City as soon as shooting completed). They were also handed just enough cash to buy food for their trip—though some of it wound up being spent on booze. On the night before they headed into the forest, "Heather," "Josh," and "Mike" checked into a motel and, with the cameras rolling, got wasted in the name of *vérité.* "Nothing sexual happened, but there probably was some singer-songwriter performances, and maybe some spoken-word poetry," says Leonard. "Thank God that never made it into the film." Also cut from the motel shoot: several moments in which Heather and Josh antagonize each other. The project's off- and onscreen realities were already starting to overlap, just as team

Haxan had hoped. "The job was finding the conflicts between characters," Leonard says. "And Heather and I were at each other's throat for a good part of the shoot."

For the most part, though, the *Blair Witch* team—and the actors who play them—appear to be in good spirits in the early moments of their trip, their personalities taking shape quickly: Heather, the enthusiastic, determined director on duty; Josh, the calm, pragmatic cameraman; Mike, the slightly dubious, slightly cranky chain-smoking sound guy. On October 23, the three of them marched into Seneca Creek State Park, carrying their gear, some food, and their soon-to-be-waterlogged wardrobes. Because the trio's "disappearance" was supposed to have occurred in 1994, the actors' clothing epitomized that era's shapeless, GAP-grunge look, a combination of flannel shirts, ever-so-slightly-baggy blue jeans, and forehead-swallowing beanies (it helped that Leonard had the long hair and semiglazed demeanor of an early-nineties video store clerk). Anybody spotting the trio would have guessed they were a bunch of bored graduate students ditching class for the week.

Once the actors were in the woods, it didn't take long for the producers' "real-time improvisational torment" to begin. At night, the Haxan team might shake the actors' tents; or use boom boxes to blast the sound of creepily chattering children; or hang up mysterious, cross-like "stick men" on the tree branches nearby. Some of their efforts almost backfired: a few nights in, the filmmakers dressed up one of their friends in long white stockings, and covered his head in white pantyhose, to give him a ghostlike appearance. He fell off a log and into the water before the scene could begin. When he was finally ready to go again, a camera fell to the ground, breaking open. It would take hours to fix. "It was late at night, we were tired, and we were freezing," says Sánchez. "That's when I thought, 'Why are we even doing this? This fucking thing is never going to work.'"

The cast members had their own hesitations. On one especially rainy day, they arrived at their location and found that the Haxan team hadn't yet completely set up their camp. Early on in the *Blair Witch* process, the actors had been warned not to break continuity: "The

filmmakers told us, 'If you ever come out of the woods, it's over,'" says Williams. But they were soaking wet, with blisters on their feet and with no way to get dry. "The three of us were trained actors," says Donahue, "and at a certain point, it was like, 'This is ridiculous. You guys don't have to put us through all this.'" It was time to yell "Bulldozer!" and pack it in for the day. The trio walked to a nearby house, knocked on the door, and were treated to hot cocoa while they waited for the filmmakers to arrive and put them up in a hotel for the night.

The actors went back into the woods the next day, but the psychological and physical duress of the *Blair Witch* shoot had begun to infect the characters' relationships. The more Heather got the team lost in the woods, the more irritated Mike and Josh became. And with the cast members feeling frazzled and combative, the narrative of *The Blair Witch Project* began to take some unexpected turns. At one point, an irked Mike kicks the team's map into the creek—a decision Williams made on the spot, and the kind of improvisatory move the filmmakers were hoping for. Mike's cackling revelation that he's tossed the team's exit plan confirms what the audience already knows: these kids are doomed.

Sure enough, it's not long before Josh disappears, his teammates finding blood-covered tatters of his flannel shirt in the woods. Leonard's trip to the woods for *The Blair Witch Project* was over, though he didn't mind: He had tickets to see a Jane's Addiction concert in New York City, and wanted to get out of town as soon as possible.

Soon after Josh's exit, Heather filmed what would become the movie's emotional climax. The unnerving power of *The Blair Witch Project* doesn't come from the rattling tents, nor from the creepy cries from the forest. It's the pre- and postterror downtime, during which we see the young campers in various stages of boredom or playfulness: Mike making fun of his chest hair; the team shopping for marshmallows before heading into the woods. Those real-life details give *Blair Witch* its credibility—and make the trio's fate seem all the more terrifying. But the film's most crushing moment comes when Heather records a sniffling, wide-eyed, two-minute monologue directly to the camera. By

now she knows she's going to die in the woods, and she apologizes to everyone's parents, including her own. Then, as the snot quivers under her nose, she finally admits defeat: "I'm scared to close my eyes. I'm scared to open them." It's an agonizing scene—equal parts confession, explanation, and self-eulogy.

For the last days of filming, members of the Haxan team relocated to a dilapidated nineteenth-century house that had been covered with kid-sized, fake bloody handprints. At night, a few of the filmmakers hid in the house to help orchestrate the story's finale: After running through the house in search of Josh, a screaming Heather comes upon Mike, who's standing frozen in the corner, facing the wall. "It was supposed to be a surprise for her," says Sánchez. "But the first time we did it, the light on her camera ran out of power, so that whole scene had to be reshot the following day." In the movie's final moments, Heather's equipment crashes to the ground. Cut to black.

The Blair Witch Project was over, at least for now. On October 31, filming wrapped, and the remaining cast members headed home. They were exhausted. They were hungry. And they were ready to go inside.

In April 1998, *Split Screen* aired the second segment of the Haxan team's work in progress, which now included the footage of Donahue, Leonard, and Williams in the woods. Pierson, the show's host, once again presented the footage as earnestly as possible, urging curiosity seekers to go to the web to find out more. Thanks to reruns, *Split Screen*'s official site had become jammed with witch hunters, and Pierson would eventually convince Haxan to set up its own site, blairwitch.com. Most late-nineties movie websites were unabashedly promotional, populated with movie clips or press photos. The *Blair Witch* site was more elaborate, with grainy crime scene photos, hazy eyewitness testimonies, and strange claims about ancient evils. "That's where the mythology started being fleshed out," says Sánchez, who built the site.

Blairwitch.com had been launched right near the end of a conspiracy-crazed decade. A generation raised on Watergate, the

Warren Commission, and whispered late-night urban legends had seen their once fringe fears go mainstream. You didn't have to dig too deep to find tales of cover-ups and unexplained phenomena—they were everywhere you looked, from Oliver Stone movies to radio shows such as *Coast to Coast AM* to Fox's hit series *The X-Files*. And the more truth that was out there, the more people believed there were *bigger* truths being obscured. When the unregulated, unwieldy internet finally arrived in the early nineties, it was the ideal vehicle for spinning rumors and speculation. Within months of the launch of the *Blair Witch* site, its message boards were populated by amateur sleuths who wanted to know if the legend was real—or who wanted to help maintain the ruse. It was only a matter of time before their efforts drifted from the web to the real world.

On Halloween 1998, one such fan called *The Mark & Brian Show*, a popular morning-drive radio program in Los Angeles, asking if they'd ever heard of the Blair Witch story. A lengthy on-air conversation ensued, leading other *Blair Witch* enthusiasts to call *their* local DJs. At one point there was so much incoming traffic to their site that it temporarily crashed. Before the year was over, an official Blair Witch email newsletter, organized by Sánchez, would grow to nearly 10,000 subscribers. Did those people *really* believe in the Blair Witch? Or were they doing this for fun, as part of a delicious, decentralized put-on? All the Haxan team knew was that they had people on the hook for their film—and they hadn't even released a trailer yet. "For a group of filmmakers who have an unfinished movie and are now trying to get into Sundance, this is all a bull's-eye for us," says Haxan cofounder Michael Monello.

It's impossible to know how much this preemptive excitement impacted the movie's Sundance chances. But in November 1998, the Haxan team got word that their low-budget experiment had been accepted to the festival. After an impromptu party in their Orlando office—"We spent the night banging on bongos, smoking it up, and drinking beer," says Myrick—the Haxan members set out to raise more money, so they could fine-tune the film's technical aspects for Sundance and pay for other festival-related costs. By selling individual shares in the movie,

the Haxan team earned enough to cover everything from posters to air-fare. The total *Blair* costs so far, according to Hale: around $150,000.

The team also hired a publicist, Jeremy Walker, who'd seen *The Blair Witch Project* at a New York screening in the fall of 1998. "As I watched the movie, I thought, 'They might actually pull this off,'" he says. "And by the end, I was totally convinced. And scared." (The Haxan team had recorded the screening in order to gauge the audience's fright levels.) Leading up to Sundance, Walker says, "the big-picture plan was actually a little-picture plan. We wanted to maintain as much mystery as possible." No prefestival screenings were held for the press, and instead of giving magazine editors a selection of publicity stills to choose from, Walker released just one shot, featuring Heather's partially illuminated face. "It was all purposely underplayed," he says.

As the movie's debut had crept closer, though, so did a shared sense of doubt: How was a visually akimbo horror movie going to play to a Sundance crowd that, in recent years, had championed feel-good dramas and noble documentaries? At one point, the filmmakers even considered pulling *Blair Witch* from Sundance altogether and instead taking a bigger slot at a smaller festival. In the weeks before the film's Park City debut, expectations were kept to a minimum. "I was excited," recalls Williams, "but the directors said to me, 'We're in this midnight movie section, so don't get *too* crazy.'"

From a distance, it didn't look like a line—it looked more like a swarm. As midnight approached on Saturday, January 23, 1999, hundreds of movie fans were squeezed into the alleyway alongside Park City's Egyptian Theatre, hoping that somebody would let them into the sold-out premiere of *The Blair Witch Project*. The temperature was dropping below thirty degrees, and everyone was dressed for the winter chill, some wearing black ski caps emblazoned with the film's cryptic stick man symbol. They'd been standing there for hours now—the final moments in what had a been, for some, a months-long obsession with the scattered online clues about *Blair Witch*. All of that intel had only made

the film's followers more curious—and more confused. Was *Blair Witch* a snuff film? A gonzo student project gone awry? The hopefuls who'd huddled together in the theater's overflow line wouldn't be getting any answers tonight. There wasn't a spare ticket to be had.

As the Haxan filmmakers walked into the theater—which had hosted such Sundance breakthroughs as *Reservoir Dogs* and *sex, lies, and videotape*—they were told that it was so stuffed with potential buyers that they'd likely have to give up some of their own seats. "We had to do a little bit of negotiating to get our friends and family in," remembers Myrick. "We weren't anticipating that kind of enthusiasm." Before the lights dimmed, he and Sánchez headed to the bathroom to get a breather before the screening began. "We were looking at each other in the mirror going 'This is it, dude,'" Myrick says. "Who knows how many other filmmakers have had that conversation in that room? It was such a Hollywood moment."

Shortly after midnight, the film finally unspooled, opening with its stark, silent onscreen introduction:

In October of 1994, three student filmmakers disappeared in the woods near Burkittsville, Maryland while shooting a documentary.

A year later their footage was found.

For the next eighty-one minutes, the crowd watched as Donahue, Leonard, and Williams traveled deeper into the woods of rural Maryland, their bickering and shivering depicted in half-color, half-black-and-white footage that would occasionally go out of focus. Though *Blair Witch* paid homage to the pop-horror hits of the seventies—as in *Jaws*, many of the movie's terrors were teased, rather than seen—it also incorporated the crazy rhythms and ADD-addled storytelling of modern nonfiction television. Shows such as *COPS* and *The Real World* had popularized a new narrative form in the nineties, one that did away with hand-holding exposition and careful framing; instead, the camera zipped and zoomed, almost as if it was self-guided, to focus on

whatever image was the most urgent. By the time the whipsawing *Blair Witch* arrived, Myrick and Sánchez could jam together as much data as possible—and move as quickly as possible—without worrying if the audience could keep up. "This was the first time digital editing was really in the hands of people with no money," says Haxan's Robin Cowie.

At first, the reaction among the Sundance crowd was worrisome, with a handful of audience members walking out—including some well-connected studio buyers. "I thought, 'Oh, this is a bummer,'" Donahue remembers. "'We're probably not going to be able to sell it.'" But the rest of the moviegoers stayed put, clearly uncomfortable. "It was a weird reaction," says Sánchez. "Sometimes they'd laugh, but mostly they were quiet." As he'd later find out, that was the way many viewers would engage with *The Blair Witch Project*: not as passive spectators but as nervous bystanders, their dread spreading like a contagion as they watched the film's cast become terrorized—and picked off—by unseen forces.

At 2:00 a.m., after a mostly polite Q&A session, the audience emptied into the sidewalk, and Myrick and Sánchez relocated to a small party at a nearby apartment. The crowd's hushed response and the sporadic walkouts had made for a hard-to-read response. "At the time," says Hale, "the way it went down at Sundance was that somebody jumped you in the lobby and shook your hand, and you made the deal right there. When that didn't happen, we were kind of like, 'What the hell?'" After years of working on *Blair Witch*, nearly everyone at Haxan was having money problems—as was the company itself. Just before the filmmakers had flown to Utah, the phone in their Orlando office had been shut off. "We had it all on the line," says Cowie, whose wife had given birth to their first child before Sundance began. "We had pooled our resources together, and I had spent pretty much all of my savings. But we believed in the movie." Their hope was that *Blair Witch* would land a small home video or cable TV deal, to help earn back some of their investment. "We were all in a precarious financial situation," Sánchez says. "If *Blair Witch* didn't sell, I'd have to declare bankruptcy."

To some in the Egyptian Theatre that night, *Blair Witch* was a

prolonged headache—a "piece of shit," in the words of October Films cofounder Bingham Ray. But the movie's glitchy weirdness made it all the more appealing to Artisan Entertainment, a home video company that was now looking to move into the low-budget movie business. In 1998, Artisan—led by its CEO, Amir Malin—ventured to Park City and plucked its first major discovery: Darren Aronofsky's $60,000 black-and-white math mystery *Pi*, about a justifiably paranoid numbers whiz who tries to game the stock market and winds up being pursued by both religious zealots and Wall Street true believers (imagine your eleventh-grade calculus textbook if it had been written by Rod Serling). Wiry and brain-boggling, *Pi* had no chance of winning over mainstream audiences. So the company had turned it into an avant-garde event. "People felt we should change the name," says Artisan marketing head John Hegeman. "But *Batman & Robin* had just come out, so I thought, 'Screw that: If Batman could have the bat logo, the Pi sign will be *our* logo.' And we had a great website, which let us learn the power of the internet and how to make a movie feel like counterprogramming." *Pi* earned more than $3 million in theaters—three times what Artisan had paid for it—and proved that Sundance was still a place where an occasional out-of-nowhere oddity could become a minor sensation. But it was a film whose success seemed impossible to replicate: a cheap little mystery with no stars, only an intriguing hook. What were the odds Artisan would ever find a movie like that again?

Hegeman had come to Sundance that year to find out. So had the studio's president, Bill Block. Both were at the Egyptian for the *Blair Witch* premiere. "We noticed three young women in front of us squirming in their seats, reacting to the movie in a way that you could just feel," Hegeman says. After the screening had ended, the two men were standing outside the theater, discussing *The Blair Witch Project*'s prospects, when they noticed a group of frightened-looking older women huddled together near the alley.

"Is everything okay?" one of the Artisan staffers asked.

"Our car is parked on the other side, and we're afraid," a woman replied. "We just saw the most terrifying movie we've ever seen."

Afterward, Hegeman remembers, "we called the producers and said, 'We want to make a deal.'"

At around 3:00 a.m., the members of Haxan were summoned to a nearby condo to negotiate with Artisan. In the hours after the screening, they'd gotten word that there were a few interested studios, including Miramax. Later in the week, the Weinsteins' company would get into another one of its high-profile, high-blood-pressure bidding wars, spending a reported $10 million to acquire *Happy, Texas*, a comedy about two jailbreakers who pose as gay lovers in a small southern town (it would end up grossing less than $2 million). But Miramax didn't pursue *Blair Witch* as aggressively as Artisan did—in fact, *no* studio did. "There wasn't much competition," says Malin, the CEO of Artisan. "This wasn't *Shine* or one of those coveted Sundance stories." The final price for *The Blair Witch Project*: $1.1 million, which the team agreed upon in the predawn hours.

Soon afterward, *Blair Witch* costar Michael C. Williams and his fiancée landed in Park City, having missed the movie's premiere. Famished, they stopped to eat at a ski lodge, where Williams repeatedly tried to get in touch with his *Blair Witch* colleagues. No one was picking up the phone. "I'm kind of in a bad mood, like, 'We're just sitting here. What the hell do they expect us to do?'" Williams then overheard another diner reading from a report about the movie's million-dollar deal. "I grabbed the paper out of this guy's hands," says Williams, "and I said, 'Sorry, man—but I'm *in* that movie!' And he said, 'Good for you.'" A few minutes later, a stranger wearing sunglasses approached Williams and informed him that he had to leave immediately—he was needed at a photo shoot for *Premiere* magazine. Says Williams, "I looked at my fiancée, and I was like, 'Off we go.'"

It was one of the final quiet moments of what would be a disorienting year—not just for Williams, but for *everyone* involved with *The Blair Witch Project*. Within a few months, *Blair Witch* would be a countrywide phenomenon; Myrick and Sánchez would be magazine cover stars; and its three promising young cast members would be declared dead.

2

"AFTER THE GAME IS BEFORE THE GAME."

FOLLOWING
GO
RUN LOLA RUN

In the days after its late-night Sundance premiere, *The Blair Witch Project* continued to claim victims throughout Park City. Owen Gleiberman, then an *Entertainment Weekly* film critic, caught a sold-out screening in which the entire audience sat in terror ("It felt like we were united in fear," he says). Moviegoers went into *Blair Witch* unaware it was a work of fiction and were often shocked when the cast members suddenly materialized afterward for a postcredits Q&A. "When the actors came on-stage, I didn't know *what* was going on, or if somebody had come back from the dead," says actor Taye Diggs, who caught an early *Blair Witch* screening. "That movie scared the shit out of me. It took a minute for me to get that it wasn't real."

At one point during the days-long fuss over *Blair Witch*, film critic Glenn Kenny, who was covering the festival for *Premiere* magazine, hopped aboard one of Park City's shuttle buses for a late-night ride. During the trip, he struck up a conversation with a young filmmaker

sporting a gray overcoat, looking "down in the mouth," Kenny says. "He'd brought a film to Park City, and he was disappointed that the only movie anybody was talking about was *Blair Witch*."

A few years after that bus ride, Christopher Nolan would be steering such big-budget studio films like *Batman Begins* and *Insomnia*. But in 1999, he was a twenty-eight-year-old writer-director who'd traveled to Park City to screen *Following*, his time-splintering, seventy-minute debut feature. "I think Glenn's probably exaggerating a tiny bit," Nolan says. "No, you know what? He's probably right. We shot *Following* on black-and-white sixteen millimeter. So when you're sitting there with somebody telling you about somebody *else's* film on black-and-white sixteen millimeter—and they've done something far more radical in that respect—that would probably have made us a little down in the mouth."

Following wasn't competing at Sundance that winter. Instead, Nolan and producer Emma Thomas—who was also on the bus that night—had landed the movie a slot at Slamdance, the neighboring film festival that had launched in Park City in 1995, right in the middle of the decade's indie frenzy. By the time Nolan showed up with *Following*, the two events were drawing mobs of filmmakers, many of whom took to the streets in the hopes of luring passersby to their screenings. "It was insane," Nolan says. "We'd be putting up homemade posters for our film, and there'd be somebody walking behind us, covering our poster with *their* poster. It wasn't competitive, because there was a good spirit about it—a sense of excitement about movies."

Nolan had been caught up in that same movie mania for years. As a child, he had divided his time between Evanston, Illinois, and the United Kingdom—his mother was American, his father English—and first started making movies when he was a kid, directing stop-motion films using an 8mm camera that belonged to his father, an advertising executive. As he got older, he become transfixed by such ethereal head trippers as *Blade Runner* and *Pink Floyd—The Wall*, as well as golden-age noirs such as *Out of the Past*, a 1947 film in which Robert

Mitchum played an ex–private investigator who's pulled into the orbit of a shadowy crook.

In the early nineties, after graduating from college in London, Nolan found himself awed by the exploding American indie film movement, thanks to recent imports such as *El Mariachi*, *Clerks*, and, in particular, Tarantino's heist-gone-wrong caper *Reservoir Dogs*. "It was a colossal film in England—it played for over a year," Nolan says. "But no one in England was making films like that. My thinking was 'Well, why not? If they can do that in America, why not do it here?'"

Nolan's own feature-film career began a few years later, while he was living in London's West End. One day, he returned to his apartment and found that the plywood door had been kicked in. Someone had forced his way inside, grabbed some valuables, and carried it all away in one of Nolan's own bags. "I remember realizing the door wasn't what was keeping people out," Nolan says. "It was this social pact that we have—this respecting of people's property and of people's boundaries." Those boundaries—and the way people choose to either observe or subvert them—had been on Nolan's mind even before the robbery. Walking through London's crowded streets, he'd observed that pedestrians never kept pace with one another; it would be too weird, a violation of unwritten social norms. "I started noticing there were all these protocols that we live by in a city, in order to preserve our individuality," he says.

He merged all of those ideas into *Following*. It starred Jeremy Theobald as the Young Man, a nervous, unemployed wannabe writer who follows pedestrians around London, under the self-deluding ruse of gathering material for his work. Eventually, one of his subjects—an enviably stylish smooth talker who calls himself Cobb (Alex Haw)—confronts the Young Man, goading him to break into a nearby flat. As he becomes more adept at thieving, the Young Man unwittingly becomes part of a grander, far more violent scheme.

Working with a self-funded budget of just $6,000, Nolan shot *Following* over the course of several weekends. Each scene was rehearsed

thoroughly beforehand, to preserve film stock and time, and production often took place around friends' homes in London or on the streets—all without a permit and with just a small group of helpers in tow. "There was a great sense of adventure about all of us getting in a London taxi," says Nolan, "because we could fit all of the equipment, all of the cast, and all of the crew in one cab."

Following fused together many of Nolan's early cinematic loves: it's a pulpy, underworld-skimming thriller reminiscent of *Out of the Past*, with a dreamlike alienness that could only have been created by some-one who'd studied Stanley Kubrick and Ridley Scott. But just when you think you know where *Following* is headed, the movie cuts from the fu-ture to the past—and then back again. Soon enough, it becomes clear that *Following* is unfolding not as a straight-ahead tale of crooked be-havior but as a slowly untangling nonlinear tale that leaves its viewers as twisted as its protaganist.

Nolan credits Tarantino's story-splitting crime anthology *Pulp Fic-tion* with giving filmmakers a permission slip to futz around with story structure. But he also points to the at-home technologies that changed the way viewers absorbed movies—and the way they controlled them. For decades, movies would leave theaters and head to television, a me-dium that demanded linear storytelling. "Back then, if the doorbell rang because the pizza guy was there, you had to get up, pay, get a plate, and sit back down—and then pick up the movie without having missed anything too vital," says Nolan. "Then VHS comes along, and you can hit pause. Immediately, you've got a profound shift in the potential of story structure and density of storytelling. You can put more and more detail in the frame."

As DVDs were introduced in the late nineties, it became even easier to move around within a film—or to skip parts altogether. All of that, Nolan says, "had an impact on how filmmakers looked at narrative and at the potential of narrative. We wanted to make it more nonlinear." By the end of the decade, a split-apart story such as *Following* made sense to moviegoers, even if they needed an extra viewing to put all the pieces together.

It would be a while before audience members would get their first look at Nolan's debut. *Following* had been submitted to Sundance, only to be rejected. But the movie soon found its way not only to Slamdance, but also a handful of other festivals, garnering attention from critics and producers. And though *Following* never earned a wide release, its reception put Nolan "in that tricky moment that a lot of young filmmakers have," he says. "They've done a film that people think is cool and has some value, and people say, 'Well, what do you want to do next?'"

At the time *Following* was developing a following, Nolan was working on an even more defiantly time-tampering murder mystery, this time about a tattoo-covered, memory-deficient loner trying to solve the murder of his wife. "The script had a similarly unconventional approach to structure," says Nolan. "And because people had seen *Following*, they knew I could make it coherent for the audience." In 2001, Nolan would return to Park City with his newly finished follow-up, *Memento*. This time he'd landed the film into Sundance, where it became a hit—the movie *everyone* on the bus was talking about. He finally had his Sundance success story; it just hadn't unfolded in quite the order anyone would have expected.

The idea that time could be bossed around—that a movie could jump forward or backward, making up its own rules along the way—played out in several films unspooling in Park City that year. One of them was *Go*, a keyed-up, perspective-shuffling tale of Los Angeles twentysomethings who get thrown into various drug- and gun-related capers. *Go* was capricious and untamed, much like its director, Doug Liman. He was easy to spot at Sundance that year: all you had to do was look for the naked guy on the slopes.

During the festival, the thirty-three-year-old Liman had decided to celebrate *Go*'s premiere with a party at a private mountain condo. To the semisurprise of his guests, he and a pair of college friends had stripped nude, strapped on some skis, and begun cruising down the side of the hill. It didn't take long for the trio to be spotted by a nearby family. "I

guess they called the police," Liman remembers. "'Cause they were waiting at the bottom of the mountain when we got there." Liman and his pals hid in some trees near a chairlift before finally sneaking back up to the condo in the freezing cold. If any filmmaker was going to take his Sundance success to extremes, it was Liman—a "mad scientist," according to *Go* costar Taye Diggs. "I'd gone to a performing arts high school, so I grew up with cats who were quirky. But Doug was on a wavelength that was kind of beyond us mere mortals."

Go marked a long-overdue Sundance victory lap for the filmmaker, whose *Swingers* had been rejected by the festival just a few years earlier. Written by Jon Favreau, who costarred alongside Vince Vaughn, *Swingers* followed two bachelors as they navigated the retrominded nightclubs of Los Angeles. Released in 1996 by Miramax—which seemingly didn't know what it had—*Swingers* was an instantly quotable buddy comedy ("You're so money, and you don't even know it.") with an endearingly big-thumping heart. *Swingers* had been successful enough to earn Liman studio attention, and to put him in contention to direct films such as *Good Will Hunting*—which he turned down.

Instead, Liman went with *Go*. The script had been sitting around in one form or another since the early part of the decade, back when screenwriter John August had been adapting children's books such as *A Wrinkle in Time* and *How to Eat Fried Worms*. "I was only getting sent movies that involved gnomes, dwarves, and Christmas," August says. He originally conceived of *Go* as a short film, one that might lead to more grown-up projects. It had been inspired by his time shopping at what was known as "Rock 'n' roll Ralph's"—a grocery store located on Los Angeles' raucous Sunset Strip. "I always wondered: What was the after-work life like for these cashiers?" August adds.

Over the years, *Go* evolved into a feature-length screenplay, following several young sorta heroes—including a few bored supermarket employees—who get zonked on ecstasy, turn a hotel room ablaze during a threesome, and just narrowly avoid getting killed, all over the course of one night. August told their story via a trio of chronology-hopping

chapters, with characters and story lines being put on pause for long stretches, before eventually tumbling back atop one another by the end.

Go had all the hallmarks of a post–*Pulp Fiction* DIY comedy caper, what with its drugs, guns, and quipping crooks (and, like *Swingers*, it had a deep empathy toward its screwed-up young Angelenos). It was the kind of film that, had it been made ten years earlier, would have been released by a scrappy distributor, and rolled out across art house and campus theaters. But after a last-minute indie financing deal fell through, the movie was scooped up by Columbia/TriStar, a mainstream-minded division of Sony. TriStar had spent the last few years producing big-star multiplex monsters such as *Godzilla* and *The Mask of Zorro*. It wasn't in the business of releasing nervy, twisting, cheap little R-rated comedies like *Go*.

The Sundance-born indie movement had changed that. As low-budgeted films picked up cultural momentum, the major studios began to look painfully out of touch. It was a situation underscored by the 1997 Academy Awards ceremony, in which only one major-studio release— the Tom Cruise romance *Jerry Maguire*—had earned a Best Picture nomination. The other categories were dominated by indies, many of which featured lesser-known names and slim budgets, such as *Secrets & Lies* and *Fargo*. Hollywood had been temporarily kicked out of its own party. "Remember, it was the Academy—the ancient, hidebound, *mainstream* academy—that nominated all of these movies," notes the film historian Mark Harris, then an editor at *Entertainment Weekly*. "That tells you where the excitement was."

TriStar Pictures had missed out on some of that excitement: In the early nineties, the studio had paid Tarantino $1 million for his *Pulp Fiction* script—only to turn it down and let it migrate to Miramax. ("They were scared of it," Tarantino said of TriStar, "and they didn't think it was going to be funny.") A few years later, though, "studios with deeper pockets started to get interested in being a little more daring and taking a few more chances," says Harris. Suddenly a movie like *Go* seemed like a smart investment. Not only did it give Sony some cool cred, it also put

the studio in the unpredictable orbit of one of the decade's most sought-out young directors.

Liman had found much to relate to in August's script, which reminded him of his own troublemaking youth. In the mideighties, while a freshman at Brown University, Liman and a few friends were arrested for stealing a stoplight, and wound up spending the night in jail—right in the middle of exams. "My sense of my place on the planet increased a thousandfold," he says. "These cops didn't care that it was exam week. I was like, 'Oh, my little life doesn't matter in the grand scheme of things.' Within a week, I'd come to appreciate that what I thought was the worst thing to happen to me was actually the *best* thing that could have ever happened to me."

To cast *Go*, Liman and August pulled from what was a remarkably plentiful reservoir of young late-nineties actors, including Sarah Polley, a former child star who'd recently starred in the harrowing, Oscar-nominated *The Sweet Hereafter*; Katie Holmes, who played an earnest teen on The WB's hit *Dawson's Creek*; and Broadway star Diggs, the swooned-over discovery of the 1998 romance *How Stella Got Her Groove Back*. With his cast in place, filming commenced on a movie on which, according to Liman, "every day was impossible." That included the day Liman, acting as his own cinematographer, drove around LA filming police cars, only to be momentarily detained by the cops; the day a crucial sequence was accidentally recorded entirely without sound; and the day he got into a fight while filming one of *Go*'s rave scenes (he kept shooting throughout the dustup).

Every aspect of *Go* was sanity stretching. Halfway through filming, August—who'd been recruited to direct second-unit scenes, a unusual assignment for a screenwriter—found himself standing at the outskirts of an airport in Santa Monica, weeping quietly. Polley had just injured her back while shooting a scene on the hood of a car and was headed to the hospital to get an X-ray. "I could see the whole movie falling apart," August says. "I walked to a spot in the distance, stayed there a minute or two, and then came back to work." Polley eventually recovered—as did August, who'd look back at the shoot with the

kind of fondness one might have for a charming yet thoroughly insane ex-love. "*Go* was a scrappy production and one that was very much running on adrenaline," he says. "But that's also the way the movie wanted to feel."

That frenzied feeling hovered over the film's postproduction, during which Liman and August rewrote and reshot a major sequence. They also fended off Sony's insistence that the movie's twenty-nine-minute Vegas-set middle sequence be scrapped altogether. Though the two men eventually won that fight, the studio execs became so frustrated with Liman that they'd sometimes go around his back and complain to the film's editor, Stephen Mirrione. He secretly recorded their conversations, which he then played over the end credits during early screenings, much to the execs' chagrin (and Liman's delight). "It was almost a requirement that we antagonized the studio," Liman says, "because there was such an antiauthority quality to the film." In a final act of defiance, Liman and Mirrone chopped up the famed Columbia logo—featuring a regal, torch-wielding woman—and intercut it with scenes of light-dazzled ravers.

By early January 1999, more than five years after August had first written his attention-getting short script, *Go* was finally ready to go. When the movie debuted at Park City, it was an instant hit with festivalgoers. In the same way that *Trainspotting* had conjured up the under-the-nail scuzz of midnineties junkie culture, *Go* embodied the sweaty, sometimes smush-brained euphoria of Generation Ecstasy, pinging between car-crashing action and hallucinatory comedy (such as when one blotto character has a telepathic conversation with a cat). It was a movie that never slowed down, never explained itself. *Go* was always on the run.

Growing up in Wuppertal, Germany, Tom Tykwer would sometimes cut school in order to enter a galaxy far, far away. He and a friend had become fixated on a *Star Wars* arcade game, one in which users climbed into a fake cockpit, took over the controls of an X-wing fighter, and were

guided by the voices of characters such as Obi-Wan Kenobi ("Use the Force, Luke") to defeat Darth Vader. "We were getting good at it," Tykwer remembers, "and we said, 'Okay, let's break the world record.'" One day in the early eighties, Tykwer and his friend embarked on an all-day *Star Wars* spree, swapping turns for hours before eventually hitting what they were told was a new record score—a feat that landed them in the local newspaper. "The *Star Wars* game was a revelation, because it was the first one that had a real immersive quality," he says. "I spent months inside video games."

He wasn't alone. Before the decade was over, video consoles would move from arcades to basements, as three-lives-for-a-quarter classics such as *Pac-Man* were slowly being replaced by at-home Atari or Nintendo machines. And the nineties would see a burst of innovative home computer adventures, ranging from first-person shoot-'em-ups such as *Doom* to sprawling role-playing epics such as *Myst*. It seemed possible to exist *forever* in these new games, which were dense and intelligent and could run for hours at a time, as users accumulated more onscreen powers. Players no longer needed to use the Force to beat the records; they *were* the Force.

With video games chomping away at young people's wallets and attention spans, a few movies had attempted to bring arcade culture to the big screen, usually with awful results, such as the midnineties duds *Super Mario Bros.* and *Street Fighter*. But Twyker wondered what it'd be like if instead of adapting a video game, a movie captured what it was like to *play* one, mimicking the medium's accrued-wisdom logic and wily energy. That's how in the summer of 1997 he found himself dashing down a long corridor in a wheelchair, trying to keep up with the woman with the red hair.

Tykwer, thirty-two, had undergone foot surgery right in the middle of directing *Run Lola Run*, a zipping, time-ripping action-romance. Set and filmed in Berlin, *Lola* opens with a pace-setting quote by the German football legend Sepp Herberger: "After the game is before the game." Soon enough, the film's titular runner, played by Franka Potente,

receives a panicky phone call from Manni, her failed-hood boyfriend. He tells Lola that if she can't get him 100,000 deutsche marks in twenty minutes, Manni—who's in debt to a gangster—will be forced to rob a grocery store. So Lola sets off in her gray tank top, black Dr. Martens boots, and flame-colored hair, racing across the streets of Germany to find him in time. After Lola's initial rescue attempts end in failure, she goes again, and then again, getting three chances to make things right. In just eighty-one fleeting minutes, *Run Lola Run* repeatedly resets itself, sending our heroine back to the beginning of her quest—albeit savvier and stronger than before.

By the time *Run Lola Run* began filming, Tykwer was in need of a new life himself. The German-born writer-director had yet to enjoy a breakthrough hit and was now nearing financial ruin. If the $2 million *Lola* wasn't a success, Tykwer's filmmaking career would likely be over. Risking everything on a movie such as *Lola*—an action movie that was more interested in free will and fate than in explosions and gunplay— was "quite stupid," he says. "But sometimes stupidity pays off."

Like *Following* director Christopher Nolan, Tykwer, had gotten an early start on his storytelling career, filming an 8mm remake of *Godzilla* in the backyard of his parents' house in Wuppertal when he was just ten years old (a few firecrackers were employed for special effects). Tykwer had little formal training, having been rejected by the German film programs to which he'd applied. Instead, he had studied movies by constantly watching them. In the mideighties, Tykwer took a job as a projectionist at Moviemento, a three-screen Berlin theater, just as the Cold War was winding down. "The Wall was still there, and Berlin was a complete island," he says. "People slept between eight a.m. and three p.m., and the rest of the time they were busy being drunk or being stoned or watching and discussing movies." Tykwer was eventually promoted to programmer at the theater, running everything from French New Wave movies to silent films to whatever Tykwer felt like seeing that week. "It was heaven," he says. "It was like, 'What if we do a triple Roman Polanski feature Monday at midnight?'"

Tykwer eventually screened his own debut film at Moviemento: 1993's low-budget *Deadly Maria*, a murderous domestic-set horror tale of a housewife who lashes out at the men around her. He followed that with 1997's *Winter Sleepers*, a chilly drama about several interconnected lives colliding in the Alps. By then, he and a few other directors had formed a production company called X Filme (it was inspired by United Artists, the studio cofounded in 1919 by such filmmakers as Charlie Chaplin and D. W. Griffith). "We were bored of German movies and wanted to get different stuff out there," Tykwer says. "We were creatively enthusiastic but economically disastrous." X Filme's *Winter Sleepers* had gone almost half a million dollars over budget, and Tykwer and his partners had no way to pay their bills. Their bailout plan: to make one more movie, as quickly as possible, and see if it could earn enough money to keep their company alive.

Tykwer had come up with the idea for *Lola* while still editing *Winter Sleepers*, writing a brief treatment that outlined Lola's trifecta of fates. "I wanted to do a film about the energy of my generation," he said, "an energy which all too often is kept bottled up inside." In the movie, Lola's story comes to three very different endings: In the first run, she's shot dead by the police. That's followed by an arc in which Lola watches Manni get killed by a speeding truck. In the final scenario, Lola and Manni reunite in time and escape together unscathed.

During each story, Lola and Manni encounter a series of strangers—from bank guards to homeless drifters—whose lives are depicted in quick flash-forwards, their fates changing radically based on the decisions Lola or Manni make. Their stories are told via a mix of color film, black-and-white video, bursts of animation, still photos, or split screen (the latter a trademark of Tykwer's beloved Brian De Palma). And it's all set to a bass-pulsing techno soundtrack, including several tracks cowritten by Tykwer and featuring vocals by Potente. "I don't believe in trouble/I don't believe in pain," she sings on "Believe." "I don't believe there's nothing left/But running here again."

Tykwer had written the script with Potente in mind. Born in West

Germany, her acting career had started after an especially Lola-like string of coincidences: In 1995, while hanging out in a bar in Munich, a casting agent had followed her into the bathroom, unaware that Potente was an acting student. The agent had asked her to audition for a VJ gig on MTV; she didn't get the job, but her tryout tape had led to a starring role in a German indie, which had brought her to Tykwer's attention. The odds were "one in a million," Potente says. At the time she was cast as Lola, she wasn't exactly fit to play an avid runner. "I was a chain smoker, a partying twenty-three-year-old," she says. "But Tom wanted a real person running—he didn't want anyone supertrained."

As Potente began filming *Lola* in Berlin in July 1997, the difficulties of playing a constantly-in-motion character became clear. The summer sweat caused her red hair coloring to run down her neck. And, in addition to the chunky Docs, Potente had to wear her first thong. "They said, 'You can't wear normal undies,'" she remembers. "I was like, 'Oh, my God. I *hate* this.'" She would run all day, the filming sometimes stretching into eighteen-hour days. "Toward the end, someone would bring a couple of beers. We'd shoot through the night, go to breakfast, maybe sleep an hour or two, and then go back to work. That's how we rolled."

Potente collaborated closely with Tykwer, who'd occasionally hand her scraps of paper featuring some brief, abstract mantra. "He would say, 'Let this guide you,'" she remembers. At the time, Potente says, "I didn't really see the bigger picture. But he was guiding me. You have to understand: I'm a small-town girl who was never introduced to intellectualism of any kind. It was the first time someone offered up that kind of perspective on the world. Tom brought that into my life. We wound up being a couple for five years after that."

Berlin was under heavy reconstruction during filming that summer: the Cold War had only recently ended, and parts of the city were still putting itself back together. When Tykwer and his crew were trying to keep up with Potente, they had to be careful to avoid bumps and potholes in the street. "A lot of the stuff we shot, we just grabbed," says Potente. "We had no permission." The city's chaotic state was a visual reminder

of what had been, for many Germans, decades of social and cultural stasis under the long-running (and soon to end) regime of chancellor Helmut Kohl. "We'd been living in a very conservative, very unprogressive political climate, and we were exhausted," Tykwer says. With *Run Lola Run*—or *Lola Rennt*, as it was known in Germany—Tykwer said he wanted to make a story about "breaking the chains of our existence."

Tykwer also wanted to whirl together his various pursuits, which included philosophy, animation, and, in particular, video games. With each high-speed run, Lola becomes more aware of the results of her actions, leading her to adjust her approach during the next run. She even gets three lives—the once standard allotment for quarter droppers everywhere.

Run Lola Run's reinvigorating powers worked offscreen as well. Potente first saw the movie with an audience at a Munich film festival. "When it was done," she says, "people would jump up, like it was a German soccer game. I remembering tearing up, thinking, 'I have no idea what the fuck's going on, but it's big.'" The film opened in Germany in the summer of 1998 and became an instant phenomenon, grossing around $14 million—a huge figure for the region—and pulling Tykwer and his company out of debt. The movie was inescapable, with red-haired women becoming a common sight in Berlin. The city's mayor at the time, Eberhard Diepgen, even copied the movie's look for a campaign poster, much to Tykwer's disappointment (he once described the politician as "stupid, boring, old-fashioned"—in other words, everything Potente's hero wasn't).

Run Lola Run wouldn't arrive in the United States until a few months later, debuting in January at Sundance, where Miramax tried to acquire the film (after talks fell through, Harvey Weinstein reportedly threw a lit cigarette at young Miramax exec Jason Blum, who'd go on to produce such hits as *Whiplash* and *Get Out*). It was released by Sony Pictures Classics that summer, earning more than $7 million in the United States—enough to make it among the highest-grossing foreign-language films of the nineties. At one point, Potente would be pulled aside by actor Natalie Portman, who wanted to show off a picture

of her Halloween costume that year: Lola. She wasn't alone in wanting to be Potente's character. There was something so enviable about Lola's ability to reboot her own reality over and over again, until she found one she liked better. *Run Lola Run* offered the tantalizing possibility that none of us is ever truly trapped. We can change whatever we want: our lives, our mind-sets, our bodies. Even our jobs.

3

"WE NEED TO TALK ABOUT YOUR TPS REPORTS."

OFFICE SPACE

Mike Judge was sure he was having a heart attack. The pounding in his chest, the "tight tingly thing" running through his arms—he'd never felt anything like it before. It was just a few months until the debut of Judge's first movie, 1996's *Beavis and Butt-Head Do America*, and the thirty-three-year-old writer-director was behind the wheel of his car, panic overpowering his body. "I pulled over and got out," he said, "because I wanted someone to see me in case I passed out or died." He eventually got a call from his manager. "It's an anxiety attack," Judge was told. "Welcome to Hollywood."

Unlike other writer-directors of his generation—the ones who had studied Steven Spielberg and crafted 8mm minimovies in their backyards—Judge hadn't fantasized about becoming a filmmaker. When he was growing up in Albuquerque, New Mexico, the idea of working in show business didn't even seem possible. "You'd never hear of anyone who was a TV writer," he said. The son of an archaeologist father and a

librarian mother, Judge spent his youth toiling at fast-food chains and construction sites, imagining what it would be like to have his own work space. "When you're doing landscaping, the idea of a cush office job seems wonderful," he says.

After graduating in 1986 from the University of California, San Diego with a degree in physics—"I was good at math without having to work too hard," he said—Judge relocated to Texas. Soon, he found himself in an endless rut of temp assignments and engineering gigs, giving him his first real exposure to the cubicle culture that was reshaping American life. Thanks in part to the mergers-and-acquisitions mania of the Reagan era—as well as the burst of tech and health companies during the Clinton years—the American workplace had undergone a stultifying transformation at the end of the twentieth century. Imposing, impersonal office parks began sprouting up in suburbs and smaller cities. Once inside, employees often found themselves trapped within sprawling bureaucracies, their lives dictated by pointless busy work as their tiny cubicles slowly began to feel like prisons. "I got a job alphabetizing purchase orders, and it was just torture," Judge says. "I'd have rather been out loading chain-link fence."

During one of his earliest engineering stints, Judge had attempted to strike up a conversation with a coworker. "I said, 'Hey, how's it going?'" he remembered. "He just launched into this thing about how he was going to quit because they moved his desk three times." By then, Judge had been teaching himself animation, and he used that one-off encounter as inspiration for his first series of cartoon shorts, which starred a meek, mealy-mouthed office drone named Milton. All Milton wants is his prized stapler, his completed time sheets, and the luxury of being left alone. But Bill, his faux-chummy boss, keeps siphoning away Milton's office supplies, as well as his pride. Bill—whose requests conclude with a drawn-out "Ee-yeah" or "Buh-bye"—was based upon the department heads Judge had encountered during his tour of the white-collar wilderness. "There was this baby-boom generation of bosses who had such a phoniness to them," says Judge. "They were like, 'I'm the cool

boss.' That always irritated me. I would much prefer the boss from the fifties who would just come up and say, 'Move your desk. Thanks.'"

One of the shorts, a 1990 clip titled "Office Space," concludes with Milton, alone in his work space, mumbling a violent revenge fantasy: "I'm going to set the building on fire." Two years later, it would appear on MTV's anarchic animation compilation *Liquid Television*. But it was overshadowed by another one of Judge's creations: a brief short featuring Beavis and Butt-Head, who'd soon have their own series on MTV. *Beavis and Butt-Head* was an astutely observed account of dead-end suburbia, focusing on two ding-dong dirtbags who play "frog baseball" and sporadically chant, "Fire! Fire! FIRE!" The show was an instant hit, making Judge both a folk hero and a pop-culture pariah. Before its first season was over, Beavis and Butt-Head would earn the cover of *Rolling Stone*—which dubbed them "the voice of a generation"—as well as the anger of South Carolina senator Fritz Hollings, who railed against the societal damage being done by "Buffcoat and Beaver."

To keep up with the demand for episodes, Judge moved his family to upstate New York, and began working nonstop at MTV's Manhattan studios. He'd hoped to avoid the life-swallowing corporate job, but here he was—toiling away for hours for a giant conglomerate, barely getting home in time to see his newborn kid, eventually getting that roadside panic attack. Even a fast-food job gave you a day off every once in a while. "I was so stressed out and miserable," Judge said. Given the show's ratings success, a Beavis and Butt-Head movie was inevitable. When *Beavis and Butt-Head Do America* opened to enthusiastic reviews in December 1996 and made twice its $10 million budget in a single weekend, "it was the sweetest feeling," Judge said. "The first time I ever enjoyed the success of Beavis and Butt-Head."

Not long after finishing *Beavis and Butt-Head Do America*, Judge turned his attention to a new movie—a live-action expansion of the "Milton" cartoons, one loosely modeled after *Car Wash*, a loosey-goosey

1976 ensemble comedy starring Richard Pryor and George Carlin. Judge spun many of his engineering experiences into his new script, *Office Space*, about a despondent, cubicle-corraled programmer named Peter Gibbons, who toils at a generically named software firm, Initech. "Ever since I started working," Peter says, "every single day of my life has been worse than the day before it." Each morning, he trudges to a bland office park, where he's tasked with mundane duties, such as prepping Y2K software or completing the vaguely named "TPS reports." After visiting a hypnotist, he winds up slipping into a blissful trance that empowers him to stop caring about making money. Peter decides to drop out of the nine-to-five existence—but his new straight-shooting attitude just winds up getting him promoted. Enlightened and empowered, he recruits two of his Initech coworkers, Samir and Michael Bolton, to join him as he tries to steal from his own company. Their plan ultimately fails, but by the end of the film, Initech's headquarters are in flames and Peter is happily working a construction job.

If eighties work-comedies such as *Working Girl* and *The Secret of My Success* had depicted the corporate-climbing lifestyle as sexy and emboldening—a way to get rich, get laid, or both—*Office Space* was intended to reflect the new decade's collective middle-class malaise. "Something was boiling underneath the American workplace that was going to come out at some point," says Judge. "And 1999 was the year it happened." When Peter takes a power drill to his cubicle, knocking it down so that he can get a window view of the world outside, he's rejecting a life full of stupor-inducing duties, technologies, and luxuries. It was an epiphany that would propel other 1999 films such as *Fight Club*, *The Matrix*, and *American Beauty*—stories in which the heroes abandon their jobs before finding themselves. Yet no movie zeroed in on the life-sapping sloggery of modern work quite like Judge's *Office Space*. Things grow so dire for Peter that, at one point, he even jokes about shooting up Initech: "One of these days . . . " he says before making a machine-gun noise.

Twentieth Century Fox had all but begged for the chance to produce *Office Space*, with the goal of making it as soon as possible. "I

was on the fence," Judge says. He didn't think the story was fully re-
alized, and even after revising his script, Judge knew *Office Space* all
came down to casting: The movie wouldn't succeed unless he found
the right coworkers. And luckily, one of the first to apply was Gary
Cole. Then forty-one, Cole had starred in network dramas such as *Mid-
night Caller* and had recently played Mr. Brady in a pair of big-screen
versions of *The Brady Bunch*. He was sent Judge's *Office Space* script
and a video with two early "Milton" shorts, having been asked to au-
dition for the role of Bill Lumbergh, the oily office honcho. Bill is a
constant menace, a patronizing drip who hovers over his workers' cu-
bicles, drives a sports car with a MY PRSHE license plate, and who's
sneeringly referred to by his last name. After taking in Judge's original
Lumbergh voice-over—with its prolonged, flattened "Buh-bye"s and
"Ee-yeah"s—Cole realized that "there was no better way to do this than
what's on the video," he says. "I figured, 'I'll just mimic that as best as I
can, and see what happens.'"

During a brief read-through, Judge realized he'd found his *Office
Space* creep. Cole had suffered through a few Lumberghs of his own
by the time he got to *Office Space*, most notably in the seventies, while
working as a salesman in a mall shoe store near Chicago. "The boss was
never particularly pleasant, and he was never particularly abusive, ei-
ther," Cole says. "He was just kind of a dick. Like, 'I'm in charge.'" Cole's
shoe store boss had an affection for garish two-toned shirts, which be-
came part of his poor-man's-Gordon-Gekko look, along with slicked-
back hair and a pair of glasses so huge, they looked as though they
might topple off the bridge of the actor's nose.

Judge's faith in *Office Space* received another boost when he hired
thirty-two-year-old Ron Livingston—who'd recently played a small
supporting role in *Swingers*—to star as Peter Gibbons. Livingston re-
lated to Peter's existential plight, having watched his own generation's
corporate-life aspirations curdle in the late nineties. "We'd come out of
the Alex P. Keaton years, where young people were like, 'Screw all of this
hippie nonsense. How do I get a job as a stockbroker?'" Livingston says.
"We'd had a decade of that, and it was time for the wheel to spin around

to the other side. But there was still this idea that you'd be throwing away your life if you tried to change."

To support himself in the early days of his career, Livingston had worked countless temp jobs, finding that he enjoyed their perpetatic rhythms. "You can just say, 'I can't do it tomorrow,' and they give you another one," he says. "Which in a weird way is what the movie is about: not getting locked into something you don't want to get locked into." Many of his *Office Space* costars, though, had been miserable in their previous occupations. David Herman, who'd play the role of the perpetually miffed Michael Bolton—a man who hates his job *and* his name—had spent the midnineties on Fox's sketch series *MADtv* and suffered throughout. "I never liked the show," Herman says. "It was like, '*Get Smart* and *Get Shorty* is *Get Smarty*!' Arrrrrgh. I spent two and a half years doing that show, trying to get off the whole time."

Herman eventually started a self-sabotage campaign, making his *MADtv* characters speak in random gibberish and *dadadada* noises until he and the producers agreed to part ways. By then he was also at work on his latest animated TV series, *King of the Hill*, which was how Judge wound up casting him as the glowering Michael Bolton. "It was the exact opposite of what I was doing on *MADtv*," Herman says. "It was this huge gift."

For the role of Michael Bolton's cubicle mate Samir Nagheenanajar—the stress-prone, Jordan-born programmer who's perhaps the most reluctant rebel of the trio—Judge cast twenty-six-year-old Ajay Naidu, who'd just worked on Darren Aronofsky's *Pi* and who also had some brief experience in the cubicle world. "I kept those jobs for a day and a half," Naidu says. "I had dealt with petty bureaucracy." Because Naidu was a break-dancer—one who'd wind up spending a good portion of the film's Austin, Texas, shoot performing with a local dance crew—he and Judge decided that Samir would be able to kick it, too. "A lot of the people who work in those offices are cool dudes on the side," says Naidu. "So it made sense that Samir could break-dance and that he worked the best he could to not be a nerd."

In fact, no one in *Office Space* is looked down upon. Even Milton,

the nebbish castoff played by character actor and *King of the Hill* performer Stephen Root, was treated with underdog-status sympathy. Milton's merely a fringe player in *Office Space*; his rage quietly builds as his beloved red stapler is taken away from his desk. Yet he's emblematic of Judge's ground-level understanding of how unextraordinary people live, with all of their secret hopes and hard-to-hide hang-ups. "Mike's not the guy you think he would be from *Beavis and Butt-Head*," noted Root. "He's a very soft-spoken, shy guy. And he's very observational: All the guys in *Office Space* were guys that he knew. He takes it from life."

There was something recognizable in all of Judge's *Office Space* creations—including Lawrence, Peter's way-chilled-out construction worker neighbor, who desires little more in life than a few beers and "two chicks at the same time." Lawrence is Peter's semisage, pushing him toward enlightenment by reminding his neighbor that happiness is less complicated than it seems. ("You don't need a million dollars to do nothing, man," Lawrence says. "Take a look at my cousin—he's broke, don't do shit.")

The studio initially had big plans for Lawrence, envisioning the briefly glimpsed character as a potential big-star cameo role. Johnny Depp and Billy Bob Thornton both briefly considered the part but eventually backed out. (One *Office Space* worker says that Thornton wanted $5 million for the role.) "They went through the entire list, and it got down to me," jokes Diedrich Bader, who in the late nineties was starring on ABC's *The Drew Carey Show*. He'd arrived at his audition for Lawrence with another character's voice in his head: Dignan, the spacey schemer played by Owen Wilson in Wes Anderson's recent comedy *Bottle Rocket*. Bader planned on adapting Wilson's frazzled drawl for his tryout—until he saw Wilson himself walk out of the audition. "I knew I couldn't do a better Owen Wilson than Owen Wilson," Bader says, "so I came up with Lawrence in the audition room."

Bader had spent part of his youth in the South, where as "a little high school stoner," he'd became enamored with the hippie-haven photo on the inside cover of the Allman Brothers Band's 1973 album *Brothers and Sisters*. That helped inspire not only Lawrence's handlebar mustache but

also his good-old-boy vibe—one best exemplified by his signature phil-osophical send-off, which he delivers in a baritone drawl: "Fuckin' A."

Just as Judge was finding his cast, 20th Century Fox began to have doubts about *Office Space*. Having lost out on Depp and Thornton, the studio was uncomfortable with the lack of star power. "They thought I was just an animation guy who didn't know what I was doing," Judge says. "They'd say, 'Well, if we're not going to get anybody famous, let's at least get somebody funny.' And I'd say, 'Well, sorry, but I think this guy *is* funny.'"

There was one name, however, upon which the director and the studio could agree: Jennifer Aniston. The twenty-nine-year-old *Friends* star was one of the most recognizable and best-liked comedy actors in the world, yet her film career had so far consisted of a handful of mar-ginally successful, just-pleasant-enough romantic comedies. Aniston and Judge shared a manager at the time, and he'd been a fan of hers since he had done some animation work on Aniston's short-lived Fox sketch series, *The Edge*, in the early nineties. So he didn't hesitate when her name came up for the role of *Office Space*'s Joanna, a waitress at a fake-cozy chain restaurant called Chotchkie's. She and Peter wind up in a low-key love affair that finds them going fishing, watching kung fu movies, and happily doing nothing. "She's a little bit of a stoner chick," Aniston said. "Everything to Joanna is just like, 'Huh. Okay, that's great.'"

Fox felt the same way about Aniston, whose decision to join *Office Space* ensured that Judge would be able to keep his cast intact. "It helped put the studio at ease a bit," Judge said. "At least they had one famous person." Judge was also given permission to shoot in his home town of Austin, which would stand in for the film's never-named, midsized-city setting—a move that would also hopefully keep the studio at a safe dis-tance. Fuckin' A.

As executions go, it was swift, severe, and bloodless. Under a cloudy Texas sky in the spring of 1998, the core cast members of *Office*

Space—Livingston, Herman, and Naidu—walked onto an abandoned field, dressed in slacks and workshirts. Livingston was wielding a baseball bat, and for the next few minutes, as their ties flapped in the air, the men smashed and stomped their victim with fury, sending entrails across the grass. When it was all over, they walked away in quiet relief, leaving behind a mangled carcass.

Though Judge was only two days into the ten-week *Office Space* shoot, he and his cast had already killed off one of the movie's key villains: a beeping, whirring, piece-of-shit office printer. In the years since Judge had left the engineering world, computers, printers, and fax machines had altered the hierarchy and rhythms of the American office, relieving workers of some of their most mundane tasks—while simultaneously creating entirely *new* sets of mundane tasks. As he was working on his *Beavis and Butt-Head Do America* script, Judge had been tortured by a Hewlett-Packard printer that kept flashing a PC LOAD LETTER message. *When I'm done writing this movie,* he thought, *I'm going to videotape myself smashing this printer with a baseball bat.* Instead, he made the machine one of *Office Space*'s tormentors. The printer-smashing sequence would be the film's cathartic call to arms, the moment when Peter encourages his demoralized coworkers to destroy their high-tech nemesis, all set to the assaultive strains of Geto Boys' gangsta rap creeper "Still."

Shortly after the printer homicide, production on *Office Space* would move indoors, to a newly vacated Austin office that would serve as Initech's dispiriting headquarters, and where the cast and crew would be not too far from a few real-life tech companies. For anyone who'd toiled in the cubicle cloisters of the nineties, the offices of Initech looked unsettlingly familiar—which was the point. From the cold gray workstations to the faux-festive decorations on Chotchkie's walls, nearly all of the design elements in *Office Space* were generic, the kind of drab decor that almost never appeared in movies. Such visual details were hardly accidental. Though Judge sought out input from his actors, Cole remembers the director being "ultraspecific" about certain details, such as the amount of time Lumbergh's coffee mug should be lifted up

into the frame. "As an animator, you control the behavior of all your characters," Cole says. "And *Office Space* is so specific in so many ways that if you started removing details, it wouldn't work."

The filming of *Office Space* did allow for a few improvised moments, however, such as when Michael Bolton (the programmer) describes Michael Bolton (the singer) as a "no-talent assclown" (Herman had heard the term the night before filming, while on a date with a woman he'd eventually marry). And during a cubicle powwow scene featuring the twenty-eight-year-old actor Greg Pitts—then starring in a sitcom with Damon Wayans—Judge inadvertently coaxed what would become one of *Office Space*'s most imitated moments. As Drew, Initech's fratty office gossip, Pitts has a brief exchange in which he reveals he's going to try to hook up with "that new chick from logistics." In the script, Pitts says, it noted that Drew's spiel concluded with a crude gesture indicating cunnilingus—which Pitts, feeling a bit self-conscious, had initially underplayed. "Mike came up to me and said, 'You can do whatever you want here,'" says Pitts. "I went to my trailer and came up with about five different options for the scene. And one of them was the 'Oh face.'"

Long before *Office Space*, Pitts had dated a woman who, he says, would make "a very expressive face" during sex. "I thought it was funny to sometimes make that face at her, out of context," he says. (Perhaps not surprisingly, the relationship didn't end well.) Pitts, who had never starred in a studio film before, was worried he'd look like an idiot. "I was a young actor," he says. "I was fragile." But he managed to channel his past for his *Office Space* appearance. "[If] things go well, I might be showing her my Oh face," Drew tells his coworkers, before moaning "*Oh. Oh. Oh.,*" with his mouth hanging open garishly. "Mike later told me that, when he showed the 'Oh face' dailies to a woman in the wardrobe department, she fell out of her seat laughing," Pitts says.

The studio wasn't nearly as enthusiastic about Judge's *Office Space* footage. Not long into production, he'd begun to hear from studio reps worried about the film's progress. "They didn't like the movie," he says. "They wanted everything to be big and over the top. It went from 'We'll do a low-budget cast, get whoever you want' to 'Why the hell are we

making this movie with these nobodies?'" As Root later noted, "Mike was put under scrutiny with Fox from day one. *Office Space* has long scenes without a lot of action in them, and he had to say, 'This is a thing that develops and pays off.' And he had trouble convincing them of that."

If Fox was expecting *Beavis and Butt-Head Get to Work*, they were surely stunned to discover that Judge's new movie was a dark, slow-drip comedy about depression and existential longing. "Once the studio realized the movie was mostly about day-to-day banalities and not guys getting kicked in the balls, they were like, 'Wait, is this a comedy? Why aren't people smiling more?'" says Herman.

There were even moments when the studio execs bypassed Judge, and took their frustrations straight to the cast. "Apparently, they hated us," remembers Naidu, who says the studio initially wanted him to wear a wig. "They thought I was ugly. I was like, 'Me?' I didn't think I was an eyesore!" Livingston, meanwhile, was pulled aside by a Fox representative early on during production, not long after he had filmed a scene in which Peter—having visited a cognitive hypnotist—falls into a state of smiling, Zen-faced calm. "Someone from the studio sat me down," Livingston recalls, "and said, 'You're doing this all wrong. Your character has got to fight the power. You can't be so blissful about it.' I was in a vulnerable spot, but I stuck with it. I found out later that they thought I was on drugs."

Still, many of the cast members wouldn't learn of the studio's complaints until years later, as Judge tried to keep the actors insulated from the film execs' feedback. That meant he absorbed a lot of the stress himself. He was accustomed to working in animation, where he could at least suffer in anonymity. The scrutiny of a $10 million live-action studio film was entirely new to him. "There were moments," he says, "when I felt more stressed out than ever."

The disputes between Judge and Fox carried on through postproduction. One crucial point of contention: "They hated the music," Judge says of the rap-heavy soundtrack, which included the likes of Ice Cube and Scarface. After one test screening, the studio held a focus group meeting featuring several young viewers. It was overseen by a woman

whom Judge suspected was trying to steer the respondents against the movie. "She was like, 'What about the rap? It was kind of vulgar, right?'" Judge says. "And these kids were like, 'No, that was funny!' It was these mall rats explaining to executives why the music worked. The focus groups saved me. That made the battle a lot easier."

Judge was able to keep his soundtrack, but he couldn't convince the studio to rethink its marketing strategy, which included a poster featuring an office worker covered in yellow Post-it notes and the tagline "Work sucks." "It looked like an Office Depot commercial," says Judge. "And the guy looked like Big Bird." (To Judge's dismay, Fox sent at least one worker covered in fake Post-its to walk around a basketball game, in order to promote the film.) The trailer, meanwhile, gave *Office Space* the vibe of a stretched-thin sitcom pilot, with barely a hint of the film's underlying angst or ire. As *Office Space* was nearing its release date, Judge knew the movie was doomed. "I thought, 'Oh, well. I may never make another movie,'" he says. "It was kind of comforting."

When *Office Space* opened on February 19, 1999, its competition included a remake of the sixties sitcom *My Favorite Martian*, as well as *Shakespeare in Love*—the latter of which had been playing for more than two months. Judge decided to split town on opening weekend, taking his kids and then wife on a beach trip: "I just wanted to be on vacation somewhere and not deal with it." It was probably for the best. *Office Space* barely landed in the top ten, earning a little more than $4 million. Herman went to see it opening day in a large theater in Los Angeles—and found himself sitting alone. That same weekend, Bader and his wife attended an *Office Space* screening at a different LA multiplex, only to realize that they, too, had the theater all to themselves. "It put me in this oddly existential mood," says Bader. "I was questioning myself very deeply, thinking 'Do I not have the taste of most Americans? This movie's excellent. And nobody's here.'"

Judge may have been frustrated by *Office Space*'s failure, but he always believed his movie was funny. That sentiment was reaffirmed in the days

after its release, when he got a call from *Office Space*'s first high-profile fan: Jim Carrey, who invited Judge to a meeting at the actor's home. The next to reach out to Judge was Chris Rock, who left Judge a voice mail encouraging him to keep making movies (Judge kept the message for years). Comedy dignitaries that Judge had never even met, such as *Animal House*'s John Landis and *Airplane!* cocreator David Zucker, also declared their affection for *Office Space*. Judge was even asked to talk with Madonna about a possible movie. "She said, 'You know who my favorite character is, right?'" remembers Judge. "'That Michael Bolton guy. There's something sexy about him. He's so angry.'"

The rest of the world, though, needed some time to catch up on *Office Space*. Many months after the movie's brief theatrical slog, Judge found himself in a Blockbuster video store, eavesdropping on a conversation between two young girls who were debating renting *Office Space*. "One of them said, 'Oh, my God. Have you seen this? I can't describe it, but we've got to watch it,'" Judge remembers. "And that kept happening."

The DVD format, which was still on the rise in 1999, would give *Office Space* a lucrative afterlife. "Mike was down for a couple of years," noted Root. "Then, when the movie became the rental of the year, it kind of vindicated him." Like Pink Floyd's eternally popular *The Dark Side of the Moon*, Judge's movie seemed to never go away, eventually selling thousands of copies every week. Around the same time, the movie became a near-constant presence on Comedy Central, which aired it more than thirty times in less than two years.

The film's cast members were among the first to realize just how big *Office Space* had become. "I'm walking around Chicago, and people are yelling Lumbergh dialogue at me," says Cole. "I was dumbfounded: 'How do these people know about this movie? It died a year ago!'" One day, around that same time, Bader and his wife were out for a drive when a cherry-red pickup truck pulled up alongside them, a pair of tattoo-covered rockabilly-types sitting in the front seat. When they spotted Bader, one of the men excitedly screamed out: "Hey, Lawrence, what would you do with a million dollars?"

"Two chicks at the same time!" Bader replied. Then the actor turned to his wife. "Holy shit!" he told her. "They saw *Office Space!*"

So did millions of others, drawn to *Office Space*'s casually insightful one-liners, spot-on workspace details, and way-too-relatable rage. "People hate their fucking jobs," says Naidu. "They feel dehumanized, and they commiserate with the guys in *Office Space*. They *are* those guys." By 2003, Fox had sold more more than 2.5 million copies of *Office Space*—making it one of the most successful home video releases in the studio's history. "The residuals on that DVD paid for my roof," says Bader.

When Judge was first considering going ahead with an *Office Space* movie, he worried that the soul-gobbling cubicle life was already an outdated target. "To me, *Office Space* is sort of set in the eighties, even though it was released in 1999," he says. "In fact, I thought, 'Maybe I'm too late on this.'" As it turned out, *Office Space* was right on time. A few months after the film's release, in the summer of 1999, Steve Jobs stood onstage at an Apple event in New York City, showing off how quickly the internet worked with the latest Apple model. To the crowd's amazement, he picked up his laptop and walked across the stage—without being reined in by a cord. The internet-everywhere era had begun, and users would no longer need to be chained to their desks to go online. The advent of Wi-Fi, Jobs promised, would "free you from these doggone wires." The audience members, many of whom rose to their feet, began applauding and screaming.

The unleashing of the internet quickly realigned the American workplace. Employees might have been free of those doggone wires, but now they were permanently connected to their jobs, as the nine-to-five routine was replaced by the twenty-four-hour buzz of phones and laptops. Suddenly your office was following you home: if you happened to forget to fill out your TPS reports that day, no problem—now you could take care of them in your kitchen, long after your shift had ended, taking time away from your real life. Granted, you weren't stuck in a cubicle anymore. But you *were* trapped in the digital hum of a giant machine—one that wasn't going to let you go free without a fight.

4

"WHOA."

THE MATRIX

One day in 1992, Lawrence Mattis opened up his mail to find an unsolicited screenplay from two unknown writers. It was a dark, nasty, almost defiantly uncommercial tale of cannibalism and class warfare—the type of story that few execs in Hollywood would want to tell. Yet it was exactly the kind of movie Mattis was looking for.

Only a few years earlier, Mattis, in his late twenties, had abandoned a promising legal career to start a talent company, Circle of Confusion, with the aim of discovering new writers to represent. He'd set up shop in New York City, despite being told repeatedly that his best hope for finding talent was to be in Los Angeles. Before that strange script showed up, Mattis was starting to wonder if those naysayers had been right. "I'd only sold a few options that paid about five hundred dollars each," Mattis says. "I was starting to think about going back to law. Then I get this letter from these two kids, saying 'Could you please read our script?'"

The screenplay, titled *Carnivore*, was a horror tale set in a soup kitchen, where the bodies of the rich are used to feed the poor. "It was funny, it was visceral, and it made it clear that whoever wrote it really knew movies," Mattis says. Its writers were Lilly and Lana Wachowski, two self-described "schmoes from Chicago" who, in later years, would be referred to by many colleagues and admirers simply as "the Wachowskis."

By the time they contacted Mattis, the Wachowskis had been collaborating for years, having spent their childhood creating radio plays, comic books, and their own role-playing game. They'd been raised in a middle-class neighborhood on Chicago's South Side by their mother, a nurse and artist, and their father, a businessman. Growing up, their parents had encouraged them to discover art, especially film. "We saw every single, solitary movie that was out," said Lana. "I would go through the newspaper and circle them, and I would figure out a plan on how I would see them all."

The Wachowskis loved morally murky fifties classics such as *Sunset Boulevard* and *Strangers on a Train*, as well as such sixties and seventies thrillers as *Repulsion* and *The Conversation*. But one notably tough-to-replicate big-screen experience occurred in 1982, when the teenage siblings took in repeated screenings of *Blade Runner*—a grim, grimy future noir that was exiled from theaters almost as soon as it opened. "Everyone hated *Blade Runner*, except for us," Lana said.

Lana and Lilly would both eventually drop out of college; afterward, they worked at a construction company they'd cofounded, while also writing comics books and screenplays. Much of their early filmmaking knowledge was divined from *How I Made A Hundred Movies in Hollywood and Never Lost a Dime*, the memoir/handbook by famed indie filmmaker Roger Corman, the director of such B movies as 1960's *The Little Shop of Horrors*. "We were inspired," Lana said. "We wanted to try to make a low-budget horror movie." After finishing their *Carnivore* script, they found Mattis by picking his name out of an agency guide. It was a good time to shop around a movie idea, no matter how outré,

as the market for original scripts had exploded, turning screenwriters into superstars. In 1990, Joe Eszterhas had earned a reported $3 million for *Basic Instinct*; that same year, *Lethal Weapon* creator Shane Black had wound up as the subject of a lengthy *Los Angeles Times* profile after receiving nearly $2 million for his action comedy *The Last Boy Scout*. "Hollywood deals started showing up in the mainstream press," says Mattis. "And people were selling scripts for crazy amounts of money every day."

Mattis signed the Wachowskis shortly after reading *Carnivore*. The script's gnarly eat-the-rich story line all but guaranteed it wouldn't get made, but it attracted enough interest in the siblings that their next effort—a dark tale of dueling contract killers titled *Assassins*—would sell for $1 million. At the time of the deal, the Wachowskis were renovating their parents' home. Not long after, they left the construction business for good.

The big-screen version of *Assassins*—starring Sylvester Stallone and Antonio Banderas, directed by *Lethal Weapon*'s Richard Donner, and released by Warner Bros.—would be a shock to the Wachowskis. Their script was rewritten, prompting Lana to describe the film as "our abortion." The siblings took greater control of their next film, *Bound*, a pulse-racing thriller starring Gina Gershon and Jennifer Tilly as lovers who swindle a mob goon out of his millions. *Bound* would be the siblings' directorial debut, and they made it clear from the beginning who was in charge. On one version of the film's screenplay, they wrote the warning "This is the sex scene, and we're not cutting it."

After debuting at Sundance in January 1996, the lusty, grisly *Bound* was released that fall, becoming a minor hit—especially at the offices of Warner Bros. The studio had just watched its own erotic revenge thriller, an expensive remake of the fifties French stunner *Diabolique*, fail to turn on viewers. According to Lorenzo di Bonaventura, then a top development executive at the studio, Warner Bros. cochairman Terry Semel saw *Bound* and exclaimed, "Goddamnit—this thing probably cost a fraction of our picture, and it's so much more interesting."

Di Bonaventura already knew what film the Wachowskis wanted to make as their follow-up. In fact, he'd already bought the screenplay— one that had stumped nearly everyone who encountered it. The Wachowskis' new story was so audacious, so future-forging, that all you could do was read it and wonder: What is *The Matrix*?

For much of the early nineties, when they weren't writing spec scripts or building elevator shafts, the Wachowskis fantasized about creating a sci-fi comic book that would allow them to sample all of their cultural obsessions. "We were interested in a lot of things," said Lilly, reeling off a list of the siblings' shared pursuits: "making mythology relevant in a modern context, relating quantum physics to Zen Buddhism, investigating your own life." They were also into Hong Kong action movies; early film fixations such as *2001: A Space Odyssey* and Jean-Luc Godard's 1965 French sci-fi noir *Alphaville*; the power of the still ascending internet; and Homer's *The Odyssey*, which each sibling had read multiple times.

Writing by hand, the Wachowskis filled up multiple notebooks with ideas for what they called *The Matrix*, their creative sessions soundtracked by the aggro-rock white noise of Rage Against the Machine and Ministry. Eventually they scrapped the comic book concept and decided to download years' worth of concepts and sketches into a screenplay. Their elaborate script for *The Matrix* follows a bored young office worker who moonlights as a hacker named Neo. One night, Neo meets Morpheus, a cryptic sage who reveals that we're all living in an evil computer-run simulation called the Matrix. Morpheus offers Neo a choice: He can swallow a blue pill and return to his dull office job, living happily (and obliviously) ever after in a fake reality. Or he can swallow a red pill and set off on a conscious-shifting transformation, acquiring all sorts of new powers before taking down the Matrix for good—and fulfilling his prophecy as "the One." Neo chooses the red pill, and as he begins his journey toward becoming a gun-wielding, kung fu–fighting supersoldier, his reaction is relatably real: "Whoa."

Mattis, who had studied philosophy in college, recognized similarities between *The Matrix* and the ideas of René Descartes, the seventeenth-century French thinker who wrote about man's inability to know what is truly reality. "When I first read the script, I called them and said, 'This is amazing! You wrote a script about Descartes! But how do I sell this thing?'" Mattis began circulating their script in 1995, right around the time that the internet—once the dial-up domain of academics, hackers, and military employees—was on its way to becoming a broadband phenomenon. Online, reality was becoming bendable. From the moment users picked a screen handle or even an email address, they were getting the chance to rewrite their own existence and create a whole new version of themselves—new name, new gender, new hometown, new *anything*. People were stepping into their own virtual worlds every day, and the Wachowskis' script for *The Matrix* had a question for them: Now that we can create as many realities as we want, how do we know which one is actually "real"?

It was a timely query, one wrapped in an otherwise action-filled script, full of twists, chases, endless gunplay, and even a helicopter slamming into the side of a skyscraper. Yet there was no pill that could convince most studio execs to see *The Matrix* as a viable movie. The only company to show any real interest was Warner Bros., which had already bought the script for *The Matrix* years earlier, and then let it languish while the duo worked on *Bound*. "Nobody understood it," says di Bonaventura, who, along with producer Joel Silver, was an early supporter of the movie. "They would go, 'How does this work? I'm sitting in a room, but I'm actually living in a machine? What the fuck are we doing?'" Di Bonaventura asked the Wachowskis to pare down the screenplay—which had enough ideas for three movies—and suggested they go off and make *Bound*, in order to prove they could direct. But even after that movie's success, the heads of Warner Bros. needed more convincing. So the Wachowskis enlisted the hyperdetailed comics artist Geof Darrow to design much of the foreboding technology of *The Matrix*, including the Sentinel, a war machine that resembles an electric, spermlike insect, and the body-harvesting Power Plant. The

Wachowskis also hired artist Steve Skroce to draw nearly six hundred detailed storyboards, breaking down the movie shot by shot.

Finally the Wachowskis laid out all of their *Matrix* materials for Warner Bros. cochairmen Semel and Bob Daly. "It was an unusual show," says di Bonaventura. "One of the Wachowskis was explaining the story, and the other was making sound effect noises." Afterward, di Bonaventura remembers, Semel asked the exec if the company was going to make money on *The Matrix*. "I thought for half a second and said, 'We're not going to *lose* any money.'" *The Matrix*'s budget was estimated at around $60 million, a huge investment in an idea that couldn't be distilled to a single-sentence pitch. But that amount was far less than what Warner Bros. had spent on *Batman & Robin*, a disastrously overpriced franchise entry that would be all but scoffed out of existence before 1997 was over. Warner Bros., like the rest of the major studios, had watched moviegoers grow increasingly tired of unsolicited remakes and retreads. They wanted new adventures, new ideas. "Sequels were faltering," says di Bonaventura. "And a lot of genres were dying: action-comedy movies, buddy-cop movies. We knew we needed to do something different."

His bosses agreed. The Wachowskis would get their $60 million budget—as long as they filmed in Australia, where it would be cheaper. After years of waiting, the schmoes from Chicago would finally be able to construct *The Matrix*. Now they just had to find the One.

By the late nineties, it was possible to sum up Keanu Reeves's acting career in a single word: *woe*. The decade had begun promisingly enough, with Reeves playing an undercover surf cop in *Point Break*, a time-traveling metal head in *Bill & Ted's Bogus Journey*, and a soft-spoken male hustler in *My Own Private Idaho*—all in 1991 alone. A few years later, in 1994, the success of the high-velocity thriller *Speed* had promised to turn Reeves into the next die-hard action hero. Instead, he had steered his movie career from one strange, stupefying destination to the next. There was a drippy period romance (*A Walk in the Clouds*) and a

dippy modern romance (*Feeling Minnesota*), not to mention a few bogus action efforts, such as the cyberpunk adventure *Johnny Mnemonic*. As the decade came to a close, Reeves—who was in his early thirties—had begun to fret a bit about where he fit into Hollywood. *Oh, my God, have I disappeared?* he remembered wondering. *Will a studio want to see me?*

His fears weren't misplaced. Reeves had recently completed the trashterpiece *Devil's Advocate* for Warner Bros., starring as a lawyer who goes up against Satan. That movie would be a modest hit upon release late in 1997, but at the time of the *Matrix* casting, Reeves wasn't high on the studio's wish list for Neo. According to di Bonaventura, the role had been passed on by Will Smith (who wanted to make *Wild Wild West*), Brad Pitt (who'd just been through *Seven Years in Tibet*), and Leonardo DiCaprio (who didn't want to do another special effects movie after *Titanic*). "It got to the point where we offered it to Sandra Bullock and said we'd change Neo to a girl." She said no, too.

In early 1997, Reeves found himself at Warner Bros' headquarters in Burbank, California. He'd arrived at the lot for his first meeting with the Wachowskis, who'd recently sent the actor their screenplay of *The Matrix*. "When I first read that script," Reeves said, "it made my blood happy." That day, the siblings showed Reeves some of their designs, and as the conversation continued, it became clear that it wouldn't be their last. "They told me they wanted [me] to train for four months prior to filming," Reeves recalled. "And I got a big grin on my face and said, 'Yes.'" Noted Lana Wachowski, "We knew it would take a maniacal commitment from someone, and Keanu was our maniac."

Reeves was also a lover of sci-fi and philosophy, one who didn't flinch when the Wachowskis asked him to prepare by reading such treatise as Jean Baudrillard's perception-bending 1981 *Simulacra and Simulation*. "One of the great misunderstandings about Keanu is that people don't think he's smart," says di Bonaventura. "Maybe it's because of the Bill and Ted movies. But Keanu gives me books I cannot make heads nor tails of. And in Keanu, the Wachowskis found somebody who was an intellectual searcher."

The hunt to find who would play Morpheus, Neo's calm, clinical

guide to the Matrix, would be even more drawn out. Warner Bros. offered the role to such stars as Arnold Schwarzenegger and Michael Douglas, who both declined. The Wachowskis, meanwhile, were pushing for Laurence Fishburne, who as a teenager had starred in Francis Ford Coppola's carnage-filled Vietnam War epic *Apocalypse Now* and had earned an Oscar nomination as the abusive Ike Turner in 1993's *What's Love Got to Do with It*. They'd met the actor in Las Vegas in the summer of 1997, at the boxing match in which Mike Tyson had bit the ear of Evander Holyfield. "I had a dream about a man who wore mirrored sunglasses and spoke in riddles," Lana Wachowski would later tell Fishburne, "and when I met you and heard your voice I knew that you were that guy."

But studio execs worried that Fishburne, despite having won both an Emmy and a Tony, wasn't well enough known overseas for the role. Their choice was Val Kilmer, who'd recently played the Dark Knight in 1995's hit *Batman Forever* but who'd earned a reputation as a not-worth-the-drama nuisance during the filming of a recent remake of *The Island of Dr. Moreau* (quite a feat, considering that his costar was the legendarily impossible Marlon Brando, who spent part of the *Moreau* shoot waddling around with an ice bucket on his head). "The Wachowskis had heard all the stories about Val," says di Bonaventura, "and I said, 'Yeah, but it gets the movie made.' So we have a meeting with him at the Bel-Air Hotel, where he proceeds to pitch why Morpheus should be the lead of the movie. I knew within two minutes of the meeting we were dead." Kilmer was soon out of contention, and the job went to Fishburne, who said he had always thought of Morpheus as "Obi-Wan Kenobi and Darth Vader rolled into one—and maybe some Yoda."

The third major *Matrix* role to fill was Trinity, a high-flying, fast-kicking operative who assists Morpheus aboard their underground ship, the *Nebuchadnezzar*. Jada Pinkett Smith auditioned for the part, "but Keanu and I didn't click," she said. "We just didn't have any chemistry." The Wachowskis ultimately went with Carrie-Anne Moss, a Canadian-born actor who'd starred in such nineties TV dramas as *Models Inc.* and *F/X: The Series*. (She'd also performed in a Canadian fantasy series called *Matrix*.) As part of her days-long screen test, Moss sparred

and practiced with stunt performers. Afterward, she said, "I couldn't walk for days." The Wachowskis wanted the actors to do most of their own physical work so the camera wouldn't have to cut away to stunt performers. Still, Moss said, "I remember thinking 'They don't *really* think I'm gonna do this stuff, like jumping from one building to another. Of *course* I'm not going to do that!'"

In the fall of 1997, before filming began, the *Matrix* team spent months in a massive, frills-free warehouse in Burbank, where the film's cast endured daily training sessions overseen by Yuen Woo-ping, a legendary Chinese director and martial arts choreographer who'd steered such overseas hits as *Drunken Master*, Jackie Chan's 1978 kung fu breakthrough. Working with Yuen's team of stunt technicians, the actors stretched, kicked, and sparred for hours on end. Sometimes they were strapped to wires and flung through the air—the stars of a high-tech, high-ambition action film hovering over a pile of dinky mattresses. "After the first day, I was so shattered and so shocked," said actor Hugo Weaving, who'd been hired to play Agent Smith, Neo's obsessive nemesis. "I realized I was so unfit." (Not long into training, Weaving injured his femur, requiring him to walk on crutches until he could heal.)

Reeves also had to be handled delicately. In the late nineties, the actor learned he'd done some serious damage to his spine: "I was falling over in the shower in the morning, because you lose your sense of balance," he said. He eventually discovered that two of his vertebrae were fusing together. "Keanu's doctor told him that he had to have this operation, or he'd become a quadriplegic," says Barrie M. Osborne, a *Matrix* executive producer. Reeves underwent surgery before filming, and once he arrived in Burbank for training, he wore a neck brace and was forbidden to kick for several months. Luckily, there were other ways to prepare: during preproduction and filming, the actor said, "kung fu dojos" were set up, in which the cast members could "stretch and watch kung fu movies."

The Wachowskis weren't subjected to the same brutal regimen, as writing and directing a multimillion-dollar movie was taxing enough. Still, they were always nearby during the months-long training and

easy to spot. For the Wachowskis, there'd be "none of that Hollywood thing," Moss said around the time of filming. "They're from Chicago. They wear shorts. They wear baseball caps. They watch basketball games."

The siblings' love of their hometown Chicago Bulls was so strong, they'd arranged for Warner Bros. to provide a satellite TV on set so they could watch the 1998 NBA Finals. They'd also insisted on bringing along many of their *Bound* collaborators, including cinematographer Bill Pope, editor Zach Staenberg, and Joe Pantoliano, whom the siblings cast as Cypher, the teammate of Morpheus and Trinity. Cypher is the most skeptical inhabitant of the Matrix—and, in some ways, its most relatable one. After years of living in the techno-shithole of the real world, he ultimately sells out his friends in order to escape to the blue-pill life of the Matrix.

Pantoliano had played pragmatic weasels for years, most famously in eighties hits such as *The Goonies* and *Risky Business*, the latter of which found him tormenting Tom Cruise as Guido, the Killer Pimp. Yet he'd never prepared for a movie quite as strenuously as he did for *The Matrix*. "They wanted me to be in the best shape of my life," says the actor, who was in his midforties at the time of filming. "No drinking, eating steamed vegetables, working out at a gym. I'm a fucking character actor! This trainer they hired said to me, 'You can do three thousand sit-ups a day, but that ain't going nowhere.' So I talk to my buddy, a plastic surgeon, and decide I'm going to get an eight-thousand-dollar liposuction procedure." Pantoliano sent the bill for the surgery to the studio, claiming that the liposuction counted as "research and development." (He says he was never reimbursed.)

After the *Matrix* team finished rewiring their bodies in Burbank, they'd be shuttled off to Sydney, where the Wachowskis would be filming their ambitious sci-fi tale. They'd spent years fantasizing about what *The Matrix* could look like and had planned its production as carefully as possible: Months of physical training. Pages of detailed storyboards. Hours of explanatory meetings. Yet one of the most exhausting

challenges of making *The Matrix* was also one of its biggest revelations: bullet-time.

The term itself appears toward the end of the *Matrix* screenplay, during a scene in which Neo is under attack on a skyscraper rooftop. A Matrix operative named Agent Jones fires at him from close range—but by now Neo has spent so much time in the Matrix, he's learned to manipulate it. Here's how the the moment is described in the film's shooting script, from August 1998:

[Jones's] gun booms as we enter the liquid space of—

Bullet-time.

The air sizzles with wads of lead like angry flies as Neo twists, bends, ducks just between them . . . Neo bent impossibly back, one hand on the ground as a spiraling gray ball shears open his shoulder.

The Wachowskis' description of the scene was brief, excitable—and totally puzzling. "Liquid space"? What did that even mean? And how was Keanu Reeves—a guy who'd just undergone neck surgery—going to bend "impossibly back"? For a long time, no one was quite sure how "bullet-time" would play out on the screen—including the Wachowskis themselves. "People would say, 'Well, how are you gonna do that?'" remembered Lana. "And we were like, 'We're working on it.'"

The idea behind bullet-time was that the camera would move at regular speed but capture movement in slow motion. That would create the "liquid space" in which it felt as though the all-seeing camera could move *anywhere*, picking up every detail. What the Wachowskis wanted, Lana said, was for the visuals to "push at the boundaries of reality." But the realities of filmmaking pushed back. The siblings initially toyed

with the idea of putting a slow-motion camera on a high-speed rock-etlike device—an idea that was nixed for various reasons of safety and practicality. Instead, bullet-time would have to be created with digital effects, which in recent years had allowed filmmakers to not only mint new creatures and galaxies, but to also refurbish the world we already knew.

For decades, the visual effects field had been dominated by Industrial Light & Magic, the San Francisco–based firm George Lucas had founded in the midseventies, in order to make the first *Star Wars* film. But the surge in nineties CGI had launched several scrappy visual effects companies, including Mass Illusions (later renamed Manex Visual Effects). The company's breakthrough effort, the 1998 Robin Williams drama *What Dreams May Come*, took place inside a sumptuous, digitally created afterlife that earned Manex an Academy Award for visual effects. But by the end of the decade, the company was still working out of an old building at Naval Air Station Alameda, a decommissioned federal base near the San Francisco Bay. The run-down industrial facility was filled with empty weapons-testing areas and the remains of charred computers—what Manex VP of technology Kim Libreri describes as "a weird techno-garden of blacked-out electronics." To work at Alameda was to be reminded that the institutions that were supposed to protect us—and the technologies that kept them running—were just as fallible as we were. Sometimes, they could even turn *against* us. In Manex's headquarters, "if you blew your nose, black stuff would come out," says Libreri. "It was like we were being eaten by something."

It was a fitting environment within which to create the immersive, invasive ones-and-zeroes world of *The Matrix*. Libreri and Manex's senior visual effects supervisor, John Gaeta, first met with the Wachowskis in 1996, when the directors were still fine-tuning their script. "They were trying to understand how to manifest the things that they saw in their head," says Gaeta, who notes that the Wachowskis wanted to evoke "the feel of virtual reality—the feeling of having power over time and space—while being bound to physical cameras." The concept seemed

overly ambitious, especially for two filmmakers who'd never made an effects-intensive film before. "People were superskeptical about the Wachowskis' abilities to pull off bullet-time," says Libreri. "And trying to get artists to work on *The Matrix* was already hard. Some of them were like, 'Keanu Reeves? Virtual reality? Are you making another *Johnny Mnemonic?*'"

The bullet-time technology would be needed for a handful of crucial *Matrix* sequences, including Reeves's rooftop showdown. On an all-green soundstage in Sydney, Reeves was connected to wires and placed amid a cascading semicircle made up of 120 still cameras. The wires pulled Reeves backward to the ground, contorting his torso to a ninety-degree angle, as the still cameras went off in quick succession around him—their combined images circling the actor as he fell backward. At the same time, his backward bend was captured by a pair of motion picture cameras. Later, all of these elements were blended together with a digitally insterted background and several airborne bullets.

That single shot would take nearly two years to complete and run an estimated $750,000 in computer costs. It quickly proved to be a worthwhile investment. Libreri remembers one internal screening of *Matrix* footage during which Reeves—seated in the front row—began lying back in his chair, excitedly re-creating his rooftop bends. At that same session, the team previewed another key effects sequence, in which a camera swirls around Trinity as she leaps up and kicks a cop. According to Libreri, "Joel Silver got up and said, 'That's it! This is where everybody's going to get up and scream!'"

The Manex team would create more than four hundred digital shots for *The Matrix*, its members sometimes finding themselves in the middle of the film's extravagant action sequences. One weekend, while helping with a complicated helicopter sequence over downtown Sydney, digital effects producer Diana Giorgiutti received a call from her parents, who were nearby. "They said, 'Are you shooting, by any chance?'" Giorgiutti says. "And I'm like, 'Yeah. I'm actually cabled to a railing on the forty-fourth floor of a building.'"

Giorgiutti became close to the Wachowskis during the shoot,

hanging out in the siblings' office as they vented about studio head-aches and huddling with them during filming. At one point she asked if they were interested in splitting up some of the directing duties, to save time. "We don't do that," one of the Wachowskis told her. "We work together as one."

Throughout the making of *The Matrix*, that unified front never wa-vered. Filming in Australia gave the siblings a geographic distance from Warner Bros., as well as plenty of autonomy: "It felt like we were a se-cret," says costume designer Kym Barrett. Yet there were still moments when they found themselves at odds with the studio. "Warners was wor-ried about the budget," says *Matrix* producer Osborne, who notes that the studio had already chosen scenes it would ax if the movie started racking up costs.

It was a threat the studio tried to make good on at least once. About two-thirds of the way into filming, the Wachowskis pulled aside *Matrix* editor Zach Staenberg and showed him an email they'd received from a Warner Bros. exec. It said the filmmakers were running over budget and that certain scenes would need to be cut. "They shot that morning, and then broke for lunch," says Staenberg. "And they did not return from lunch."

A producer eventually dispatched Staenberg to visit the siblings in their office, where they were watching a Bulls game. "They had a way of talking that was very much like twin speak," remembers Staenberg. "And they said, in their almost offhanded way, 'If we don't have those scenes, we don't have the movie—and they can get someone else to fin-ish it.'" After a few hours, the Wachowskis received a call from the stu-dio, telling them not to worry about the cost overruns. "They basically played poker, feeling they had a strong hand—and they were right," says Staenberg. He adds: "*The Matrix* was made over-schedule and over-budget, but it was made on the Wachowskis' terms."

It helped that Staenberg had edited together a few early sequences

and sent them back to Burbank, in order to calm execs' nerves. "The studio could see the movie was going to be really special," says Osborne, "and that took a lot of the heat off."

One moment that especially excited Warner Bros., even in rough form, was a wall-pulverizing shoot-out that takes place in a cavernous skyscraper lobby. It's an intensely physical scene, with Neo executing a quadruple kick, and Trinity cartwheeling off the side of a wall. Moss had been especially nervous about the lobby stunt: "The weekend before I had to do it, I was in the training center in tears, saying: 'I can't do it! I can't do it!'" she said. An hour before the cameras rolled, while practicing with her trainers, she injured her ankle and fell to the ground, moaning "Oh no, *oh no*," as a team of stunt workers rubbed her back. She was able to perfect the cartwheel later that day during rehearsals but struggled once the cameras were rolling, letting out what sounded like a loud, anguished "FUCK!"

The lobby sequence found Moss and Reeves running and fighting while clad in what appeared to be impossibly tight-fitting leather get-ups. *Matrix* costume designer Barrett had rummaged through fabric suppliers in New York City, seeking out affordable, lightweight materials, such as vinyl, that could give the characters their cool, shiny S&M style—while also being true to the Wachowskis' story. "In the script, it talks a lot about people appearing and merging into worlds," says Barrett, who before *The Matrix* had worked on director Baz Luhrmann's rococo 1996 film *Romeo + Juliet*. "I thought, 'How can you do that and not get seen?'" The shiny black Lycra outfit worn by Trinity was a solution. "I wanted her to move like an oil slick on water," Barrett says, "with layers of reflection."

All of the *Matrix* outfits were intended to signify the characters' respective journeys. Reeves's long black jacket, which he wears during the rooftop battle—donning it almost like a cape as he confronts the Matrix head-on—was designed to "have an ancient feeling, as well as a slightly ecclesiastical feeling," Barrett says. "I wanted him to change from the reluctant hero to someone who had taken on this responsibility." Barrett's

Matrix work also required her to design multiple pairs of sunglasses, one for nearly every lead character—a nod to the film's bigger theme of obscured identities. "All of our lenses were reflective," she says. "You couldn't see their eyes unless we wanted you to."

Like many of the *Matrix* cast and crew, Barrett wound up working on the movie longer than she'd expected. Warner Bros. had allowed the shoot to extend from 90 days to 118, giving the siblings enough time to film nearly every scene they wanted. Reeves's final day of filming, in late summer 1998, found him nearly naked in a giant techno-pod, as Neo's energy is sucked away by spiderlike robots—the grim reality that awaits all of us in the Matrix. Reeves had already endured major surgery, as well as months of body-altering training, for the role. But his final day as Neo would require one last transformation: right before filming, he'd sat in a bathtub, shaving his head, eyebrows, and body.

Afterward, the newly hairless Reeves noticed that people had trouble making eye contact with him. But if they were looking at him strangely now, just wait until they got a load of *The Matrix*.

In the months leading up to the release of the Wachowskis' strange sci-fi fable, Warner Bros. had one major worry: *The Phantom Menace*. The first *Star Wars* movie in more than fifteen years was due in the summer of 1999, right around the time Warner Bros. had planned on opening *The Matrix*. But an R-rated, visually dense cyberadventure was all but certain to be squashed by *The Phantom Menace*, which was hovering over the competition like a mega-million-dollar Death Star. The studio asked the Wachowskis to speed up the postproduction process, in order to get *The Matrix* ready for the spring.

Otherwise, Warner Bros. had grown increasingly confident in their more than $60 million investment. After one successful *Matrix* test screening, the film's creative team was called into a meeting with co-chairs Bob Daly and Terry Semel, as well as dozens of other top staffers. "Terry said, 'We love this movie,'" remembers editor Zach Staenberg.

"Their only note to us was to take five to ten minutes out. We ended up taking five and a half minutes out, and they never even looked at that final cut." At that same post-screening meeting, Semel would predict the film was "going to make a lot of money." But Staenberg says that the studio's approach to filmmaking wasn't driven solely by profits. "To me, *The Matrix* is a studio version of an auteur film. It was handled almost the way Warner Bros. used to handle Stanley Kubrick: they'd send him the money, and then keep their distance."

That became clear immediately upon the movie's release on March 31, 1999. Opening on a Wednesday evening to get a jump start on Easter weekend moviegoing, *The Matrix* made nearly $37 million in its first five days and instantly reawakened Reeves's leading-man career. More crucially, from the moment it arrived, *The Matrix* inspired countless theater lobby discussions about the movie's deeper implications—talks that would spill onto the internet for months and eventually years. To some, the movie was simply a dizzying action flick, one that ended on an impossibly id-pumping final scene: Reeves, decked out in his black coat and dark shades, flying through the sky to the righteous roar of Rage Against the Machine's "Wake Up."

But to others, *The Matrix* was itself a wake-up call, one that tried to make sense of the confusion and unease that were beginning to take hold in the late nineties, a period when things were going a bit *too* smoothly. "That decade was so comfortable," says Mattis, the Wachowskis' longtime manager. "The stock market was up, and people were making money. But there was a splinter in the mind's eye: something felt wrong. In all of that comfort, people started thinking, 'There's something missing here.'"

The Matrix nudged viewers to develop their own slowed-down, omniscient, bullet-time view of the world around them: Who controls my life? Am I happy or just happily distracted? Do I even exist at all? Such existential turbulence wasn't exclusive to the nineties. But it had grown deeper during a decade in which technology had become so soothing—and so controlling. When the Wachowskis began writing *The Matrix*,

the mainstream web was still in its modem-wheezing early days. By the time the film was released, more than a quarter of all households in the United States were connected to the internet—a number that would shoot up dramatically in the years that followed. At-home computers that had once been used for word processing, recipe storage, and playing *The Oregon Trail* could now support webcasts, multiuser games, avatar-cluttered message boards and comments sections, and various other time-slurping satisfactions. (Soon enough, there'd even be hours of free music to graze upon, thanks to the June 1999 debut of Napster, the song-sharing site cofounded by a *Matrix*-loving college student named Shawn Fanning.) When hacker turned hero Neo describes his ascent into "a world where anything is possible," he's voicing the optimism of the brave new web. "*The Matrix* was ten years ahead of its time," says *Run Lola Run*'s Tom Tykwer, who cites the film as the first to truly understand the way the online world was becoming "our second home."

But that immersion into a digital nirvana came with all sorts of troubling side effects: system-shattering viruses; an emerging ailment dubbed "internet addiction"; and the premeltdown panic over Y2K. By the end of the twentieth century, there was a lingering belief that the machines might outsmart us. Such a premise had animated sci-fi movies for decades, from *2001: A Space Odyssey* to *The Terminator*. Now, though, there was a real-world sense that mankind might be losing its edge. In 1996 and 1997, chess legend Garry Kasparov played against Deep Blue, an IBM-created supercomputer, in a series of matches that were treated like a man-versus-machine title bout. "I'm a human being," the frustrated Kasparov declared after losing one of the games. "When I see something that is well beyond my understanding, I'm afraid."

The Matrix wasn't alone in augmenting that fear, as a pair of similarly future-shocked films that arrived just weeks after its release. In *eXistenZ*, written and directed by genius sicko David Cronenberg, Jennifer Jason Leigh played a celebrity video game designer whose latest creation drops players into a fake world so believable, she's targeted by reality-defending terrorists. And in the *Blade Runner*–referencing noir

The Thirteenth Floor, thrill seekers are transported into a fake 1930s Los Angeles, a journey that inevitably results in real-world murders and madness.

Both films took viewers down a virtual reality rabbit hole. But they were overshadowed by the plausible terrors—and potential empowerment—of *The Matrix*. It's a movie in which machines keep humans in a comforting trance, while secretly sucking away their very existence ("Be afraid of the future" advised one early *Matrix* tagline), while also offering a way to fight back: the truth-revealing red pill. In the Wachowskis' world, Neo's acceptance of the pill is a brain-breaking move, one that wises him up to the dystopian reality being camouflaged by the Matrix before setting him on a larger, more hazily defined search for freedom.

"This world has the Matrix all over the place," Lana Wachowski said. "People accept ways of thinking that are imposed upon them rather than working them out themselves. The free-thinking people are those who question every sort of Matrix, every system or thought or belief, be it political, religious, philosophical."

Reality was right in front of you, if you looked hard enough. The question was whether you would want to live in a world that, at times, could be well beyond anyone's understanding.

SPRING

If you are just joining us, two young men, apparently dressed in long black trench coats, opened fire about an hour and a half ago at a high school just outside of Denver. . . . *Believe when I say/I want it that way.* . . . **GATESES GIVE RECORD $5 BILLION GIFT TO FOUNDATION** . . . We would like to emphasize that this is a parent information line—it has been set up for parents of Columbine High School students only. . . . *The streak is over! Susan Lucci!* . . . *In my dreams/I'm dying all the time.* . . . By midnight on Thursday, every cigarette billboard in the country must come down as part of the $206 billion agreement. . . . We were all under the tables and the girl who was sitting right across from me was shot in the head right there. . . . It took just five weeks for the Dow Jones industrial average to get from 10,000 to 11,000—the fastest assault on a 1,000-point milestone so far. . . . *Upside, inside out/She's livin' la vida loca.* . . . Perhaps we may never fully understand it. Saint Paul reminds us that we all see things in this life through a glass darkly—that we only partly understand what is happening. . . . **BUSH IOWA TRIP SIGNALS REAL START OF 2000 RACE FOR THE PRESIDENCY.**

5

"I DON'T WANT YOUR LIFE."

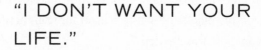

VARSITY BLUES
SHE'S ALL THAT
CRUEL INTENTIONS
10 THINGS I HATE ABOUT YOU
AMERICAN PIE

Even in the early months of 1999, there was a sense of constant forward momentum—a feeling of hurtling toward *something*, even if it was just the mysterious deadline of the century's end. But on April 20, everything seized up.

The stark facts of what happened at Columbine High School that day are just as jarring now as they were then: Shortly after 11:00 a.m., two students entered the school dressed in black trenchcoats, and armed with guns, knives, and explosives. Over the course of nearly an hour, they murdered thirteen classmates and teachers before shooting themselves. The two had long been planning the killings, which took place shortly before graduation. If the numerous bombs they'd placed around the school grounds had worked, the death toll could likely have reached into the triple digits.

The mass shooting, one of the largest such attacks in US history at the time, immediately prompted moments of silence across the country.

Once those ended, the questioning began: What would make two teen-age boys want to murder their classmates, then take their own lives?

For some people, the response was obvious: a too-far-gone popular culture. Critics derided shoot-'em-up video games such as *Doom*, as well as the grim rocker Marilyn Manson, who contributed a self-defending op-ed to *Rolling Stone*. "It was unthinkable that these kids did not have a simple black-and-white reason for their actions," he wrote. "And so a scapegoat was needed."

The biggest scapegoat of all was Hollywood. Newspapers noted the Columbine shooters' apparent fondness for 1994's *Natural Born Killers*, the Oliver Stone–directed murder-spree romance. Reporters also pointed out the school-destroying subplots of such films as *Heathers*, *Carrie*, and even the cartoonish seventies comedy *Rock 'n' Roll High School*, starring the Ramones. Newscasts reran footage from the 1995 film *The Basketball Diaries*, focusing on a fantasy sequence in which a trenchcoat-clad teen, played by Leonardo DiCaprio, shoots up a classroom.

The most immediate target, however, was a film that, in many US towns, was still playing right down the street: *The Matrix*. Footage from the movie was featured in multiple TV reports addressing onscreen violence. There was no discernible connection between the events in Colorado and the film itself, but for some, the mere sight of Neo in his dark duster, blasting everything in sight, was enough to tether *The Matrix* to the killings. "Keanu and an accomplice enter the bad guys' building strapped to the nads with automatic weapons hidden under long black trench coats," noted a columnist in *Mother Jones*. "This is by far the single most popular movie in America. So now let's all act so terribly shocked about the kids in Colorado."

A few members of the media defended the Wachowskis' work: "In three weeks, 15 million people have seen *The Matrix* and not gone berserk," wrote *Time* film critic Richard Corliss. But the film's popularity—it would pass the $100 million mark the same week of the Columbine murders—only added to the anti-Hollywood rhetoric coming out of Washington, DC. "Our children are being fed a dependable daily dose

of violence, and it sells," President Clinton said after the massacre. That summer, he urged movie theaters to card young ticket buyers trying to get into R-rated movies—perhaps forgetting that America's teens have long had a corner on the fake ID market. Clinton also ordered a federal study to determine whether studios deliberately marketed violence to young viewers. The backlash quickly became a bipartisan effort, with Republican representative Henry Hyde, who decried the "culture of death and violence," proposing a ban on sales of graphic material to minors. Hyde had a very specific threshold for film violence: "Any movie that has more than 50 killings is pushing the envelope," he said.

No Hollywood-specific legislation would ever make it through Congress. But movie studios enacted their own crackdowns, just in case. The Katie Holmes student revenge thriller *Killing Mrs. Tingle* was retitled *Teaching Mrs. Tingle*, while *"O"*—a violent, high school–set retelling of Shakespeare's *Othello*—was taken off the release schedule altogether (it wouldn't hit theaters for more than two years). Disney even canceled a planned adaptation of the popular young-adult horror series *Goosebumps*. Television executives scrambled, too, with The WB postponing a season-finale episode of *Buffy the Vampire Slayer* in which a monster interrupts a high school graduation ceremony.

For weeks afterward, questions about Columbine dominated magazine covers: "What Made Them Do It?" (*Time*); "How Well Do You Know Your Kid?" (*Newsweek*); "Why?" (*U.S. News & World Report*). The media pointed their microphones toward anyone who might offer insight into teenage behavior. A few days after the attacks, while attending the premiere of *Idle Hands*—a teen-horror comedy that itself had nearly been yanked from theaters—*Buffy* star Sarah Michelle Gellar found herself defending her show to reporters. Just a few years earlier, in *Scream 2*, Gellar had played a college student who rejects the idea that movie carnage leads to offscreen violence: "That is *so* Moral Majority," her character sneers. Now Gellar was having the same debates in real life. "Columbine upset me on so many levels," she says. "But to blame us, and ask these questions . . . I guess, at that point, everyone was looking for answers."

No one would find them. Instead, the faces of blank-expressioned adolescents were plastered across newsstands, accompanied by headlines such as "How to Spot a Troubled Kid" and "The Secret Life of Teens." It wasn't just the Columbine killers that had everyone suddenly so worried: one month after the shootings in Colorado, a fifteen-year-old shot up his high school in suburban Atlanta, injuring six of his classmates. And news reports told of other supposed Columbine-inspired young killers being thwarted at the last minute. After that one day in April, it seemed as though US teenagers were either living in terror or embodying it. "Violence is like a movie," one youth-crime counselor told *Time* that spring. "It's coming to a theater near you."

Yet many of the films that arrived in 1999 presented a sharply different portrait of high school life. Made long before Columbine, they exist in a happy vacuum, one that was sealed off right before certain twenty-first-century realities could seep in. And they arrived at a time when American teens made up a cultural ruling class, one that possessed great promise and power. While their parents schlepped to their soul-battering office spaces, the country's teenagers—all 31 million of them—were bopping in the back seat, demanding to hear the latest *NSYNC or Backstreet Boys, or gossiping about the newest episodes of *Buffy* and *Felicity* and *Dawson's Creek*, safe in the knowledge that they were about to run the world. Throughout 1999, you could stand almost anywhere in Times Square and hear the wail of shrieking teens outside MTV's *Total Request Live*, their voices rising like some bubble-gum-loving wraith.

Movie studio execs clearly heard those cries. In 1999, a brief but far-reaching teen-movie movement entered its senior year, as mall cineplexes were flooded with tales of high school swooning and prep school cruelty—enough to sell more than $400 million worth of tickets. Only a few years earlier, the genre had all been declared over. "In the early nineties, there were no teen movies," says Andrew Fleming, the director of the 1999 comedy *Dick*, starring Kirsten Dunst and Michelle Williams as two girls who befriend Richard Nixon. "I remember reading an *LA Times* story that basically said, 'Teenagers don't go see movies

about themselves.'" By the decade's end, that was *all* they wanted to see. Surprise hits such as *The Craft*, *Clueless*, and *Scream* had kicked off a phenom *Entertainment Weekly* dubbed "teensploitation." It was a nod to how quickly and cheaply the new teen movies were being produced in order to keep young moviegoers happy. "It was the easiest audience to get," notes Sheryl Longin, who cowrote *Dick* with Fleming. "Teenage boys would go to pretty much any movie that got attention. They'd all rush out on opening weekend, because that's all there was to do. And studios cashed in on that."

Teensploitation films were relatively low-risk investments for executives, as most cost between $7 million and $13 million. There were so many high school movies in the works that studios began seeking out new faces to cast. Finding them would be as easy as turning on the TV.

The girls couldn't be held back. They were pressed up against one another, straining against the barricades, trying to get closer to the kid with the floppy blond hair. Only a few months ago, hardly anyone would have recognized the young actor, much less have asked for his autograph; now there were hordes of teens surrounding him at this late-nineties signing event. When the crowd finally managed to swarm past security, the freaked-out James Van Der Beek was thrown into a cop car and sped away to safety. "It was instantaneous," Van Der Beek says of his end-of-the-decade fame frenzy. "And there was no volume button for it."

Van Der Beek's ascent had begun in early 1998, when he made his first appearance as Dawson Leery, the sensitive, Spielberg-worshipping high schooler on *Dawson's Creek*. The series became an instant hit for The WB, a fledgling TV network that had launched in 1995 with a batch of African American–starring sitcoms but whose programming would grow younger (and whiter) as the decade progressed, with dramas such as *Buffy*, *7th Heaven*, *Felicity*, *Charmed*, and *Roswell*. Created by *Scream* writer Kevin Williamson, *Dawson's Creek* filled a teen-soap sweet spot for a generation that had been too young for *Beverly Hills, 90210*. Within

weeks of its debut, Van Der Beek and his castmates—Michelle Williams, future *Go* star Katie Holmes, and Joshua Jackson, who'd costar in *Cruel Intentions*—were fixtures on newsstands and entertainment shows, their agents suddenly inundated with screenplays.

"I went from doing this little pilot—on a network I couldn't even watch on my closed-circuit TV at college—to all of a sudden being in contention for major Hollywood movies," says Van Der Beek. "I was very picky. I had the brashness of a twenty-year-old: 'I'm just gonna make my choices.'" When he received the script for *Varsity Blues*—about a backup quarterback who leads a rowdy, tight-knit southern team to victory—Van Der Beek, a former player himself, was excited. But the original version of *Varsity*, he says, was too much in the vein of boob-baring eighties films such as *Porky's*. Van Der Beek reconsidered only after being promised by director Brian Robbins that the movie would hew closer to author Buzz Bissinger's gritty 1990 high school football tale *Friday Night Lights* (which itself would be adapted into a film in 2004).

Varsity Blues centers on an anguished nice guy named Jonathan "Mox" Moxon, who mostly sits on the sidelines, reading Kurt Vonnegut and biding time before he can escape to Brown University. The adults who run his small Texas town slowly bring out a fury in Mox. After watching his evil coach repeatedly abuse his players, Mox grabs a shotgun and blasts a poster featuring his face. And Mox pushes back against his controlling, football-obsessed father, dismissing him with a line that could have been spoken by any of the angry young characters of 1999: "I don't want your life."

For Van Der Beek, it wasn't hard to tune in to Mox's ire. "When I was seventeen," he says, "I had a director who was a complete asshole who tried to destroy people. I'd had a couple of different authority figures who were destructive." But because his *Dawson's Creek* character was such a softie, Van Der Beek had to audition three times to play Mox. And there were concerns, even in the teen-mad late nineties, that his star power could quickly die. At one point while Van Der Beek was testing for the role, a *Varsity* producer looked at his face on the cover of *TV Guide* and declared, "This is *this* year's guy. When the movie comes out,

is he gonna be *last* year's guy?" Van Der Beek, who was within earshot, thought to himself, *How the fuck am I supposed to get ahead? Last year, you wouldn't even have* seen *me for this!*

When Van Der Beek finally landed the role, he joined a cast that included Jon Voight as Bud Kilmer, his cruel coach, and Ali Larter as Darcy Sears, an insecure cheerleader dying to escape small-town Texas. Larter, then twenty-two, was working as a model and commercial actor when she got the role; by then, she'd witnessed a lot of teen desperation up close. "Living in New York and Los Angeles, you often see young people putting themselves in Darcy's situation, because they don't have the self-worth they need," Larter says. "I didn't judge her, and I knew how desperate she felt. I could understand, because I'd wanted so much to be an actress."

The *Varsity Blues* cast assembled in Austin, Texas, in the summer of 1998 to begin filming. Van Der Beek had put on thirteen pounds of muscle for the role, aided in part by creatine supplements, to bulk up for the football sequences. At times, though, the actor's *other* job intruded. Almost every night, *Dawson's Creek* fans who'd figured out his jersey number would approach him for autographs during shooting, testing the young actor's sanity. (They also approached Voight, the Oscar-winning star of such iconoclast classics as *Coming Home* and *Midnight Cowboy*, and asked him to quote his recent giant-snake thriller *Anaconda*.)

The off-the-field sequences weren't always easier. Not long into the *Varsity Blues* shoot, Van Der Beek and Larter filmed the movie's uncomfortable, anticlimactic love scene, in which Darcy tries to seduce Mox by wearing a whipped-cream bikini adorned with a pair of cherries—only to be turned down. "It was my first day of filming, and I was just like a puppy with big paws—I didn't really know what I was doing," says Larter, who actually wore shaving cream for the shoot. "But it was important for me to show what she was willing to sacrifice within herself to get out of that town."

Varsity's telegenic cast would be seized upon by MTV Films, the young studio that had launched in the midnineties, hoping the network's brand recognition would draw young viewers to theaters. Though it had a number one movie with Mike Judge's *Beavis and Butt-Head Do*

America, the studio had yet to find a live-action hit. MTV Films staked out an uncompetitive mid-January release date, and pumped out ads on *Total Request Live*, the network's daily teen-culture romper room. The studio's marketers cannily played up *Varsity*'s rebellious spirit, filling the airwaves with Van Der Beek's "I don't want your life" speech as Foo Fighters riffs blasted in the background. For a generation that had spent the decade feeling overshadowed—first by the self-aggrandizing boomers, then by the self-absorbed Gen-Xers—*Varsity* seemed like a fist-pumping declaration of independence.

Selling *Varsity* as a youth-in-crisis tale—full of earnest strivers and noble hotheads—worked better than anyone could have expected. Shortly after opening night, Van Der Beek picked up his breakfast from a catering truck at the *Dawson's Creek* set and saw that someone had written a message for him on tinfoil, congratulating him on having a number one movie. When *Varsity* stayed at the top spot for a second weekend, it was clear that the movie's brio was finding some unexpected fans. "Did any of you see *Varsity Blues*?" Courtney Love asked a room full of reporters that year. "The subtlety on that guy blew me away." Love was so taken with the film—and with Van Der Beek—that she asked to present with him at MTV's Movie Awards that summer. "I didn't consider myself cool enough for Courtney Love," says Van Der Beek. "I was worried she would make fun of me." Instead, she talked to him about his horoscope, delighted to learn that Van Der Beek had been born in March. "She was like, 'You're a Pisces. I *knew* it. Kurt was a Pisces.'"

Varsity's teenage angst had paid off well: the movie stayed in theaters for three months. But in 1999, *Varsity*'s number one teen-movie title would quickly be claimed by *another* high school story. This one was a bright, unashamedly mainstream romantic comedy that would surprise everyone, in no small part because of the studio logo that preceded it.

Harvey and Bob Weinstein had been early investors in the teensploitation phenomenon. After the back-to-back midnineties successes of

Scream and *Scream 2*—released through Miramax's Dimension Films subsidiary—the brothers unleashed several low-budget, youth-aimed thrillers: *Phantoms, Halloween H2O: 20 Years Later*, even a direct-to-video *Children of the Corn* sequel. Yet none of the Weinsteins' post-*Scream* teen titles would be as lucrative as *She's All That*, a PG-13 high school comedy released by Miramax just as the company was hitting its middlebrow high-water mark of *Shakespeare in Love*. Set in a sunny, deep-pocketed California high school, *She's All That* was a suburban fairy tale whose plot was partly inspired by George Bernard Shaw's 1913 play *Pygmalion*: after soccer stud Zack is dumped by his girlfriend for a cast member from *The Real World*—perhaps the most nineties romantic obstacle of all time—he bets a friend that he can turn a quiet, bespectacled loner named Laney into prom queen material.

To those who thought Miramax had already strayed far from its rebellious, *Reservoir Dogs*–releasing past, *She's All That* seemed like its own iffy wager. Michael Eisner, the CEO of the Walt Disney Company, warned Weinstein that he was "fucking with the brand name" by moving into lighthearted teen-tale territory. Weinstein didn't care. As he told Eisner, he'd green-lit what he called a "piece of shit" movie to prove that Miramax could compete with the bigger studios. Besides, there was little financial risk in making *She's All That*. An obscure young screenwriter named M. Night Shyamalan had agreed to punch up the script, in order to escape a Miramax deal he'd made years earlier. And Weinstein had gotten the cast for cheap—including the young actor cast as the heroine: Rachael Leigh Cook.

A nineteen-year-old native of Minneapolis, Cook had starred in a handful of family films before landing a supporting part in Miramax's incest comedy *The House of Yes*, starring the indie fixture Parker Posey. "I really wanted to be Parker," says Cook. "I thought she was the coolest cool girl in the world." The genial teen uplift of *She's All That*—which would be Cook's first leading role—was far removed from the dark, Sundance-debuted *House of Yes*. But the high school romance resonated with the actor, who'd grown up watching 1980s teen sagas such as *The Breakfast Club* and *Pretty in Pink*—occasionally misguided but

deeply empathetic depictions of high school life, both written by John Hughes. "I grew up madly in love with his movies," says Cook. "They'd lived in people's hearts and minds a decade before. And I think the popularity of *She's All That* was born out of that void."

Unlike other high school movies of the eighties, Hughes's films often found its mismatched teen characters—whether a brain, an athlete, a basket case, a princess, or a criminal—overcoming their various class and status obstacles. *She's All That* was made in that same spirit. The movie's hearts-and-minds-winning moment arrives when Laney finally agrees to a date with Zack, the rich-kid class president played by *I Know What You Did Last Summer*'s Freddie Prinze, Jr. After initially dismissing him as a boor, Laney finds herself descending the stairs of her modest home, having shed her suburban boho attire: her glasses are gone, and instead of her usual overalls, she's wearing a tight red dress that, according to Cook, was a bit *too* snug-fitting. "The main dress had gotten dirty in another scene, and I had to use one that was too small," she says. "I remember thinking 'I cannot breathe at all. This is a terrible mistake.'"

The stairs sequence culminates with Laney clumsily falling into Zack's arms, all scored to the woozy strains of Sixpence None the Richer's "Kiss Me." Later in the movie, the two wind up at their school's improbably ornate prom. Cook, like many young nineties actors, had been performing since her early teens, which required her to miss out on a few offscreen milestones. "I sporadically went to high school, so I didn't go to my prom," she says. "No one asked me; I didn't even know when it was." The two-day *She's All That* dance, she says, "was a proxy-prom experience. But a fake prom is in some ways better than the real thing."

For Cook, and for moviegoers, *She's All That* was an eighties teen-dream fantasia, updated to reflect late-nineties realities. In many of the crummier Reagan-era teen movies, the high school hierarchy was simple: The good-looking athletes were jerks, while the outcasts were quietly suffering saints. *She's All That*'s characters weren't quite as neatly defined. Much like Mox in *Varsity Blues*, Prinze's character is an Ivy-bound jock who, at one point, tries to impress Laney by hacky-sacking

his way through a performance art show (a scene reportedly added to the script by Shyamalan). The school nerd, meanwhile, is edgy, combative, and often downright churlish—hardly the type of meek loser who'd long served as teen-movie martyrs.

She's All That's admittedly reductive message—hey, smart kids can be cool, too!—arrived in a year that saw the beginning of a countrywide revenge of the nerds. In the fall of 1999, NBC premiered *Freaks and Geeks*, the beloved Judd Apatow–produced high school comedy whose heroes included several gawky, awkward eighties smarty-pants. Right around the same time, filming began on the first of what would be three world-devouring *Lord of the Rings* movies. A powerful new breed of intellectually adroit, culturally curious neo-nerd was on the rise—not just in Hollywood but also in the code-crunching caves of Silicon Valley, where the dorks would eventually rule all. Laney might as well have kept her glasses on—within a few years, everybody else would. "If you made *She's All That* today," says Cook, "that scene would go in reverse."

Released in late January, the PG-13 film made $16 million on its first weekend—one of the biggest debuts in Miramax history, nearly doubling what *Pulp Fiction* had earned when it opened. *She's All That* became so inescapable, and its stars so recognizable, that shortly after its release, Cook was temporarily forced to go incognito. "I thought, 'I know. I'll wear glasses,'" she says. "Then I was like, 'You dummy—you disguised yourself as the character in the movie!'"

It was a dork move—but no one would have razzed her for it. *She's All That* made it clear that for a new generation of teens, the old high school tropes no longer applied. In the movies of 1999, athletes could be brains, and brains could be basket cases. But none of them were having as much fun as the criminals.

Roger Kumble was down on his knees in Hollywood's Le Petit Bistro restaurant, begging Reese Witherspoon to be in his movie. For months, the thirty-two-year-old screenwriter had been putting together *Cruel Inventions*, his update of Pierre Choderlos de Laclos's *Les Liaisons*

Dangereuses. The indelicate 1782 novel—about a pair of bored, nasty aristocrats who concoct a salacious bet involving a virtuous young woman—had already been adapted multiple times, with two movies in the late eighties alone. But Kumble's *Cruel Inventions* would be the first to be set among the most debauched demographic of all: modern-day teenagers.

Kumble had recently had a hit with his play *"d girl"*, a behind-the-scenes showbiz satire starring *Friends'* David Schwimmer. He'd read the original *Les Liaisons Dangereuses,* but it wasn't until Kumble saw the brutal, Sundance-beloved drama *Welcome to the Dollhouse* that he began thinking about writing his own version. "That movie had an incredible effect on me," he says. "I realized you could actually portray high school as mean and truthful."

Kumble's movie, eventually retitled *Cruel Intentions*, revels in its nastiness from the get-go. Much of its scheming takes place in an opulent Upper West Side mansion, where a cruel private school princess, Kathryn, kills time by doing bumps from the cocaine-concealing rosary around her neck. Bored, she makes a wager with her womanizing stepbrother, Sebastian: If he can sleep with Annette—a new-to-town, virginal nice girl—Kathryn will give him what he's always wanted. "I'll fuck your brains out," she tells him, adding "You can put it *anywhere*."

For the role of Kathryn, Kumble cast Sarah Michelle Gellar, who'd won a Daytime Emmy Award for playing a manipulative young hellraiser on *All My Children*. But it was her fierce, wry turn on *Buffy the Vampire Slayer*, in which she portrayed the show's demon-offing hero, that made Gellar a teen-culture superstar. The character was so beloved, in fact, that one *Cruel Intentions* producer couldn't see her as Kathryn and asked her to consider playing the goody-goody Annette instead. "I said, 'You don't understand. I was the bad girl on soaps!'" remembers Gellar. She spent the next three months "stalking" Kumble, she says, even showing up at a Halloween party he was attending: "I probably dressed like a goth Elvira," she says.

Gellar eventually persuaded the producers to cast her as Kathryn—a decision that rattled executives at The WB, not to mention her

representatives. "My manager said, 'People are starting to love you. Why would you want to ruin it?,'" remembers Gellar. (Said manager was later spiked.) And the movie didn't thrill *Buffy* creator Joss Whedon, who referred to *Cruel Intentions* as "porny" at a *Buffy*-related event before its release. "I was mad at him for that," Gellar says. "But I don't think he'd seen the movie at the time. *Cruel* was very personal to me, because it was the first time I'd been given really adult material."

Gellar would turn twenty-one while filming *Cruel Intentions*—just old enough to remember the tyranny of teen life. "I went to a private school in New York City, but I was a scholarship kid," she says. "I witnessed firsthand the Kathryns of the world—the poor little rich girls who were really nasty but were so sophisticated in the way they did it."

Ryan Phillippe, whom Kumble would cast as Sebastian, had also watched the well-off from afar. "I grew up without money," the Delaware native says. "So in some ways, making *Cruel Intentions* was a way to castigate the kids who had more than I did—the ones who pulled up to school in a BMW, while I had a beat-up Hyundai." Like Gellar, Phillippe had started his career in soap operas, playing a gay teen on *One Life to Live* before landing supporting roles in macho dramas such as *Crimson Tide* and sex-intensive indies such as *54*. Phillippe received Kumble's script while working on *I Know What You Did Last Summer*, the horror hit that would graduate him to big-studio stardom. "I was looking for things that were a little bit punk or that poked fun at society," he says. But he also wanted to make a film like *The Breakfast Club*—"the kind of seminal teen movie that gets passed down, that you always wind up watching when it's on TV."

Though *Cruel Intentions* was only Kumble's first feature, he'd earned the attention of a major studio, Sony, and landed two on-the-rise young movie stars for his cast. But he couldn't find the right actor to play Annette, the resolute romantic who goes from being the target of Sebastian's scheme to the object of his affections. Kumble needed an actor who could not only convincingly and playfully spar with Phillippe but could also convince the studio that *Cruel Intentions* was worth the $11 million investment. "Ryan would come to my house and read with

other actors," Kumble says. "And one day while we were sitting around, I was like, 'What about your girlfriend?'"

Not long afterward, in early 1998, the two were at the West Hollywood restaurant, making their desperate pitch. "Roger and I really lobbied her," says Phillippe. "We got her drinking, and we were like, 'You gotta do this movie! Please! Please!'"

Witherspoon, then in her early twenties, had been acting in studio dramas and indie thrillers for nearly a decade, all the while navigating an impossible-to-predict trajectory. She'd thwarted a serial killer in the grimy *Freeway*, liberated a repressed small town in the fantastical *Pleasantville*, and stabbed Mark Wahlberg in the back with a peace pipe in the fun-schlock thriller *Fear*. "I was always into fiery female characters," Witherspoon says. "They had to have a point of view, and they had to have a strong belief system. I wasn't interested in playing 'the girlfriend.'"

She'd initially said no to starring as Annette, until Kumble agreed to revise the script. "She was like, 'The part needs to get better,'" Kumble says. By the time *Cruel Intentions* started production in Los Angeles in early 1998, Kumble and Witherspoon had reworked her virginal character, who falls hard for Phillippe's schemer. Their romance required the young couple—who'd met in 1997 at Witherspoon's twenty-first birthday party—to share some intimate onscreen moments, including a brutal breakup fight that made both actors uncomfortable. "We had been living together for a year and a half," says Witherspoon. "Ryan wanted me to hit him really hard, and I think I hurt his ear." Once filming on the scene was completed, the drained Phillippe threw up. "I was probably just being a dramatic a-hole," he says, "and indulging in the moment, because it was my real-life girl."

Cruel Intentions' primary comic relief came courtesy of Cecile, a naive new student who's used as a pawn by the evil Kathryn. She was played by twenty-six-year-old Selma Blair, who'd just spent the last few years in New York City. "I lived in Salvation Army [housing], trying to make it as an actress," Blair says. "I would have been happy if I'd gotten a gum commercial." She was quickly pulled into the teen-culture

craze, almost scoring a lead role on *Dawson's Creek*—until Katie Holmes walked into the audition on the same day. Though she lost the *Dawson's Creek* job, there were plenty more teen roles available. "It was a relatively easy time for people who were over eighteen but still looked young," she says. "I didn't have a lot of experience—but neither did a lot of other kids."

Blair, whose biggest part to date had been a small one in the comedy *In & Out*, would soon find herself in the middle of *Cruel Intentions'* most controversial scene. On a bright afternoon in the late spring of 1998—the kind of day, says Gellar, in which "everyone in the universe goes to Central Park"—hundreds of onlookers gathered near a wide green patch of Manhattan, not far from where Gellar and Blair were lounging on a picnic blanket. The noise from the crowd filled the park, and every so often, a camera flash went off in the near distance. Gellar had acted since she was four years old; she was no stranger to the commotion that accompanied big shoots. Yet even she was surprised by the fuss. "I remember a *Die Hard* movie filming on 72nd Street and everybody going to watch," she says. "But this little movie was not *Die Hard*."

In the scene being filmed that day, Kathryn offers to help the sexually inexperienced Cecile practice her make-out skills. A nearly fifteen-second-long kiss between the two soon follows, ending with a slick line of saliva dangling between their lips. Decades later, the spit-clinging exchange would seem timid, even banal. But late-nineties teen mania, and the young stars who'd made it possible, had brought with it a renewed skittishness about teen sex. The amnesiac parents of 1999—some of whom had spent their own adolescence eyeballing David Cassidy's treasure trail on the cover of *Rolling Stone*—were now shocked (shocked!) to find their kids listening to entendre-trotting teen pop songs ("I'm a genie in a bottle/You've gotta rub me the right way") or staring at photos of Britney Spears's seventeen-year-old midriff. For concerned adults and the youth-obsessed media, *Cruel Intentions*'s girl-girl make-out scene was a tantalizing talking point. Before the film was even released, a cover story in *Premiere* magazine extensively covered

what it called "The Kiss," noting that the movie's sexed-up scenes had "launched a thousand closed-door meetings at The WB."

Everyone was jittery about The Kiss—especially Blair. "I was so sexually naive," she says. "I was probably nervous to kiss a girl, because I was nervous to kiss a guy at that time." For Gellar, the biggest stresses of that day turned out to be the constant flashbulbs: "Wherever you looked, there was paparazzi," she says. In fact, a cameraman hiding nearby captured the moment of impact, and the next day, a photo of the lip-locked pair appeared in the *New York Post*. "When you're a New Yorker, you hide your head in shame when you're in the *Post*," says Gellar. "But you're also kind of excited."

So was Sony Pictures. By the time *Cruel Intentions* was about to open in March, the movie had been hyped via magazine covers and tabloids (The WB, whose executives had changed their minds about the film's salaciousness, decided to push it heavily during prime time). On opening weekend, Kumble says, "There were signs at theaters that read, 'We will not sell tickets to *Cruel Intentions* if you're under seventeen.' People were buying tickets for other movies and sneaking in." *Cruel Intentions* would make more than $13 million in its first weekend. As it turned out, there was nothing America's scamming, sex-brained teenagers desired more than a story about *other* scamming, sex-brained teenagers—even if that story was a few hundred years old. Which was very good news for the creators of *10 Things I Hate About You*.

As a high school student in small-town Washington, Kirsten "Kiwi" Smith worked at a mom-and-pop video store, giving her access to not only the by-then-mandatory John Hughes films but also to such sleepover hits as *Just One of the Guys* and *Desperately Seeking Susan*. Those were films about young women, aimed at young women, made at a time when most of the blockbusters of the day focused on boys (or boyish men). "Movies like *The Goonies* or *Raiders of the Lost Ark* didn't have that many girls," says Smith. "And if there were girls, they were side characters."

Smith later moved to Los Angeles, where she worked as a script reader for a small Hollywood production company. One day, she received a screenplay from Karen McCullah, an aspiring writer living in Denver. They exchanged letters for months before finally meeting face-to-face for a work date in a Los Angeles bar in 1996. That night, scribbling on cocktail napkins, they began planning their first joint effort: a thriller about a group of angry women who start bare-handedly murdering Navy SEALS. The Geena Davis thriller *The Long Kiss Goodnight* was due out soon, and Smith and McCullah "were going to get in on this female-action badassery," says Smith. But *Goodnight* bombed, and "no one got excited by that script. So we decided to write something in our favorite genre: a teen movie."

Inspired by *Clueless*'s retelling of Jane Austen's *Emma*, Smith and McCullah hit on the idea of updating William Shakespeare's sixteenth-century tale *The Taming of the Shrew*, about an independently minded young woman who's "reformed" by a suitor. Their version would cast the tale as a high school romance, one in which the tamer is a rebellious enigma named Patrick, and the shrew is Kat, a so-over-this-shit senior whose popular younger sister isn't allowed to date until Kat does. Patrick is eventually bribed by another student to romance Kat, and as with the teen schemes in *She's All That* and *Cruel Intentions*, the anything-but-star-crossed lovers in *10 Things I Hate About You* eventually come together.

Smith and McCullah's script refashioned *Shrew* to fit their own experiences. When Kat recites the film's titular poem, outlining all of Patrick's various offenses, it's based on McCullah's high school diary, in which she detailed a boyfriend's faults. "It had things like 'Always thinks he's right' or 'Won't listen to anybody's opinion,'" McCullah says. And Smith, who'd long been interested in women's studies, helped instill Kat's suburban riot-grrrl spirit, as well as her affection for female punk acts such as the Raincoats and Bikini Kill. The movie, Smith says, "was a fusion of bawdy humor and a punk feminist spirit."

After the *10 Things* script was completed, it went through a couple of minders before finding its way to Seth Jaret, a talent manager who'd

started representing writers from his Hollywood apartment. Jaret was yet another beneficiary of the nineties script boom, having recently sold the screenplay for what would become the Matt Damon/Edward Norton gambling drama *Rounders*. "The market was incredibly robust," Jaret says. "And there were scripts so admired, they'd be passed around by executives, who'd read them for pleasure."

One studio that was especially interested in *10 Things* was Touchstone Pictures, the largely adult-themed Walt Disney division that had sat out the recent youth-flick movement. After Touchstone optioned *10 Things*, Smith and McCullah got to work on revising their script, incorporating one of the studio's key demands. "They said Kat seemed too angry, so she needed to not have a mom in order to explain her anger," says Smith. "She couldn't just be a fucking surly feminist. That's a classic Disney note: 'Get rid of the mom.'" Even with that change, Kat was allowed to be more enraged—and more self-liberated—than many other big-screen females of the time, taking several pointed swipes at the patriarchy. "I guess in this society," she says in *10 Things*, "being male and an asshole makes you worthy of our time."

Disney and the producers soon assembled the film's young cast. Kat would be played by a seventeen-year-old New Yorker, Julia Stiles, who'd appeared on such TV shows as *Ghostwriter* and *Chicago Hope*. The role of Patrick, meanwhile, went to Perth-born eighteen-year-old Heath Ledger, who'd starred in a handful of Australian soap operas. After Ledger got the role, Smith and McCullah were tasked with rewriting a few of his lines to accommodate the actor's Australian accent. "We were supposed to get coffee, and we ended up going to a bar on the Sunset Strip," says McCullah. "He never got carded. It wasn't like hanging out with a teenager at all."

During filming in and around the Seattle area in 1998, Ledger's hotel room "became ground zero for group hangs," says Smith. "He had this natural leader thing, and his place was the perennial party for all the kids." Ledger occasionally entertained visitors with his didgeridoo, a towering Australian wind instrument that only added to his otherworldliness. One night, while hanging in Ledger's room, Jaret accidentally

picked up the didgeridoo from the wrong end. "He corrected me and said, 'No, no no—don't grab it upside down, or the spirit of the instrument will be lost,'" remembered Jaret. "Here's this young actor, but he has this wisdom about things."

Ledger could also be a goof, as evidenced by the scene in which Patrick woos Kat by sliding down a speaker pole, boogieing across some football field bleachers, and belting out Frankie Valli's three-decades-old hit "Can't Take My Eyes Off You," accompanied by a high school marching band. "I haven't sung in years, I haven't danced in years," Ledger said shortly after filming the sequence. "They wanted a bit of Gene Kelly and Fred Astaire. It was totally choreographed—and then I just made it sloppy."

Though *10 Things* lacked the teen star power of *Varsity Blues* or *Cruel Intentions*, McCullah felt confident that it would topple its opening-weekend competition. "I saw the trailer for *The Matrix*," she says, "and I thought, 'That looks terrible. We are totally going to be number one.' I still believed that—up until the night when *The Matrix* opened huge."

10 Things came in second behind the Wachowskis' sci-fi machine, a remarkable achievement, considering *10 Things'* comparatively miniscule hype level. Decades later, McCullah remains perplexed by *The Matrix*'s success: "I've never made it all the way through," she says. "I'm going 'Why are they in the sewers, eating porridge and wearing dirty sweaters? Don't they want to live in the happy, shiny, clean world?'"

The biggest high school comedy of the nineties began with an appropriately oversized name: *Untitled Teenage Sex Comedy Which Can Be Made for Under $10 Million Which Studio Readers Will Likely Hate but I Think You Will Love.*

That was the quippy title screenwriter Adam Herz used to pitch the bawdy teen comedy he'd written. Herz, then in his midtwenties, was desperate to get the movie made, having failed in his efforts to sell a film script or TV pilot. He was considering leaving Los Angeles and

moving back to his hometown in Michigan when the hit-needy Universal Pictures—likely wooed by the words "teenage," "comedy," and "under $10 million"—finally bought his script, the title of which would later be reduced to a far catchier two words: *American Pie*.

A lightly risqué, brightly optimistic age-of-coming tale, *American Pie* follows a group of suburban high school guys who vow to lose their virginity before prom night. It was a T-and-A caper in the vein of eighties comedies such as *Fast Times at Ridgemont High* and *Porky's*. "My high school wasn't like *Dawson's Creek*," Herz said. "No one had life-crushing dilemmas." In *American Pie*, there was no moping, no rage, and barely even a hint of adolescent angst. All its characters wanted was to get laid and maybe fall in love. If you took away the film's webcam subplot and blink-182 cameo, *American Pie* could easily have taken place at any high school in the last fifty years.

To steer *American Pie*, the studio recruited a pair of siblings who were well past their own adolescences: Chris and Paul Weitz, brothers who'd recently written the animated bug comedy *Antz* and now wanted to direct. They weren't the most obvious choice for a movie that opens with a kid masturbating into a tube sock. "Our take on it was almost old-fashioned," says Chris Weitz, who was twenty-nine when *American Pie* was released (his older brother, Paul, was thirty-three). "There's a kind of a sweet-natured, good-hearted quality to what these kids are doing. And we were depending on the experiences of our actors to give an authentic sense of what it was like to be a teenager."

The Weitz brothers soon set off to cast an ensemble film that included no fewer than ten teenage roles. "We wanted it to feel like *American Graffiti*, where you're seeing a bunch of people and wondering why you haven't seen them before," says Chris Weitz. Universal had its own suggestions, including Jonathan Taylor Thomas, the heartthrob young costar of the Tim Allen sitcom *Home Improvement*, and Kate Hudson, who'd just begun her acting career and was better known at the time as the daughter of Goldie Hawn. Both turned it down—as did *Cruel Intentions* star Selma Blair, who says she was offered any of the female roles

she wanted. "I was like, 'I just can't do another teen movie,'" Blair says. "Which was so dumb. I should have just ridden that wave."

The Weitzes' would pull their cast from just about everywhere: indie cinema, sitcoms, prime-time fantasy dramas, theater, and studio films. They even found a guy whose biggest credit was Home Depot. That's where Seann William Scott was working at the time he auditioned for the movie—though maybe "working" isn't quite the right word. "I wasn't doing shit, dude," Scott says. "I rounded up carts, and they promoted me to plumbing—and I didn't know anything about plumbing. So I would clock in and walk from aisle to aisle for eight hours, looking like I was busy."

Scott, originally from Minnesota, had been in Los Angeles for a few years, hoping to make it as a dramatic actor, with little interest in comedy. But he wound up trying out for the role of Steve Stifler, the hard-partying jerkwad who, in one scene, gets his comeuppance by unknowingly drinking a beer spiked with semen. Scott didn't think he had a chance at scoring a high school movie: "I've looked forty-five years old ever since I was in seventh grade. But I had nothing to lose. I made Stifler like Hannibal Lecter—you're not really supposed to love him, but you do."

In *American Pie*, Stifler's mom is an alluring Mrs. Robinson–inspired flirt, played by improv comedy alumna Jennifer Coolidge. During a party scene, one student even starts shouting out an acronym in her honor: "MILF." "I'd never heard that term before," says John Cho. "In fact, I was uncomfortable saying it."

The South Korean–born Cho was cast as "MILF Guy No. 2" after Chris Weitz—who'd already hired him to play a member of the school jazz choir—saw the actor rapping during a table read. By then Cho was in his midtwenties and had collected a handful of film and TV credits. During the nineties, "I'd felt very disconnected from American teen entertainment," he says. "When I was in high school, the big show was *Beverly Hills, 90210*, and I thought, 'I don't know this place, I don't know these people.' It was super whitewashed." His *American Pie* role

4

would consist basically of that one chanted line, but "it was an important moment in my career," he says. "It meant something in the way that people perceive Asian Americans. You saw a guy with an Asian face being undeniably American. And people were saying 'That guy's not foreign at all. I know him.'"

Another new face in *American Pie* was Chris Klein, a Nebraska-raised actor who'd recently been discovered by director Alexander Payne and cast in the spring 1999 comedy *Election*. In *American Pie*, Klein would play Oz, a star lacrosse player who winds up joining the choir. As a kid, Klein had pursued acting and singing, but by the time he was in high school, "I had made myself an athlete," he says. "I was the guy in jeans wearing a leather jacket, driving a 1982 Camaro Z28." When he read the role of the jock/jazz singer Oz, "I thought, 'That was me,'" he says. "The kids of *American Pie* are strange bedfellows: Oz is a jock, but he's friends with those who aren't. I identified with that. I had friends all over."

Unlike Klein, Shannon Elizabeth had absolutely nothing in common with her *American Pie* character, a Russian exchange student named Nadia. Elizabeth was a teenager in Waco, Texas, when she got a role in a music video by the R&B group Hi-Five. It was a small part, but afterward, the video's director—future *Training Day* helmer Antoine Fuqua—encouraged Elizabeth to pursue modeling. That eventually helped her get to LA, where she appeared in TV episodes and a few indies before auditioning for *American Pie*.

The Nadia role required Elizabeth to appear nude onscreen. She needed to master a Russian accent. "My boyfriend at the time said, 'Remember in acting class last week, when you did that French accent? That was fine. Do that,'" Elizabeth says. "I realized I wasn't doing a French accent at all." Shortly after showing off her modified Russian, she got a call from her manager, telling her she'd gotten the part. While talking to him, she ran across her front yard and stepped in a hole along the way, twisting her ankle. "I was half happy and half crying," she says.

Nadia's unlikely boyfriend in *American Pie* is a nervous perma-virgin named Jim, played by sitcom actor Jason Biggs. After being told

that getting to third base is like sticking your finger in "warm apple pie," Jim decides to drop his pants and screw a pie on his parents' kitchen table. Much to his mortification, he's interrupted in midthrust by his father, played by *SCTV* alumnus Eugene Levy. "Jason's reaction, his sweat, his honesty—it played real," says Klein. "It wasn't just cheap, banana-peel thrills."

Biggs's onscreen shame may have been due partly to the fact that the actor, twenty at the time of filming, was genuinely terrified about boffing a pastry onscreen. Right before shooting commenced, he said, "I'm calling my manager freaking out, like, 'Am I really going to do this? What if no one sees it but I'm still the guy that put myself out there in such a crazy way?'" Ultimately, though, "I knew this was funny. And the only way this scene was going to work was if I wholly committed to fucking the absolute shit out of this inanimate object" (his scene partner was a hollowed-out faux pie made of Styrofoam). After he finally committed to the moment, Biggs was left to his own devices. "We weren't quite exactly sure how we were going to shoot it or how explicitly," said Paul Weitz. "We were like, 'Okay, Jason, you're going to be standing up humping the pie here.' And then we just walked off. It was up to JB to come over and yank down his pants further and start humping."

Later on, the kitchen scene would cause problems with the MPAA—one of a handful of moments that would bring *American Pie* dangerously close to an NC-17 rating. "You'd receive these extraordinary memos about the number of thrusts into a pie," says Chris Weitz. "And eventually, you negotiate it down to a certain number." The filmmakers and the MPAA wound up settling on two thrusts. Another sequence that led to back-and-forths with the ratings board found Elizabeth, as Nadia, masturbating to one of Jim's porn magazines, unaware that her activities were being webcast to his classmates. That moment also needed to be edited down—although, decades later, it's hard to imagine such an invasive, potentially illegal act would appear in a teen film at all. "In retrospect, that's pretty bad," says Chris Weitz. "I don't think it would seem as innocent now as it did back then."

For all of the bad-boy behavior in *American Pie*, it's the female

characters who are often the most sexually at ease, making the guys do what they want and almost always getting their way: after her webcam escapade, Nadia forces Jim to strip down to his boxers and dance for her, unaware that *he's* now being broadcast to the school. In *American Pie*, the girls are just as interested in sex as the guys, if not more so— they're just cooler about it. It was a notable revision of teen life from the eighties films, in which the horndog pursuers were almost always dudes. "The women in the movie have control," said Alyson Hannigan, who plays *Pie*'s secretly assertive band nerd (when she hooks up with Jim, she commands him to "say my name, bitch!"). *American Pie*, Hannigan said, is "pretty much a chick flick."

Universal didn't sell it that way, though, as trailers for *American Pie* played up the pie-humping scene and blasted James's early-nineties hit "Laid." The studio had confidently placed *American Pie*'s release date in midsummer, right around the same time as big-star films such as *Wild Wild West* and Adam Sandler's *Big Daddy*. "When we were shooting it, I remember thinking 'This movie's going to make a fucking hundred million dollars,'" Seann William Scott says.

His estimate was off—but not by much. *American Pie* would earn nearly $103 million in the United States, making it one of the most successful high school movies of all time. Cho, who'd recently returned from filming a movie in China with Willem Dafoe—and who'd all but forgotten about the teen comedy he'd shot the year before— was shocked to find people yelling "MILF!" at him as he walked down the street. Even the recent post-Columbine crackdown on teens and R-rated films couldn't slow the movie's momentum. "It turned out that theater owners were not that keen on checking IDs," says Chris Weitz. "Or maybe they didn't mind if you bought a ticket for *Tarzan* and went into *American Pie*."

The success of the bright-eyed *American Pie*, coming less than three months after Columbine, in some ways felt like a rebuke of reality. As *10 Things I Hate About You* cowriter Karen McCullah points out, American teenagers had been forced to go "from trying to figure out how to dance like Britney Spears to trying to figure out how to stop from getting shot

at school." At a time when high school had never seemed scarier, *American Pie* reassured audiences that the teens of 1999 weren't that different from the teens of 1979 (or, for that matter, the teens of 1959).

But the movie also served as a graduation ceremony for the modern teen-film phenom. By the time *American Pie* arrived, the decade's teen boom was already on the decline. For every youth movie that had succeeded in 1999, several others had quickly dissipated: *Jawbreaker, 200 Cigarettes, The Rage: Carrie 2, Wing Commander, Drop Dead Gorgeous.* A few would become posthumous hits later that year on home video. But the studio executives who'd invested in the boom clearly saw that it couldn't last longer—and after 1999, the number of big-studio teen films would drop year after year.

It was an inevitable decline. The generation of kids—both on the screen and in theaters—who'd made the teensploitation era so big didn't want to stay in high school forever. They were ready to grow up.

6

"SIGN UP FOR TOMORROW TODAY!"

ELECTION
RUSHMORE
THE VIRGIN SUICIDES

If any director was going to sit out the late-nineties teen-film frenzy, it was Alexander Payne. "The last thing I could ever conceive myself doing was making a high school movie," he says. "*Fast Times at Ridgemont High* is a masterpiece, but there hadn't been any good ones since. I didn't want to be a part of it."

That's why Payne, then in his midthirties, initially didn't bother to read the short, unpublished comedic novel sent to him in 1996. Set in suburban New Jersey, *Election* detailed a high school student government battle between some unlikely political players: Tracy Flick, an uber-achiever who's determined to become student body president; Paul Metzler, a dopey but beloved rich kid running as her nice-guy opponent; his frustrated sister, Tammy, who upends the race by becoming a third-party candidate; and the book's aggrieved grown-up, Jim McAllister, a middle-aged teacher who's so irked by Tracy's ambition that he conspires to prevent her from winning.

Election had been written a few years earlier, after Tom Perrotta had found himself caught up in the 1992 US presidential race. Perrotta, then a teacher and aspiring novelist, had watched Bill Clinton fend off not only his challengers—George H. W. Bush and Ross Perot—but also questions about his alleged infidelities. "The Republican talking point was 'If he's cheated on his wife, he's going to cheat on the country,'" says Perrotta. "It seemed like they were advancing this simplistic, moralistic philosophy about character. Something wasn't right about it." Perrotta was also intrigued by an incident that had occurred that fall, when a pregnant Wisconsin high schooler had been elected homecoming queen and a school official had responded by burning the voting results.

Both incidents were on Perrotta's mind when he wrote *Election*, a brisk multinarrator novel that gave him "a situation where *everybody* running for president has a secret—and only the reader knew them all." But after an agent warned that the book would be a tough sell, Perrotta put his manuscript into a drawer, where it languished for years as he worked on other projects, like his 1997 breakthrough novel *The Wishbones*. It wasn't until a friend connected him with producers Albert Berger and Ron Yerxa that *Election* was revived. Perrotta got his still unpublished manuscript to the producers, who optioned *Election* for $20,000. "We saw it as something more than a high school film," says Berger. "Though we *like* high school films."

The producers then sent *Election* to Payne, an indie-movie prodigy thanks to his recent debut feature, *Citizen Ruth*, which he'd cowritten with Jim Taylor. *Citizen Ruth* was a gleefully discomforting comedy about a lower-class glue-sniffing wreck, played by Laura Dern, who's unwittingly pulled into the national abortion battle. "Alexander's one of the only people who puts real life on film: the way people live, what their houses look like, what their clothes look like," says *Election* star Reese Witherspoon. "He cares about all the details." While Payne was figuring out what to do after *Citizen Ruth*, he received the *Election* manuscript, which he ignored for weeks before finally agreeing to give it a read.

"Tom Perrotta was a revelation to me," says Payne. "In one moment

of description, he talks about the school principal sniffing his wrist because he had a smelly watchband. And I sometimes have smelly watchband problems. I'm like, 'Oh, God—he's got me. If he's observing that, what else is he observing?'" Payne also admired the structure of the book, in which each chapter is written in the first-person voice of a main character. "I'd drunk the elixir of *Goodfellas* and *Casino*," he says. "And I was attracted to the idea of multiple voice-overs." Soon Payne and his writing partner, Taylor, were living on separate floors of the same Los Angeles apartment building, writing their version of *Election*. "The book seemed like something we could use vampirically," says Taylor. "It had an attitude."

Payne and Taylor's first step in adapting *Election* was pulling Perrotta's characters out of New Jersey and resettling them in the flatter, far more remote environs of Omaha, Nebraska. That was where Payne had been born and raised and where he'd graduated from a distinguished Jesuit prep school. It was also where he'd set both *Citizen Ruth* and his 1990 short-film breakthrough *The Passion of Martin*. "It's kind of like my little Czech Republic," says Payne. "It's where you can put small, local, particular comedy. And you can scout locations in your brain."

To find a building that could substitute for *Election*'s fictitious G. W. Carver High, Payne searched high schools throughout Omaha, trying to locate one that fit his visual scheme—he wanted Carver to look a bit like a prison—and where he'd be allowed to film while classes were in session. That hope disappeared once Omaha school officials got ahold of the *Election* script. In its first few pages, it's revealed that Tracy Flick has had an affair with Jim's close friend, a married geometry teacher named Mr. Novotny. "Her pussy gets *so wet*," Novotny marvels to Mr. McAllister shortly before being fired. "You can't believe it."

The Omaha school superintendent was equally incredulous about *Election*. "He got scared," Payne says. "He said, 'This shows a relationship between a student and a teacher. No, no, no. No way in hell.'" Payne was forced to relocate shooting to the satellite town of Papillion, where the faculty at Papillion-La Vista High School granted him permission to film on weekdays.

In order to make *Election*'s onscreen school seem as real as possible, Payne hired local teachers and students to play small supporting roles. But he'd need someone far more experienced to star as Tracy Flick, the movie's determined, unrelenting teenage achievement machine. Perrotta had based Flick in part on some of the students he'd encountered while teaching at Harvard and Yale in the early nineties. "There were these incredibly smart, ambitious, charismatic young women," he says, "and I realized they were qualitatively different from my generation, because they'd been raised by feminist mothers. They were going to conquer the world, and I could see they made people uncomfortable."

Tracy's introductory scene in *Election* takes place in the predawn hours at Carver High, where she kicks off her campaign near the front door of the school, wearing a bright permafixed smile. A poster reading TRACY FLICK FOR PRESIDENT! SIGN UP FOR TOMORROW TODAY! hangs over her head. Later, she all but assails voters with her homemade PICK FLICK cupcakes. "Some people say I'm an overachiever," Tracy says in a voice-over. "But I think they're just jealous."

Tracy would have to be played by someone who could radiate confidence and smarts—which might explain why Witherspoon was able to land the role after one meeting with Payne. "I said to Alexander, 'I guess you could hire somebody else for this job, but I'm the best person for it,'" Witherspoon says. "I was channeling the character." For Payne, it didn't hurt that Witherspoon, twenty-one at the time of filming, looked young enough to be a teen. "I wanted that genuine high school feeling, not a pretend one," he says. "And her intelligence and thoughtfulness were so clear."

Paramount, which was releasing the movie through its MTV Films division, had bigger plans for the role of Jim McAllister, her beleaguered teacher. "They wanted whoever was the most famous, whether they were right or not," says Payne, who made futile overtures to stars such as Tom Cruise. "I had to offer it to names that horrified me for this part." There was, however, one actor who would *love* to play Mr. McAllister:

Matthew Broderick, a recent Tony winner for his turn in Broadway's *How to Succeed in Business Without Really Trying*, and a movie star ever since he had played the school-skipping, "Danke Schoen"ing teen hero of 1986's *Ferris Bueller's Day Off*. By the time the *Election* script got to Broderick, he was in his midthirties and had just signed on to a leading role in the ginormously expensive remake of *Godzilla*, his first action movie. "I didn't really know what I was looking for," he says of his late-nineties career plan. "I was trying to get from being young—you know, Ferris Bueller or whatever—and moving into the next age. I was not quite ready for the father part, but I wasn't the high school student, either. I was trying to find good material for grown-ups."

Broderick had received the *Election* script knowing that another actor had already been offered the part (possibly *Shawshank Redemption* star Tim Robbins, who Payne says was an early contender). "I kind of read it angry," Broderick says, laughing. "I was like, 'Oh, man—this is exactly the kind of movie I *never* get to be in.'" But once the role became available again, Payne hired Broderick after a meeting on the set of *Godzilla*. "We were like, 'How perfect is that? Ferris Bueller's grown up, and he's this beaten-down teacher,'" says *Election* producer David Gale. "It was fun to think about that, even if the audience wasn't necessarily going to make the connection." (Payne certainly didn't. According to Taylor, "he hadn't even seen *Ferris Bueller's Day Off*.")

While touring high schools in Omaha, Payne had been introduced to Chris Klein, an eighteen-year-old local high school senior who'd studied theater and played sports and was about to head off to Texas Christian University in the fall. "Where I'm from, going to Hollywood to try to be an actor isn't really a thing," says Klein. "But I dreamed about it." He auditioned for the film over the summer but didn't dwell on his chances too much. Besides, he says, "there were no stakes. I was going to college."

A few months later, while in his dorm room, Klein got a call from Payne, asking if he wanted the role of Paul Metzler. Klein, unsure, asked if he could see the script, which he read in his dorm's laundry room.

"I phoned Alexander back and said, 'Listen, I really appreciate the opportunity. But the character you want me to play gets a blow job in this movie. And I've got a grandma that's gonna see this.' Alexander said, 'You're gonna have to trust me. Just come on home, and let's work on the movie.'"

Around the time Payne was readying *Election*, filmmakers Wes Anderson and Owen Wilson were at work on their own tale of overly determined youth: *Rushmore*, a prep school comedy about a precocious loner who becomes friends with a glum millionaire. Anderson and Wilson had first met in 1989, while sophomores at University of Texas at Austin, where they discovered a shared affinity for directors such as Martin Scorsese, Robert Altman, Terrence Malick, and John Cassavetes—the independent-minded filmmakers who'd emerged during the sixties and seventies.

Anderson and Wilson would soon write their own film, a spry black-and-white crime comedy short titled *Bottle Rocket*. Directed by Anderson in 1992 and shot around Texas, it starred Owen Wilson and his brother Luke as a pair of aspiring burglars (a feature-length version, produced by *Terms of Endearment* writer-director James L. Brooks, was released in 1996). Their follow-up was set in no particular time and no particular place—yet *Rushmore* was clearly informed by the writers' shared Texas upbringing. Both had attended all-boys private schools when they were younger, though their pursuits had varied: in Houston, Anderson wrote three-act, action-packed plays with titles such as *Battle of the Alamo* and had once attempted a stage adaptation of *Star Wars*. "It's difficult to mount that," he said, "especially with the limitations of an elementary school production." Wilson, meanwhile, was a self-described troublemaker who'd been expelled from his Dallas school after cheating in a geometry class.

All of those extracurricular activities would shape Max Fischer, the high-energy menace of Rushmore Academy. Like Tracy Flick, Max

dominates his school yearbook: he's captain of the school's debate team, founder of the Astronomy Society, and president of the French Club, among several other titles. He also stages elaborate, carefully art-directed plays on school grounds, including a dramatic adaptation of *Serpico*.

During one of Rushmore's chapel assemblies, Max becomes entranced by Herman J. Blume, a local steel magnate who, like Max, grew up without money. "Take dead aim on the rich boys," Blume advises the students. "Get them in the crosshairs, and take them down." (It's a line Wilson had once overheard spoken by his father.) Blume, who can't stand his own two kids, is charmed by Max's all-encompassing passion for his school: "You just gotta find something you love to do," Max tells him, "and then do it for the rest of your life. For me, it's going to Rushmore." Their mutual admiration is threatened, however, when both fall for Miss Cross, a recently widowed teacher. Enraged at Herman, Max sets off on a revenge spree that ultimately leads to his expulsion.

One of the first to read Anderson and Wilson's *Rushmore* script was Barry Mendel, a former agent working as a producer at Disney. "I was two years into a three-year deal and had gotten absolutely nothing going," says Mendel. "I'd had a really good career as an agent, and it looked like I had torched it." Mendel had seen the original *Bottle Rocket* at Sundance and afterward had called every Wes Anderson and Owen Wilson he could find in the Austin phone book until he finally tracked them down, hoping to represent them. Instead, the three became friends, and Mendel was asked to produce *Rushmore*. "What we had going for us was that the script was funny and emotional," he says. "But it was also very antiestablishment."

All of which could have been said about the film that had most influenced *Rushmore*. "Whenever we write a script," Anderson said, "we end up feeling like we just stole a hundred things from *The Graduate*." There were echoes of *The Graduate*'s Benjamin Braddock in Max's casual defiance, as well as in his youthful crush on Miss Cross. And both

characters' turmoil were offset by pinwheeling sixties pop: *The Graduate* was scored with Simon and Garfunkel hits such as "The Sounds of Silence" and "Mrs. Robinson," while *Rushmore* leaned heavily on British-invasion nuggets.

But Anderson and Wilson's love of *The Graduate* was best exemplified by a scene that takes place early on in *Rushmore*, scored to the Kinks' melancholy "Nothin' in the World Can Stop Me Worryin' 'Bout That Girl." The despondent Herman Blume—stuck in a lousy marriage, with a pair of bratty sons—putters along a diving board in a Budweiser-branded swimsuit before cannonballing into the family pool. When he sinks to the bottom, it's an age-reversed reminder of a scene in *The Graduate* in which Benjamin hides out in the bottom of his parents' pool. That movie depicted a young man chafing at his parents' plastic concerns; thirty years later, *Rushmore* caught up with a similarly disaffected boomer, now an unsatisfied middle-ager.

When it came to who would wear Blume's beer logo–emblazoned swim trunks, Anderson already had an actor in his crosshairs: Bill Murray. The star of *Ghostbusters* and *Caddyshack* had continued his run of wry comedies into the early nineties, most notably with *Groundhog Day* and *What About Bob?* But his more recent efforts had been coolly received. "I made a number of movies in a row which were good, but they weren't huge hits," he said. "And I kept thinking 'Maybe I should strap on an automatic weapon and get more serious about having a hit movie or something.' But I calmed down and said, 'If I just keep doing ones that I like doing, one of them is going to hit.'"

Even in the early days of his career, when he'd starred on *Saturday Night Live*, Murray had earned a reputation for being tough to tame. "I was a little terrified, because I'd heard stories about him," Anderson said. "He's a guy who can walk into a crowd of people and take control of it in a way I never could." Murray was sent multiple copies of *Bottle Rocket*—which he apparently never watched—before spending an hour on the phone with Anderson. The actor was mostly interested in discussing *Red Beard*, a 1965 Akira Kurosawa drama about two doctors,

which Anderson hadn't seen. "At the end," Anderson recalled, "he said, 'Yeah, I think I would do *Rushmore* with you.'"

Anderson wound up securing his own alma mater, St. John's School in Houston, to double for Rushmore Academy. But finding someone to play the school's self-appointed star student, Max Fischer, would take nearly a year. While writing *Rushmore*, Wilson said, "I kind of imagined a kid like Wes: kind of a very thin, kind of pale kid who looked maybe a little bit like a young Mick Jagger—that slightly kind of uncooked look." Instead they went with Jason Schwartzman, a bushy-browed drummer with no big-screen acting experience—though he had been born into a Hollywood pedigree as the son of *Rocky* star Talia Shire and the nephew of *Godfather* director Francis Ford Coppola. After being recommended to a casting agent by his cousin Sofia Coppola, Schwartzman showed up at his audition wearing a homemade Rushmore blazer. Anderson immediately knew he'd found his Max Fischer.

To portray Miss Cross, the object of Max and Herman's affections, the filmmakers approached Olivia Williams, a London stage actress who'd just had her first starring role in Kevin Costner's apocalypse-set dud *The Postman*. "I'd barely been in front of a camera before that," she says. "Before it came out and the critics decided it was terrible, I had the pick of the scripts. I had a stack of them, and *Rushmore* was just in a very different league of writing." She soon flew to Houston to meet with Anderson. "He and Jason were in the room, and they were already buddied up and wearing matching sneakers," she says. "I had no idea what they made of me."

Not long afterward, in the fall of 1997, the entire *Rushmore* cast assembled in Houston—including Murray, who'd grown a mustache for the part, as Anderson wanted him to look a bit like the cable TV baron Ted Turner. Blume was "a guy who wants to start over again," the actor said. "He wants to cut off the limb he's on and go back to the root somewhere. He wants to get back down. And I've had that feeling many times." Murray's urge to start over likely kicked in as he arrived on the *Rushmore* set. "I think he was thinking 'Who are these crazy people?

Who's this kid?'" says Williams. "He turned up, and was like, 'This is a fucking shambles. What am I doing here?'"

On the night before filming, Murray, Schwartzman, and Anderson spent an uncomfortable hour rehearsing in the director's hotel room, where Murray grew frustrated with his "wiseass" young costar. "There was some trouble, there was some friction," said Schwartzman. "He was having a bad night. I was having a bad night. You could just feel the awkwardness in the room." When the hour was up, Murray said, "I went and got really drunk in a Texas hotel bar. And it was not a good week for me." (Not long after the hotel room fiasco, Anderson remembered, "Bill took us out to a restaurant where we ate chicken-fried steak. After that, everything was fine.")

Despite the touchy first day or so, Mendel says Murray "was an immediate champion of Wes. He just got him." The actor had taken a massive pay cut to play Herman Blume and even volunteered to chip in when Anderson was struggling with the studio over an expensive shot. "We were a little on the edge, budget-wise," says Mendel. "He left us a blank check that he signed and said, 'If it costs forty grand and you've got to get it—get it. I want you to have what you want.' We never used it. But it was a sign of how committed he was to the movie."

So was Schwartzman, whom Williams describes as "very Method." One night he turned up at her hotel room dressed in a waiter's uniform, carrying a "trolley load" of chocolates. "He came and sat on the bed in my room," she says. "And I said, 'What is supposed to happen now?' We sat a little longer, then I said, 'I'm quite tired. Why don't you go back to your room but leave the chocolate here.' It was very funny and very awkward. It was a scene out of the movie." Years later, Williams would compare her *Rushmore* experience to *Lost in Translation*, the 2003 Sofia Coppola–directed drama in which Murray plays an American actor out of sorts in a Tokyo hotel. "I was filming this charming, sort of timeless film in these old parts of Houston that I didn't even know existed," she says. "I was utterly bemused by everything I came across." During her downtime, Williams explored the city—with Murray taking her out for her first-ever cheesesteak. She also perused a script she'd brought to her

hotel room, a strange sci-fi story called *The Matrix*: "I couldn't make head nor tail of it," she says.

Rushmore was just as disorienting for Schwartzman, the film's young lead, who was starring in his first movie while trying to keep up with his schoolwork. "There were so many other things going, like, 'How am I going to get this essay in on time?'" he said. "That took away the stress of making a movie." After filming completed, he returned home to California, unsure how to process what had just happened. "I didn't really talk about the movie," he said. "It was like I just woke up from a dream."

Back in Omaha, few students paid much attention to the new girl who'd just arrived at Papillion-La Vista High School. After being escorted around the grounds, Reese Witherspoon would spend the next few days sitting in classes before abruptly disappearing. At Payne's suggestion, she'd slipped into Papillion-La Vista for some back-to-school undercover work, posing as a transfer student to prepare for the role of Tracy Flick. "None of the students knew who I was," she says. "They were just a bunch of teenagers. They didn't care."

Some local adults, however, were very aware of *Election*'s presence in Omaha—and weren't thrilled about it. Payne and Taylor's script included not only a lesbian relationship between potential student body president Tammy Metzler and a classmate but also a scene in which Mr. McAllister retreats to his basement to watch a porn film. "It was quite a big deal," says Nicholas D'Agosto, a Nebraska native who was hired to play Larry, Carver High's morally upright vote counter. "Omaha's a very Catholic town. There was a dual feeling of 'Can you take the risqué subject matter out?' and 'There's a movie coming to town, with Matthew Broderick!'"

The star was easy to spot in Omaha, taking bicycle rides around a city that sometimes overwhelmed him. "If you're from the East," Broderick says, "that flatness of Nebraska is amazing and sort of terrifying. You look out from the football field at that high school, and you just see

the sky. It's a pretty lonely feeling. But I think that's part of the movie—and it's definitely part of the characters."

Though Broderick was best known to the locals for his 1986 high school hit—a WELCOME FERRIS sign had been hung at Papillion-La Vista before filming started—he'd begun his film career while in his twenties. Early on, he was mentored by such older costars as Jason Robards. "I know it's old-fashioned, but I always try very hard to be nice to youngsters who are starting out," he says. During filming, he paid a visit to Klein's home, where Broderick and his wife, Sarah Jessica Parker, met with the young actor's parents: "I think they wanted to know that show business isn't bad," he says. It was part of an informal moviemaking education for Klein, who also sought advice from Witherspoon. "At lunch, I'd ask her any questions about Hollywood that I could," says Klein. "She taught me what a manager was, what an agent was. She was on her way up, and she knew *Election* was a big deal."

For Witherspoon, who'd always longed to inhabit "fiery female characters," Tracy Flick was a five-alarmer: a young woman who's succeeded at everything she's attempted so far and who now sees the student body presidency as a near birthright. Playing Tracy, says Witherspoon, "allowed me to lampoon all of my least-liked people." The actor grew up in Nashville, Tennessee, where she attended private school. "There was a girl I could not stand: her self-importance, her inserting herself into everything, her constant proselytizing about her own achievements. I was like, 'Ugh.' And I got to play her in a movie."

For all of Tracy's ethical stumbles—at one point, she rips down her opponents' posters—*Election* coscreenwriter Jim Taylor says the filmmakers "never saw Tracy as some kind of satanic-driven force. I have empathy for her. There are reasons for her anger." Though the point's never directly made in *Election*, much of the miserable treatment Tracy receives comes at the hands of men: Mr. Novotny takes advantage of her. Mr. McAllister scraps the votes that would bring her victory. One boy yells "Eat me raw!" during her campaign speech; another messes with her school campaign display. The young woman at the heart of *Election*

is viewed by nearly everyone as a success-obsessed automaton—unlike the wonder boy of *Rushmore*, whose unmoored ambitions are seen by some as charming.

Tracy was a rare character in a high school movie—or in *any* movie, really: confident in herself but not always sure why; outgoing yet deeply alone; book smart but socially unlearned. She's stuck in that strange teenage space where she wants tomorrow today. As Taylor puts it, "She's trying to be an adult."

Those secret pains of adolescence—particularly for young women— also reverberate throughout 1999's *The Virgin Suicides*, a movie that required Sofia Coppola to wage a campaign of her own. She'd fallen for Jeffrey Eugenides's novel, which had a been a critical hit upon its release in 1993. Set in suburban Michigan in the mid-1970s, the book follows the short lives—and the shocking deaths—of the Lisbon sisters, five secretive teenage girls who beguile the local boys. Coppola had been turned on to *Virgin Suicides* by her friends Thurston Moore and Kim Gordon, members of the fuzzy-dreamy New York City rock band Sonic Youth. At the time, Coppola was in her midtwenties and living in Los Angeles, just a few hours away from the Napa Valley home base of her parents, writer-director Francis Ford Coppola and documentarian Eleanor Coppola. "I grew up with guys, so this really girly world in the book was appealing to me," Coppola says. "And it had an understanding of the mystery between boys and girls. That was a fresh memory, because my teenage years weren't so far behind."

At the time she read *The Virgin Suicides*, Coppola wasn't a director; in fact, she wasn't even sure if she wanted to make movies at all. Her first film credit had come in 1972, when she had appeared as a newly baptized infant in her father's Oscar-winning *The Godfather*. For the next several years, she'd travel to her father's movie sets, sometimes making small cameos in his films, before her father cast the teenage Coppola as a mob daughter in 1990's *The Godfather Part III*. The reviews ended an

onscreen career she'd never desired in the first place. "The critics tore me apart," she said. "But I didn't want to be an actress. If I had, then it would have been harder."

Coppola spent the nineties as a sort of alt-culture cosmonaut, exploring everything from fashion to photography to TV. It wasn't until she made 1998's *Lick the Star*—a black-and-white short about a group of wannabe murderous seventh graders—that she began to consider becoming a director. "It brought together my interests," she says. "And I was surprised that I knew how to do it, just from being around set so much. I didn't realize how much I'd learned."

Coppola knew that the odds of her adapting *The Virgin Suicides* were slim: not only had she never directed a feature before, but the rights to the book had already been sold, with the producers hiring a male writer-director. "He was making it really dark and sexual," Coppola says. "I was like, 'I hope they don't mess up what I love about the book.'" On her own, Coppola began adapting the first few chapters, just as an exercise. "I said to her, 'Sofia, don't break your heart,'" remembered her father. "'Don't write a script, because you're not gonna be able to do anything with it, because you don't own the book.'" But she ignored the advice, working on her *Virgin Suicides* adaptation whenever she could. She was even developing it during a late-nineties trip to London, where she filmed a part in *Star Wars: The Phantom Menace*, directed by family friend George Lucas. ("On my first day of shooting," she says of *The Virgin Suicides*, "I got a fax from him saying 'May the Force be with you.'")

Before she realized it, Coppola had finished an entire feature-length script. *The Virgin Suicides* begins in Grosse Pointe, Michigan, where the local teenage boys live in awe—or is it fear?—of the elusive Lisbon sisters. Gliding around the suburbs in their matching floral-print dresses and preppy sweaters, the girls are beautiful, inseparable, and totally indecipherable. But when one of the sisters kills herself by jumping out of her bedroom window and impaling herself on a fence, the family slowly begins to unravel. Eventually, the Lisbons will become near prisoners in their own home, communicating with the worshipping boys by

playing pop records over the phone. Before the film ends, all of the sisters commit suicide in their parents' home. The exact reasons are never explained, though one clue might lie in an exchange between a doctor and Cecilia, the youngest Lisbon:

DOCTOR: You're not even old enough to know how bad life gets.
CECILIA: Obviously, doctor, you've never been a thirteen-year-old girl.

"When you're a teenager," says Coppola, "that's when you're most poetic—having time to daydream, indulging in your crushes and melancholy feelings." She was eager to see a teen movie with "real, awkward kids," she says. Onscreen, "they always seemed older and not relatable—except for in John Hughes movies, which I loved. And I felt there weren't art films made for young audiences." Years later, Coppola would come to understand another reason why she'd responded so strongly to Eugenides's tale of bewilderment and loss: her oldest brother, Gio, had died in a boating accident when she was fifteen years old. His death "gave me a connection to *The Virgin Suicides*, which is also about loss," Coppola said.

Coppola took her unsolicited *Virgin Suicides* script to the film's producers—who, as it turned out, were about to lose their original director. Coppola got the job. "I was terrified," she says.

To help secure *The Virgin Suicides*' budget, which Coppola estimates was under $2 million, the writer-director hired a trio of established actors, some of whom had worked with her father: James Woods and Kathleen Turner were cast as the girls' parents, while Danny DeVito took a brief part as the family doctor. Meanwhile, the role of the aloof, bewitching Lux Lisbon—described by one character as "the still point of the turning world"—went to Kirsten Dunst, the sixteen-year-old star of such studio hits as *Interview with the Vampire* and *Jumanji*. "I was at the precipice of going from a child actor to being able to play a girl who dates," says Dunst. "*The Virgin Suicides* was that moment for me, where people could see me in a different light."

At the time, the actor and high schooler wasn't particularly interested in independent cinema, instead opting for trips to see *Romeo + Juliet* and *Titanic* with her friends. One of the few nineties indies she *had* sought out was the shocking NC-17 street-rat drama *Kids*. "My friend and I tricked my mom into renting it for us: 'It's called *Kids!*' We thought we were gonna see some gnarly sex scenes. And it was just depressing."

The Virgin Suicides was nowhere near as explicit as *Kids*. But Lux was certainly the most adult character of Dunst's then-young career: She sleeps with the local stoner stud Trip Fontaine on the school football field; fools around on the roof of her parents' house; and finally kills herself via carbon monoxide poisoning in the family garage. Emotionally, she seems light-years beyond the teen boys she so thoroughly confounds. Lux is gazed upon by everybody and understood by no one.

To play Trip Fontaine—the mop-haired smoothie who becomes absorbed with Lux—Coppola hired Josh Hartnett, a nineteen-year-old actor from Minnesota who'd spent part of his high school years working at a video store, watching "everything I could get my hands on," he says. Hartnett's VHS store stint coincided with a mid-decade bounty that included *Bottle Rocket*, *Fargo*, and *Trainspotting*, but his favorite director was *8½* maestro Federico Fellini. "It was those formative years, when you're discovering your independence and you seek out whatever's going to give you a window into a new world."

Like many of his peers, Hartnett had been pushed toward the teen-movie modern explosion, starring in horror films such as *The Faculty* and *Halloween H20: 20 Years Later*. (He was also in contention for *She's All That* and *10 Things I Hate About You*.) "That's where the money was, and that's where they wanted me to be," he says. "But once you're in that groove, it's hard to get out of it. So I tried to do as many as I could that were on the edge, like *The Virgin Suicides*."

Just *how* on the edge Coppola's film had become wasn't clear until right before production. At the last minute, one of *Virgin Suicides*' financial partners changed his mind, offering less money than originally promised. Eventually, "my dad loaned us the last little chunk of money

we needed from our winery," Coppola says. "He saved the day." Francis Ford Coppola also visited the Toronto set during the summer 1998, at one point telling his daughter, "You should say 'Action' louder, more from your diaphragm." ("I thought, 'Okay, you can go now,'" Sofia Coppola remembered.)

For Hartnett, who was a few years older than most of the other cast members, the *Virgin Suicides* shoot found him at an odd time—a little too old to spend all his time with the kids, a little too young to keep up with the adults (when he turned twenty during filming, the actor received a bottle of Francis Ford Coppola Winery wine from his director, along with a note that read, "You're not a teen heartthrob anymore"). But his turn as the perfectly named lothario Trip Fontaine would prolong the actor's teen-idol status for a while longer. Fontaine enters the school strutting lankily down a hallway to Heart's "Magic Man," looking comfortably in awe of himself. Hartnett based him loosely on a former classmate, a kid who had spent an entire year "doing a pseudo–Jim Morrison impression," he says. "Or maybe it was a Val Kilmer impression. I don't know what it was."

Hartnett's face-swallowing wig, meanwhile, presented some problems for a make-out scene he filmed with Dunst in Fontaine's car. "That was terrifying for me," says Dunst. "He lost his wig in one take, and later on, he told me I'd bit him! I was like, 'Oh, my God.' He was cute, and I was the most mortified sixteen-year-old on the planet." Dunst also struggled with a sequence in which Lux brings a series of men home for romantic rendezvous on her parents' roof as a group of curious boys watch from across the street. "Sofia knew I was nervous," Dunst says. "She shot it very abstract, so I was just nuzzling against them. She would always find a way to make me comfortable."

As for the director, her own discomfort would set in shortly after filming wrapped, when Coppola saw a rough cut of the footage. She'd initially alarmed the producers by shooting so much excess film, including long takes of the girls hanging around their bedroom. Now she was struggling to figure out how to put it all together. "My dad told me your movies are never as good as the dailies and never as terrible as the

rough cut," she says. "But I was so depressed by it. I felt like I'd really let people down and made this terrible movie."

After Coppola pieced the film together—adding a soundtrack that included several hypno-pop tracks by the French band Air—she felt much more at peace with *The Virgin Suicides*. The movie was accepted into the lineup for the 1999 Cannes Film Festival in May, where it debuted alongside two other tough but mesmeric stories of youth: *Rosetta*, a powerfully bleak tale of a poor, impulsive Belgian teen, and *Ratcatcher*, a seventies-set account of growing up amid the garbage-strewn streets of Glasgow. All three films found their young characters on the precipice between adolescence and adulthood, trying to wrap their heads around the sort of life complications—poverty, violence, self-harm—that most adults can barely begin to understand themselves.

In the case of *The Virgin Suicides*, the grown-up subject made some people nervous. "There were distributors worried that it was going to set off a chain of suicides," says Coppola. "But I always thought young audiences were smart." As it turned out, the concerns about the movie's persuasive powers were moot. When *The Virgin Suicides* was finally released in theaters in the spring of 2000, "nobody saw it," says Coppola. Like so many adult movies about adolescence from that period, *Virgin Suicides* would have to wait to thrive in its afterlife.

Long after Alexander Payne finished shooting *Election*, he was still trying to figure out how to end it. "It's the only movie I made where we had two Christmas parties in the cutting room," he says.

The conclusion Payne had originally shot for *Election* had found Tracy and the newly divorced Mr. McAllister—who had lost his job after rigging the school election—sharing an awkward reunion: Tracy asks him to sign her yearbook, but when he looks it over, he realizes that there are no other signatures. They're both alone, in their own way. "The camera pulls back, and you get a sense that, at the end of the day, they have a weird connection," says *Election* coproducer Albert Berger.

But as *Election* was being edited, it became obvious that Tracy and

Mr. M. were never going to find a harmonious middle ground. They are who they are. "The movie we made was really snarky," says Taylor. "And that ending, which I think is beautiful, didn't mesh."

Paramount Pictures CEO Sherry Lansing agreed, volunteering more money for additional scenes. It was Lansing who suggested that McAllister should return to teaching, and Payne and Taylor incorporated the idea into their new ending: Mr. M. has relocated to a dinky apartment in New York City, where he's working as a docent at the Museum of Natural History, entertaining school groups. "That's right," he says, utterly deluded about how far he's fallen. "I'm teaching again!" Notes Berger, "It's the first time I'd ever heard of a studio wanting a *more* cynical ending."

After waiting for Broderick to complete filming on another movie, the *Election* team reconvened in New York and Washington, DC, to shoot McAllister at work at his new job—and to capture his final encounter with Tracy Flick. While visiting the capitol, McAllister spots Tracy, now an aide to a Nebraska congressman. He fumes as he stares her down— "Who the *fuck* does she think she is?"—before tossing a drink onto her car and running away.

The new ending of *Election* made everyone happy—the filmmakers, the studio executives, and the actors—though it took Witherspoon a while to get used to her depiction of Flick. "When I first saw the film, I was in shock," she says. "I walked out thinking 'Oh, my God, that's the performance I gave?' I was like, 'God, how repellant.' Ultimately, though, Alexander found a compassion for that character."

Early audiences, however, were nowhere near as sympathetic. "*Election* had terrible test scores," says MTV Films exec David Gale. "You get this theater filled with people who think they're going to see this broad teen comedy, and all of a sudden, there's a guy saying 'Her pussy gets so wet.' There was this collective gasp from the theater, and people started walking out in droves."

According to Gale, panic quickly set in among some of Paramount's executives. "I had terrible calls with people at the studio," he says. " 'How could you do this to us? This is a bad movie.' " Paramount then released a dumb, noisy trailer that confusedly presented *Election* as the tale of a

religious teen—one with "an ego the size of the Grand Canyon"—who teams up with her mom to run for class president. It was akin to a trailer selling *Jaws* as a fishing-trip comedy. Clearly, no one knew what to do with *Election*. "We'd go into marketing meetings, and it was like there was a dead pig on the table," says Yerxa. "It was a dispiriting time."

In the weeks before *Election*'s opening, its producers began to worry that the movie might not even be released at all. "Paramount was considering going straight to video," Yerxa says. Studio chief Lansing eventually intervened, and *Election* wound up getting a final push before its late April release. It wouldn't be enough to alter *Election*'s fate. Though the film was an overachiever with reviewers, eventually topping *Premiere* magazine's year-end critics' poll, *Election* quickly slipped from view, probably because nobody quite knew what it was: A teenage comedy about flailing adults? An adult comedy about pushy teenagers? *Election* was neither, which made it impossible to explain to moviegoers.

Similar confusion had greeted *Rushmore* a few months earlier: After opening wide in February, the movie was seen as a spiky alternative to the happy-ending high school tales of the time (*Rolling Stone* hailed it as "a romantic triangle about clinical depressives"). And for those who'd strived to conquer their own personal Rushmores, it was hard not to become enamored with Max—or, for that matter, the guy who played him. "I fell in love with Jason Schwartzman from that movie," says Selma Blair, who dated the actor in the early aughts. "I sought him out after seeing it. I was doing a photo shoot, and the photographer knew him. I said, 'I'll only stay longer if you get Jason Schwartzman here.' We kissed on camera and were together after that." To this day, she says, "I can't even watch *Rushmore* without sobbing, because it's so perfect."

But *Rushmore*, like *Election* and *The Virgin Suicides*, underperformed at the box office, making less than $20 million. All three films were no doubt hindered in part by their R rating—a testament to their maturity, but one that likely kept younger moviegoers away. It would take some time before these films found their audiences, first via home video, and later on the internet, where their young heroes became virtual hall-locker pin-ups, immortalized in Tumblr shrines and

GIF collections. A character like Max Fischer, notes *Rushmore*'s Olivia Williams, has "a huge imagination and a desire to make a mark in the world. But he's hampered by circumstance and by an inability to break out of the straitjacket he's in. Doesn't every kid feel that?"

It was certainly a feeling shared by Lux Lisbon, or Tracy Flick, or even the floppy-haired Trip Fontaine. None of them managed to crack the centuries-old mysteries of young adulthood in 1999. Instead, they reminded viewers that they weren't alone in trying to solve them.

"AT LAST, WE WILL HAVE REVENGE."

STAR WARS: EPISODE I—THE PHANTOM MENACE
GALAXY QUEST
THE IRON GIANT

He'd started work early that day, dropping the kids off at school before heading to his northern California headquarters, where he trudged up the stairs to a small, neatly cramped office he called "the hole." His desk was surrounded by books covering everything from philosophy to mythology to the Civil War. It was November 1, 1994, and as the trees swayed in the breeze outside, George Lucas—sporting a Hoth-white beard, dad jeans, and a green-and-blue flannel shirt—took a seat and began to write.

> *A disheveled boy, ANAKIN SKYWALKER, runs in from the junk-yard. He is nine years old, very dirty, and dressed in rags.*

It was day one on what would eventually be known as *Star Wars: Episode I—The Phantom Menace*, Lucas's first *Star Wars* movie in more than a decade. "It's great to be able to sit by myself and just be able to do this," Lucas said that morning. "I don't feel a lot of pressure."

Clearly he wasn't spending too much time outside of the hole. In 1993, when Lucas announced his plans for what was then called *Star Wars: Episode I*, he'd incited instant clamoring among fans. The original *Star Wars* saga—three space adventures set a long time ago in a galaxy far, far away—had been one of the most successful cinematic undertakings of all time, earning billions of dollars in tickets and toy sales. *The Phantom Menace* wouldn't be a sequel but the first of three "prequels," set long before the originals. By the summer of 1999, when *The Phantom Menace* finally opened in theaters, sixteen years would have passed between *Star Wars* films. No other major movie franchise had experienced such a lengthy gap.

But no other movie franchise was *Star Wars*. In the months before *The Phantom Menace*'s release, anticipation was so high that when the movie's trailer debuted in the fall of 1998, theaters sold several thousand dollars' worth of tickets to films such as *The Waterboy* and *Meet Joe Black*—just so moviegoers could walk in, watch the *Phantom Menace* preview, and walk out again. In the final weeks before the movie's opening night, audience members would start camping outside theaters, filling city sidewalks with lightsaber-wielding pretend Jedis. *The Phantom Menace* was "probably the most craved movie ever," noted *Vanity Fair*, one of several magazines to feature the sci-fi prequel on its cover that year.

But the fans who'd been craving more time in the *Star Wars* galaxy also had very strong opinions about Lucas's handiwork. On a late-December day in 1996, not long before before filming on *The Phantom Menace* was set to begin, a warning to Lucas appeared on an internet discussion group dedicated to *Star Wars*. It was written by a twenty-something living in a back room in his father's house in Austin, Texas. "Listen to the fans," the message implored. "They are your only hope." The letter writer was concerned about rumors he'd heard that Lucas was digitally sprucing up the original *Star Wars* trilogy, which was soon to be rereleased in theaters. Already there were grumblings that Lucas's "corrections" had gone too far, worrying some *Star Wars* lovers. "I would be wary of angering them," noted the commenter. "Within a week, this

could grow very out of hand." He then suggested that some *Star Wars* fans might use the web to retaliate, lodging their complaints online. "Lucasfilm may not place a lot of faith in these net movements," the writer acknowledged, "but they can be a dangerous little firecracker." He signed off his plea with his name: Harry Jay Knowles.

Over the course of the next several years, journalists from around the world would depict Knowles—the founder of a movie gossip site called Ain't It Cool News—as a verbose, egomaniacal, decidedly uncool outcast who was happily futzing with Hollywood's fortunes from some dank southern basement. That was a slight exaggeration. In truth, Knowles notes, "Texans don't have basements."

The rest of the myth surrounding Knowles—which he happily helped spread throughout the nineties—was largely accurate. He'd been born in Austin, the son of two movie fanatics and memorabilia dealers who often took their young son to film and comic book confabs when he was still a toddler. Knowles, who'd been teased for being plus-sized since he was young, had originally wanted to be "a fat character actor." But when he was rolled over by a massive dolly while working at a fan gathering in 1995, he wound up being paralyzed for months. During that time, he spent hours on the then-uncharted internet. "It was an amazing place," he says. "Everybody had fake identities. Nobody was themselves. I enjoyed the freedom of it." Working from his bed, he began collecting rumors about forthcoming movies, eventually starting his own site, Ain't It Cool News, named for a John Travolta one-liner from the film *Broken Arrow*. "I figured everyone in the world has ten thousand people that think like them," Knowles says, "and if you can connect to those ten thousand people on the internet, you can get a following."

Knowles launched Ain't It Cool News in 1996, right around the time Lucas was reviving his *Star Wars* saga. But with those films still years away, Knowles filled his minimally designed site with updates from other in-the-works movies. Networks of anonymous "spies"—eager to

show off their insider intel—fed him casting and director rumors and unauthorized sneak-peek images. Some users even submitted early test screening reviews of unfinished movies such as *Titanic*. The leaks irked film studio execs, who were uncertain whether to schmooze Knowles or sue him. But he wasn't alone in using the internet to create a counter-narrative to Hollywood's carefully managed hype machine. In 1998, Knowles appeared in *Vanity Fair*'s "Hollywood issue," alongside several other online film writers, whom the magazine had dressed up as pocket-protected eighties nerds and collectively dubbed "the scourges." Knowles was by far the most prominent scourge of them all: as Ain't It Cool News ascended, he earned a spot on *Entertainment Weekly*'s list of powerful showbiz players and received offers to buy the site that he claimed reached as high as $30 million.

Ain't It Cool News became so powerful that Knowles—whom one newspaper had called "King Geek"—started to believe he knew how to make and market movies better than the studios did. "I'd like to think of myself as sort of a Food and Drug Administration for the film industry," he said in 1998.

By then, studios and filmmakers were inviting Knowles to film sets and premieres or even to appear in their movies—many of them no doubt hoping for positive coverage. He was even given a primo seat for that year's premiere of *Godzilla* in New York City's Madison Square Garden. "It was extraordinary studio propaganda," he says. "Sitting behind me was Muhammad Ali. Sitting next to me was the Taco Bell dog, on a pillow in a model's lap. And they had a rock concert setup, so every time Godzilla stepped, your sternum would vibrate." Knowles wrote an effusive review of the movie—putting him firmly in the minority—and then changed his mind, acknowledging that he'd been seduced by his surroundings. But the *Godzilla* about-face reinforced a growing suspicion among some readers: Knowles could no longer be trusted. King Geek had built a fiefdom of followers just as opinionated as he was, and many of his readers soon turned against him, haranguing him in the site's comments section. When he'd started Ain't It Cool News, he'd tried to warn Lucas about the dark powers of the still-evolving web. But he had

proved that even he could be felled by the dangerous little firecrackers of the internet—and by the end of the decade, they were exploding everywhere.

George Lucas had good reason to wait more than a decade to return to the billions-grossing *Star Wars* franchise: he'd need to save up some money.

The writer-director had started out making cinéma vérité–style shorts in the late sixties, before becoming part of the Easy Riders, Raging Bulls mob that included Francis Ford Coppola, Steven Spielberg, and Brian De Palma. Lucas's feature career began with a pair of early-seventies studio releases: the chilly sci-fi experiment *THX 1138* and the road-running ensemble *American Graffiti*. Both were low-budget movies made with studio executives "breathing down my neck," he said. The success of the *Star Wars* films granted him some autonomy, but decades later, Lucas wanted complete control over *The Phantom Menace*—meaning he'd have to finance it himself. In the eighties and nineties, he'd begun storing away profits from the numerous effects and technology companies he co-owned, including Industrial Light & Magic. The new *Star Wars* movie would cost Lucas $115 million, but at that price, he could be his own boss. "I purchased my freedom from the machine," he said.

Lucas had started outlining the prequel in the seventies, collecting notes in a red binder he was still using two decades later. His ultimate story for *The Phantom Menace* at first seemed fairy-tale simple: Anakin Skywalker—the powerful young slave boy who will eventually grow up to be Darth Vader—is rescued by two Jedi Knights and united with a young queen who's fighting to save her planet. But Lucas had some other ideas he wanted to work into *The Phantom Menace*—grand notions of power and realpolitik. They took the unfortunate form of several dialogue-clogged scenes about taxation, shipping routes, and voting procedures. Some moments from *The Phantom Menace*—such as the screen-crawling heads-up that "the taxation of trade routes to

outlying star systems is in dispute"—made the movie feel more like *FedEx 1138* than *Star Wars*.

But the online fans who'd spent the late nineties tracking *The Phantom Menace*'s progress didn't know that yet. They were caught up in the daily rush of best guesses, semitruths, and impossible lies that were circulating throughout the web: that Charlton Heston was going to play the young Yoda; that the movie's title would be *Star Wars: Balance of the Force*; or that it would include a plague of frogs. "Just people spinning fictions," Lucas said, "trying to make themselves feel good or make themselves important."

What *Star Wars* followers knew for sure was that *The Phantom Menace* would feature a few recurring characters, including Yoda—played not by Heston but by the famed puppeteer Frank Oz—and the tagalong droids R2-D2 and C-3PO. The aloof Obi-Wan Kenobi would be returning as well, this time in the form of *Trainspotting*'s breakout star Ewan McGregor. The rest of the *Phantom Menace* crew was almost entirely new, including Qui-Gon Jinn, a cryptic Jedi master, played by *Schindler's List* star Liam Neeson; Queen Padmé Amidala, the headstrong young monarch, portrayed by *The Professional*'s Natalie Portman; and the evil Darth Maul, a warrior with a double-headed lightsaber and a hatred for the virtuous Jedis: "At last, we will have revenge," he hisses.

The film's most mysterious newcomer, though, was Jar Jar Binks, an elastic frog-bunny alien hybrid who befriends the Jedi, and speaks in a strange, childlike patois ("Meesa called Jar Jar Binks!"). Lucas had watched in the nineties as digital effects reached a staggering new apex seemingly every year: There'd been the body-morphing bad guy of *Terminator 2: Judgment Day*; the massive dinos rampaging through *Jurassic Park*; and the titular sinking ship of *Titanic*. Lucas decided it was time for the first digitally generated lead character. The plan was for Jar Jar to be played on set by an actor who could develop the creature's movement and style. That performance would serve as a guide later on, when effects artists inserted the CGI-rendered Jar Jar into the film.

But who could possibly play a spazzy, jolly, almost childlike alien? The most obvious answer, of course, was Michael Jackson—who in fact

had lobbied for the role, only to be turned down by Lucas. A lengthy talent search ensued, one that would take *Phantom Menace* casting director Robin Gurland around the world. "Jar Jar was one of the last roles we cast," Gurland says. "I was looking for someone who could really sell the physical aspect of the character but who also had the acting chops to give it a literal voice—and it's very difficult to find that in one performer."

As filming was getting closer, Gurland spotted Ahmed Best, then in his early twenties, onstage during a San Francisco performance of the dance extravaganza *Stomp*. It had been a tough show for the young dancer and musician: an out-of-town Stomper was visiting the city, so Best had been relegated to a supporting role, leaving him fuming. "I turned into an asshole that night," Best says. "I thought, 'If you think you can out-anything me onstage, you got another fucking thing coming, and I'm going to prove it.' And I did." Best's show-offy turn wound up winning Gurland over: "I couldn't take my eyes off him."

After the *Stomp* show, Best was summoned to Lucas's Skywalker Ranch, where he was squeezed into a tight-fitting motion capture suit, which would allow the special effects artists to record his movements digitally. At one point, Lucas himself showed up to watch Best in motion. "I was doing a break-dance glide," remembered Best. "I was going back to '84. I was going to get this gig."

Best, who'd spent his early years in the Bronx before relocating to New Jersey, had seen the original *Star Wars* movies countless times as a kid. Getting the role of Jar Jar made him the luckiest fan in the world—which may be why he approached the role with Sith-like seriousness. On a flight to London for some *Phantom Menace* prep, a flight attendant poured scalding hot tea on his lap. Best, who didn't want to jeopardize his job, was forced to remain silent as he endured a painful costume fitting. Not long afterward, on an early morning in 1997, he was standing in a hut in the middle of a wide stretch of desert in Tunisia, the North African country where Lucas had shot the first *Star Wars* film. As crew members hovered about, Best was tucked into his cumbersome head-to-toe Jar Jar outfit, which, when complete, would display Jar

Jar's popping eyes and amphibious snout. The heat was promising to once again break the three-digit barrier, but Best was calmly, quietly *nuh-nuh-nuh*-ing a familiar tune: the *Star Wars* theme. "We laughed all day long," he says of his *Phantom Menace* experience, which included hanging poolside with Portman and McGregor and watching Kenny Baker—the actor who played R2-D2—taking off-the-clock hits from a violet bong.

Lucas wasn't anywhere as relaxed. The filmmaker, then in his early fifties, hadn't directed a movie since 1977's *Star Wars: Episode IV—A New Hope*, opting instead to produce its sequels, as well as such potential legacy scorchers as *Howard the Duck*. Now he was overseeing a shoot that spanned sixty-five days and three countries and would include more than a year and a half of postproduction work. He was well aware that the future of his movie empire depended on the success of *The Phantom Menace*. "There's no way to know what's going to happen," he said during a break in filming one day. "You can destroy these things, you know. It *is* possible."

Dean Parisot looked around and realized he was surrounded. It was August 1998, and the filmmaker was attending a science fiction convention in Pasadena, California. "I go into the men's room, and there's four Klingons on either side of me, peeing at the urinal," says the director, referring to the strangely foreheaded *Star Trek* villains. "They had a Klingon dog, and they were even *speaking* in Klingon."

Parisot, in his midforties, was visiting the confab as research for a movie he was working on: *Galaxy Quest*, a sci-fi comedy in which the cast members of a *Star Trek*–like TV show—also titled *Galaxy Quest*—encounter aliens who believe the long-canceled series is real. The movie begins and ends at a massive convention much like the one Parisot was visiting that day, where attendees were walking the floor in elaborate creature makeup and waiting in line for a hurried glimpse of *Lost in Space* star June Lockhart, who was signing her $25-a-pop autographs while wearing a rubber glove.

Such fan gatherings—once relegated to smoke-choked hotel rooms and deep-carpeted convention centers—were now lucrative, highly polished big businesses. In August 1970, the first iteration of what would become San Diego Comic-Con International had attracted just a few hundred visitors. Decades later, Comic-Con was an annual summer pilgrimage not only for comic book and movie lovers but for the corporations eager to win their approval. In July 1999, more than 40,000 attendees showed up for the multiday event, where 20th Century Fox would hold a panel with news about its forthcoming *X-Men*—a movie that hadn't even begun filming yet. It was a risky move, considering that details about the movie would inevitably wind up on the internet, where they'd be picked apart by *X-Men* fans. Only a few years after the arrival of Ain't It Cool News, the web was filled with preemptive critics who would look at a lone leaked costume photo or read a secondhand review of a trailer and immediately declare BEST. MOVIE. EVER. or WORST. MOVIE. EVER. with a single post. Fans had grown more powerful than one could possibly have imagined, their online fiefdoms growing larger and more vocal each year. "Before the internet, you didn't know *who* was going to show up for a movie," says Parisot. "And suddenly there are websites where people talk about their favorite things to an absurd degree—especially in the science fiction world."

Fandom had evolved—if not quite fully matured—since the original *Star Trek* series had premiered in 1966. Parisot had loved the show as a kid, having once tried to convert his mother's gray station wagon into the saga's famed USS *Enterprise* by putting toy rockets on the roof rack. It made him an apt choice for *Galaxy Quest*, as the film's lead character—a cocky, fan-ambivalent middle-aged actor named Jason Nesmith, played by Tim Allen—was a ringer for *Star Trek* star William Shatner. *Galaxy Quest* begins with Nesmith being accosted by a group of disarmingly smiley costumed characters, whom he assumes are just especially weird *Galaxy Quest* lovers. As he soon learns, they're aliens who don't merely love the show; they *live* it, even recreating the series' famed spaceship, hoping the *Galaxy Quest* crew could use it to help protect them from an intergalactic warlord.

After realizing that his show's biggest fans are about to get annihilated, Nesmith recruits his former TV costars to help fight back. One of them is Sir Alexander Dane, a stage-educated, deeply miserable thespian, played by the English actor Alan Rickman. None of Dane's fans cares about his stage work. They just want to hear him recite his *Galaxy Quest* catchphrase—"By Grabthar's hammer, by the suns of Warvan, you shall be avenged!"—for the millionth time. *Galaxy Quest* was as much about performers as it was about the people who worship them, and Rickman, himself a theater veteran with several huge screen credits to his name, could understand Dane's predicament better than most. "Alan loved the idea of the actor's plight in Hollywood," says Parisot. "He talked about how, in spite of all his great work on the stage in London, all he was known for was *Die Hard*."

Rickman wasn't much for *Star Trek*, a show the actor once said he would "fly across the room" to turn off. He did, however, have an appreciation for the emerging convention culture that *Galaxy Quest* was lampooning. "It's easy to mock, and there are some weirdos," he said, "but these people are living out their fantasies." (Not long after *Galaxy Quest*, Rickman would begin work on the first of eight *Harry Potter* films—putting him into the orbit of fans more obsessive than even the biggest *Die Hard* diehard.)

By the time *Galaxy Quest* was approaching its release date, Parisot had also taken note of the new ways in which buzz—good, bad, meh—was spreading. It was now possible for film fans to broadcast their film reviews immediately, not just online but on their way out of the theater to the parking lot. "That year, for the first time, I watched people coming out of theaters on their phones, talking about the movie," he says. "I was astounded by it."

His movie would need that sort of chatter to succeed. DreamWorks, the Steven Spielberg–affiliated studio behind *Galaxy Quest*, was convinced that the movie could be sold as a family film, despite its lead character being a grumpy drunk who at one point stares down a bunch of nightmare-inciting, sharp-toothed alien cannibals (an early test screening with younger kids backfired, after parents complained about

the movie's foul language.) The studio also created a purposely janky-looking fake fan site filled with fawning interviews and blowhardy opinions—a spoof of the overly obsessive sites that had launched in the wake of Ain't It Cool News.

None of it worked, as *Galaxy Quest* debuted at a disappointing number seven in its opening weekend. But over the course of the next two weeks, *Galaxy Quest* actually moved *up* the box office charts—an almost unheard-of pivot. A movie about a cult-beloved show was finding its own true believers, many of whom were spreading the word online. And they were proving more powerful than Grabthar's hammer. "The fanboy-fangirl audience finding it was probably what allowed it to continue in the theaters," says Parisot.

DreamWorks had been legally prohibited from invoking *Star Trek* in its advertisements, and Parisot says that studio lawyers had urged him not to reference the franchise in the film (advice he ignored). So the director wasn't sure what to expect when, months after *Galaxy Quest*'s release, he was summoned to a mysterious lunch with *Star Trek: The Next Generation* captain Patrick Stewart. "He waits for about two minutes so I can squirm, before saying 'I loved it.' Then, for the next forty-five minutes, he was just laughing and quoting lines."

There was another crucial *Galaxy Quest* endorsement that year. It underscored just how powerful the online hordes had become, and that came from the recognized authority on the sort of worlds—both real and make-believe—that the movie depicted. It was notable enough that Rickman brought it up during an appearance on *Late Night with Conan O'Brien*. "Henry Knowles, is it?" the actor said. "*Harry* Knowles. I think I'm quoting him directly from his ain't-it-cool-dot-com thing: 'This is the greatest film that has ever been made.' I rest my case."

Even in the darkness of the screening room, it was impossible not to see the look of despair—maybe even shock—on George Lucas's face: *What happened?*

It was 1998, and there were still months to go before the release

of *The Phantom Menace*. With filming completed, the writer-director had assembled a handful of colleagues in a small private theater to watch a rough cut. Lucas was dressed in a gray sweater that matched his swooping, surflike crest of hair. By the time the movie was over, his face had turned nearly the same color. Few filmmakers walk away from rough cuts unscathed, but Lucas seemed genuinely surprised by what he'd seen. "It's a little disjointed," he said afterward. "It's bold in terms of jerking people around, but I may have gone too far in a few places."

Lucas had good reason to fret. Even before the movie's release, some worrying word of mouth about *The Phantom Menace*—much of it generated online—would manage to slip through the shields. In the summer of 1998, the New York *Daily News* picked up a faulty internet rumor claiming that footage from *The Phantom Menace* had been ruined in the lab—it was now "as fuzzy as an Ewok"—and claimed parts of the movie would have to be reshot. And in January 1999, *Newsweek* ran an item that cataloged some fans' fears: the movie's tone seemed too jubilant, the article noted, and some of its digital effects threatened to come off as "cheesy."

There was also a small but worrying preemptive Jar Jar backlash formulating. Ahmed Best's all-CGI creature was glimpsed briefly in the film's trailers, but his cartoony persona and singsongy patois—"Yousa say peoples gonna die?"—was enough to alarm some fans. "We saw the first *Phantom* trailer way back in January," said *South Park* cocreator Trey Parker. "We were like, 'This is the new Ewok! This is what's going to ruin the new movie!'" He and his partner, Matt Stone, would rush to add a last-minute Jar Jar spoof to their *South Park* movie, due that summer. And before the opening of *The Phantom Menace*, a Seattle comic book store worker launched an online group dubbed the International Society for the Extermination of Jar Jar Binks. Such potshots weren't going to halt *Phantom*'s momentum, obviously. But after a half decade's worth of unchecked *Star Wars* mania, a troubling question was forming in at least a few filmgoers' minds, one that had previously been unspeakable: What if the new *Star Wars*—a movie they'd been craving for

sixteen years—wasn't worth the wait? "All I can do now," said Lucas, "is throw it out there in the real world, and see what everyone thinks."

Around the time Lucas was tempering everyone's expectations—even his own—about *The Phantom Menace*, Brad Bird was struggling to get *anyone* to care about *The Iron Giant*. Then in his early forties, the writer-director had already enjoyed an enviable run of animation jobs, working for Disney in the eighties before serving as a consultant on *The Simpsons*. He'd also overseen his own episode of Spielberg's 1980s anthology TV series *Amazing Stories*: the gently subversive "Family Dog," about a kind pooch who's stuck with rotten owners and eventually transforms into what one character describes as a "snarling, white-hot ball of canine terror."

Now Bird was the one showing his teeth. By early 1999, he'd found himself locked in a cold war with Warner Bros. over the fate of *The Iron Giant*, his animated Sputnik-era fable. Adapted from the 1968 novel *The Iron Man* by the famed poet Ted Hughes—who wrote the book while reeling from the suicide of his estranged wife, Sylvia Plath—*The Iron Giant* follows a lonely kid who befriends a towering space robot. The movie was Bird's first chance at a feature film after numerous setbacks. "I'd had so many projects in development hell, and they'd taken up so many years of my life," says Bird, who'd later go on to direct such hits as *The Incredibles*. "If you've seen *Cool Hand Luke*, where's he forcing a guy to dig a hole and then to refill it—that's what it's like." Now, having finally gotten a movie green-lit, Bird was in a room with executives from his studio, having just shown them rough footage and artwork from *The Iron Giant*. "It was very exciting," he remembers. "And then one guy said, 'You know, I don't know how to sell this movie.'"

A brief pause followed as Bird absorbed what he'd heard. "I'd been polite for too many years," he remembers. "I said, 'If I told you I didn't know how to direct this movie, I'd be fucking fired! Are you telling me you can't figure out how to sell a giant robot and a kid? That's Popcorn 101!'" By then, he says, "I'd grown a pair of balls."

Warner Bros. had originally envisioned *The Iron Giant* story as a musical, with songs by the Who's Pete Townshend, who'd adapted Hughes's book for a 1993 stage show. At the time, Bird says, "everyone was trying to imitate Disney, who was having success with musicals— *The Lion King, Aladdin, The Little Mermaid*—while everyone else was failing miserably." Bird's vision for *The Iron Giant,* however, had little potential for sing-alongs. "I went into a pitch meeting and said, 'What if a gun had a soul and didn't want to be a gun?'" Bird remembers. He then outlined the film's premise: Set in small-town Maine in 1957, it would follow Hogarth—a Superman-loving nine-year-old who lives with his single mom—as he discovers the gentle, slightly befuddled robot hiding in the woods. The two become friends, playing in a junkyard and reading comic books, while a paranoid federal agent tracks them down, convinced that the giant's crash landing was part of some Commie plot. After it's discovered that the Giant can weaponize himself, a showdown ensues, one that nearly leads to nuclear annihilation—until the Giant flies into space and blows himself up, saving the day.

On its surface, *The Iron Giant* was a charming boy-and-his-'bot tale, complete with a sneer-worthy villain and a ticking-clock finale. But Bird's story would also contend with questions of morality that would feel especially pressing in the post-Columbine age. At one point, Hogarth, having learned of the Giant's capacity for destruction, tells him, "It's bad to kill. Guns kill. And you don't have to be a gun. You are what you choose to be."

Bird hadn't set out to tell a story about mankind's propensity for destruction. But it had been on his mind. "I lost a family member to gun violence," he says. (Years before *The Iron Giant*, Bird's sister Susan had been murdered by her husband; a dedication to her appears in the film's end credits.) "I wasn't going around thinking 'I've got to make a movie about that particular part of my life.' But it infused it. We have the capacity for great love and for great destruction, and every living thing has this ability to choose from either side of the menu. And when we do kill, we're not only killing a thing—we're killing the connections it has to others."

One of *The Iron Giant*'s early supporters at Warner Bros. was *Matrix*

sherpa Lorenzo di Bonaventura, who'd recently been tasked with overseeing the studio's animation division. He loved Bird's "What if a gun had a soul?" approach. "I related to that notion as a guy who'd made a lot of violent action movies," he says. "And it was a pretty easy movie to agree to make, because I didn't like anything else the animation division had. And we needed to make *something*."

As production got under way on *The Iron Giant*, though, a real-life behemoth came crashing to the ground: Warner Bros.' animation division. The studio's attempt to compete with Walt Disney and Dream-Works had become undone by costly failures such as the little-seen musicals *Cats Don't Dance* and *The Quest for Camelot*. "The division ended up losing a shitload of money," says di Bonaventura. Bird would be able to keep working on *The Iron Giant*, but he'd have to do it on a much smaller budget—reported to be around $50 million—than most other animated-film directors. And he'd have to do it while Warners' animation branch was euthanized right in front of him. "They were literally closing floors of the building," Bird says.

The upheaval left *The Iron Giant* without a firm release date; at times, Bird worried that the movie wouldn't even get released at all. His irritation was shared by his *Iron Giant* team members, who'd been working on the film for years. "Our crew was very frustrated," he says.

That partly explains how a detailed article on *The Iron Giant* wound up on Ain't It Cool News on February 1, 1999. According to Bird, a member of the film's production staff—"one of our obsessed animators," he says—had allowed an Ain't It Cool contributor named Drew McWeeny to see a version of *The Iron Giant* in rough form. "At first I was very upset," Bird says. "That's like somebody looking at a drawing you've just started sketching and commenting on it like it's a painting. I talked to the crew and said, 'This is not cool.'" But later, he says, "I'd end up being oddly grateful for it." McWeeny's piece wasn't a review so much as it was a plea to Bird's bosses:

Right now, somewhere in Glendale, there's a whole group of heroes working tirelessly to finish an extraordinary gem of a picture, a

*very special film that deserves, in my opinion, to be one of the
year's biggest hits. . . .*

 *Unfortunately, there are forces in play on the Warner Bros.
lot in Burbank that threaten to undermine this movie, force [sic]
that are working against their own best interests . . . what will
Warner Bros. be—heroes or villains?*

Though the version screened for Ain't It Cool News was incomplete, with more than half of it still in rough-form black and white, the movie was "already an absolute masterpiece," McWeeny declared. That endorsement—as well as some stellar test screening scores—helped attract the attention of the *Los Angeles Times*, which in April ran a prominent story questioning whether Warner Bros. had done enough to make audiences aware of the movie. "Warners may not have realized how good a film it had," said the paper.

All of a sudden, the online excitement for *The Iron Giant* helped turn the once-doomed movie into a sight-unseen classic. In the week before its release, Warner Bros. made a bold final pitch to filmgoers, releasing several minutes from *The Iron Giant* online with an introduction recorded by Bird. "The web guys loved this movie," says Don Buckley, then a Warner Bros. executive. "We utilized every digital tool we had." It was a then-unheard-of move for a major studio and an acknowledgment that the internet—which had been burying Warner Bros.' *Wild Wild West* in bad buzz for months—might also be an ally.

On *The Iron Giant*'s opening weekend, Bird was on vacation, awaiting the movie's fate. The reviews for the film, much like its test screening responses, had been almost exclusively effusive (one exception: the right-leaning *New York Post*, which derided *Giant* as "a left-wing fable about McCarthyism and nuclear warfare. Ethel and Julius Rosenberg, this robot's for you"). But by the time the final box-office tallies were in, *The Iron Giant* had barely made it into the weekend's top ten. "I was crushed by the numbers," Bird says. "To have it declared dead that quickly is disastrous." Bird did receive an encouraging telephone call from writer-director Guillermo del Toro, then best known for his cult

horror hit *Cronos*. "He basically talked me off the ledge," remembers Bird, "and told me the film would stick around."

The Iron Giant's online supporters pointed fingers at the studio, haranguing Warner Bros. for running misleading ads—or for not running enough ads at all. On Ain't It Cool News, Knowles even published the email address of one of Warner Bros.' top execs, encouraging readers to send in their ideas for remarketing the movie. But despite all of the efforts to revive *The Iron Giant*, there was no way to convince grown-up moviegoers to see it. "I loved that movie," says di Bonaventura. "But maybe it was ahead of its time."

For those who did see it however, *The Iron Giant* felt very much of the moment. It's a movie that thoughtfully considered the senselessness of gun violence, released less than four months after Columbine. And the film's Sputnik-era setting and all of the march-of-progress anxiety that came with it were an avoidable reminder of the fears surrounding Y2K. "Technology always presents that sort of feeling," says Bird. "We always have some new development coming that could possibly make things better. But there's always this twin side to it—that it could be the thing that ends life on Earth." That may have been a hard message for moviegoers to grasp that year. But there'd be plenty of time to think on it while *The Iron Giant* slept, waiting to awaken again.

The security detail that day was impressive—most impressive. In order to claim their seats, moviegoers needed not only a hard ticket but also a fluorescent hand stamp bearing the 20th Century Fox logo. Those would help get them through the four check-in stations and past several imposing guards. It was May 1999, and *The Phantom Menace* was finally being screened for a group of critics in New York City. Before the presentation got under way, an official pleaded with attendees, asking them to speak out if they saw anyone trying to record the movie. But everyone's eyes were stubbornly fixed to the screen. When the familiar prologue—"A long time ago, in a galaxy far, far away"—came on the screen, there were "robust cheers" within the theater, noted *Time*

magazine. After sixteen years, *Star Wars* was back, its bright yellow logo blasting onto the screen, accompanied by John Williams's walloping score.

But 133 minutes later, the mood in the room had notably changed. "For whatever reason," *Time* noted, "the audience was quieter at the end than at the beginning."

Actually, as moviegoers around the world were about to find out, there were plenty of reasons to greet *The Phantom Menace* with stunned silence. What the New York crowd had experienced would be replicated around the country on May 19, 1999, as millions of fans took their seats in their local theaters, waiting to see if *The Phantom Menace* lived up to their fantasies. They'd eventually stumble outside looking as though they'd just awakened from carbon freeze, trying to understand what they'd witnessed: a gorgeous but irrefutably clunky space jam about taxes, blood samples, and interplanetary law. "I went on opening night, hoping to recapture some part of my seven-year-old self," says *American Pie*'s Chris Weitz, "and it was not recaptured." The magic of those original films—which had been lunkheaded at times but were also empirically dazzling—was almost entirely gone. Lucas hadn't answered to anybody while making *The Phantom Menace*. There were no studio notes to reckon with, no pushy producers forcing him to rethink or refine his ideas. This was on him.

The disdain for *The Phantom Menace* was loud enough to reach Lucas, who semidefended the film with a shrugging "What were you all expecting?" pragmatism. "The critics pretty much hated the first three movies," he noted. "They said the dialogue is bad, the acting's wooden, no story, too many special effects . . . you'd think that, after a while, they'd figure out that's what these things are." He was equally blunt about *The Phantom Menace*'s expository exchanges. "I'd be the first person to say I can't write dialogue," he said. As for the complaints that *The Phantom Menace* was full of too many cutesy side characters? "I'm sorry if they don't like it," he said. "They should go back and see *The Matrix*."

Lucas could afford to be dismissive of the anti–*Phantom Menace* rebellion, which had already earned an all-too-easy nickname: "the

fandom menace." For every moviegoer tearing the film down, Lucas knew, there were plenty more lining up outside theaters. By the early summer, *The Phantom Menace* was already on its way to earning more than $400 million—placing it right behind *Titanic*'s record-setting $600 million haul. It was as if *The Phantom Menace* existed in two different realities: the online world, where it was the most derided movie of the year, and the real world, in which it was the most desired.

Within weeks, the *Phantom* bashing would coalesce around a single character: Jar Jar Binks. Fans complained that he was a kiddie-pleasing drag, *wesa-* and *mesa*-ing his way through a grown-up movie, and speculated that he'd been crassly concocted by Lucas solely to sell more toys. When Knowles gave Jar Jar a thumbs-up in his *Phantom Menace* review—"Guess what? Mesa [*sic*] Luved Him!"—it elicited roars of disbelief on Ain't It Cool News, where readers were calling for Jar Jar to be either redubbed or, failing that, decapitated in a later installment. To some fans, King Geek's gushing take on everything *Phantom Menace*-related was simply unfathomable—further proof that he couldn't separate a big movie from the noise that surrounded it. But the larger problem for Knowles was that by the time *The Phantom Menace* arrived, there were so many movie news outlets that Ain't It Cool News seemed markedly less essential; it had spawned a movement it couldn't keep up with. Within a few years, Knowles's scoop-obsessed methodology would be adopted by mainstream magazines, making his site decidedly less cool than it had been in its late-nineties heyday.

As for Lucas, he initially seemed oblivious to the Gungan din surrounding Jar Jar. "Most of the people who go to the movie—at least 95 percent—love Jar Jar," he said. There *were* scattered supporters of Jar Jar—including some who had experienced *Star Wars* fanaticism firsthand. "I thought all of the negative talk was absolute bullshit," says Frank Oz, the longtime Yoda puppeteer, who reprised his role for *The Phantom Menace*. "I read the script beforehand, because Yoda's that wise—he has to know what's going on with everything. And I said to George, 'This'll be a breakout character.'" When he finally saw *The Phantom Menace*, Oz says, "I absolutely loved Jar Jar. I know people

laugh at me, but he's one of my favorite characters—he had an Abbott and Costello kind of feel."

At the time of *Phantom Menace*'s release, Jar Jar was promoted as a technological marvel, one that had been brought to life by ILM's innovative motion capture techniques and digital advances. Such hype overshadowed what was, at the time, an entirely new form of performance. Without Best, the character's excitable, loose-limbed persona would likely never have translated to the screen. "George and I watched Buster Keaton movies together and talked about him," Best says. "Some of the Jar Jar scenes are direct Buster Keaton scenes." Such moments required Best to exude the character's elastic physicality, despite being yoked with a still-in-the-works technology. "I did my job," he says. "I was believable enough for people to believe that this character existed. George said, 'Do a thing,' I did a thing, you know what I mean?"

But the fury toward Jar Jar soon reached the mainstream press, where critics and academics seized upon one of the other main sources of derision: that Jar Jar was a buffoonish, borderline racist caricature. The *Wall Street Journal* described Jar Jar as "a Rastafarian Stepin Fetchit on platform hoofs, crossed annoyingly with Butterfly McQueen." The author and academic Michael Eric Dyson, then a professor of African American studies at Columbia University, told CNN he had spotted "stereotypical elements" in Jar Jar: "the way he spoke, the way he walked. Even when he said 'meesa' . . . taken very quickly, it could be like 'massa, massa.'" By June, the complaints were escalating so quickly that Lucasfilm was prompted to release a statement, noting that "There is nothing in 'Star Wars' that is racially motivated. . . . To dissect this movie as if it has some direct reference to the world we know today is absurd."

The negative response to Jar Jar was so powerful that Lucas eventually reached out to Best, who'd gone from starring in a touring theater production to being on the cover of *Rolling Stone* in character. Best was out for a walk in New York City's Washington Square Park that summer when Lucas phoned him. Throughout the controversy, Best had largely remained quiet, even though he'd been taken aback by many of the complaints. "I was shocked with the racial implications," he says, "but

always knew they had little to no merit." During his talk with Lucas, the writer-director pointed out that *Star Wars* had always been singled out for criticism. "George said, 'This happened with the Ewoks. It happened with Chewbacca. It happened with Lando Calrissian,'" Best recalled. "He was used to this. He knew what was going to happen." Twenty years from now, Lucas said, things would be very different, and people would see this character in a new way. Best just needed to focus on the future.

But that was hard to do when the actor's present-day existence was being attacked on the internet. "It's really difficult to articulate the feeling," he says. "You feel like a success and a failure at the exact same time. I was staring at the end of my career before it started." At one point that year, while walking along a steel girder on the Brooklyn Bridge, Best looked down at the East River and contemplated suicide: "I felt tired of having to defend myself and defend my work," he said, adding: "I just wanted to play a part."

Best had been an early adopter of the web: in the nineties, he'd studied computer programming and even launched his own small-scale retail site. He was online and connected to the greater *Star Wars* fan community—and thus couldn't avoid the blowback. He watched as two of the forces that had shaped his creative life—the fandom of Star Wars and the freedom of the web—were turned against him. "I had death threats," he says. "I had people say, 'You destroyed my childhood.' That's difficult for a twenty-five-year-old to hear."

Lucas must not have liked what he heard about *The Phantom Menace*, either. Not long after the film's release that summer, the filmmaker who'd spent decades championing technology decided to give up on the internet for good. He even stopped using email. Who needs the internet when you can live in your very own galaxy far, far away?

SUMMER

First lady Hillary Rodham Clinton confirmed Friday that she will form an exploratory committee next month. . . . **THE UBIQUITOUS PALM-PILOT: TOOL OR TOY?** . . . Lance Armstrong completed the final leg of his long journey to Paris today, winning the Tour de France 33 months after cancer threatened his life. . . . *I did it all for the nookie.* . . . **JOHN KENNEDY'S PLANE VANISHES OFF CAPE COD** . . . at Pier 30 overlooking San Francisco Bay, Tony Hawk of San Diego became the first skateboarder ever to land the 900, his sport's equivalent of the four-minute mile. . . . *Maybe all I need is a shot in the arm.* . . . *I know your friends just fine. Charlotte is the brunette, Miranda is the redhead, and Samantha is trouble.* . . . Brandi Chastain whipped off her jersey, twirling it like a lariat over her head as 90,185 fans erupted in celebration. . . . **INQUIRY ESTIMATES SERB DRIVE KILLED 10,000 IN KOSOVO** . . . It seems that Woodstock '99 did bring back one custom from the classic days of rock: treating women like sexual toys, often against their will. . . . **HUMAN IMPRINT ON CLIMATE CHANGE GROWS CLEARER** . . . *Hey, Dirty! Baby, I got your money.*

8

"FIDELIO."

EYES WIDE SHUT
THE MUMMY

By 1999, there was only one long-running movie property bigger than *Star Wars*: Tom Cruise. The thirty-six-year-old had spent the decade playing cocksure, self-redeeming charmers, turning films such as *Jerry Maguire* and *Mission: Impossible* into global hits. He'd also enjoyed one of the most meticulously stage-managed careers in Hollywood, presenting himself to the world as likable, striving, and diligently flaw free—"the most perfect man on the planet," in the words of the crush-harboring talk show host Rosie O'Donnell.

Cruise's career had been on an enviable ascent since he'd boogied in his briefs in 1982's *Risky Business*. But his fame reached unimaginable heights in the nineties, a decade in which movie-stardom became a remarkably powerful pursuit. Film culture *was* popular culture, and actors such as Cruise, Eddie Murphy, Harrison Ford, and Jim Carrey were its A-list demigods, their stardom annoited or maintained by a cozy cattle-shoot of magazine profiles, talk show appearances, and "news"

bulletins on shows like *Extra* and *Entertainment Tonight*. As a result, movie stars were often afforded an unquestioning reverence, one normally reserved for third-world despots. In 1999's *Notting Hill*, Julia Roberts stars as Anna Scott, an internationally beloved film actor who falls for William Thacker, a humble bookstore owner played by Hugh Grant. Anna's stardom is so overpowering that, during a breakup scene, she has to remind William that she's not quite as larger-than-life as she seems. "The fame thing isn't really real, you know," Anna says. "Don't forget: I'm also just a girl, standing in front of a boy, asking him to love her."

Anna's notoriety nearly upends William's life—but it's a small price to pay for living out every filmgoer's fantasy. In the pre-Instagram, pre-Twitter era, "movie stars were rare and unattainable," says Jill Bernstein, then an editor at *Premiere* magazine. "And *Notting Hill* satisfied that feeling everybody had in the nineties: 'Oh my gosh, if only I could meet this superstar. What would *that* be like?'"

There was another upside to all of this adoration, of course: money. For 1996's *The Cable Guy*, Jim Carrey received an astonishing $20 million payday, immediately establishing a new benchmark for superstar salaries. That figure would eventually become the asking price for actors such as Mel Gibson, Bruce Willis, and Sylvester Stallone. Even fictitious movie stars were getting ridiculous sums: At one point in *Notting Hill*, the marquee-dominating celeb played by Roberts reveals the paycheck on her last movie: $15 million. "Julia made me rewrite it," says *Notting Hill* screenwriter Richard Curtis. "I'd written $13 million, and that was her only script note: 'I don't want to lowball it.' She thought, if her price was going to be out there, she wanted it to be the right one."

Thanks in no small part to the success of *Notting Hill*—one of Roberts's two romantic comedy hits that year, along with *Runaway Bride*—the actor's price was about to go up. Before 1999 was over, it was announced that she'd be getting $20 million for Steven Soderbergh's drama *Erin Brockovich*, making her the highest-paid female actor in the world. What executives got in exchange for those high-income stars was peace of mind—the confidence that audience members would show up and support their favorite actor on opening weekend.

And throughout the nineties, no actor quite instilled as much confidence as Cruise, who could seemingly turn any movie into a $100 million-plus hit. It was his *quan* that had convinced studios to finally commit to movies such as *Born on the Fourth of July* and *Interview with the Vampire*, both of which had been rotting in development for more than a decade before he came along. There was, of course, an unmistakable careerist streak to all of Cruise's moves: he wanted to be number one. But he also loved movies and the people who made them. As a kid, he'd frequently switched hometowns. Yet no matter where his family wound up, the local theater had become one of Cruise's few reliable hangouts. "In good times and poor times," he said, "movies were my lifesaver."

The film that loomed largest over Cruise's youth was *2001: A Space Odyssey*, Stanley Kubrick's grandly cryptic science fiction tale that begins with the dawn of man and ends with a hypercolored head trip through time and space. Cruise had first seen *2001* in 1968, perched on his father's shoulders in a packed-to-capacity theater in Ottawa, Canada. Afterward, he had found himself lying in the snow in his parents' yard, staring at the stars and contemplating the film he'd just seen. "I couldn't stop thinking about it," he said. "What is life? What is space? What is existence?" He was six years old.

Around the time Cruise was mulling over the ramifications of *2001*, Kubrick himself was musing over *Traumnovelle* or *Rhapsody: A Dream Novel*, a 1926 novella by the Viennese playwright Arthur Schnitzler about a married couple who confess their sexual fantasies to each other and the fallout that ensues. Kubrick had been thinking of adapting it into a movie as far back as 1968. But he had ultimately let it slip away, instead going to work on such films as *Barry Lyndon*, *The Shining*, and the Vietnam-War-is-hell epic *Full Metal Jacket*. By the time of *Jacket's* release in 1987, Kubrick had been living outside the United States for almost two decades and had largely stopped speaking to the press. As a result, word had spread that he was living the life of an eccentric, obsessive hermit, self-exiled in the prison of perfectionism, constantly re-editing his now decades-old movies. There were more random rumors,

as well, such as the one claiming that he was afraid to be driven more than thirty miles an hour. "Part of my problem is that I cannot dispel the myths that have somehow accumulated over the years," Kubrick said in one of his final interviews. For clarity's sake, he added that he sometimes hit eighty miles an hour while cruising in his Porsche.

When it came to making films, however, Kubrick kept a slow speed. For decades, he'd toy with revisiting Schnitzler's novella. But he didn't fully make it his focus until 1994, when he summoned screenwriter Frederic Raphael—whose credits included the time-futzing 1967 marital comedy *Two for the Road*—to his home in England. The two would soon get to work adapting *Traumnovelle*, relocating the story in modern-day New York City. Kubrick would later revise the script during filming, sometimes faxing pages to his cast at 4:00 a.m. But the version of *Eyes Wide Shut* that wound up onscreen followed Bill Harford, a doctor who lives with his wife—a former art dealer named Alice—and their young daughter in Manhattan. After a night on the town that finds Bill and Alice flirting with fellow partygoers, the couple get stoned and begin to bicker, leading to a series of strange and potentially dangerous sexual run-ins, including a few ornate orgies. It wasn't the kind of movie you'd want to watch with a six-year-old sitting on your shoulders.

One of the first to read the *Eyes* script was Warner Bros. co-CEO Terry Semel, who immediately knew which actor could justify *Eyes'* $65 million budget: "I want Tom Cruise," he told the director. By 1995, Cruise was coming off a run of $100 million–grossing recent hits that included *The Firm*, *A Few Good Men*, and *Vampire*. Kubrick, though, had soured on name performers after making *The Shining* with Jack Nicholson. Movie stars, he told Semel, "have too many opinions."

Semel called Cruise and asked if he'd want to meet with Kubrick. "Tom said something like, 'I'll be there in the morning,'" Semel remembered. Soon enough, in late 1995, Cruise was in a helicopter, heading toward Kubrick's estate, where the director had readied a landing pad. "He was just waiting, alone in a garden," Cruise said. "He walked me around the grounds, and I just remember thinking, 'This guy is kind

of a magical, wonderful guy.'" They spent hours in Kubrick's kitchen, discussing the ninety-five-page *Eyes* script, as well as the New York Yankees—one of the many obsessions the two men shared, along with cameras and airplanes.

Cruise also lobbied Kubrick to consider casting his wife, Nicole Kidman, whom he'd met on the set of the 1990 race car drama *Days of Thunder*. Kubrick likely didn't need much convincing. Then in her late twenties, the Australian-raised Kidman had first established herself as a raw power in the 1989 thriller *Dead Calm*, and by the midnineties, she was on her way to winning a Golden Globe for the wicked murder comedy *To Die For*. Like her husband, Kidman had grown up with an eye on Kubrick's work: As a teenager, she had skipped school to see Kubrick's brutalist landmark *A Clockwork Orange* and had watched *The Shining* on a date (though she had spent part of the movie making out in the back row). *Eyes Wide Shut* presented the chance to be part of not just a movie, but a high-end *event*, one that would reunite audiences with one of the twentieth century's most revered disappearing acts. She didn't need to read the script in order to be persuaded. "I didn't care what the story was," Kidman said. "I wanted to work with Stanley."

Kubrick seemed equally eager to get rolling. "He said, 'Look, I need to start shooting this right away in summer, because I want to finish the movie by Christmas. Okay?'" remembered Cruise. The actor wasn't so sure. He'd studied Kubrick's filmmaking style. Making *Eyes Wide Shut*, he figured, would take *at least* a year.

Kidman and Cruise, along with their two young children, relocated to England in late 1996, living in a small house not far from London's Pinewood Studios, where filming would begin on *Eyes Wide Shut* that November. The set was heavily secured yet sparsely populated. "Kubrick had a really small crew," said *Magnolia* writer-director Paul Thomas Anderson, one of the few visitors to the set. (Cruise, one of his *Magnolia* stars, had ushered him past security.) "I asked him, 'Do you always work

with so few people?' He gave me a look and said, 'Why? How many people do *you* need?' I felt like such a Hollywood asshole."

Kubrick's team would watch as the shaggy-bearded director—often dressed in a dark jacket over a button-down shirt, his eyebrows arched like bat wings above his glasses—conferred with Cruise and Kidman, discussing a scene he might have just rewritten the night before. Kubrick would work late into the evening, with filming occasionally stretching past midnight. Sometimes he got what he needed after just two takes; other times he might require eighty. "It was just this strange, strange existence," said Kidman, who spent hours hanging out in Kubrick's messy office, playfully sparring with the director. "We just gave ourselves over to it." At one point, she and Cruise spent weeks on a scene in which their characters argue in the couple's bedroom, filmed on a set modeled after an apartment Kubrick had once owned in New York City. Kidman redecorated the space to resemble the actors' real-life bedroom, leaving her makeup in the bathroom, tossing her clothes to the ground, and placing spare change by the bedside—just like Cruise did in their actual home. "By the end, we felt as if we lived on that set," she said. "We even slept in the bed."

The only person more deeply immersed in *Eyes Wide Shut* was Kubrick himself. "It took a while to find the path to working with the man and not the legend," says filmmaker and *Eyes Wide Shut* actor Todd Field. In the years since Kubrick had been away, a younger generation had become enthralled with his decades-long filmography, one that was filled with what Cruise once called "perfect visions": Savage comedies like *Dr. Strangelove or: How I Learned to Stop Worrying and Love the Bomb*; gorgeously infectious dramas like *Paths of Glory* and *Barry Lyndon*; and movies that fit somewhere in between, like *Lolita*. His followers tended to obsess over his movies frame by frame, and many of them had spent the decade assuming he might never return. Field had been driving one day when he got an out-of-nowhere call from an agent telling him that Kubrick was trying to track him down. "I was so startled," says Field, "I ran into another car."

Field was in his early thirties when he was cast as *Eyes*' Nick

Nightingale, a jazz pianist and old friend of Bill. The actor, who'd starred in both indies (*Walking and Talking*) and big-studio blockbusters (*Twister*), was hired without an audition, and on his first day of work, he was escorted to Luton Hoo, an English estate that would serve as one of *Eyes*' filming locations. Field nervously wandered the building for hours, taking photographs of the estate, before finding a safe distance from which to watch Kubrick run some lighting tests. "After a few minutes," Field says, "he turned, looked straight at me with that gaze of his, smiled, and said, 'You're here. Come inside and see what we're doing.'" When Field introduced himself, Kubrick laughed and replied, "I know who the fuck you are. I hired you."

According to Field, the director put coworkers at ease by screening dailies in his trailer and asking for feedback—and by showing off his sense of humor. "Stanley had a very dry one," he says, "and he'd tease and provoke you in a way that actually demanded you get your back up a little and show some spine." At one point during filming, Kubrick did an impression of Steve Martin's dim-witted hero from *The Jerk* (decades earlier, he'd actually met with Martin to see if he'd be interested in starring in *Eyes*).

Field had been contracted to work on *Eyes Wide Shut* for just six weeks, but he'd wind up shooting on and off for seven months, even though Nightingale appears on screen in just a few scenes. He's one of several cryptic characters that Bill—unraveling with jealousy after Alice's confession—encounters during a late-night stroll through Greenwich Village. Consumed by visions of Alice having sex with another man, Bill walks head down through a fabricated New York City that Kubrick had reconstructed at Pinewood Studios. He'd labored over nearly every detail of this fake Gotham, reinventing the city in which he had been born and raised yet hadn't visited in years. According to Warner Bros.' marketing veteran Don Buckley—who'd first worked with the director on *The Shining*—the studio kept a cargo container on Manhattan's West Side, which it filled with items Kubrick had requested, such as a New York City taxicab. At one point, the director asked if a few local newspapers would supply him with "honor boxes," the vending

machines that populated New York's streets. When one of the New York tabloids refused the request, a Warner Bros. publicity staffer used a bolt cutter to remove an honor box. "The guy worshipped Kubrick—we *all* did," says Buckley. "So Stanley got his boxes."

Kubrick also got actual footage of Manhattan city streets, having dispatched a team of camera operators to the city to shoot sidewalks and storefronts. When Cruise's character is seen pacing around the Village in *Eyes Wide Shut*, the footage comes from a variety of sources: Sometimes, the actor is walking through the Pinewood set; other times he's on a London street that doubled for New York; and for a few quick scenes, the actor is on a treadmill, keeping pace as the background footage of New York City is projected onto a screen behind him. When edited together, the various shots would add up to something alien and unsettling. Even to viewers who didn't live in New York City, something about the Manhattan streets of *Eyes Wide Shut* seemed slightly off, as though Kubrick—for all of his love of verisimilitude—had been trying to conjure up memories of how the city had looked decades earlier. It was like being plunged into a dream: all the details were there, but not quite in the right places.

Bill's walk eventually leads him to a jazz club where, over drinks, Nightingale tells him about a mysterious, semiregular job he's landed: he plays piano blindfolded, while everyone else wears costumes and masks, including several women. Bill learns the password for entry—*fidelio*—and decides to check out the party for himself. After procuring a black robe and a gold-hued Venetian mask, he winds up inside a Long Island estate, where nude women participate in strange rituals and masked figures screw on couches and tables. Finally he's taken to a high-ceilinged chamber, where his identity is revealed in front of dozens of grotesquely masked figures. All the while, an icy piano note strikes in the background: *plink, plink, plink, plink* . . . Bill finds his way home at dawn, visibly shaken and—much like the audience—not entirely sure what he's just seen. "When you look at *Eyes Wide Shut*," Cruise said, "there's the sense of 'Is this a dream, or is this a nightmare?'"

As the carefully guarded filming of *Eyes* carried on over months and

months—with various holiday breaks and intermissions in between—it seemed to outsiders that the film's production had become some sort of nightmare in itself. KUBRICK'S "EYES WIDE SHUT" STILL OPEN, noted the *New York Times* in April 1998. The story pointed out that cast members Jennifer Jason Leigh and Harvey Keitel—both of whom had brief supporting roles in *Eyes*—had left the movie midshoot.

"Sometimes it was very frustrating," said Kidman, "because you were thinking, 'Is this ever going to end?'" The planet's best-known star couple had been out of commission for nearly two years. Remembered Cruise, "There were a lot of people in my life that were saying 'When are you coming home?'"

Cruise's indefinite *Eyes Wide Shut* stint not only upended the actor's personal relationships; it threw entire segments of the film industry out of whack. Thanks to Cruise's commitment to Kubrick, Paramount was forced to delay work on its new multimillion-dollar *Mission: Impossible* sequel, originally set to open in the summer of 1998 (it would finally be released two years later). Other big-budget films that Cruise had been developing were paused. About six months into the production of *Eyes Wide Shut*, Cruise gently asked Kubrick if there was an end date in sight. "People were waiting, and writers were waiting," Cruise said. Hollywood would just have to be patient; there was, after all, only one Tom Cruise.

The ripple effects of Cruise's disappearance proved how powerful top-tier movie stars had become. A performer like Cruise could impact a studio's bottom line with a single *yes* or *no* decision. And when executives *did* land a major star for a movie, the film's budget all of a sudden exploded. In addition to those ten-figure salaries, most stars got pages' worth of add-on perks: One magazine anonymously cited the "Hollywood action hero" whose $20 million contract demanded his trailer be outfitted with a specific make and model of humidor (to this day, the star's identity remains a Schwarzzenigma).

These were troubling developments for executives, who found themselves investing millions of dollars in projects whose success or failure often rested on a single name. And when one of these pricey star-driven efforts failed, the results were near-catastrophic: In 1999, Warner

Bros. was rumored to have spent close to $200 million on Will Smith's sci-fi comedy *Wild Wild West*, a movie that managed to keep even the tumbleweeds away (it made a relatively meager $113 million).

There was another reason why studio heads were seeing Kubrick's wisdom and losing some of their love of movie stars in 1999: With so much clout, they were more than just highly opinionated—they could be huge pains in the ass. Kevin Costner spent much of the year in a public spat with Universal, the studio behind his baseball drama *For Love of the Game*, after execs demanded several moments be cut, including the actor's full-frontal nude scene. "They probably don't want to make movies with me, and I don't want to make movies with them," Costner told *Newsweek* as part of an antipublicity tour that helped doom his own movie. Jim Carrey, meanwhile, would film nearly all of *Man on the Moon* in-character as the cuckoo comedian Andy Kaufman, bullying those who dared get in his path. Executives would eventually bury *Man on the Moon*'s behind-the-scenes footage, Carrey said, "so that people wouldn't think I was an asshole."

It was the kind of excessive star-tripping lampooned in *Bowfinger*, a showbiz comedy written by Steve Martin and directed by Frank Oz. It starred $20-million-a-movie performer Eddie Murphy as Kit Ramsey, an ego-swaddled nineties box-office champ who's become a victim of his own paranoia and hubris, and whose personal foibles nearly sink his career. The studios had no choice to capitulate to the real-life Kit Ramseys of the world—the movie stars whose names could bring people to theaters on opening night. They were determined to find a new generation of actors, ones who were likable and recognizable, but who weren't more powerful than the movies themselves—at least, not yet.

Which partly explains why, in the summer of 1998, Brendan Fraser found himself with a price on his head.

The twenty-nine-year-old actor had traveled to the desert of Morocco to face *The Mummy*. Set in the 1920s, it found Fraser as a dusty soldier named Rick O'Connell who teams up with a librarian and her brother to

find an Egyptian "city of the dead"—and winds up battling an ancient evil. Many of the film's scenes took place in the Sahara Desert, meaning the actor was in perilously close proximity to Algeria, the North African country entrenched in a bloody civil war. "I was being driven home one night while the sun was going down," says Fraser. "And my driver pointed to a track between two mountains and said, 'If you go over that, you will never be heard from again.' " Later, while having beers at a hotel bar with *Mummy* producer Jim Jacks, Fraser mentioned the driver's advice. "Oh, yeah," Jacks told him. "If you go over there, you'll end up getting a grenade thrown at your head. But don't worry—I took out a million-dollar life insurance policy on you.'"

Just a few years before, Fraser wouldn't have commanded such a high premium. After first gaining attention in 1992's hit drama *School Ties*, he'd forged the kind of hard-to-predict path that was only possible in the nineties, dividing his time between goofball comedies like *Encino Man* and stark dramas like *Gods and Monsters*—making him likely the only actor to work alongside both Pauly Shore and Ian McKellen. Fraser slowly built up his movie-star portfolio with a mix of low-cost ensemble indies and polished studio films, an approach shared by other emerging actors of his generation, including Ben Affleck, Matt Damon, and Matthew McConaughey. By decade's end, it was impossible to define a "Brendan Fraser movie" except to say that it most certainly had Brendan Fraser in it. "There was a notion in the nineties that you do one movie for them, one for you," Fraser says. "One for love, one for money. You find a way to combine art and commerce."

In the summer of 1997, Fraser has starred in *George of the Jungle,* a live-action remake of the sixties cartoon that made $100 million in the United States—a surprise to pretty much everyone involved. All of a sudden, Fraser went from "likable dude who does a little of everything" to something far more rare: An actor whose presence could (theoretically) guarantee a huge opening weekend. Yet Fraser wasn't so big that he could demand the $20 million paychecks of someone like Cruise, making him a safe big-studio investment.

And Universal was putting a *lot* into *The Mummy*: About $80 million,

a massive figure for a film that was reviving a decades-old franchise, one that few young moviegoers took seriously—if they'd even seen it at all. The original series had launched in the early thirties, and wound down in the fifties with an Abbott and Costello adventure. The latest *Mummy* would be arriving right after a year in which several expensive revivals of vintage movies and TV shows—including *Godzilla, Psycho, Lost in Space, The Avengers,* and *Mighty Joe Young*—had underperformed. Reboots and remakes were seen by critics and audiences as lowbrow acts of desperation. The perception, says Fraser, was that "you weren't doing new work. That instead of giving people something new, you were reverting back to the library and opening up the cabinet of monsters."

Universal's newly hired president, Stacey Snider, though, believed there was a future in the past, sending execs home with packets detailing the studio's nearly 5,000 scripts and old films—part of a years-long project to mine the company's vaults. The company, which had lost millions on recent big-name films like Brad Pitt's *Meet Joe Black,* was trying to reverse its fortunes. "The studio was in trouble," Fraser says. "They needed a hit."

Universal developed multiple versions of a new *Mummy* before finally okaying a script by writer-director Stephen Sommers that was filled with CGI critters and epic battle scenes. For Fraser, *The Mummy* "was a big production," he says. "We were training with weapons and camels—and we were training our gastrointestinal tracts at the same time, whether we wanted to or not." He also nearly wound up visiting the city of the dead himself. On the third day of production, Fraser was filming a scene in which Rick is hanged in front of hundreds of onlookers. When the noose fails to kill him, he's left twisting and choking in the wind. Once a stunt performer had safely executed the fall, Fraser was outfitted with a noose for his eye-popping, face-contorting close-up. A technician was controlling the rope around Fraser's neck, and after a so-so first take, it was decided he needed to pull the line harder.

A few minutes later, says Fraser, "I'm standing on the balls of my feet with the rope pretty tight around my neck, thinking, 'I'll just sell the hell out of this.' I'm making my eyes red, bugging out." Fraser was having a

hard time getting air through his mouth, so he took three deep breaths through his nose and held them. He began to choke, his plight not registering with the cast and crew, who simply figured it was part of his performance. "The only way to describe what happened next," Fraser says, "was that it was as though you turned a dial—*eummmmmmmm*—and turned off the Death Star." Fraser awoke to find himself on the ground, with rocks and dirt in his mouth, and hundreds of extras staring at him in wide-eyed silence.

After filming on the scene was completed, Fraser met with his physician, who told him he was lucky to have fallen the way he did. "There's a chance you died," Fraser's doctor said. "Your heart can stop, and hitting the ground can kick-start things. You had a close one there."

Fraser's accident was one of several on-set obstacles—which included sandstorms, scorpions and snakes, and a hemorrhoids-stricken camel—that gave *The Mummy*'s production a sense of frenetic, mostly happy chaos. "We had no idea what film we were making, in its essence," says Fraser. "It could have been a straight-ahead action picture, with all the running and gunning we did. It could have been a 'knock two skulls together and hear coconuts clapping' comedy. It could have been edgy and dark and a little freaky." Instead, the finished *Mummy* was a sort of high-adventure hybrid, a mix of pulpy scares, cartoony one-liners, and some dust-covered romance between Fraser's character and the gutsy librarian Evelyn, played by future Oscar winner Rachel Weisz. Still, Fraser and the filmmakers worried that *The Mummy* might be disintegrated by the *other* CGI-crazy spectacle opening that month: *The Phantom Menace*. What match was the guy from *George of the Jungle* against young Darth Vader himself? "Everyone was terrified," says Fraser. "People were camping out for *Star Wars*. And I would've been in line with them."

When *The Mummy* opened on May 7, however, it earned $43 million in its first weekend—making for one of the highest openings ever at the time. Its success, says Fraser, "took the town by surprise." And Universal wasted little time in reanimating its success: Over the next decade, Fraser would star in two sequels, making him the face of a

billion-dollar-earning trilogy. And that number doesn't include merchandising. Shortly before the premiere of *The Mummy*, Fraser received a strange and slightly humbling reminder of his place in the movie-star ozone. A box full of *Mummy* gear had arrived at his home, including his own Rick O'Connell action figure, complete with guns, a stick of dynamite, and sound effects. "He had little speaker-holes in the butt," says Fraser. "And if you raised its arm, it would say a catchphrase—'I just knew it was going to be a great day!'—and make an explosive *booosh* sound. Whoever they got to record the voice sounded like Harvey Fierstein. So Harvey says, 'Oh, I just *knew* it was going to be a great day,' and then there's a dynamite fart out of his ass. I laughed out loud. I couldn't believe it: 'This is me. This is happening. *This happened.*'"

Tom Cruise's work on *Eyes Wide Shut* had gone until day four hundred of filming, in June 1998. It was "a day that I had both looked forward to, and dreaded," said Cruise. When they finally wrapped, it was late at night, and on the way out, Cruise gave Kubrick a hug and a kiss, and said, "I love you, Stanley." The director turned to Cruise and replied, "You know. I love you too."

Kubrick would keep going for nearly another year, editing the movie in relative peace away from the studio. He'd spent decades preparing *Eyes Wide Shut*. He wasn't going to rush. "The most important thing to Stanley," Cruise said, "was time." Finally, in March 1999, Cruise and Kidman got a look at the movie that had swallowed the last few years of their lives. The location was a private screening room in Warner Bros.' Manhattan headquarters. Kubrick wouldn't be present for the film's unveiling, but he did make his presence known by issuing a long-distance edict: as the nearly three-hour-long film unspooled, Warner Bros.' in-house projectionist would have to look away from the screen. Kubrick didn't want any stray eyes in the house.

By that point, no one quite knew what to expect of *Eyes Wide Shut*—including the people who'd paid for it. Kubrick and his cast members were so insulated from Warner Bros. that few executives even knew

what the film was about. When Semel had first read the script, he'd stayed in a Kubrick-appointed hotel in London and waited for it to be delivered to his room. For years, movie fans and journalists had been forced to make do with a brief one-sentence teaser description, stating that *Eyes* was "a story of sexual jealousy and obsession."

That single line had prompted the internet to go wild with speculation about the plot of *Eyes Wide Shut*—some of it only slightly less fantastical than the talk about *The Phantom Menace*. There were claims that Cruise and Kidman, who'd been married since 1990, were playing husband-and-wife psychiatrists sleeping with their patients. Others believed that Kidman's character was a heroin addict or that Cruise would appear in a dress. But as the filming of *Eyes Wide Shut* had continued unabated, its release dates coming and going, the biggest mystery surrounding the movie became whether it would ever open at all.

Now, almost two and a half years after their odyssey had begun, Cruise and Kidman were the first people outside Kubrick's inner circle to see the film. The screening ended shortly after midnight, after which the actors watched it again. "The first time, we were in shock," Kidman said. "The second time, I thought, 'Wow! It's going to be controversial.'"

On that late night in New York City, after finally seeing the film, Cruise would eagerly call the director to share his and Kidman's feedback (stricken with laryngitis, she'd jotted down her reactions on paper). "We were so excited and proud," said Cruise, who had to leave to begin working on a *Mission: Impossible* sequel in Australia. The day after arriving, he picked up the phone, expecting to hear Kubrick, who had a penchant for late-night calls. Instead it was one of Kubrick's associates, telling Cruise that the director was dead. He'd suffered a heart attack less than a week after delivering his movie—and with just four months to go until *Eyes Wide Shut*'s release. "Trying to define it, without Stanley here, is . . ." Kidman later said, her voice trailing off. "It's tainted the experience a bit for Tom and me."

Though Kubrick didn't live to discuss the film he'd been thinking about, off and on, for more than four decades, he did make a final semi-public statement before its release. It explained, in part, why it had taken

so long to mount his final vision. In 1998, while still deep in production on *Eyes*, he had recorded a videotaped acceptance speech for the Directors Guild of America, which had given him a career achievement award. Wearing a dark blazer and blue button-up, his half-lidded gaze pointed straight at the camera, Kubrick described directing as being akin to "trying to write *War and Peace* in a bumper car in an amusement park." He then invoked the myth of Icarus, whose artificially constructed wings melted when he flew too close to the sun. "I've never been certain whether the moral of the Icarus story should only be—as is generally accepted—'Don't try to fly too high,'" he said, "or whether it might also be thought of as 'Forget the wax and feathers, and do a better job on the wings.'"

Kubrick's own mythos had only become larger—and all the more inscrutable—after his death. And with the director gone, the task of selling *Eyes Wide Shut* would fall on the film's star couple.

"People think it's going to be some huge sex romp," Nicole Kidman said shortly before the July 1999 opening of *Eyes Wide Shut*. "They're wrong."

It was hard to blame moviegoers for thinking they were going to get something at least *slightly* pervy. The film's trailer featured Cruise and Kidman bare-skinned in front of a mirror, devouring each other as the skittering riffs of Chris Isaak's blues shuffle "Baby Did a Bad Bad Thing" played underneath. Combined with the years of rumors about *Eyes*' supposedly sex-filled plot, there was a growing belief that Hollywood's most genetically accomplished celebrity couple was about to go at it onscreen. "The whole world was so mesmerized by the idea that Tom Cruise and Nicole Kidman were going to be having actual sex on film," said Alan Cumming, who had a brief role in *Eyes* as a bellhop who attempts to flirt with Cruise's character. "They had expectations of it being about something else—which I think Stanley engendered by that trailer."

There were indeed plenty of sexually robust moments in *Eyes*: Alice stands nude in the couple's bathroom and later appears in Bill's jealous fantasy having sex with a stranger. The orgy sequence, meanwhile, was adorned with humps and thrusts. But the excess sex in Kubrick's film posed a challenge for Warner Bros. When the Motion Picture Association of America's ratings board threatened to slap the film with a commercially lethal NC-17 rating, the studio responded by digitally inserting black-robed figures that obscured some of the action. The faux figures appear only for about a minute, but they'd prove to be the year's second-most controversial CGI creation, right after Jar Jar Binks. Film critic groups condemned the MPAA, and at the conclusion of an *Eyes* screening on the Warner Bros. lot in Burbank, Roger Ebert stood up from his seat, faced the crowd, and railed against the studio's decision with "religiosity," remembers Todd Field. "His sense of possessiveness struck me as odd. In hindsight, I suppose I understand it. Stanley belonged to everyone."

By the time *Eyes Wide Shut* was close to its July 16 release date, the years of curiosity and controversy had turned it into a genuine summer event. When the film's poster appeared in theaters, the name of its three main draws were listed in attention-grabbing bold lettering: CRUISE, KIDMAN, KUBRICK. The film's married-couple stars appeared on the cover of *Time* in a shirtless embrace; inside the magazine, in a photo spread by famed glamour grabber Herb Ritts, Cruise playfully licked his wife's chin. At a press screening in New York City, lines formed around the block. "Once people were inside the theater, they were fighting over seats to get as close as possible to the screen," notes Warner Bros. publicist Willa Clinton Joynes. "It was chaos."

Although critics and Kubrick lovers were excited about *Eyes Wide Shut*, there was no easy way to prepare audiences for a movie that, like so many of Kubrick's films, obscures as much as it reveals. In its final moments, after Bill and Alice reconcile, the couple take their young daughter to a toy store, where they attempt to process the events of the last few days:

ALICE: I do love you. And you know, there is something very important that we need to do, as soon as possible.

BILL: What's that?

ALICE: Fuck.

After nearly three hours of sex-obsessed arguing and wandering, those who'd eagerly sought out *Eyes Wide Shut* in theaters had a similar thought: *Fuuuuuck.* What exactly was going on in *Eyes Wide Shut*? Were Dr. Bill's nighttime adventures real or part of a dream? Was New York City *supposed* to look so fake? Were we really supposed to believe that a wife's adulterous fantasy would make a married man so frustrated that he'd seek out an orgy? Also: Who gets worked up into that much of a rage while high on *pot*?

Cruise's response to anyone seeking answers proved how much he'd studied Kubrick: You have to decide for yourself. "It's a movie you can't just see once," he said. "To try to review it after one sitting? My hat is off to you. I do not know how an individual can do that." Somehow the critics found a way. The initial responses included a few unadulterated raves but largely expressed polite disappointment. There was a sense that Kubrick's film had come straight from the sixties, its lead character so conservative, its sex scenes so comically baroque, that it bore little relation to late-nineties realities. "I was happy that he had chosen to go after something very difficult: the idea of what should and shouldn't remain unspoken in a marriage," says Steven Soderbergh. "He was trying to get at something that was emotionally ambitious in a way that most of his films aren't." Still, he says, "the things that I had issues with were the result of him not being out in the world very much. Tom Cruise is out and about, and it doesn't feel like he's in any world that I've ever experienced." Notes Christopher Nolan, "I was so excited to see it—and I was very, very disappointed."

The film's commercial verdict was rendered swiftly. *Eyes* debuted on July 16, 1999—the same night a small plane carrying John F. Kennedy, Jr., and his new wife, Carolyn, crashed into the Atlantic Ocean. The news likely didn't have a direct impact on *Eyes*, but it darkened the

national mood, making Cruise and Kidman's R-rated love-on-the-rocks fantasy an even tougher sell. The movie opened at number one at the box office with $21 million that weekend but departed from the top ten within weeks, becoming Cruise's lowest-grossing leading-man movie of the decade. *Eyes* did have its defenders: Martin Scorsese later named it one of the best of the decade; the film's last line, Scorsese said, was "a beauty." And even some of those who'd initially been let down by *Eyes Wide Shut* would open up to it in later years. "Watching it with fresh eyes, it plays very differently to a middle-age man than it did to a young man," says Nolan. "There's a very real sense in which it is the *2001* of relationship movies."

Decades later, though, some of Kubrick's fans would still be debating whether audiences really saw the *Eyes Wide Shut* he wanted to make. The director was famously never at peace with his movies even after they were released, having gone back to reedit both *The Shining* and *2001: A Space Odyssey* in the days *after* their initial premieres. If Kubrick hadn't died that winter, what version of *Eyes Wide Shut* would audiences have been given? "What we have is Stanley's first cut," says Field. "If post-production on past films is taken into even modest consideration, it's clear *Eyes Wide Shut* would have been a different film."

Then again, moviegoers were lucky to have gotten their eyes on Kubrick's final film in *any* form. If the years-long work on the movie hadn't been forced to such an extreme end, Kidman said, "Stanley would have been tinkering with it for the next twenty years."

9

"I SEE DEAD PEOPLE."

THE SIXTH SENSE
THE BLAIR WITCH PROJECT

There were times when M. Night Shyamalan would look at the movie posters on his walls—*Jaws, Alien, Die Hard*—and wonder what it would take for his own films to hang alongside them. *How do you make that happen?* he'd think. *How can you make movies that get under everybody's skin?*

Shyamalan had been making movies since he was a kid in Pennsylvania, where he had directed backyard-set Spielberg homages. He was so set on a film career that in the late eighties, before heading off to college at New York University, he posed for a full-page mock *Time* magazine cover for his high school yearbook. "NYU Grad Takes Hollywood by Storm!" read the headline, alongside a picture of Shyamalan in a tux. "Even in film school," he later said, "everybody else was into Godard, and I was the one with the *Raiders of the Lost Ark* hat on."

After school, he returned to the tony suburbs of Philadelphia, far away from the industry he wanted to conquer. Despite the distance,

Shyamalan soon had two full features to his credit. At twenty-one, he'd written, directed, produced, and starred in *Praying with Anger*, a self-discovery drama about a young Indian American who visits his parents' homeland. It made the rounds at film festivals and earned a few encouraging reviews but never received a large release.

His next attempt, *Wide Awake*, was written as a gentle family dramedy, based on Shyamalan's Catholic school upbringing. But making the movie was a devastating experience. Shyamalan directed the film for Miramax, but when Harvey Weinstein wanted to recut it, Shyamalan and the film's star, Rosie O'Donnell, battled back, resulting in heated back-and-forths, including one argument in which Weinstein reportedly called O'Donnell a "cunt." The result: *Wide Awake* loitered on the company's shelves for years, before finally opening on just a few screens. Seeing his film get squashed would strengthen Shyamalan's resolve not to get pushed around. But it also forced the writer-director, then in his late twenties, to recalibrate his creative ambitions. He didn't just want to make movies; he wanted to make "cultural phenomenons."

While *Wide Awake* was in limbo, Shyamalan had begun writing a new movie, one inspired by an eerie scene that had been playing in his head: a vision of a little kid at a wake, talking to himself. He came up with a suitably mysterious title—*The Sixth Sense*—and an equally creepy script about a middle-aged man and a young boy whose relationship leads to a shocking revelation. The little kid, it turns out, has the ability to see . . . serial-killer victims. "It was a rip-off of *The Silence of the Lambs*," Shyamalan says of his first *Sixth Sense* attempt. He stuck with the concept for a while, producing multiple drafts focusing on a jaded crime scene photographer and his spookily powered son. But the story wasn't working. He was forcing an idea rather than following one. "If you start listening to the movie rather than your own agenda, good things happen," Shyamalan says. "It starts telling you 'I don't want to be this. I want to be *that*.' "

Shyamalan kept revising, knocking out even more drafts, occasionally pausing to watch such films as the chilly upper-class drama *Ordinary People* or the unrelenting horror show *Repulsion*. By the time he'd

finished, his serial-killer plot was gone. The new *Sixth Sense* focused on Malcolm Crowe, a child psychologist whose marriage becomes strained after he's shot by an intruder. As he drifts away from his wife, Malcolm begins spending his days with a new patient, a quiet nine-year-old named Cole Sear who claims to have an uncanny ability: "I see dead people." The script's final pages included another walloping reveal: Malcolm, it turned out, actually died from his bullet wounds—and Cole had been tasked with guiding him out of the world of the living. *The Sixth Sense* was part marital drama, part little-boy-lost saga, and part ghost story—one with a deep certitude about the comingling between the living and the dead. "I come from an Indian immigrant culture," says Shyamalan. "Ideas about the supernatural are very commonplace. It's not a big leap of faith to believe in that."

When he was first starting his career, he'd flown to Los Angeles, hoping to convince a group of executives to let him direct a script he'd written. Shyamalan showed up for his meeting in a pin-striped suit his mother had bought for him, "looking like some high school kid trying to get a job," he remembered. When it came time to sell *The Sixth Sense*, he took steps to ensure that he'd be taken seriously. He bought a new pair of shoes, checked into Los Angeles' Four Seasons Hotel, and told his agents that the bidding for his new script would start at $1 million—and that he would be the director, no matter what. "Night was very confident," notes *Rushmore* producer Barry Mendel, who also helped oversee *The Sixth Sense*. "And he was very focused."

So were studio execs, who eagerly competed to buy Shyamalan's script, topping one another's offers until Disney agreed to give Shyamalan everything he wanted. The winning bid: $3 million. He also bargained to get out of his still existing deal with the Disney-owned Miramax by agreeing to rewrite parts of the studio's *She's All That*. "When the money came in for *Sixth Sense*," he says, "I was like, 'Pay off the house. Save everything. Who knows if this will ever happen again?' I'd already felt my career was over twice." (Shyamalan's fortunes got another boost when his script for *Stuart Little* helped the talking-mouse film become one of 1999's biggest family hits—though he wasn't too

thrilled with how his "period piece" *Stuart* screenplay had turned out: "I left to do *The Sixth Sense*," Shyamalan lamented, "and they added the fart jokes.")

At one point while writing his *Sixth Sense* script, Shyamalan had written down the name of the actor he'd hoped might some day play Malcolm Crowe. It was a star whose face had long stared back from one of the posters Shyamalan kept on his walls. And he knew a thing or two about coming back from the dead.

In early 1997, Bruce Willis found himself in the middle of a financially brutal free-for-all. That winter, the forty-one-year-old actor had walked away from *Broadway Brawler*, a hockey comedy that was already twenty days into shooting. Willis, serving as both the star and a producer, was so unhappy with the production that he'd fired the director—the Oscar-winning *Shampoo* star Lee Grant—and essentially doomed the movie for good. Now the actor was on the hook for the film's production costs, which by some reports had already passed $10 million. A lawsuit seemed inevitable.

Moving quickly, Willis's agent set up an arrangement with Disney: the studio would take care of the money spent so far on *Broadway Brawler*, and in exchange the actor would make three movies for Disney. Willis's first film under the arrangement would be 1998's meteor attack adventure *Armageddon*. The next would be the decidedly quieter *Sixth Sense*. When Willis turned to the final pages of Shyamalan's script and realized his character's fate, "I was blown away by the fact that my character was dead," he said. "I didn't see it coming."

For Shyamalan, the New Jersey–raised Willis—who'd spent months in Philadelphia filming *12 Monkeys*—was more than just a semilocal hero. The actor had starred in two of the writer-director's favorite films: 1994's *Pulp Fiction*, in which he had played a principled palooka, and the 1988 *yippy-ki-yay*-ing high-rise adventure *Die Hard*, one of the many movies Shyamalan had enshrined on his wall. "When I was growing up, he was *it*," says Shyamalan. "When *Die Hard* opened, we all went

in my friend's Jeep to see it." Willis had never played a character quite as restrained, or as remorseful, as Malcolm Crowe. *The Sixth Sense*, Willis realized, "was an opportunity to not have to run down the street with a gun in my hand."

The search to find the right actor to play Cole, Malcolm's young patient, would take months. "I looked at tons of kids," says Shyamalan. By the time he met with Haley Joel Osment, the ten-year-old was well versed in the *Sixth Sense* screenplay—and in the industry. Osment's career had started when he was four years old, after his picture was taken in a Los Angeles IKEA. From that, he wound up in a Pizza Hut commercial, which eventually led to a role in *Forrest Gump*, playing Forrest's son. When the *Sixth Sense* screenplay arrived, Osment rehearsed extensively with his father, a stage actor, as they discussed the script's themes. *The Sixth Sense*, Osment says, "is about people fearing the inability to communicate with one another. So it was easy to get pulled into the aloneness my character feels and the frustration that he has."

During Osment's audition with Shyamalan, after an especially emotional scene, both he and the director were in tears. "I called the casting director and said, 'I don't want to do the movie if it isn't this kid,'" says Shyamalan.

Osment's mother was an English teacher, and while filming around Philadelphia in the fall of 1998, the young actor often showed up on the set of *The Sixth Sense* with a book in his hand: *The Hobbit, The Lord of the Rings, Ender's Game*. When he wasn't reading or filming, he went to Eagles games, watched dailies with Shyamalan over Wendy's burgers, or hung out with his father in their twenty-seventh-floor hotel room, taking in dark films such as *Aliens* or *Night of the Hunter*—all part of his research. "I was watching these movies for the first time and looking out of our window at night and seeing this *Blade Runner*–like view," says Osment. Making *The Sixth Sense*, he says, was "kind of like a field trip." On set, though, he "was deeply in his character," says Shyamalan. "Everybody quieted down the second he walked in."

In one scene, Cole enters a room in a state of near shock; before filming, Osment repeatedly threw his body against a fake wall in order

to appear frazzled. And for the moment in which Cole reveals his secret to Malcolm—"I see dead people"—Osment was able to get misty on cue for numerous takes. "With another younger actor," Willis said, "they would stop the scene and put the fake tears in his eyes. This kid, every time—at the exact right moment—started crying organically."

For Osment, one of the trickier *Sixth Sense* moments finds Cole in a car with his frustrated single mother, Lynn, played by the Australian actor Toni Collette. As Cole and Lynn sit in traffic, waiting for an accident to clear on the road ahead, Cole tells her that he can see ghosts, proving it by relaying a message from his late grandmother.

> **COLE:** She said you came to the place where they buried her. Asked her a question. She said the answer is "Every day." What did you ask?
>
> **LYNN:** Do . . . do I make her proud?

Osment performed the scene more than a half-dozen times, trying not to be distracted by the rain, the cold, and the extra with a fake head wound standing nearby. The moment was equally challenging for his costar, albeit for different reasons. "I just sat there, thinking about my own grandparents," Collette said. "I just started to weep naturally." Shyamalan had cast Collette in part due to her performance in *Muriel's Wedding*, the 1994 comedy in which she had starred as an ABBA-addicted outcast. When the actor read the *Sixth Sense* script, "I was at a really fragile point," she said. "It made me feel good about being alive. It made me feel okay about dying."

One of the last major roles to be cast was that of Anna, the seemingly chilly wife whom Malcolm watches from a distance, not realizing she's in mourning for her dead husband. Several actors turned down the role. "We thought it was the ultimate acting challenge," notes Mendel, who says Marisa Tomei and Claire Forlani were among the performers who declined. With time running out, the filmmakers called Olivia Williams, who'd recently finished shooting *Rushmore*, and asked her to meet right away. At the time of the call, Williams was hanging around

in sweatpants, sorting some receipts. "In the script, there was a line that describes Anna as looking like an angel," says Williams. "I thought, 'Oh, that's gonna be tough to pull off.' But they wanted an unselfconscious person to play the wife, someone who wasn't recognizable." There was one condition, she was gently informed: in order to play Anna, she'd have to lose weight. "I told them I thought women in grief tended to eat more, rather than less. But they didn't go for that."

Filming on *The Sixth Sense* started shortly after Willis announced his split from Demi Moore, his wife of more than a decade. The public breakup forged a connection between Willis and Williams. "I'd recently been sort of abandoned at the altar," says Williams. "So we bonded about shattered relationships." One of the actors' first scenes together was a brief wedding video sequence, featuring their characters in happier times. It led to a briefly bumpy moment between Shyamalan and Willis, who was used to getting his way with directors. When Shyamalan asked the actor to adjust one of his line readings, he demurred. "I think we got it," Willis told him. Shyamalan steeled himself. "I'm like, 'This is it. This is the moment,'" says Shyamalan. "I leaned in and whispered, 'Here's what I was thinking, blah blah blah.' He looks at me, and before he has a chance to tell me what he thought, I go, 'Roll sound. Here we go!'"

After the scene was completed, Shyamalan was walking to his car when he got word that Willis wanted to meet him. "I was like, 'Holy shit, I'm dead,'" remembers Shyamalan, who was nervous about irking his star. "I'm easily derailed. I need gentle people around me." Unsure of what to expect, he headed to Willis's trailer. The actor was seeing good things for *The Sixth Sense*. "He goes, 'I've only felt this one time, with Quentin on *Pulp Fiction*,'" remembers Shyamalan. "I flew back to my car. I don't think my feet touched the pavement."

Not everyone shared Willis's confidence. Before filming on *The Sixth Sense* was completed in late 1998, the filmmakers learned that Disney—hoping to insure itself against any losses from the reportedly $40 million film—had sold off the rights to an outside production company to lessen the financial risk. Though Disney would still distribute *The Sixth Sense*, the decision felt like "the ultimate vote of no confidence," says

Mendel. "We didn't know what to make of it." By that point, even Shyamalan had realized how tough it would be to make the next *Jaws* or *Die Hard*. "I thought, 'I just want it to gross $40 million, so they'll let me direct again,'" he says. He'd started to adjust his expectations, which was probably for the best; after all, what were the odds of a spooky little movie coming out of nowhere and becoming a cultural phenomenon?

After purchasing *The Blair Witch Project* at Sundance, executives at Artisan Entertainment had begun discreetly hyping up their million-dollar investment. A disastrous New Jersey screening shortly after the festival—in which several audience members walked out before the film was over—had convinced the Haxan team to cut a few minutes, replace some of the shakier footage, and dedicate more than $300,000 on a new sound mix. But the dismal early preview also made it clear that Artisan couldn't spring *The Blair Witch Project* on unsuspecting movie-goers. "We had to get word of mouth percolating," says Artisan marketing head John Hegeman. "We wanted it to be like a very cool downtown club, where people drive by and say, 'Why is there a line there?'"

Thanks to the website launched by Haxan, the film's production company, there were already a sizable number of *Blair Witch* maniacs online. But bringing in a wider audience while maintaining *Blair Witch*'s underground feel meant that Artisan had to sell the movie without *looking* as though it were selling it. That spring, the company hired college students to cover campuses with "Missing" posters featuring pictures of the *Blair* cast. The studio also previewed *Blair Witch* for students before summer break, always choosing a crappy theater in order to make the experience seem as rickety as possible. Even some of the press screenings in New York and Los Angeles were held in dumpy rooms. "We wanted people to feel like they were going to see something snuffy," says Hegeman. A few days after screening *Blair Witch*, journalists would come into work and find an unmarked, unofficial-looking envelope waiting on their desks; inside would be one of the film's creepy stick man figures. Some writers, who'd been spooked by the movie,

weren't amused. "One of them said, 'I walked right down to the corner and put that motherfucker in the trash can,'" remembers *Blair Witch* publicist Jeremy Walker.

Artisan would reportedly spend close to $15 million marketing *The Blair Witch Project*, though not all of the company's efforts were quite so gimmicky. In May, the movie screened at the Cannes Film Festival, and a *Blair Witch* party was held on the beach, featuring towering trees and a tent that emitted screaming noises. Hundreds of revelers showed up, including Spike Lee and Mel Gibson, who stood at the bar surrounded by a flank of bodyguards. After being rebuffed by Gibson's handlers, members of team Haxan eventually made their way to the shore and shared a joint with Jeff Dowd, the film producer who'd served as the inspiration for "The Dude," Jeff Bridges's philosophical rambler from *The Big Lebowski*. "It was so overwhelming by that point," says *Blair Witch* coproducer Robin Cowie, "and so much out of our control."

By then, separate trailers for *Blair Witch* had already premiered on both Ain't It Cool News and MTV News, including a haunting, minute-long preview featuring Heather's apologetic monologue—"I am so, so sorry"—over a blacked-out screen. And an hour-long television special, *Curse of the Blair Witch*, was being put together for the Sci-Fi Channel, consisting of the faux-historical footage that had originally been intended to be part of the finished film. *Curse*, which would air shortly before the film's mid-July release date, dug into the made-up myths of Burkittsville in as straight-faced a manner as possible.

For all the promotional power behind *Blair Witch*, one crucial element of the film was conspicuously underplayed before its release: its cast. Heather Donahue, Joshua Leonard, and Michael C. Williams had granted several interviews at Sundance, and that spring, they'd gone camping with a reporter and photographer from *Premiere* magazine as part of a lengthy feature story. But the actors had spent most of their postfestival time away from *Blair Witch*. Donahue filmed a Steak 'n Shake commercial, while Williams—who'd signed with an agency—was waiting for acting work while moving furniture in upstate New York. Leonard, meanwhile, had relocated from New York City to Los Angeles,

where he'd recently undergone treatment for addiction. "When we made the film, I had a nasty drug problem, but was still kind of barely holding it together," he says. After shooting wrapped, Leonard's problems worsened, prompting him to check into rehab; by the time of the Sundance premiere, he was sleeping on a bunkbed in a halfway house in West Hollywood and working catering gigs to pay his bills. "During the fest, I had to make daily calls home to my drug counselor to assure him I hadn't fallen off the wagon. In hindsight, it was all pretty fortuitous timing: If I hadn't gotten cleaned up beforehand, I don't know if I would've survived the shitstorm that was about to hit." For the most part, though, Leonard and the rest of the actors were discouraged from taking part in the film's initial push. "We wanted them to be dead," says Hegeman. "If they're alive, the jig is up and everyone knows it's just a movie."

In July, not long before the film's opening, the actors' individual pages on the Internet Movie Database, or IMDb—an online resource for filmmakers and fans—were changed so that each performer was listed as "deceased." Donahue, Leonard, and Williams were all unknowns, and they stood to get a huge career boost from *Blair Witch*. Being declared dead meant that some casting agents, producers, or directors who were interested in hiring the actors—and who didn't know the movie was a ruse—might accidentally pass them over. "It was like, 'Ugh, when are they gonna take that off the site?' " says Williams.

The actors were also asked to keep their distance from the film's premiere. Artisan planned to initially release *Blair Witch* in just a handful of theaters, to ensure packed screenings. At the film's mid-July opening-night celebration at Manhattan's Angelika Film Center, the theater's lobby had been filled with *Blair Witch* paraphernalia, and lines had formed around the block. A few of the attendees were ringers: Hegeman's team had purchased tents, sleeping bags, and chairs from a nearby sporting goods store and paid some college kids to camp outside the Angelika, in order to bait the press. But the studio didn't need to fake the moviegoers' enthusiasm. The theater's multiple *Blair Witch* showings, some of which went late into the night, had easily sold out.

Across the street from the Angelika mayhem, standing under some

construction scaffolding, were the three stars of *The Blair Witch Project*. "I remember thinking 'This is amazing. The theater's packed!'" says Williams. But they could only watch their new fans from afar. In order to keep their movie alive, Donahue, Leonard, and Williams would have to disappear. The studio couldn't have potential moviegoers seeing dead people.

M. Night Shyamalan thought he was going to have to strangle somebody. It was the spring of 1999, not long after *The Sixth Sense* had wrapped, and Shyamalan was at a multiplex a few hours outside Los Angeles, where his movie was being test screened for the first time. When he'd arrived at the theater, he had eyed the marquee, wondering if he should try to slip away and see that cool-looking science fiction film he'd been hearing about: *The Matrix*. But the writer-director was worried that he'd be too nervous to enjoy the film. Instead he took a seat at the *Sixth Sense* screening, placing himself in the middle of the audience.

As the film began, whatever worries Shyamalan had had about the screening soon turned to rage, as he listened to a young man sitting nearby lob sarcastic comments at the screen. "It's a dynamic I've since become very familiar with," says Shyamalan. "This feeling of 'I'm going to fight you until you earn my silence.'" As the film continued, Shyamalan began counting the gaps between wisecracks: "There was ten minutes without snarkiness. Then twenty minutes. Then silence." Afterward, he noticed that the guy had rated the movie as "Excellent" on his scorecard. "I was like, 'Huh,'" Shyamalan says, "because I'd literally wanted to choke this dude for the entire movie."

Early audience members tended to react strongly to *The Sixth Sense*. At a later screening, one approached Shyamalan and promptly began lecturing him. "Is [Willis's character] supposed to be dead at the end?" she demanded angrily. "Because that's never going to work." The woman was certain that *Sixth Sense*'s third-act revelation—in which Malcolm Crowe realizes he's been dead all along—had been botched. She began recounting a scene to Shyamalan that wasn't even in the film.

The director realized that some people were walking out of the movie debating whether the twist held up. Not wanting viewers to be distracted, he inserted a series of flashbacks, reinforcing Malcolm's isolation. Willis knew *The Sixth Sense* would live or die based on how well the movie masked his character's demise. "I went, 'If we can pull this off, it would be brilliant,'" Willis said. "No one thought we could. *We* didn't think we could. We worked so hard every day on the arithmetic of how to fool the audience."

Despite the occasional enraged audience member, early responses to *The Sixth Sense* had been mostly strong—which was why Shyamalan was so surprised to learn that Disney wanted to release the movie on August 6. The month was often a dumping ground for junky late-summer films that weren't expected to hang around for long. "They put it in the graveyard," he says.

For Disney, there was no obvious place in which to slot *The Sixth Sense*. It was an overcast, PG-13 horror drama without excess gore or ghouls, starring an actor who'd spent much of the decade playing mouthy action heroes. "They didn't know what it was," says Lisa Schwarzbaum, who attended a New York City press screening while working as a film critic for *Entertainment Weekly*. "They actually brought critics in and wanted to know 'Is this anything? Can you tell us what we have?'" One of Schwarzbaum's *Entertainment Weekly* colleagues, editor Mark Harris, was so convinced the studio was burying *The Sixth Sense* that he immediately revealed its third-act twist to his future husband, *Angels in America* playwright Tony Kushner. "I said, 'I saw this movie today, and I'm going to tell you the whole plot, because you're never going to see this. It's going to open and close in a week.' He punishes me to this day for that."

The magazines landed on Dan Myrick's desk one day in early August. When the *Blair Witch Project* codirector looked them over, all he could do was laugh. There he was on the cover of *Time* alongside his directing

partner, Eduardo Sánchez. The two were staring back from beneath a giant stick-man figure, accompanied by a headline noting *Blair Witch*'s "rags-to-witches" rise. And right next to *Time* was the latest *Newsweek*, which had also dedicated its cover to the film. The two *Blair Witch* stories were arriving on newsstands at the same time, a rare bit of pop-culture synchronicity that reinforced just how mammoth the movie had become.

A few weeks earlier, *The Blair Witch Project* had opened in a small number of theaters in the United States. Before the weekend was over, it was clear that the months of *Blair Witch* rumors and teases had given the film an unfathomable urgency. "It was a madhouse," said one Los Angeles theater worker. "Lots of crowds, lots of disgruntled people because they couldn't get tickets." By the time the movie had expanded to more cities and theaters, it had become impossible to ignore. Warner Bros. changed the release date of its dumb-fun smart-shark adventure *Deep Blue Sea* by a few days to try to not get too close to *Blair Witch*, and Universal delayed the release of its superhero spoof *Mystery Men* by an entire week.

Audience members, meanwhile, tried to get out of one another's way. Accounts of moviegoers vomiting during *Blair Witch* screenings—maybe because of the shaky camerawork, maybe from nerves, maybe due to the sight of other moviegoers barfing—began appearing in newspapers such as the *New York Post*, which dubbed the film "The Blair Retch Project." There were also tales of attendees screaming at the film's climax; of theater employees escorting frazzled viewers to their cars; of teenagers going home too afraid to be near woodsy areas. According to the *Time* cover story, *The Blair Witch Project* was "a rite of passage, fraternity hazing and haunted-house trip rolled into 81 agitated minutes." And many pledges wobbled out of the *Blair Witch* ride convinced that the disappearing act they'd witnessed was real. "You mean it's not?" one moviegoer asked a *Time* reporter. "The website made it sound as if it was. I can't believe it."

In just a few weeks, the *Blair Witch* phenomenon was on its way to

passing $100 million at the box office. But as the movie was breaking records, Donahue, Leonard, and Williams were still being kept out of sight. Artisan—the indie studio now experiencing its first smash hit— couldn't have the actors defusing the film's are-they-or-aren't-they confusion. "We'd sit down at weekly staff meetings and hear 'The cast want to go on *The Tonight Show*,'" says Artisan CEO Amir Malin. "And that's the last thing we wanted. We weren't the actors' agents. We had to do what was best for the film."

Blair Witch star Williams was understanding of the studio's motives: "Fifty percent of the film's success is because people thought it was real," he says. But for his castmates, watching *Blair Witch*'s initial success from afar could be frustrating. "The only nice thing Artisan ever did for us was when we crossed $100 million at the box office, the three of us got fruit baskets," says Leonard. "It was a nice fruit basket. But if we popped up in any way publicly, they would squash it. I totally get why they did it. I don't understand why they were so disrespectful in the process." The ruse was so effective that at one point Donahue's mother received a sympathy card from someone believing her daughter was dead. "Everybody wanted to make money," says the actor. "And they didn't give a rat's ass about us."

A few weeks into the film's run, Artisan finally loosened up—the movie had become so big that it was impossible to keep the actors' existence a secret anymore. Donahue gave an interview to the *New York Times* in which she disputed the IMDb-enabled rumors of her demise. Afterward, she'd appear on *The Tonight Show with Jay Leno*, where fellow guest Ben Stiller "disappeared" from the couch, replaced by a stick-man figure. Williams would announce that he was quitting his furniture-moving job to the audience of *Late Night with Conan O'Brien*. And all three reunited for that *Newsweek* cover, looking spooked as they stood above a headline that read "Why the Low-Budget Hit Scares Hollywood."

In reality, many in the industry weren't scared of *Blair Witch*'s ascent so much as they were baffled by it. To viewers who'd been raised

on the rapid-firing, stylistically erratic video games, music videos, and commercials that had ruled small screens in the nineties, *Blair Witch* was a jerky thrill. And film critics were, for the most part, cheered by the film's sheer ballsiness. But those who preferred more traditional storytelling were utterly turned off by *The Blair Witch Project*: Wait, *this* is what the kids want to watch? "'*Blair Witch*' may do $200 million worldwide," said October Films cofounder Bingham Ray, "but it's still a piece of shit."

Ray, who'd dismissed the film earlier that year at Sundance, was merely among the first decriers in what would soon become a major *Blair Witch* backlash. The jeering was inevitable, given the movie's chopped-up style, not to mention its near-claustrophobic amount of hype. The debate over whether *Blair* was a triumph of marketing or moviemaking began almost immediately: after one of the film's midnight screenings at Angelika, a few audience members could be heard murmuring "Bulllllshit!" Those chants only became louder as the movie grew bigger. "As it became a blockbuster, a lot of people just went out of curiosity," says Leonard. "It wasn't their kind of movie, and they got pissed off: 'How did you trick me into watching that shitty-looking movie?'" In the years that followed, Leonard would occasionally be approached by strangers jokingly demanding their money back.

But it was Donahue who would bear the brunt of the *Blair Witch* haters. "Some of those moments are blocked like trauma for me," she says of the backlash. "I had people coming up to me on the street, mad at me for being alive." Heather's performance as "Heather"—a flawed, focused, occasionally combative fuck-up—was so convincing that people assumed she was just like her character. "Heather got a bad rap in Hollywood, because her work was never accepted as a performance," says Walker, the film's publicist. And the ire toward Donahue was certainly fueled by the fact that her tough-but-doomed character was a woman. "If it had been a male lead in there, would people have behaved differently?" asks Donahue. "Would he have had as much baggage from the role?"

As the cast members of *The Blair Witch Project* were finding out, some viewers didn't believe they were acting at all. "They almost did *too* good of a job," says Myrick. Donahue, Leonard, and Williams couldn't win: people either thought they were dead or believed they weren't legit actors—that they were just a bunch of kids who'd been terrorized by the filmmakers. To moviegoers, the on- and offscreen versions of Heather, Josh, and Michael all melted together. "I had these casting agents sit across from me and say, 'I *know* you weren't acting,'" says Williams. "That's when I started getting frustrated."

The hysteria over *The Blair Witch Project* and the mounting resentment over its success finally converged on September 9, less than two months after *Blair Witch*'s opening weekend. That night, the film's three stars arrived at Manhattan's Metropolitan Opera House for the 1999 MTV Video Music Awards, where they'd be presenting a directing trophy. By then *The Blair Witch Project* was headed toward what would be its final weekend in the box-office top ten. But it was still relevant enough that MTV had promoted the awards with a series of *Blair Witch*–spoofing videos starring Janeane Garofalo, Method Man, and host Chris Rock as disgruntled campers. *Blair Witch* was so recognizable, and its cast so sought out, that the actors had quickly gone from being dead to being dangerously overexposed. The sudden fame was a lot for the twentysomething performers to handle. "When the limo showed up to take us to the awards, I refused to get in because it was white—and I thought white limos were tacky," says Leonard. "I made them get a black limo. That's what success can do for your head in a very short period of time. I was at the point where I thought town cars would *always* be picking me up prestocked with jelly beans."

Before taking the stage at the Met, the *Blair Witch* actors learned that, as part of their presenter banter with comedian Buddy Hackett, MTV wanted them to roast themselves. "The awards show copy had me saying, 'I've had my fifteen minutes, and now I'm going to go away,'" says Donahue. "And I said, 'Fuck you, I'm not saying that. I will rewrite this, or you will rewrite this. I'm not going to degrade myself so I can be part of your circus.'" The "fifteen minutes" line was cut, but Rock's

introduction of Hackett and three actors still managed to get in a dig at *Blair Witch*: "He's a great comedian," Rock said, "and their film is a joke."

In the weeks before the release of *The Sixth Sense*, as M. Night Shyamalan watched *Blair Witch*'s surprise liftoff, he'd become concerned that the movie's momentum would overshadow everything around it—including *The Sixth Sense*. He couldn't even bring himself to watch *Blair Witch* during its release: "Too much anxiety," he says.

During *The Sixth Sense*'s opening weekend, Shyamalan spent time at a theater in suburban Philadelphia, where his movie was playing alongside *Deep Blue Sea*. "I watched people picking movies," he says. "'One for the *The Sixth Sense* . . . one for the shark movie . . . one for *The Sixth Sense* . . . one for the *The Sixth Sense* . . .'" And he'd been dialing into a special phone line, where a recorded voice gave him an update on the grosses. He still wasn't sure how the film had fared until a phone call woke him up one morning that weekend. "Not bad," Bruce Willis told his bleary-eyed director. "Number one."

Shyamalan had hoped to gross $40 million during *The Sixth Sense*'s run. Instead the movie earned more than half that—$27 million—in its first three days, putting it right above *The Blair Witch Project* in the weekend results. *The Sixth Sense* would stay at number one for more than a month and a half, eventually making nearly $300 million in the United States, the biggest non–*Star Wars* movie of the year. Shyamalan had his phenomenon.

The Sixth Sense's sustained box-office triumph was partly due to the fact that, much like 1992's similarly twisty *The Crying Game*, most moviegoers kept mum about the film's final moments. "Generally, when there's a surprise ending like that, people go out and tell their friends," said Willis. "But for some reason, they didn't. It was phenomenal. They just said, 'No, you've got to see it.'" Even on the internet, where fans were eager to earn points by spilling movie secrets, the people largely kept quiet—though there was the occasional loudmouth. "I remember

reading an AOL movie chat where someone said, 'He's dead the whole time,'" says Osment. "I was like, 'I bet you're the kind of person who likes to pull the wings off butterflies.'"

Osment quickly became the focus of the press's *Sixth Sense* fixation, often sounding more polished than some of his much older acting peers. "You're amazingly analytical for someone eleven years of age," one TV host told him. "It's like talking to a forty-four-year-old midget." Osment's parents also received calls from fans such as Tom Cruise and Jodie Foster, herself a former child star. "She was kind of doing a check-in," says Osment. "Because of that movie, if people didn't know me, they'd be like, 'Is he a messed-up kid?'" By year's end, both Osment and Collette were considered obvious Oscar contenders, and Osment was cast in *A.I. Artificial Intelligence*, a movie Steven Spielberg had taken over from his late friend Stanley Kubrick.

Willis's *Sixth Sense* performance—stolid and unshowy, his best since the era of *Pulp Fiction* and *12 Monkeys*—didn't generate quite as much attention. But the star's Disney arrangement gave him an enviable share of the film's box office, with one estimate placing his earnings at more than $60 million. Willis denied such reports but conceded he'd wound up with "a lot of dough." And there could have been even more of it to go around: according to Osment, as the movie was taking off, a producer tried to sell the cast on a *Sixth Sense 2*. "Somebody at one of the production companies was like, 'We can just get right back on that horse and do it again,'" Osment says. "Which would have been terrible and pointless."

As *The Sixth Sense* continued what would end up being a nine-month-long theatrical run, it became clear that the movie's biggest star wasn't one of its performers but a four-word phrase: "I see dead people." It was a line that Shyamalan had initially worried would come off as "a hair young" for the nine-year-old Cole. But Osment had been so convincing that the director was now hearing it everywhere: in commercials, in film spoofs, from random people on the street. Once, during a pickup basketball game, Shyamalan watched someone throw an errant pass against a fence. Another player, unaware the film's writer-director

was on the court, let the guy have it: "You see dead people or something?"

By the time *The Blair Witch Project* was ending its theatrical run, nearly everyone involved with the film was exhausted. The last half year or so of promotion had been more grueling than an actual week being lost in the woods. Myrick and Sánchez had appeared on *The Daily Show with Jon Stewart*—whose host had just taken over the show a few months earlier—and *The Late, Late Show with Craig Kilborn*, and would land a slot on *Entertainment Weekly*'s "Entertainers of the Year" list (they were ranked third, right between *The Sopranos* creator David Chase and Britney Spears). By then, the movie's US box office take had passed $140 million, and Haxan was also fending off a series of lawsuits from people claiming they'd played an early role in the film (at one point, coproducer Cowie had twenty-one lawyers on his speed dial). "*Blair Witch* had been so intense for so long," says Myrick. "We needed a break."

Artisan Entertainment, however, was eager for the *Blair Witch* team to get back to work. In the late nineties, the company had been restructured with money from Bain Capital, the investment group cofounded by future presidential candidate Mitt Romney. Artisan—which one magazine described as "a name brand even hipper than Miramax used to be"—was heading toward an initial public offering, one it hoped would raise as much as $100 million, and a second *Blair Witch Project* would certainly lure investors. "*Blair Witch* had franchise possibilities, and we wanted to capture this lightning and bottle it as quickly as possible," says Malin. The company asked Myrick and Sánchez to start work on a sequel, one that would be ready for release in 2000. But though the filmmakers had been considering a possible prequel to *Blair Witch*, and had even presented some ideas to Artisan, they had no interest in rushing a follow-up. "Dan and Ed didn't want to hear or say the words 'Blair Witch,'" says Haxan's Gregg Hale. "And the last thing they wanted to do was be in the woods at night."

Instead, the *Blair Witch* directors were hoping to take some time off

before starting on a comedy they were kicking around, called *Heart of Love*. And though some in Hollywood were dubious when it came to the filmmakers' talents—one studio exec asked Myrick and Sánchez if they knew how to actually write a script—the two received several persuasive job offers. They were even asked to oversee a prequel to *The Exorcist*, which was one of the movies the two had bonded over while students at University of Central Florida. But the *Blair Witch* codirectors didn't want to be part of a movie they couldn't control. "It wasn't that we were arrogant," says Sánchez. "We just didn't want to sell out."

Thanks in part to their initial deal with Artisan—which included bonuses if the movie's box office haul passed $100 million—the Haxan team members were financially secure for the first time in years. (As for the actors, Williams says that, in total, he made about $300,000 for his performance.) But no one at Haxan was prepared for the aftershocks of having such a major hit. "The stresses of *Blair Witch* were kind of pulling the partnership apart," says Sánchez. "We had this money. We had this power. We thought we could go in our own direction. But we didn't have somebody to guide us through."

The Haxan Five *were* united, however, in a dispute with Artisan. In the months after *Blair Witch*'s release, the filmmakers felt they weren't getting paid in time—and, even worse, that they weren't receiving their due share of the earnings. "There was creative accounting we weren't prepared for," says Myrick. "We had to threaten to go to court." Artisan's Malin insists that the members' box-office proceeds were paid on schedule. He also says some of the movie's profits were negated by an expensive DVD release. In early 2001, the two teams reached an agreement in which Haxan would be bought out for $25 million to $30 million. The settlement was reached just a few months after Artisan's *Book of Shadows: Blair Witch 2*, directed by documentarian Joe Berlinger, made less than a quarter of what the first film had earned. The Haxan team had watched *Book of Shadows* in Orlando, groaning and chortling throughout. (Artisan's IPO never happened, and the company was sold to another studio in 2003.)

By then Haxan was already beginning a slow decline. *Heart of Love*

would be abandoned and several TV attempts would fail. Myrick and Sánchez wouldn't direct again for almost five years, and when they returned to filmmaking, they would work separately on a series of indie horror films and dramas.

But *The Blair Witch Project* lived on in spirit, as the found-footage genre Myrick and Sanchez had popularized was utilized by several hit movies: *Cloverfield*, *Chronicle*, and the *Paranormal Activity* films. Cheap portable cameras became so prevalent—and viewers so much more accustomed to jittery edits and jerky movement—that people were no longer barfing in the aisles. One of the most successful heirs to *Blair* would arrive in 2015: *The Visit*, a Pennsylvania-set creeper that marked a comeback of sorts for its writer-director. He was a guy returning to horror after experiencing several up-and-down years. But his name was still big enough to be included on the movie's poster: M. Night Shyamalan.

10

"IT'S KARMA, BABY."

THE BEST MAN
THE WOOD

When Taye Diggs first started going out for screen roles in the nineties, he would occasionally carry a black, tight-fitting skullcap in his back pocket. So would some of his African American peers. "We had a joke that even if we were at a Shakespeare audition or a classical audition, we'd have our thug hats with us," says Diggs. "That way, if we got a call to try out for something in movies or television, we could put it on and immediately play a thug: change your dialect, mumble your vowels, cut off consonants." Diggs, an actor and singer raised in upstate New York, would wind up spending long stretches of the decade onstage in New York City—he was a member of the original cast of *Rent*—in addition to picking up the occasional TV part. But he was leery of some of the film roles available to twentysomething black actors at the time. Diggs was trying to find movies "where you just see African American people being people, as opposed to stereotypes," he says. "Nobody is a drug dealer, nobody is a thief."

Diggs had arrived in New York just a few years after the African American movie renaissance of the late eighties. It was a period in which studio executives suddenly started paying attention to the films and filmmakers they'd long ignored. "In Hollywood, Black Is In," noted a 1990 *New York Times* article, referring to a rush of talent led by *Do the Right Thing*'s Spike Lee and carried on by such writer-directors as Keenen Ivory Wayans (*I'm Gonna Git You Sucka*), Robert Townsend (*Hollywood Shuffle*), and Reginald Hudlin (*House Party*). They were all part of a new league of African American filmmakers whose work had been both critically laudable and commercially viable. And the big studios were now *very* eager to work with them. "Having a successful black film gives a studio a great social profile," Wayans said at the time. "It makes the executives smell like roses." Lee, as usual, put it even more bluntly: "Hollywood doesn't care what kind of films they are as long as they make money."

Within a few years, Lee would release *Malcolm X*—then the highest-earning film of his career—and John Singleton would become the first African American nominee for Best Director for his hit drama *Boyz N the Hood*. Those epochs were followed by the arrival of such filmmakers as the Hughes brothers, Rusty Cundieff, Kasi Lemmons, F. Gary Gray, and Julie Dash, among several others, as the renaissance turned into a full-on revolution. In 1991 alone, noted the *Times*, there were nearly twenty African American–aimed films set for release—a record number. "Black film properties may be to the '90s what the car phone was to the '80s," noted the *Times*. "Every studio executive has to have one."

Yet those execs tended to have limited imaginations about what kind of black movies could succeed. The nearly $60 million success of *Boyz N the Hood* was part of a decadelong run of what would become known as hood films: tough, violent, inner-city-set dramas. Some would become rewind-worthy classics, such as *Juice* and *New Jack City*. But by early 1996, the hood genre had become so prevalent and so played out that Wayans produced *Don't Be a Menace to South Central While Drinking Your Juice in the Hood*, a spoof flick that satirized an increasingly

familiar-feeling genre. "So will I see you again?" a young man asks his mom in *Don't Be a Menace.* "Sorry, baby," she replies. "You know there ain't no positive black females in these movies."

As the decade went on, says actor Nia Long, "Hollywood needed to see that we were more than drug dealers and baby mamas." Long had enjoyed a breakout role in *Boyz N the Hood* and later starred in the stoner hit *Friday* before quickly becoming one of the busiest actors of her generation. "In the nineties, my opportunities were endless," she says. "But there was a certain level of frustration. I felt like I was playing the same role over and over again. I wanted to do period pieces. I wanted to portray the darker side of life—and not necessarily the version in *Boyz N the Hood.*" More than anything, she says, "I was desiring the opportunity to show a different side of who we are—and who I am— as a black woman."

It was a desire clearly shared by millions of moviegoers. In 1995, Twentieth Century Fox released *Waiting to Exhale,* a drama based on the bestselling novel by Terry McMillan, and starring Angela Bassett and Whitney Houston as two of a quartet of successful African American women looking for the right partner. The film opened at number one over the Christmas weekend, surprising executives at its own studio. By the time its run was finished, it had earned nearly $70 million, leading the *Los Angeles Times* to backhandedly declare the movie "something of a social phenomenon." Afterward came a rush of black-themed big-studio family dramas and youthful romances: *Hav Plenty, Eve's Bayou, How Stella Got Her Groove Back, Love Jones* (billed on its VHS cover as "A hip *When Harry Met Sally!*"). "Black people wanted to see a different version of themselves onscreen," says Long.

By 1999, that demand had become so strong that two of the most popular African American–made films of the decade arrived within just a few months of each other. The movies shared a star, a wedded-bliss setting, and some of the same big-screen inspirations. Their origins, though, diverged greatly. One movie had been written with an eye toward the big-studio system; the other was implicitly indie-minded. Yet

they were both made by filmmakers who refused to be wed to anything but their own ambitions.

In early 1997, Malcolm D. Lee was a New York University film school grad who had a few short films to his credit but was struggling to get his first feature made. He'd written a script for an *Annie Hall*–inspired love story, which he couldn't get financed. It was one of several unproduced screenplays, and Lee, then entering his late twenties, realized he needed to rethink his approach. "I decided I was going to write something so commercial that I could sell it, and use that money to make my other movie," says Lee. That's when he noticed a story in *Premiere* magazine about the forthcoming *Soul Food*, an ensemble drama with a well-known cast that included Nia Long, Vivica A. Fox, and Vanessa Williams. Lee had seen African American dramas such as *Waiting to Exhale* take off in the last two years and knew that *Soul Food* would likely be a hit as well. "There was a hunger out there for movies about the black American experience that didn't have anything to do with the inner city or drugs or violence," he says. "I wasn't seeing myself or my friends represented on film. There was something missing."

Lee decided his studio-friendly new effort would be a wedding movie—an unexpectedly lucrative genre in the nineties, thanks to hits such as *My Best Friend's Wedding, Muriel's Wedding*, and *Four Weddings and a Funeral*. All of those films, however, had been overwhelmingly white. Lee's script, which he titled *My Homeboy's Wedding*, would follow a group of African American college friends who reunite for a weekend celebration. "I timed finishing it to coincide with the release of *Soul Food*, knowing they'd be looking for the next *Soul Food*," Lee says. "I planned it right. And then I gave it to my cousin."

When Lee was a teenager, his older cousin Spike would crash with Malcolm's family while attending New York University. "I didn't believe someone in the family—somebody black—could go and make movies," Malcolm said. "It was just unfathomable to me." Afterward, Malcolm worked as an assistant to Spike on films such as *Clockers* and *Malcolm X*.

And when the script for *My Homeboy's Wedding*—eventually retitled *The Best Man*—was completed, it was Spike who helped get it onto executives' desks. A few major studios turned the script down outright, while others asked for revisions. "But Spike was the kind of filmmaker who said, 'You don't like it? We're moving on,'" says Lee. Eventually the cousins wound up at Universal, where one executive read *The Best Man* and told them, "These people are just like me—they just happen to be black."

Lee received a budget of $9 million to make *The Best Man*—a workable figure but one that illustrated the caution with which studios approached black-themed films. Even after the prosperous box office for *Malcolm X*, *Waiting to Exhale*, and *Soul Food*, there were concerns that African American–aimed movies wouldn't cross over to white audiences. Black-themed movies had proven to be robustly profitable—especially on home video—but the perception within Hollywood was that their appeal was ultimately limited: "They're like baseball films," one unnamed producer told the *New York Times*. In the fall of 1998, the abysmal commercial reception of *Beloved*, a haunting post–Civil War drama produced by and starring Oprah Winfrey, had made already jittery execs even more nervous: If a $53 million Oscar-season release starring one of the most famous human beings on the planet couldn't interest white audiences, what could?

Luckily for Lee, he didn't require a megabudget for *The Best Man*: it was an ensemble piece, one that wouldn't be anchored by a high-priced superstar. And he certainly didn't need huge paydays to lure his cast. "There was such a fervor amongst the acting community to be a part of it," he says. "A lot of actors didn't get to play these kinds of characters."

And few nineties comedies featured quite as many characters as *The Best Man*. Set over the course of a long weekend in New York City, the movie stars Taye Diggs as Harper, a charming if self-absorbed young Chicago writer with a loving girlfriend—played by *Blade* star Sanaa Lathan—and a soon-to-be-released novel, *Unfinished Business*. When Harper travels solo to New York for the wedding of two college friends, he takes along an early copy of *Unfinished Business*, which is circulated

among the wedding party. Soon his ex-classmates realize that Harper's book is all about *them*: their flaws, their fallings-out, their various infidelities. As the group's secrets spill out, the wedding is threatened, and Harper finds himself an outcast among his own pals.

Prior to *The Best Man*, Diggs had broken out as the titular groove provider to Angela Bassett in the romance *How Stella Got Her Groove Back*. "I was the new black kid on the block," he says of the late nineties. "I got thrown into the deep end with *Stella*, but that was Angela's movie—I was just playing off her." *The Best Man* would find Diggs as the lead, as it's Harper and his book that instigate much of the story. "I never thought of it as carrying a film," he says. "That kind of made me humble enough not to get nervous and sabotage myself. And I just loved that I was getting to work with these talents I'd watched coming up."

That included Long, who based her role as Jordan—an overworked TV news producer—on a few young professional friends of hers. "Around that time," says Long, "there was this surge of energy for women to push forward in their careers and to be overachievers and to not live life in the traditional way. Jordan was absolutely a reflection of that. And I'm from Brooklyn, so I could relate to the sophistication of this city girl who wants to run the world." Throughout *The Best Man*, Jordan and Harper flirt with the idea of consummating their years-long attraction. But it's complicated by her desire to get an exclusive on Harper's book and his wishy-washiness about abandoning his girlfriend. During one spat, the frustrated Jordan smacks Harper across the face.

The moment made for one of *The Best Man*'s more difficult shooting days. "I thought Jordan slapping him was really extreme," says Long, who initially had trouble connecting to Lee's version of the scene. "There was a little bit of tension that day, a little bit of indecision. I had to muster up this level of frustration and anger that wasn't on the page." She eventually discovered that outrage—much to Diggs's discomfort. "Nia slapped the shit out of me," he says, laughing. "I would have loved a little bit of a heads-up. At first, I was like, 'I'm never going to work with her again.' But that was a lesson about process: not everyone works the way you do."

The Best Man had been inspired in part by *Diner*, the 1982 Baltimore-set comedy-drama about a group of buddies who return home for a wedding, and spend much of their time casually jawing about women. In Lee's script, that film's frankness was echoed in a lengthy shit-shooting scene between Harper and his old friends, including Lance, the deeply religious, wildly promiscuous football pro who's getting hitched, played by *Boyz N the Hood*'s Morris Chestnut, and Quentin, a rapscallion rich kid interpreted with sly, dry know-it-allness by *Dead Presidents* star Terrence Howard. As the men play cards, they bluntly trade war stories about sex and monogamy, the exchanges growing more tense as Quentin—who knows that Lance is about to learn of his fiancée's cheating past—hints at the revelations to come:

QUENTIN: You mean to tell me with all the stickin' and movin' that you've done, you don't think that Mia's ever tippy-toed out the door on you once?

LANCE: No.

QUENTIN: Well, if she did—you know, go out and get her little swerve on—don't you think she'd be well within her rights? It's karma, baby.

The card scene, which plays for nearly seven minutes—and ends in near fisticuffs—features the sort of unadulterated real talk that, just a few years earlier, might have been found in an ambling indie. Instead, it arrived via a big-studio romantic drama, one that was both culturally specific and socially universal. In *The Best Man*, best friends castigate and celebrate one another in equal measure—much in the way that overly intelligent, overly ambitious people tend to do when flailing toward their thirties. "Midway through writing this screenplay I was determined to sell," says Lee, "I was like, 'Well, there's a reason I can tell this story: this is myself.'" Adds Long, "We were playing real people. It was a slice of life that would have worked equally well if everyone was white, Asian, or Indian."

The Best Man concludes with a wedding reception featuring dozens

of cast members performing the Electric Slide en masse as the band plays Cameo's future-funk classic "Candy." It would eventually become the film's signature scene, though not everyone was able to keep in line during filming. "I am not as coordinated as people might think," says Long. "Everybody else did it with ease, but I was struggling." One of the revelers on the dance floor was Lee—who adopted one of his famous cousin's trademarks, working in a quick cameo for himself. As soon as *The Best Man* wrapped, the director would start readying his debut for its fall 1999 opening date. As he worked, Lee kept an eye on another wedding movie he'd read about. It sounded similar enough to *The Best Man* that, according to Lee, his famous cousin had nudged him to work faster: "Spike was like, 'We got to be out before *The Wood*!'"

Throughout 1997, Rick Famuyiwa could occasionally be spotted bicycling to a Niketown store in Beverly Hills, where the recent college grad had a full-time job selling sneakers. It was an outcome few of Famuyiwa's college classmates would have predicted for the young writer-director. By the time he left University of Southern California's film program in 1996, Famuyiwa was one of the school's star attractions. His student film had screened at Sundance, and he was already being pursued by agents and producers. Famuyiwa's career was so seemingly assured—and his ascent so in line with that of former USC prodigies such as George Lucas and John Singleton—that he'd already earned a nearly 6,000-word-long profile in the *Los Angeles Times*.

Famuyiwa's film school infamy was especially notable given that, growing up in the Los Angeles suburb of Inglewood, "I wasn't one of those kids running around with a Super 8 camera, making minimovies," he says. "I liked to write and play sports." Famuyiwa's parents, both Nigerian immigrants, were film lovers, so he was well versed in the likes of *Star Wars*, *Raiders of the Lost Ark*, *Jaws*, and especially James Bond thrillers, which his father collected through one of Columbia House's dodgy membership deals. Still, "the idea of making movies seemed like a long shot," he says. "Even when Spike made *She's Gotta Have It*, the

stories around that movie were about how hard it was for him to get it off the ground." When Famuyiwa enrolled at USC, he planned to study law, not filmmaking. It wasn't until the outbreak of director-driven nineties films—*Pulp Fiction*; *sex, lies, and videotape*; and especially *Boyz N the Hood*—that he changed his mind and switched to film. "Those movies were taking over the mainstream," he says, "and it made me feel like I could tell personal stories about characters that I remember from growing up—characters you don't normally see in a movie."

In 1995, Famuyiwa wrote and directed *Blacktop Lingo*, a twelve-minute black-and-white short about a group of young African Americans who meet for a pickup basketball game at a Los Angeles park, where they debate the merits of Larry Bird and argue about Bruce Lee movies. *Blacktop Lingo* was accepted at Sundance, where a smiling Robert Redford told the young director he used to play ball at the same spot where *Blacktop Lingo* was set. When Famuyiwa returned from the festival to finish his senior year, he wrote a feature-length basketball drama with one of his professors, Todd Boyd, and later began making the rounds at various studios. But executives tried to steer Famuyiwa away from his own ideas and toward broad black-aimed comedies along the lines of such nineties hits as *Phat Beach* and *Booty Call*—much to his disappointment.

Less than a year after graduating, he was spending his days at Niketown and his evenings writing. Eventually, he got a call from an official at Sundance Institute's filmmaking labs, asking if he had any new ideas he'd want to develop. Boyd, his former professor, had encouraged Famuyiwa to adapt an essay he'd written at USC about his cross-country move with his mother and his younger brother when he was in junior high. Famuyiwa used those experiences—and the recent engagement of one of his friends—to fuel a new script, *The Wood*, which was inspired by throwback dramas such as *Diner* and *American Graffiti*, as well as the sixties-set prime-time hit *The Wonder Years*. Alternating between 1986 and 1999, *The Wood* starts out just a few hours before the wedding of Roland, a hesitant groom—played by Diggs—who's gone MIA. He's eventually found in a drunken, despondent state by his two longtime

best friends: Mike, played by *Juice* star Omar Epps, and Slim, played by Richard T. Jones, who'd recently starred in the TV drama *Brooklyn South*.

As Roland sobers up, the three friends spend the afternoon reminiscing about their junior year of high school, a time when they wore Adidas kicks and bright-colored polos, debated which Prince protégée was the finest—Apollonia or Vanity—and embarked on a challenge to see who'd be the first to lose his virginity. Like the kids of *American Pie*, the young *Wood* trio are desperate and completely shameless in their pursuit of sex. They plead and cajole to no avail and at one point, young Mike simply gives up and dumps a pitcher of ice down his crotch for relief. *The Wood*'s back-in-the-day scenes play out as a series of chill nights and warm, wasted afternoons, as its likably pent-up heroes try to play grown-up Casanovas in their Lakers tees and Guess jackets—only to be baffled by every girl they meet.

Famuyiwa initially workshopped *The Wood* with different actors at the Sundance lab, filming scenes with guidance from Denzel Washington, one of the creative advisers. By then, his script had already attracted the attention of *Election* producers Albert Berger and Ron Yerxa, who'd caught an early script reading in Los Angeles and helped sell *The Wood* to Paramount's MTV Films division. The movie's $6 million budget and thirty-day shooting span was sizable enough for Famuyiwa to get the cast and resources he needed—but just negligible enough to earn him some autonomy from the studio. It also meant the twenty-four-year-old Famuyiwa could finally quit his Niketown job. "For a first-time filmmaker, the nineties felt wide open," he says. "There was still this notion that the studios wanted to find original voices and original ideas."

From its zealous opening sequence—a three-minute-long sustained tracking shot in which Epps speaks directly to the camera—*The Wood* exudes the pent-up energy of a filmmaker finally getting a chance to play: when young Mike stares down a schoolyard crush, Famuyiwa plays the scene like a bullfight, complete with fast-strummed Spanish guitars; and flashbacks to the past are introduced with the sight of

a needle dropping onto a vinyl record, a cue Famuyiwa cribbed from *Happy Days*. "I wanted to wink at all the things that made me," he says.

Famuyiwa filmed parts of *The Wood* at his own former junior high school, as well as at the donut shops and pizza joints he'd frequented as a teen. As a result, the movie "felt indie and intimate," says Diggs. At times that intimacy extended to the shoot itself: in one scene, the three old friends—now adults—are forced to strip down and shower off with a garden hose after the hungover groom vomits on their tuxes. Standing outside in the nude, getting blasted by a garden hose, would have been uncomfortable enough, says Diggs. But it became even more awkward when the actor noticed an extra camera hovering about on the set. "I said, 'Wait a minute: If you want us to get naked, what is the photographer doing on set?'" Diggs remembers. "I was told not to worry about it. And of course, those pictures went all over the internet." It was a sign that the young actor had finally crossed the latest marker of modern fame: leaked nudes.

For Diggs, the differences between *The Wood*'s rollicking, relaxed vibe and *The Best Man*'s big-studio glossiness were obvious. "I never put them in the same category," he says. "One was like *She's Gotta Have It*, the other was like *School Daze*." Yet, during filming, Famuyiwa couldn't help but feel slightly combative toward *The Best Man*, which he'd learned about just as *The Wood* was going into production. "I grew up playing hoops, so I had that competitive edge," he says. "There was some territorialism: 'Hey, we got here first!' But ultimately I felt it was cool these movies were being made."

Paramount gave *The Wood* a July 16 opening date, one that would allow for a three-month jump on *The Best Man*. But that meant Famuyiwa's R-rated film would have to find an audience in a crowded summer month that included the much hyped *Wild Wild West* and *Eyes Wide Shut*, as well as the similarly sexed-up *American Pie*. So the director became frustrated when, in the weeks leading up to *The Wood*'s release, he wasn't seeing as much on-air promotion as other MTV Films productions had received. "I was pissed: 'Why is this fucking *Varsity Blues* stuff

everywhere, and I'm not seeing anything about *The Wood?*'" he says. "MTV said something to the effect of, 'Our research shows white people don't actually spend money to see things related to hip-hop.' Which is bullshit." Though the network did air some tie-in programming and brought Epps and Diggs to that summer's MTV Movie Awards, *The Wood*'s opening night arrived with decidedly less preamble—and on fewer screens—than the studio's recent teen football hit.

Famuyiwa didn't let that dim his excitement. He spent part of *The Wood*'s first few days visiting movie theaters in Los Angeles, gauging the audience members' reactions, and taking calls from the studio about its performance. Before the weekend was over, *The Wood* would make nearly $9 million—enough to guarantee that its young writer-director wouldn't be back to selling shoes anytime soon. "It wasn't *Matrix* money," Famuyiwa says. "But when you're young, you're like, 'That's big.'" He didn't have much time to celebrate the box office, though. In a bit of flukey timing, Famuyiwa had another nerve-rattling, long-in-the-works event planned that weekend: he was getting married.

In the months leading up to the release of *The Best Man*, Malcolm D. Lee was confident enough about his debut that he lobbied to premiere the film at that summer's Urbanworld Film Festival, a multiday African American–centric gathering that had been launched in 1997 in New York City. "Spike was kind of against showing a movie that wasn't finished," says Lee. "But we went for it—and it was a huge thing for us." After Urbanworld, he says, *The Best Man* became the subject of an intense online campaign as moviegoers emailed their friends, urging them to come out for the movie's opening weekend. "We didn't have any big billboards, we didn't have a ton of commercials," he says. "Those emails bolstered us. It was just people passionate about the movie: 'Here's an opportunity to see people like us on the big screen.'"

That momentum carried straight through *The Best Man*'s October 22 opening night. That weekend, Lee's debut would be vying against

Bringing Out the Dead, the grimy, kinetic ambulance-driver drama directed by Martin Scorsese and starring Nicolas Cage. *Bringing Out the Dead* would open on nearly six hundred more screens than *The Best Man*, and Cage's face had adorned magazine covers and billboards. But by Sunday night, it was Lee's movie that had landed in the number one spot, making $9 million—nearly the exact same amount as *The Wood*. The "surprise" showing of *The Best Man* was the first of what would become a trademark of Lee's career: a sleeper hit that few white executives or box-office prognosticators had seen coming. "When it comes to movies targeted at African American audiences, they're just like, 'Well, we didn't expect *that*!' " says Lee.

Before the year was over, both *The Wood* and *The Best Man* would quadruple their budgets at the box office, boosting studio execs' confidence in the African American rom-dram. The years that followed would see hits such as *Love & Basketball*, *The Brothers*, and *Brown Sugar*—the last cowritten and directed by Famuyiwa. The movies' box-office performances invariably surprised many observers, who still couldn't grasp the size and insatiability of the African American audience that had made *The Best Man* and *The Wood* such hits. Almost every time a film featuring a black cast did well, experts would use the same word to describe its success—one Lee never saw applied to the work of his white peers. The term would even be used to describe Lee's 2017 smash hit *Girls Trip*. "People say these movies 'overperform,' " he says. "Maybe you just underestimate them."

FALL

The ball is beginning to move. In forty-seven seconds it will be 2000. . . .
Hi. My name is Lynn. I am the mother of a Pokémon addict. . . . Donald J.
Trump announced today that he was resigning his Republican registra-
tion in advance of a possible challenge to Mr. Buchanan in his expected
quest for the Reform Party Presidential nomination. . . . *I want to get
with you/And your sister/I think her name's Debra.* . . . You're in Times
Square with a couple million intimate friends. Thirty-five seconds. Get
close to somebody you love. . . . **RECORDING INDUSTRY GROUP SUES
NAPSTER, ALLEGING COPYRIGHT INFRINGEMENT ON NET** . . . J. K.
Rowling says she's "still in shock" over the response to her highly popu-
lar Harry Potter books. . . . **CURFEW IN EFFECT AS SEATTLE STRUG-
GLES TO CONTROL WTO PROTESTS** . . . *We're going for a million dollars
and all your lifelines are still intact.* . . . And we're gonna count it down
from here. In ten, nine, eight . . . "Movie renters are fed up with due
dates and late fees," said Hastings. "NetFlix.com's Marquee program
puts the joy back into movie rental." . . . *Wazzzzup.* . . . Seven, six, five,
four. . . . The Fannie Mae Corporation is easing the credit requirements
on loans that it will purchase from banks and other lenders. . . . *We be
big pimpin', spendin' cheese.* . . . **YELTSIN RESIGNS; RUSSIA'S PRESI-
DENT NAMES PUTIN ACTING PRESIDENT** . . . Three, two, one.

11

"SOMETIMES THERE'S SO MUCH BEAUTY IN THE WORLD, I FEEL LIKE I CAN'T TAKE IT."

AMERICAN BEAUTY

In the early nineties, a graphic designer and playwright named Alan Ball was walking through New York City's Times Square when he noticed a comic book on a newsstand. It was a graphic retelling of the recent saga of seventeen-year-old Amy Fisher, whom the press had dubbed "the Long Island Lolita." She'd earned the nickname after shooting Mary Jo Buttafuoco, the wife of Joey Buttafuoco, a middle-aged auto body shop owner with whom Fisher was having an affair (Mary Jo survived the attack, which took place on the porch of her suburban home). The ordeal quickly became a huge scandal, inspiring three TV movies, untold hours of news coverage, and at least one comic book. "On the cover was this incredibly virginal Catholic schoolgirl Amy, with a fat, sweaty, leering Joey Buttafuoco behind her," says Ball, who was in his midthirties at the time. "And when you flipped it over, it was the exact opposite: Joey was a clean-cut suburban husband and father, and Amy Fisher was totally slutty. And I remember

thinking 'The truth lies somewhere in between, and we will never know exactly what happened.'"

Ball would return to the Fisher-Buttafuoco affair over the next few years as he kicked around a story he wanted to tell—first as a play, then as a movie—about an upper-middle-class household undone by infidelity and resentment and devastated by an act of violence. When it finally materialized in theaters in 1999, Ball's *American Beauty* confirmed suspicions that had been building up throughout the decade: namely, that the modern American family was on the fritz.

It was a notion shared by several other movies of that year, which were rife with domestic warfare, whether it took the form of strained parent-child relations (*The Virgin Suicides*, *Varsity Blues*) or flailing marriages (*Eyes Wide Shut*, *The Insider*, and the revenge thriller *Double Jeopardy*, in which Ashley Judd's character kills her scheming husband). The sight of a family in crisis was ostensibly so relatable—and so potentially commercial—that Universal invested tens of millions of dollars into the unlovable *The Story of Us*, a tale of two middle-aged parents, played by Bruce Willis and Michelle Pfeiffer, watching their long-running relationship dissolve. In 1989, the film's director, Rob Reiner, had made *When Harry Met Sally*, a genre-defining romantic comedy that forcefully argued for the durability of love. Ten years later, Reiner was overseeing a divorce drama with a foreboding tagline: "Can a marriage survive . . . 15 years of marriage?"

The culturewide domestic crisis had been years in the making. The US divorce rate had hit a record high in the early eighties, as members of the baby-boom generation underwent a mass uncoupling. Nearly two decades later, in 1999, the kids whose folks had split up years before were finally coming to terms with their own absentee landlord parents. "I don't know my dad," notes the unnamed narrator of *Fight Club*. "He left when I was like six years old, married this other woman, had some other kids. He did this like every six years: he goes to a new city and starts a new family."

The relationships that *had* managed to stay together through the nineties, meanwhile, weren't always as stable as they seemed, as

adultery figures had been on a steady rise for nearly two decades. A 1994 *Time* magazine cover story featured an image of a broken wedding band, as well as a wonky headline—"Infidelity: It May Be in Our Genes"—that attempted to explain what many people already knew: married people were screwing around as never before. "If I told the real stories of my experiences with women, often seemingly very happily married and important women, this book would be a guaranteed bestseller," noted two-time nineties divorcee Donald Trump, in his 1997 memoir, *Trump: The Art of the Comeback.*

Trump's broken marriages, along with numerous other high-profile nineties splits, had been documented throughout the decade on tabloid shows such as *Hard Copy*, *Inside Edition*, and the too-perfectly-titled *A Current Affair*. Those were highly rated, low-blowing hits that reveled in tales of screwed-up couples with marquee names: Woody Allen and Mia Farrow; Tommy Lee and Pamela Anderson; Michael Jackson and Lisa Marie Presley; Roseanne Barr and Tom Arnold. But such luxury-class struggles weren't enough to satisfy audiences, who increasingly wanted tales of broken families and failed marriages that took place far away from Hollywood. The tabloids obliged, making semicelebs out of not only the Buttafuocos and the Fishers but also the penis-snipping Lorena Bobbitt. Even US figure-skating champ Tonya Harding wouldn't become a true headline newsmaker until she and her ex-husband, Jeff Gillooly, were accused of conspiring to harm competitor Nancy Kerrigan.

Such stories proved to be huge ratings successes, in no small part because they reinforced the idea that *everyone*'s relationships were just as messed-up as your own. "All I'm saying," noted *The Sopranos*' oft combative husband Tony Soprano, "is no marriage is perfect."

And by the end of the decade, no marriage seemed more perilously and publicly on the brink than the one being tested within the White House. Bill Clinton's infidelities had been well known for years—Hillary Clinton once described her husband as "a hard dog to keep on the porch"—but the 1998 revelation of an off-and-on rendezvous between the president and a decades-younger intern, Monica Lewinsky,

was still a shocker. The Lewinsky affair inspired a twenty-four-hour cable news cavalcade of secrets, lies, and too-intimate sex details (many of which were collected in special prosecutor Kenneth Starr's investigative report, a bestseller in the fall of 1998). It also led to Clinton's dramatic impeachment trial, which ended in his acquittal in February 1999. The whole affair created a trickle-down effect, in which the Clintons' marital strife impacted the mood of the nation: If the most powerful couple in the free world couldn't find happiness—or at least fake it convincingly—what chance did the rest of us have?

Ball's *American Beauty* idea long predated the news of the Clinton-Lewinsky relationship. But it was hard *not* to think of all that nineties dysfunction while watching the story of Lester Burnham, a mopey middle-aged husband who's become emotionally divorced from both Carolyn, his equally disaffected wife, and Jane, his constantly mortified teenage daughter. Lester's only happy when he's lustily fantasizing about Angela, one of his daughter's teenage classmates, whom he imagines hovering nude above his bed, beckoning him seductively from a sea of rose petals.

Meanwhile, Lester's next-door neighbors, the Fitts family, are even more damaged than the Burnhams: Mom's a quietly zoned-out enigma; Dad's an abusive, homophobic hard-ass who collects guns and Nazi memorabilia; and their son, Ricky, is a weed-dealing outcast who, like Heather in *The Blair Witch Project*, is most comfortable viewing the world through a video camera. The movie opens with Ricky interviewing Jane, who complains about her lame dad: "Someone really should just put him out of his misery." They're only joking about murdering Lester—or are they? "The politics of the time were in *American Beauty*, in ways that took me a while to understand," says the film's director, Sam Mendes. "In the era of Clinton and Lewinsky, the obsession about older men and younger women was preying on people's minds. And there was a post-Columbine obsession with people building guns and

bombs in the garage next door in suburbia—this sense of 'What's going on right under our noses? How well do you really know your neighbor?' That was all in the air."

At the time Ball was writing *American Beauty*, though, his primary obsession was finding a way to escape his job. In the midnineties, he had quit a gig designing infographics for *AdWeek* magazine to move to Los Angeles. Thanks to his theater work, he'd been hired to write for sitcoms such as *Grace Under Fire* and the Cybill Shepherd series *Cybill*, the latter of which he found especially dispiriting. "It was horrible," Ball says. "We started every episode with asking the question 'What is the moment of shit in this episode?' It's the moment where the moral of the story appears, when somebody learns a lesson or hugs, or whatever." Ball wanted to quit *Cybill*, but the money was too good. "I was so disgusted with myself, because I felt like such a whore. I had an office in my house, and I would come home at two in the morning, stay up for another two or three hours, and just pour all my rage into this screenplay." Early in the film, Lester grows so tired of being belittled at his own advertising magazine job that he blackmails his boss in order to free himself. "It's no coincidence that the screenplay is about a writer who, over the course of the movie, rediscovers his passion," says Ball. "Because that was happening for me."

Ball's *American Beauty* script was circulating among several small production companies when he got a call from his agent, telling him Steven Spielberg was about to give it a read. The director and cofounder of DreamWorks was looking for material for his fledgling studio, which had so far released a mix of family comedies, including *Mouse Hunt*, and somber, upscale dramas such as *Amistad*. DreamWorks didn't seem like the logical home for a script that features its ostensible hero joylessly jerking off in the shower. "I thought, 'Oh, Spielberg will hate it,'" says Ball. But during a visit to the studio's offices, Ball saw the director approaching him in the parking lot. "He was so nice," Ball remembers. "He said, 'Why I haven't I heard of you?' And I said, 'I've been working in television.'"

Mendes was also largely unknown at that point—at least among those who didn't follow the theater. Though only in his early thirties, the English-born director had overseen two of 1998's most highly touted stage shows: a lusty New York City revival of *Cabaret* and the even lustier *The Blue Room*, which had become a phenomenon far beyond Broadway, thanks to the presence of its occasionally nude star, Nicole Kidman (it was one of her first gigs after the long ordeal of *Eyes Wide Shut*). Mendes's *Blue Room* production was such a hard-to-get ticket that Kidman appeared on the cover of *Newsweek*, though Mendes did his best to ignore the hoopla. "A week before it opened, I picked up a copy of *Entertainment Weekly*," says Mendes. "They printed a map of the theater where it was playing, showing the seats from which you could see more than Nicole Kidman's ass. That was the moment I stopped reading the press."

Though he had no behind-the-camera experience, Mendes's stage run was impressive enough to earn him the attention of Spielberg, who'd seen the young director's reimagining of *Oliver!* in London, and afterward offered him the chance to make *American Beauty*. Mendes would get his first choice of actors for the film, including Kevin Spacey and Annette Bening as the embroiled Lester and Carolyn. And he was allowed to maintain the bleakness of Ball's screenplay—one of several 1999 stories, from *The Sopranos* to *Fight Club* to *Office Space*, about a particularly navel-gazing sense of white-male malaise. "I loved that Alan never came down on one side or the other on Lester," says Mendes. "In one sense, he's heroic, and in another sense, he's pathetic. And if you look across the films of that year, they were stories about outliers: the loners, the people no one pays attention to."

Within DreamWorks, *American Beauty* was a bit of an outlier itself, budgeted at just $15 million—far lower than the big-scale, ostensibly brand-building films the studio was producing at the same time, including *The Haunting* and *Gladiator*. "We were seen as 'that weird little movie that Steven likes,'" says Ball. Production on the film began in late 1998 on a studio backlot featuring pristine suburban houses that

had been used for TV sitcoms, parts of which were infested with rats. For the shoot, Mendes would be working with the seventy-two-year-old cinematographer Conrad Hall, who'd filmed such luxurious-looking sixties legends as *Cool Hand Luke* and *Butch Cassidy and the Sundance Kid*; he'd been hired at the suggestion of Tom Cruise, who'd read the *American Beauty* script. But Mendes wound up scrapping their first few days' worth of material. "Everything about it was a bit wrong," Mendes says. "The location was wrong. The lighting was wrong. Their performances were slightly over the top. Everything was ever so slightly too theatrical."

Mendes wound up meeting Spielberg at his home, where the director/studio boss threw on a DVD of *Dr. Strangelove* and discussed Kubrick's sustained-shot visual style. When the production started up again, Mendes and Hall altered their approach, moving to new sets and filming fewer takes. They also devised several visual cues underscoring Lester's solitary confinement. In *American Beauty*, he's first introduced onscreen in a boxlike shower stall; later, in his meager office space, his face is reflected on his computer monitor, surrounded by vertical lines of text that resemble prison bars. No matter where he goes early in the film, Lester appears trapped.

Though much of *American Beauty* centers on the bilious marriage between Lester and Carolyn—the latter of whom seeks freedom by having a rompy affair with a local Realtor and playing with her newly purchased handgun—the film also devotes plenty of time to the equally screwed-up kids in their lives. It's the teenagers in *American Beauty*, Mendes says, "who see the world with a greater clarity than the adults." Several young actors tried out for the roles of the three high schoolers, including Reese Witherspoon, Ryan Phillippe, Jared Leto, future *Big Bang Theory* star Johnny Galecki, and *American Pie*'s Tara Reid. It took several agonizing months, and numerous meetings, before Thora Birch learned she'd won the part of Jane, the Burnhams' alienated daughter who's saving up for breast augmentation surgery and who treats her parents with unrelenting disdain. "She was the perfect character for me

to play at that time," says Birch, who was seventeen years old when filming began and who'd been acting for a decade. "We both rebelled against the pop side of culture that was around. Jane wasn't going to be in *American Pie*—and neither was I."

It's Jane and her camera-wielding boyfriend, Ricky, played by Wes Bentley, who bear witness to *American Beauty*'s rare moment of suburban reverie—a scene Ball had been carrying around with him for years. One day in Manhattan in the early nineties, he'd found himself walking home to Brooklyn, taking a path that had brought him into the plaza of the World Trade Center. "I'd met friends for brunch and had a couple of Bloody Marys," he says. "It was an overcast day, and this white plastic bag was blowing, and it circled me fifteen times in a row. I was a little buzzed. But I believe in stuff beyond what we can perceive. And I felt like I was in the presence of something that was telling me 'You don't need to be afraid.'" He revisited that feeling in *American Beauty*, during which Ricky shows Jane a video he took of a bag swirling in the wind, occasionally plummeting to the leaf-covered pavement below. "Sometimes," Ricky tells Jane, "there's so much beauty in the world, I feel like I can't take it, and my heart is just going to cave in."

Mendes shot the floating bag scene in the early morning at a schoolyard in suburban Los Angeles, using a pair of wind machines. "It was comical," he says. "People nearby were going to work, and they just thought, 'Look at that poor fucker making his student film, clearly not having a clue.' And they were partially right!" For some viewers, the floating bag sequence, and Ricky's accompanying monologue, would come off as the none-too-deep ramblings of a teenage stoner. But for others, it was a bit of metaphysical life affirmation. "That speech spoke to me," says Birch. "It's that moment in your life when you realize everything's going to be okay, even when it's horrifying. Your heart opens up, and you really feel alive and present. We might have overdone it— but it was the moment to overdo." Adds Mendes, "I was always aware that, in the wrong context, that speech is bordering on pretentious. But I thought there was something beautiful about it at the time, and I still do. We all want to be cynical or ironic. It's difficult for people to say that

things are transcendent, that things are beautiful, that things are worth looking at."

American Beauty kept a low profile for most of the year, partly due to DreamWorks' being wrapped up in far more expensive endeavors, partly because the film was being released in a crowded late-in-the-year holiday season. "*American Beauty* was not on the radar at all," says Mendes. Though the director was still doing his best to ignore the press, he couldn't help but rush out to buy the *Los Angeles Times'* fall movie preview edition, looking for a mention of *American Beauty*. "They didn't put the movie in there anywhere," Mendes says. "I was devastated."

But *American Beauty*'s premiere that September at the Toronto Film Festival kicked off what would be several months' worth of positive reviews. *The New Yorker*'s David Denby called it "by far the strongest American film of the year." Soon afterward, DreamWorks began a slowly unfolding marketing campaign, one that included a vague, borderline-aloof poster featuring a red rose held against a woman's bare stomach and a cryptic tagline: "Look closer." The studio also released a crackerjack trailer that synthesized the movie's characters—the invisible dad, the angry wife, the restless teens—and scored them to the Who's anthem "Baba O'Riley," capping it all off with a gunshot. It tapped into a feeling that had been building throughout 1999—that something about the country was just slightly *off*. In a year that saw a pair of suburban Colorado teenage killers dubbed "The Monsters Next Door" on the cover of *Time* and a president who almost lost his job over a May–December sex scandal, the seamy underbelly of *American Beauty* felt creepily relatable.

Within months, *American Beauty* was a topic of conversation everywhere—including the White House. "An amazing film," Bill Clinton said. "'Okay, we've got this nice little neat suburban lifestyle, and we're comfortable, and now what?' I must say, it was also a disturbing movie." *American Beauty* became seismic enough that, in early 2000, *Premiere* film critic Glenn Kenny—who'd put *American Beauty* on his

best-of-the-year list—was invited onto Fox News' *The O'Reilly Factor*. The show was headlined by Bill O'Reilly, the bellowing anchor who'd hosted *Inside Edition* at the height of the Amy Fisher/Joey Buttafuoco scandal. "He thought *American Beauty* was—wait for it—un-American," Kenny says. "He was like, 'It shows drug dealing and sex, and teenagers are going to see it and think it's cool to be a drug dealer.' I was like, 'This isn't a movie teenagers are interested in seeing. It's an American art movie, you know?'"

But enough people were interested in seeing *American Beauty* to help it earn $130 million in the United States. And DreamWorks—which had watched its 1998 hit *Saving Private Ryan* lose the Best Picture Oscar to the wispy *Shakespeare in Love*—was determined to make *American Beauty* an Oscar contender. It carefully kept the movie in a relatively limited number of theaters to ensure that it didn't blow up and fade out too soon. The studio even threw a party at an LA restaurant that was set up to resemble the troubled *American Beauty* home. The invitation read, "Celebrate the Holidays with the Burnhams."

By then a backlash against *American Beauty* had already begun to arise. Depending upon which detractor you listened to, *American Beauty* was either too facile or too earnest. Mainly, though, the early bashers of *American Beauty* thought the whole thing was just too cartoonish: Who would believe that Nazi sympathizers would be living in picket-fence America? Or that a middle-aged square like Lester could be such a skeevy creep? Or that everyone in America was just so *angry*?

12

"I WANT YOU TO HIT ME AS HARD AS YOU CAN."

FIGHT CLUB

Sometimes, during their breaks, the men who worked alongside Chuck Palahniuk would gather to talk about where their lives had gone wrong. It was the early nineties, and Palahniuk was employed at a Portland, Oregon, truck-manufacturing company called Freightliner. Many of his colleagues were well-educated, underutilized guys who felt out of sorts in the world—and they put the blame on the men who'd raised them. "Everybody griped about what skills their fathers hadn't taught them," says Palahniuk. "And they griped that their fathers were too busy establishing new relationships and new families all the time and had just written off their previous children."

Palahniuk's Freightliner duties included researching and writing up repair procedures—tasks that required him to keep a notebook with him at all times. At work, when no one was looking, he'd jot down ideas for a story he was working on. He'd continue writing whenever he could find the time: between loads at the laundromat or reps at the gym or

while waiting for his unreliable 1985 Toyota pickup truck to be fixed at the auto shop. The result was a series of "small little snippets" about an unnamed auto company employee who's so spiritually inert, so unsatisfied, that he finds himself attending various cancer support groups, just to unnumb himself. He soon succumbs to the atomic charisma of Tyler Durden, a mysterious figure whose name had been partly inspired by the 1960 Disney movie *Toby Tyler*. "I grew up in a town of six hundred people," says the Washington-born Palahniuk, "and a kid in my second-grade class said he'd been the actor in that movie. Even though he looked nothing like him, I believed him. So 'Tyler' became synonymous with a lying trickster."

After meeting Tyler Durden, Palahniuk's narrator begins attending Fight Club, a guerrilla late-night gathering in which men voluntarily beat each other bloody. Fight Club comes with a set of fixed rules, the most important of which is that, no matter what, *you do not talk about Fight Club*. Many of the book's brawlers are working-class guys with the same dispiriting jobs—mechanics, waiters, bartenders—held by some of Palahniuk's friends. "My peers were conflict averse," says Palahniuk. "They shied away from any confrontation or tension, and their lives were being lived in this very tepid way. I thought if there was some way to introduce them to conflict in a very structured, safe way, it would be a form of therapy—a way that they could discover a self beyond this frightened self."

Palahniuk would bring work-in-progress chapters to writing classes and workshops around Portland, holding one successful early reading at a lesbian bookstore. "They wanted to know 'Is there a women's version of this?' he says. "They just assumed Fight Clubs existed in the world and wanted to participate." Palahniuk, then in his early thirties, had recently seen his first novel get rejected. "I was thinking 'I'm never getting published, so I might as well just write something for the fun of it.' It was that kind of freedom, but also that kind of anger, that went into *Fight Club*." He'd wind up selling the book to publisher W. W. Norton for a mere $6,000.

Fight Club's quiet 1996 release came just a few years after the arrival

of the so-called men's movement, in which dissatisfied dudes looking to reclaim their masculinity would gather for all-male retreats in the woods. They'd bang drums and lock arms in the hope of escaping what had become a "deep national malaise," noted *Newsweek*. "What teenagers were to the 1960s, what women were to the 1970s, middle-aged men may well be to the 1990s: American culture's sanctioned grievance carriers, diligently rolling their ball of pain from talk show to talk show."

Palahniuk's *Fight Club* characters, though, were younger and angrier than their aggrieved elders. A few primal scream sessions in the woods weren't going to cut it. "We are the middle children of history, raised by television to believe that someday we'll be millionaires and movie stars and rock stars, but we won't," Tyler says of his peers, adding "Don't fuck with us." It was one of many briskly written yet impactful mission statements in Palahniuk's book, which earned positive reviews from a few major critics—the *Washington Post* called it "a volatile, brilliantly creepy satire"—as well as the author's own father. "He loved it," Palahniuk says. "Just like my boss thought I was writing about *his* boss, my dad thought I was writing about *his* dad. It was the first time we really connected. He'd go into these small-town bookstores, make sure it was there, and brag that it was his son's book."

Fight Club wasn't an especially big performer in its original hardcover run, selling just under 5,000 copies. But before it even hit shelves, an early galley copy reached producers Ross Grayson Bell and Joshua Donen, the latter of whom had produced such films as Steven Soderbergh's noir *The Underneath*. Bell was put off by some of the book's violence, but as he read further, he arrived at *Fight Club*'s big revelation: the insomniac narrator, it turns out, really *is* Tyler Durden, and at night he's been unknowingly leading the Fight Club army raiding liposuction clinics for human fat—first to turn into soap, and then to use for explosives. Eventually Tyler's hordes of followers begin engaging in a series of increasingly violent acts. "You get to the twist, and it makes you reassess everything you've just read," says Bell. "I was so excited, I couldn't sleep that night." Looking to make *Fight Club* his first produced feature, Bell hired a group of unknown actors to read the book

216

aloud, slowly stripping it down and rearranging parts of its structure. He sent a recording of their efforts to Laura Ziskin, who'd produced *Pretty Woman* and was now heading Fox 2000, a division that focused on (relatively) midbudget films. According to Bell, after listening to his *Fight Club* reading during a fifty-minute drive to Santa Barbara, Ziskin hired him as one of *Fight Club*'s producers. "I didn't know how to make a movie out of it," said Ziskin, who optioned the book for $10,000. "But I thought *someone* might."

Ziskin gave a copy of Palahniuk's book to David O. Russell, who declined. "I read it, and I didn't get it," Russell says. "I obviously didn't do a good job reading it." There was one filmmaker, though, who definitely got *Fight Club*. He was the perfect match—a guy who viewed the world through the same slightly corroded View-Master as Palahniuk; who could attract desirable actors; who could make all of *Fight Club*'s bodily fluids splatter beautifully across the screen. And he wasn't afraid of drawing a little blood himself.

"I grew up in a particularly weird place and time," says David Fincher. He was raised in Marin County in San Francisco in the sixties and seventies, right as the area was being invaded by autonomy-seeking young filmmakers looking to flee Los Angeles. It wasn't unusual for residents to catch a glimpse of George Lucas—"he was the rich neighbor up the street who'd bought the house and restored it impeccably"—as well as big-studio directors such as Michael Ritchie and Philip Kaufman. "None of the kids in my neighborhood wanted to be doctors or lawyers," Fincher adds. "They all wanted to be moviemakers."

So did Fincher, who began taking film classes as far back as elementary school—which was also right around the time he discovered an aversion to bureaucracy. And authority. And unquestioned rules of any kind. "Even at a very early age," he says, "I didn't understand why you didn't have any say in your curriculum. Because I just wanted to make movies, and I didn't understand why they wanted me to learn all

of this other shit. And I had parents who were very much about pushing authority. They didn't want their kid to be taken advantage of." Fincher's father was a journalist and author, while his mother was a mental health nurse who worked in a methadone clinic; they often discussed their jobs with their young son. "My parents didn't keep much from me," he says. "They were like, 'Here's the world you're going out into.'"

In the early eighties, Fincher skipped college and went to work for the rich guy up the street, taking a job at the Lucas-owned Industrial Light & Magic—where he helped out on *Return of the Jedi*—before directing an incendiary commercial for the American Cancer Society featuring a lifelike puppet fetus puffing on a cigarette. Made for just a few thousand dollars, the ad was a black-humored homage to the spectral "Star Child" of *2001: A Space Odyssey*, and it brought on the first controversy of Fincher's career: major networks refused to run the spot, while tobacco companies objected to its bluntness.

Fincher would go on to direct several more commercials, eventually entering the world of music videos, where he'd make some of the most rewind-worthy entries of the eighties and early nineties: Madonna's epic *Metropolis* riff "Express Yourself"; George Michael's luxurious "Freedom '90"; Aerosmith's revenge noir "Janie's Got a Gun." Though his videos were often big hits on MTV, "people who worked in commercials and those who worked in features didn't cross-pollinate," says *Fight Club* editor and longtime Fincher collaborator Jim Haygood. "And music videos weren't taken seriously at all." But by the time Fincher's sultry black-and-white clip for Madonna's "Vogue" premiered in 1990, his videos were just as cinematic as anything else on the small screen.

The next year, Fincher was hired for his first feature: Fox's troubled deep-space excursion *Alien 3*. The $56 million production had already seen one director come and go, and when the twenty-seven-year-old Fincher showed up in England for filming, the film lacked a finished script. He found himself locked in combat with executives for much of the months-long shoot, making late-night calls after a long day of filming in order to justify the next day's shoot. The whole process, Fincher

said, was akin to being "sodomized ritualistically for two years." He all but disowned the film and despised the studio whose logo appeared before it.

After *Alien 3*'s disappointing reception, Fincher figured he was unemployable as a film director and returned to making commercials. It would take more than three years before the release of his next film, 1995's *Seven*, a gorgeously dismal serial-killer drama with a head-snapping final twist. It became a worldwide hit, and while Fincher was editing a follow-up, the *Twilight Zone*–indebted thriller *The Game*, he got a call from Ross Grayson Bell's producing partner, Joshua Donen, urging him to read *Fight Club*. "I was in my late thirties, and I saw that book as a rallying cry," says Fincher. "Chuck was talking about a very specific kind of anger that was engendered by a kind of malaise: 'We've been inert so long, we need to sprint into our next evolution of ourselves.' And it was easy to get swept away in just the sheer juiciness of it." *Fight Club* producer Ceán Chaffin notes, "I remember him reading it in galley form and laughing the whole time. It seemed like exactly the kind of movie he should be making."

Fincher tried to buy the rights to *Fight Club* himself, only to find that Fox had beaten him to it. Still resentful about the *Alien 3* fiasco, he had little interest in working with the studio again. But after a meeting with Ziskin, he considered returning to Fox for *Fight Club*—so long as he could make it in the grandest way possible. "I said, 'Here's the two ways you can go: you can do the $3 million version of this movie and make it on videotape and make your seditious little sharp stick in somebody's eye." But the real "act of sedition," he told the studio, would be to invest tens of millions of dollars "and to put movie stars in it and get people to go and talk about the anticonsumerist rantings of a schizophrenic madman." Fox agreed to give Fincher some time to put together a script and a cast, to see if there was any way to make *Fight Club* a reality. "It was a dark little book—not exactly the kind of fodder for a movie," says Bill Mechanic, then the studio's chairman. "I thought it would never see the light of day." (As for *Fight Club*'s author, he had no idea who Fincher even was: "I hadn't been to the movies since I was in college in the early

eighties," says Palahniuk. "I'd become really annoyed with people's be-havior in theaters.")

To Fincher, *Fight Club* was heir to *The Graduate*, another tale of a distressed young man pushing back against an older generation's ex-pectations. In Fincher's mind, "we were making a satire. We were saying 'This is as serious about blowing up buildings as *The Graduate* is about fucking your mom's friend.'" A copy of *Fight Club* would even be sent to *Graduate* screenwriter Buck Henry, to see if he'd be interested in tak-ing a crack at the adaptation. (Henry's response, according to Fincher: "I don't think there's anything funny about it.") Instead, the job went to Jim Uhls, who'd spent much of the nineties "getting hired to write things that didn't get made," he says. Palahniuk's book had resonated deeply with Uhls, who'd worked for five years as a bartender before selling his first script. "I knew what it was like to have a bullshit job," Uhls says. "It affected how you felt about yourself, in a masculine way. And after I read *Fight Club*, my jaw was on the ground for two weeks. But I was also brac-ing myself: 'It will be fun to write this, but it's never going to be made.'"

After a "marching orders" meeting with Fincher and Bell, Uhls began work on a *Fight Club* script. "The book had a billion wonderful things in it, but you can't put them all in," says Uhls. One of the screen-play's biggest innovations was the finale, in which Tyler Durden and his anonymous followers—dubbed "space monkeys"—take down the credit card companies in order to create what Tyler calls "economic equilibrium." It had come out of conversations between Uhls and Bell, the latter of whom was broke and living off credit cards. He'd watched as debt levels soared around the world in the nineties, in part because of global deregulation. At the same time, a midnineties Supreme Court de-cision had freed up credit card companies to enact record-high late fees. By the end of the decade, millions of people were feeling overleveraged. "I said, 'What if they blow up the credit card companies, and everybody woke up one day and they didn't have to pay their bills?'" remembers Bell. "We needed something where the audience members would cheer the destruction of the world."

They also needed a movie star who could pull off that destruction

with charm: Brad Pitt. The actor had become one of the decade's few newly anointed movie stars, having portrayed an emo bloodsucker in *Interview with the Vampire*, a tic-ridden loon in the Oscar-nominated *12 Monkeys*, and a newbie cop in Fincher's own *Seven*. One night in the summer of 1997, Pitt was returning to an apartment in New York City—having worked a long day on the somnambulant drama *Meet Joe Black*—when the director met him outside with a copy of the *Fight Club* script. The actor was tired, but Fincher promised him that it would be worth staying up for a bit.

Pitt was thirty-three years old at the time, unfathomably sculpted and uncannily cool, which made him well suited to play the coarsely charming Tyler Durden, who seduces *Fight Club*'s narrator, at least philosophically, with salvos such as "The things you own end up owning you." On the night the two men first hang out, Tyler convinces the narrator to do him a favor—"I want you to hit me as hard as you can"— that quickly leads to a bond-building fistfight in a bar parking lot. Tyler is Friedrich Nietzsche's Übermensch, only somehow *more* über: He drives a stolen convertible, has epic sex with a theatrically suicidal chain-smoker named Marla, and somehow makes giant red-tinted sunglasses look cool.

Even though Pitt had been marquee-name famous for much of the decade and was dating *Friends* star Jennifer Aniston—who'd personally shave Pitt's head for his *Fight Club* role—he could relate to the movie's existential uncertainty. "I'm the guy who's got everything," he said at the time. "[But] once you get everything, then you're just left with yourself. I've said it before and I'll say it again: It doesn't help you sleep any better, and you don't wake up any better because of it."

Fincher wouldn't find the right actor to play *Fight Club*'s impressionable, unknowingly anarchic narrator until he watched *The People vs. Larry Flynt*, the 1996 porn-kingpin biopic starring Edward Norton as a guileless lawyer. "I saw him deliver the speech before the Supreme Court, and I was like, 'That's the guy,'" says Fincher. "Because this character needs a kind of verbal diarrhea." He also recognized a unique malleability. "Edward's ultimately kind of a blank slate," said Fincher

at the time. "His opacity is part of the thing that makes him a terrific Everyman."

Norton, in his late twenties, was a Yale-educated theater actor who'd earned an Oscar nomination for his first film role, playing a murderer posing as a simpleton in *Primal Fear*. "I was lucky in the sense that I kind of had one of those zero-to-sixty moments," says the actor. "I didn't go through a phase where I felt like I should take anything that came my way. I had the luxury of choosing, and though I had lots of sort of commercial stuff coming at me after *Primal Fear*, none of it was particularly compelling to me." Instead he opted for a series of wildly dissimilar films, including a Woody Allen musical (*Everyone Says I Love You*); a crackling, seventies-indebted cardshark-noir (*Rounders*); and a seering neo-Nazi drama (*American History X*).

Norton read *Fight Club* in one sitting; like Fincher, it reminded him of *The Graduate*, albeit updated for the end of the twentieth century. "It took aim right at what a lot of us were starting to feel," says Norton. "The book was so sardonic and hilarious in observing the vicissitudes of Gen-X/Gen-Y's nervous anticipation of what the world was becoming— and what we were expected to buy into." When he first talked to Fincher about *Fight Club*, Norton says, "I said, 'You're going to do this as a comedy, right?'" And he was like, 'Oh, yeah—that's the whole point.'"

For weeks, Norton, Pitt, and Fincher would meet with Andrew Kevin Walker, who'd written *Seven* and revised parts of Uhl's script: "He made this amazing chair, and I came and sanded some of the edges and maybe put the little things that protect the floor on the bottom," says Walker. They'd hang at Pitt's house or at an office across from Hollywood's famed Grauman's Chinese Theatre, where they'd drink Mountain Dew, play Nerf basketball, and talk for hours, riffing on the film's numerous bull's-eyes: masculinity, consumerism, their aggravating elders. "We were sitting around, thinking of all the things we wanted to stick a fork [into]," says Norton, who was especially irked by the recent revival of the Volkswagen Beetle, an icon of the flower-power era that was being targeted to younger drivers. "They just wanted to repackage an authentic baby boomer youth experience to us—they don't even

want us to have our own," he says, laughing. "They just want us to buy sentiment for the sixties, with a little fucking molded flower that you sit in the dashboard. And they wonder why we're cynical." As they lined up their targets and worked on the script, the actors and filmmakers were "breaking apart every line like it was Shakespeare," said Pitt. "It's such a hard film to get a handle on. How do you characterize something you've never seen before?"

Throughout their conversations, all four contributed ideas to a long spiel they dubbed "a Mamet rant"—"as if to aspire to the greatness of David Mamet," says Walker. "It was stuff like 'You're not the contents of your wallet.'" Some of their Nerf session conversations were incorporated into a long anti–pep talk Tyler gives the narrator early on. "Fuck off with your sofa units and green stripe patterns," he tells him. "I say: Never be complete. I say: Stop being perfect."

After working to put together *Fight Club* for months, "I went back to Fox with this unabridged dictionary-sized package," remembers Fincher. "'It's Edward. It's Brad. We're going to start inside Edward's brain and pull out. We're going to blow up a plane. All this shit. You've got seventy-two hours to tell us if you're interested.' And they said, 'Yeah, let's go.'"

Holt McCallany could always tell if he was stuck in a bad movie. "You know when you're making a turkey," says McCallany, who began acting in the mideighties. "You're like, 'God, why did I agree to do this? Can I give back the money? Can I claim an injury? Maybe fake a death in the family or a heart attack?' And there are times when you're equally sure you're part of something very special. That was the case on *Fight Club*."

Fincher had cast McCallany as "the Mechanic," one of the legions of unnamed bruisers who join Tyler's underground movement, taking up residence in the group's dilapidated headquarters—dubbed the Paper Street House—and aiding him in his acts of urban menace. McCallany was particularly well suited for the role: he'd worked with Fincher on *Alien 3* and had trained in mixed martial arts. Perhaps more important,

McCallany, then in his midthirties, could relate to *Fight Club*'s sense of existential displacement. "Think about our grandfathers' generation," he says, "and what that must have meant to go to World War Two and fight this epic battle against this consummately evil adversary. And to return to your homeland in victory and prosperity and to see the gratitude of your friends and your family and the brotherhood that you shared. You'd carry that with you the rest of your life. But for us younger guys kicking around in 1999, we didn't have any of that. What are we supposed to do? Get a one-bedroom apartment and furnish it at IKEA?"

He wasn't alone in his frustration. In the fall of 1999, the journalist Susan Faludi published *Stiffed: The Betrayal of the American Man*, in which she interviewed everyone from gang members to shipyard employees to even Sylvester Stallone to suss out the root causes of America's "crisis of masculinity." One possible cause: a postwar emphasis on consumerism and vanity. The modern man, Faludi wrote, has been sold the idea that masculinity is "something to drape over the body, not draw from inner resources; that it is personal, not societal; that manhood is displayed, not demonstrated."

Or, as Tyler Durden might put it: "Advertising has us chasing cars and clothes, working jobs we hate, so we can buy shit we don't need." It's part of a speech he gives halfway through *Fight Club*, standing in a dank bar basement surrounded by several young men—including McCallany's "Mechanic"—who will soon be brawling in order to feel . . . *anything*.

Before filming the downstairs fisticuffs, cinematographer Jeff Cronenweth lit the room with "budget busters"—little clip-on lights that could be picked up at Home Depot. "We'd age them down and put them right in the shot," says Cronenweth, "because that's what these guys would have done, in their rudimentary way, to make their spring-up club." The *Fight Club* set, he says, "wasn't just a basement— it had character and a texture you could almost touch: the smoke, the dripping water, the aging, the points of light leaking through."

There was also, of course, a good amount of blood. Before filming, Fincher and the cast had studied tapes featuring the low-budget,

224 BEST. MOVIE. YEAR. EVER.

frills-free brawls put on by Ultimate Fighting Championship, a company launched in the early nineties. "It was so raw," Fincher said. "You see someone get hit with the palm of somebody else's hand, and their nose just moves over like an inch and a half across their face."

Pitt and Norton both took boxing and tae kwon do classes before filming. But in order to play the scrawny, creature-comforted office drone who imagines himself as god-among-men Tyler Durden, Norton couldn't look as jacked as he'd been in *American History X*. "I was supposed to be becoming the junkie version of the personality, and he gets to be Tyler, the Adonis," Norton says of his costar. "Brad is the most annoying genetic miracle in the world. We were in Stage 16 at [the Fox lot]. It was one of the biggest soundstages I had ever been in, and the craft service table ran the full length of it. And on the film where I was trying to starve myself, Brad would eat six hot dogs and half of a pumpkin pie, and only get stronger and younger while I remember just sipping my hot tea. The truth is, we probably spent more time learning to make soap than we did training for anything." (The actors had, in fact, worked with an expert soap maker before filming.)

As a result, much of the combat in *Fight Club* feels sloppily forceful—the handiwork of men taking their very first swings at life. The *Fight Club* set was "a hypermasculine environment," says McCallany. "You're talking about a film set that has forty dudes on it every day and no women."

But there *was* one woman caught up in *Fight Club*: Marla, the acidic, cigarette-devouring schemer who gets wrapped up with the narrator, unaware of his lunacy. Several actors had been considered for the role, including Courtney Love, who was dating Norton at the time. "Courtney totally understood the character—there was no fucking doubt about that," says Fincher. "She got the pathos of it." Ultimately, though, "I felt their personal stuff would get in the way of the work. And there was a lot of work."

At one point Pitt had encouraged Fincher to watch *The Wings of the Dove*, the 1997 adaptation of the Henry James novel starring Helena Bonham Carter. She'd received an Oscar nomination for the film, one of

many regal English historical dramas in her filmography. Carter wasn't the obvious choice for the bilious, scheming Marla, but Fincher found her "exquisitely emotional" in *Dove* and sent her the screenplay for *Fight Club*. The script offended some of those in Carter's orbit, including her own mother. "Mum put the script outside her bedroom, because it was a pollutant!" the actor said. "I didn't get it when I first read it, either. I thought, 'This is weird. Is this message particularly life-enhancing?'"

She met with Fincher at a Four Seasons in Los Angeles—"just to ascertain that he wasn't a complete misogynist," she said—before writing the director a long fax, outlining her reservations. "I just said, 'I've got to play it with a big heart.' Marla had to have a heart, otherwise she'd be just a nightmare. I was talking myself into it. By the end of the letter I'd convinced myself to do it." Notes Norton: "Helena is so funny. In British theater, if you break [character] laughing, they call it 'corpsing.' And she was the absolute worst. She couldn't get through a take without breaking up. It was like, 'You know, Fincher's already going to do forty of these takes—do you really want to make it seventy?'"

After being cast, Bonham Carter called *Fight Club* costume designer Michael Kaplan, who'd created the future-shocked styles of *Blade Runner*, as well as *Flashdance*'s shoulder-baring sweats. "Helena said, 'Who the fuck is Marla Singer? You're going to have to help me with this one,'" remembers Kaplan. "My response was 'Think Judy Garland for the millennium. Not the actress in *The Wizard of Oz*—think Judy Garland later on, when she was a bit of a mess, drinking and doing drugs while her life was falling apart.'" Marla's look is that of a desperate yet still self-respecting thrift store scavenger, with a wardrobe that includes wide-brimmed vintage hats and an old bridesmaid dress.

That same low-budget aesthetic also applied to Tyler Durden, Pitt's swaggering, hallucinatory megamale. "David is the prince of black and gray," says Kaplan, who worked with the director on *Seven*. "But on this, he said, 'Just this once, Michael, you can't go too far with this character.'" Durden's wardrobe grows louder as the movie continues: a blood-red leather jacket with busted-up buttons; a ratty bathrobe covered with cartoon teacups; a tank top featuring seventies porno-mag imagery

(which Fox would frantically fuzz out at the last minute when they discovered it on the *Fight Club* trailers). "I could do anything with Brad, and he could sell it," says Kaplan. Even for Durden, however, there were limits. "I still have a Polaroid of Brad wearing a tube top," says Kaplan. "Fincher looked at it and said, 'I know I said you can't go too far. But you've gone too far.'"

As for the narrator's drab nine-to-five wardrobe, Kaplan gave Norton generic, off-the-rack shirts and suits: "No style, really—clothes you'd get bored just looking at." Norton's character, a midlevel auto-recall coordinator who lives in a world full of Starbucks and IKEA catalogs, exists in a self-made prison, one promising maximum security. But like Lester in *American Beauty* or Peter in *Office Space*, the narrator is aching to see a world beyond his cubicle. The difference is that he abandons his job by repeatedly smashing himself in the face, throwing himself atop a glass table, and threatening to blame it all on his boss.

The filming of *Fight Club*'s office-life sequences, which were handled early in production, kicked off debates between Norton and Fincher that would continue throughout shooting, as the two men tried to settle on the movie's tone. "I think Edward had this idea of, 'Let's make sure people realize that this is a comedy,'" says Fincher. "He and I talked about this ad nauseum. There's humor that's obsequious, that's saying, 'Wink-wink, don't worry, it's all in good fun.' And my whole thing was to not wink. What we want is for people to go, 'Are they espousing this?'" The ensuing debates often played out on set: McCallany remembers times in the which cast members stared at the floor for half an hour, while Norton and Fincher deliberated. Over the course of countless takes, though, the two men found the proper alchemy of madcap and menace. "I was doing something in one of those office moments," says Norton, "and I looked at Fincher, like, 'Is this what you're thinking?' And he goes, 'A little less Jerry, a little more Dean.' And I knew exactly what he meant."

Norton worked on *Fight Club* for 129 days—the longest shoot of his career. On the last night of filming, he and Pitt stayed up until four a.m., listening to Radiohead's *OK Computer*, the 1997 magnum opus that,

like *Fight Club*, was a download of twenty-first-century agitation and anxieties: technology, consumerism, pop-cultural congestion. "We had them on a lot," says Norton. "Thom [Yorke] told me a long time later that, while they were touring for *OK Computer*, they had *Fight Club* on in the bus all the time."

But in the final moments on the *Fight Club* set, he and Pitt weren't contemplating what was ahead. They were still trying to make sense of what they'd just experienced. "Brad and I were smoking a joint in the trailer, trying to remember what we had done in the early days of the film," Norton says. "Like they were dreams we were collectively trying to remember."

After *Fight Club* wrapped, Fincher and his team began assembling the film's unsettling score and crazy rhythms—the elements that would make the movie feel all the more pummeling to audience members. To compose the film's soundtrack, Fincher turned to the Dust Brothers, the production duo whose album credits included the Beastie Boys' 1989 sample bouillabaisse *Paul's Boutique*, as well as Beck's 1996 deep-grooving *Odelay*. The Brothers—Mike Simpson and John King, both in their early thirties—had never scored a feature film before. In their early meetings with Fincher, who loved *Odelay*, the director pointed to Simon and Garfunkel's folk-pop tunes in *The Graduate* as an example of how he wanted the movie and its music to align. He also gave the Brothers a few sonic-specific notes. "David said, much to my chagrin, that he wanted music that sounded like it was from white guys who thought they were funky but really weren't," says King. "I was like, 'Thanks a lot.' But he was being creatively honest. We didn't have to try to deliver that—we *were* white guys that thought we were funky."

King and Simpson had spent much of the late nineties in a Silverlake home studio, where they'd recorded albums by Hanson, Mick Jagger, and Marilyn Manson. It was jammed with vintage equipment—electric pianos, effects units, a Wurlitzer—all of which would be used on *Fight Club*. "We were going retro but using state-of-the-art samplers

to make it all sound good," says Simpson. He and King worked on separate scenes around the house, with Fincher sometimes going from room to room, listening to what the Brothers had created. For the film's main theme, Simpson remembers, "Fincher wanted it to be like a bee is stuck in your ear. He wanted to give the audience the impulse to leave the theater before the opening credits were done." The result was a whirling, corrosive swarm of synths and guitars—just one of several ominous grooves that would populate *Fight Club*. "There's a schizophrenic quality to the music," says King. "But perhaps that's appropriate for the movie."

When Fincher wasn't checking in on the brothers at their home studio, he was in a house in nearby Los Feliz that would serve as *Fight Club*'s postproduction headquarters. "It was this weird abandoned mansion—kind of like the Paper Street House," says *Fight Club* editor Jim Haygood, who put the film together there. "People were coming and going, lights were coming on. The neighbors thought we were shooting porn or something. I thought, 'This is perfect.'" The movie's narrative was carefully fractured, told with sporadic flashbacks, voice-over, and even a few subliminal shots of Tyler Durden popping up unexpectedly into the frame. *Fight Club* played like a ride-along, allowing viewers to share the narrator's descent into madness. "David's thing is 'You've got to assume that people are smart—you want them in on it,'" says Haygood. "And the concept of *Fight Club*—certainly during the opening moments—was to just pile stuff on. The movie has this kind of tumbling energy, where it's always falling into the next scene."

Everyone involved with *Fight Club*'s postproduction had been rushing to meet the film's scheduled release: July 16, the same date Warner Bros. had reserved for *Eyes Wide Shut*. One especially difficult shot had taken almost a year to complete: the destruction of the credit card companies' headquarters, their glittering buildings collapsing in piles of smoke and glass as the narrator watches and wonders where his mind has gone. Fincher's team of visual effects artists worked frame by frame, creating each shattered window shard, with the director regularly calling in to get updates. "I was always wondering about, if our cell phones

were tapped, what the CIA would be thinking," Fincher said, recalling their conversations. "'Well, building number three is going to go down *really* easily.'"

In early 1999, Fox finally held its first screenings for studio executives. By then, *Fight Club*'s budget had reached nearly $65 million. It was a sizable price tag for a movie that, as Fincher had promised, amounted to a corporate-backed act of sedition. "We started to reveal to people the hand we were holding," Fincher says. "It was not a warm and fuzzy time. It was prickly."

Even to those who'd read Uhls's script or watched some of the dailies, the nearly finished version of *Fight Club* was a shocker. It wasn't just its nonstop mayhem that proved disturbing, though any movie that includes bomb-making goons running wild through a city—and ends with its supposed hero blowing a hole through his cheek—was bound to cause some recoil. What stuck with viewers long after *Fight Club* ended was the movie's piss-taking rejection of the last half century's worth of postwar social values. Money? Looks? Upward mobility? None of it mattered, and none of it was making *you*, the audience member, happy—and the makers of *Fight Club* knew it. Watching the movie was like getting a middle finger to the eye. "I had two reactions," says Bill Mechanic. "One was that anything that makes you this uneasy is great. The other was that anything that makes you this uneasy is going to be a knockdown battle."

In the weeks after Fincher first screened *Fight Club*, he says, the movie was seen within Fox as "a dirty joke." But after the April 20 massacre at Columbine High School, the attitude within the studio drastically changed. "All of a sudden," Fincher says, "it became 'How could you?'" Fincher had watched as newscasts reran the scene of Leonardo DiCaprio's trenchcoat-clad character from *The Basketball Diaries* shooting up a high school. If critics were going to look to popular culture as a possible culprit, Fincher's "plutonium-filled lunchbox," as he called *Fight Club*, gave off an unmissable glow. "We had guys shaving their heads

and dressing in black," Fincher says. "There was no doubt Columbine was going to spin this."

Fight Club's release was soon shifted from summer to mid-October—a move Fox claimed was unrelated to Columbine and instead meant to give the director a chance to reduce *Fight Club*'s overlong running time. But according to the Fincher, "they felt that if they had more time to work on me, they were gonna get me to tone some of the stuff down." Instead, no substantial changes to *Fight Club* were made as the studio waited out its release. "Here's the hilarity: You look back on it and go, 'It's not that violent a movie,'" Fincher says. "I felt we had been too circumspect. But you look at the time, and the people who got their knickers in a twist. Fox was right to be trepidatious."

The studio's decision to delay the release of *Fight Club* inadvertently distanced the film from one of the year's most notably rage-filled events: Woodstock '99. Held over the course of a long weekend in late July, the festival was marked by instances of violence, nearly all of it carried out by young men, along with several reports of sexual assault. "How many people here woke up one morning and just decided it wasn't one of those days, and you were gonna break some shit?" asked Limp Bizkit frontman Fred Durst during the band's chaos-causing set. "Well, this is one of those days, y'all!" Before the event ended, cars had been set ablaze, ATMs had been toppled, and an audio tower was burning as the Red Hot Chili Peppers played their closing-night set. ("Holy shit," noted lead singer Anthony Kiedis, "it looks like *Apocalypse Now* out there.") Some of the revelers were frustrated with Woodstock's high food costs and long lines; others simply wanted to break stuff. It made *Fight Club*'s depiction of pent-up male frustration all the more potent.

As Fox and Fincher readied the film for its fall release, Mechanic enlisted a few studio representatives to talk up the movie in Washington, DC, where the post-Columbine pushback against Hollywood was already underway. "I thought, 'I don't want this to be a poster child,'" he says. "Our publicity people were talking about the movie to get people to understand that we weren't making this as an invitation for people to get violent." Yet neither he nor Ziskin attempted to alter the

movie dramatically. "There was a lot of conversation about 'What is the smart risk here?'" says Fincher. "But the moment that those conversations began to tread even around the perimeter of whether or not we should denude the content in any way, I could say, 'I'm not going to be able to change X, Y, or Z about what we're doing.'"

But although Fincher would be allowed to release the version of *Fight Club* he'd wanted to make, he had little control over the movie's marketing—a fact that led to tension between him and the studio. "The people whose job it is to sell it were like, 'I'm not going down with this,'" says the director. One Fox marketing exec essentially told the director that *Fight Club* was a no-quadrant film, chiding Fincher: "Men do not want to see Brad Pitt with his shirt off. It makes them feel bad. And women don't want to see him bloody. So I don't know who you made this movie for." Fincher adds, "When I think of 1999, I don't think of my feet on the chair in front of me with a sixteen-ounce cup of popcorn in my hands. I think of it mostly as a series of meetings where I would slap myself so hard, I would leave with a calloused forehead."

Fincher had recorded a couple of faux public service announcements for *Fight Club*, featuring Norton and Pitt dressed in character, advising moviegoers to turn off their pagers and cell phones—adding sinister codas such as "No one has the right to touch you in your bathing suit area." They were among Fincher's "in-your-face assaultive" ideas for promoting *Fight Club*, says Mechanic. "You can't do that in commercial advertising—I don't know who that gets the message to. But at the same time, nothing we did was working." Fox's approach was to play up the aggro aspects of *Fight Club*, advertising the film during wrestling matches. "I remember thinking 'The movie's a little homoerotic. Are you sure you guys want to do this?'" says Fincher. "But by that time no one was talking to me." Adds Bell, "The publicity shots that went out were Brad bare-chested, bleeding, ready to fight. They could have done university screenings at midnight or built some sort of groundswell. But *Fight Club* went out as a big-studio film with movie stars."

In the weeks before the film's release, those stars were put on the defensive. "It's a pummeling of information," Pitt said of *Fight Club* in

early October. "It's Mr. Fincher's Opus. It's provocative, but thank God it's provocative. People are hungry for films like this, films that make them think." The movie's early attackers disagreed. In a *USA Today* column, the conservative crusader William Bennett derided the movie's "illicit, pummeling free-for-alls"—despite reportedly having not seen the film. Even more troubling was a column in *The Hollywood Reporter*, a major industry trade publication, that was published a week before *Fight Club*'s October 15 opening. Fincher's movie "will become Washington's poster child for what's wrong with Hollywood," wrote Anita M. Busch. "And Washington, for once, will be right." She added that *Fight Club* "is exactly the kind of product that lawmakers should target for being socially irresponsible in a nation that has deteriorated to the point of Columbine."

The world premiere of *Fight Club* was held in early September at Italy's prestigious Venice Film Festival. It was the first indicator that not everyone found Mr. Fincher's Opus especially funny. "It gets to one of Helena's scandalous lines—'I haven't been fucked like that since grade school!'—and literally the guy running the festival got up and left," recalled Pitt. "Edward and I were still the only ones laughing. You could hear two idiots up in the balcony cackling through the whole thing." Adds Norton: "It got booed. It wasn't playing well at all. Brad turns and looks at me says, 'That's the best movie I'm ever gonna be in.' He was so happy."

On October 13, just two days before *Fight Club*'s opening night, Mechanic called Fincher to prepare him for what was about to come. "I said there would be two judgments in the movie," he says. "One would be on Friday—which I wasn't so sure about. But there was also the judgment of history. And I thought this would be one of the great films of the decade. So I was fine to take the pummeling."

Like Mike Judge and Brad Bird—two other filmmakers who'd known their movies were in trouble that year—Fincher decided to escape. That weekend, he and *Fight Club* producer Chaffin boarded a plane to Bali.

"We were thinking 'Oh, it will be very peaceful. We'll do some yoga, we'll eat well, and get some sun on the beach,'" says Fincher. But not long after they landed, word began to arrive about *Fight Club*'s box-office performance. "The thing about the moviemaking business is that you do or die at six o'clock Eastern Standard Time," says Chaffin. "That's the old-school way: they call you up and say, 'This is what it's made tonight, and this is what we project for the weekend.' And it's either depressing or exciting. And when I got a call with the weekend figures, I was like, 'Oh, my God.' It was a stab in your heart." *Fight Club* opened with just $11 million. A month after its release, the movie would slide out of the box-office top ten altogether. "Two years of your life," says Fincher, "and you get one fax and it's like, 'Everybody go home. It's going to be a fire sale.' You do a lot of soul-searching at that moment: 'Oh, fuck, what am I going to do now?' How do you bounce back from that?"

Some of the blame for *Fight Club*'s failure was likely due to the film being sold as a brawl-filled punch-'em-up. "I had close friends say to me, a week after it was released, 'I haven't seen it yet—I'm not into boxing movies,'" says Uhls. "I was like, 'Is that really what you think it's about?'" There was also the fact that many who *did* go to theaters to see *Fight Club* had found it repellent—and were eager to warn off others. One afternoon shortly after its release, McCallany was sitting in the waiting room of his doctor's office, where the television was tuned to *The Rosie O'Donnell Show*. "I was not somebody who ever watched Rosie O'Donnell's talk show, but it happened to be on," he says. "I heard her say [something like], 'Whatever you do, don't see *Fight Club*. It is demented. It is depraved.' She went on this long tirade. I found myself looking at her, thinking 'Why in the world would you attack us?' It angered me."

O'Donnell did more than attack *Fight Club*—she gave away the film's third-act revelation, much to the frustration of the film's cast, who were no doubt hoping for the same level of secrecy that had been afforded *The Sixth Sense* ("It's just unforgivable," Pitt said). Her outraged reaction was in line with the response of many film critics. The English writer Alexander Walker called it "an inadmissable assault on personal

decency—and on society itself." (Fincher had the quote reproduced on the packaging for the *Fight Club* DVD.) That was only slightly more harsh than the write-ups that appeared in the *Wall Street Journal* (which noted the film "reeks with condescension"), *Entertainment Weekly* (a "dumb and brutal shock show"), and the *Los Angeles Times* (a "witless mishmash of whiny, infantile philosophizing and bone-crunching violence"). The entire movie was picked apart. "One guy wrote scathing things about all of us," says cinematographer Cronenweth, "but for me, he said, 'Jeff Cronenweth has perpetrated the darkest-looking movie ever for a major studio.' I think I was hurt for maybe a week. Then I started using 'That's right. I'm the *perpetrator*.'"

Norton, like many of the film's creative team, was taken aback by the hostile response to *Fight Club*. "I think the establishment, the critical culture, felt a little bit indicted by it," he says. "So they responded to it with a little bit more seriousness, and I think they missed the satirical edge of it." During a conversation with his father Norton remembers his dad mentioned how much his own father had seen *The Graduate* as "a deeply offensive and subversive movie. I think there's a fair analogy in the sense that, with *Fight Club*, you have to feel threatened by what it's saying to think it's an authentically nihilistic movie. And if you relate to what it's saying, you think it's a comedy."

The response to *Fight Club*, Norton says, "really became a sort of a Rorschach test on where you sat. Not to put an ageist kind of spin on it, but I think people over a certain age had a very hard time. It really had a fairly generational split." At one screening, Elliott Gould—the sixty-one-year-old star of such counterculture seventies comedies as *M*A*S*H* and *The Long Goodbye*—was reportedly overheard declaring, "That was awful."

That's how many greeted *Fight Club* within the film industry itself. There were grumblings around Hollywood that a major corporation like Fox should never have bankrolled such an irresponsible movie. One *Hollywood Reporter* story quoted several anonymous producers and agents describing *Fight Club* as "absolutely indefensible" and "deplorable on every level." After its release, Fox CEO Rupert Murdoch yelled

at Mechanic at a company meeting. (Mechanic can't recall the exact wording, though he says it was along the lines of "You'd have to be a sick human being to make that movie.") *Fight Club* arrived after years of animosity between the two men, and it was Mechanic who'd allowed Fincher to blow up 20th Century Fox's corporate headquarters in *Fight Club*'s final explosions (it was the same building that had served as the terrorist-targeted Nakatomi Plaza in 1988's *Die Hard*). Destroying Fox's homebase, says Mechanic, "was my anti-Murdoch thing. My 'Fuck you.'" Mechanic was fired from the studio in 2000, in part because of the aftermath of *Fight Club*.

Fincher also felt the glare of some of his peers—though it had less to do with *Fight Club*'s content and more with its commercial failings. For a while after *Fight Club*, he says, "People at Morton's would pat you on the shoulders like you lost a loved one." Not long after the movie's release, he was called to a meeting at Creative Artists Agency, which represented him at the time. "The vibe was very much 'It's good you've experienced this and that you understand we can sway you from making these kinds of life-altering, possibly career-destroying decisions for yourself,'" he says. "I just got up and excused myself. And later on, I had a conversation and said, 'How dare you? I'm really okay with this movie.'" Fincher wasn't about to disappear. And neither was *Fight Club*.

In January 2000, Norton was attending a concert at Los Angeles' Staples Center. "These young guys walked over," he says, "and they were like, 'Good to see you out, sir!'"—a reference to *Fight Club*'s Tyler Durden–worshipping followers. Recalls the actor: "I was like, 'Whoa! People are having fun with this one.'"

They weren't alone. Despite the movie's box office and critical drubbing, *Fight Club* did manage to find a few early adherents. Critics at the *New York Times* and *Rolling Stone* praised the film, and debates over the film's virtues—or lack thereof—could be overheard in movie-magazine offices for weeks and months. "I loved *Fight Club* so much—I saw it again and again," notes *Premiere* editor Jill Bernstein. "It was detailed

and delicious and ruthless. And we, as moviegoers, needed something raw like that." Even Bill Clinton was a cautious fan, calling *Fight Club* "quite good," if "a little too nihilist."

In June 2000, Fox released *Fight Club* on DVD; it sold more than six million copies in its first decade of release. A movie that had once seemed so distastefuly nihilist came to seem alarmingly prescient: It addressed the new rise of our-brand-could-be-your-life consumerism that would dominate the next century, and it provided an inadvertent blueprint for the sort of decentralized, shits-and-giggles anarchy that would later be adopted by online collectives like Anonymous. Not long after *Fight Club*'s release, days-long anti-capitalism riots erupted near a World Trade Organization conference in Seattle—another indicator of the economic frustration felt by Tyler and his peers. The movie seemed so eternally relevant, in so many ways, that the first rule of *Fight Club* became that *everybody* had to talk about *Fight Club*—even if they weren't old enough to be a middle child of history. "When my daughter was about nine years old," says Fincher, "I went to a school function, and she said, 'Oh, I want you to meet my friend Max. *Fight Club* is his favorite movie.' I took her aside and said, 'You are no longer to hang out with Max. You're not to be alone with Max.'"

13

"EVER WANT TO BE SOMEONE ELSE?"

BEING JOHN MALKOVICH

The letter arrived at the Manhattan offices of *Spin* magazine in early 1999. Its author was Richard Koufey, the purported director and star of a music video for Fatboy Slim's joyous jam "Praise You." The seemingly low-budget clip, which had been playing frequently on MTV, found the scrawny Koufey leading a group of semicoordinated dancers boogieing madly outside a movie theater. Koufey was demanding a retraction from the editors at *Spin*, which had claimed he wasn't the video's director. In response, Koufey had sent along a résumé that highlighted, among other achievements, his work in the B-52s' "Love Shack" video and his cameo in *Dirty Dancing*. Surely, that would all prove Koufey *wasn't* the guy *Spin* claimed he was: Spike Jonze.

The ruse didn't work. For one thing, even with his giant glasses and rat-tailed hairdo, Koufey was a dead ringer for Jonze, the filmmaker and prank lover. There was also the fact that the "Praise You" video felt *exactly* like a Spike Jonze production—as hazily defined as that term

might have been. The twenty-nine-year-old had been responsible for some of the decade's most vividly playful music videos—the kind you taped off MTV and passed around the dorm room. He'd turned the Beastie Boys into seventies cop show heroes for "Sabotage"; dropped Björk into the song-and-dance Broadway homage "It's Oh So Quiet"; and recast the Notorious B.I.G., Puff Daddy, and their hangers-on as swagger-wielding, lip-syncing preteens in "Sky's the Limit."

"Praise You," which had been codirected by Sofia Coppola's brother Roman, marked the first time Jonze himself had taken such a prominent—albeit semi-incognito—role in his own work. Born Adam Spiegel and raised in the Maryland suburbs near Washington, DC, Jonze spent his teen years hanging around a local BMX shop and immersing himself in the concrete confines of skateboard culture. Later he moved to California to start his career as a visual artist. By then he'd become Spike Jonze—a name supposedly inspired by his own hairdo as well as the big-band satirist Spike Jones. Much of Jonze's early work came via skating magazines, which published his ballsy, cheeky photographs of airborne decks and nutso skater boys. Those pictures helped define the fish-eyed, flip-kicking spirit of the early-nineties skate-punk movement. A few years later, Jonze was directing music videos and commercials, including a 1995 Nike ad in which Andre Agassi and Pete Sampras play tennis in the middle of Manhattan traffic. His works shared a warm but bratty sense of humor, as well as an unruly ethos—the result of his years immersed in BMX and skateboarding. Being in those worlds means "you don't look at things normally," noted Mark Lewman, one of Jonze's early collaborators. "You look at a hockey rink and see a place to skateboard. You look at a bench as a thing to do tricks off of."

That was how Jonze approached his own celebrity—as yet another oddly angular platform that he could mess around with and turn into something new. Throughout the nineties, the director rarely gave interviews. When he did, he invariably tried to undermine them, whether by appearing in the form of a smiling puppet or by trying to stage a series of fake fights while wandering around LA with a reporter from *Spin*: "I wanted the whole article to be about how I keep getting my ass kicked,"

the dismayed Jonze told the writer, pointing out the fake blood capsules he'd brought with him. He once posed for a magazine photo spread with a bullhorn over his head. In his work, and in his life, he made sure you could never really get a good look at him.

Jonze was soon being pursued by film producers, who tried to lure him toward big-budget films such as an *Ace Ventura* sequel. He declined, instead spending the late nineties working on an adaptation of the beloved children's book *Harold and the Purple Crayon*. He spent almost a year and a half on *Harold*, even hiring David O. Russell to help him out. But the movie suffered during the development process. "I didn't really know what I was up against, trying to work in a machine like that," Jonze said. "It had slowly, day by day, moved away from what I was trying to do."

Jonze's next project had no chance of getting stuck within the major-studio machinery—in fact, for years, it barely had a shot at being made at all. It simply existed in Charlie Kaufman's head.

Throughout the early nineties, Kaufman had become used to seeing his most audacious ideas be completely ignored. He'd written for numerous failed TV sitcoms, some of which had lasted barely a season, such as *Misery Loves Company* and *Ned and Stacey*. Kaufman didn't care much for television, and sometimes wrote his frustrations into his scripts. While working on the 1993 Bronson Pinchot show *The Trouble with Larry*, he proposed a nonsensical story line in which the hero breaks his roommate's miniature mummy and decides to replace it with a tightrope-walking monkey in a full-body cast. The idea didn't make any practical sense—which, for Kaufman, was part of the appeal. "It was like saying, 'This form is such bullshit, let's play around with it,'" he remembered. (The episode was never produced.)

In between TV gigs, Kaufman worked on a screenplay he'd been writing on the side: *Being John Malkovich*. It was the story of a flailing puppeteer, Craig Schwartz, who's reduced to taking a filing job at a mysterious Manhattan company, one whose headquarters reside on the

low-ceilinged seven-and-a-halfth floor of a Manhattan building. That's where Craig accidentally discovers a portal that allows him to enter the body of the actor John Malkovich for fifteen minutes at a time—after which he's dumped alongside the New Jersey turnpike. Craig teams up with, and falls for, an ambitious coworker named Maxine. Together they charge visitors $200 a pop to slide into Malkovich, luring them with a cryptic come-on they place in a classified ad: "Ever want to be someone else? Now you can."

Kaufman's script for *Malkovich* had been around since 1994. "It got a lot of attention and it was fun for people to read," Kaufman said, but "nobody was interested in producing it." Eventually the screenplay made its way to Jonze, who saw the title and thought, *What is this?* "I thought I'd just read five pages, and I read the whole thing and instantly was in awe of it," he remembered. "Everyone said it was unmakeable. I guess I didn't know any better." Kaufman, in his late thirties, had no idea who Jonze was. "I wasn't in the MTV community," he said.

The two spent a year together revising the script and abandoning its original ending, which involved Craig, among other things, entering a puppeteering duel with the Devil. *Malkovich* would soon find its way to Single Cell Pictures, a production company cofounded by R.E.M. singer Michael Stipe, which had struggled to find a studio to back it. At one point, Stipe and his producing partner, Sandy Stern, pitched the movie to New Line Cinema studio chairman Robert Shaye. The exec's response underscored one of the film's biggest obstacles. "Shaye turned to me and said, *Being John Malkovich*? Why the fuck can't it be called *Being Tom Cruise*?" recalled Stern.

Malkovich, then in his midforties, wasn't the kind of performer whose name usually went above the title, much less *into* the title. He'd been a respected, in-demand actor for more than two decades. After starting his career on the stage in the seventies as part of the famed Steppenwolf theater troupe, he had wound up onscreen, often cast as chilly, cerebral creeps. He'd starred as the scheming lover Valmont in 1987's *Dangerous Liaisons* and played an obsessive would-be assassin

in 1993's *In the Line of Fire*, for which he had earned an Academy Award nomination. He was the perfect celebrity portal for Kaufman's script: well known but unknowable.

For Jonze and Kaufman, the only way to make *Being John Malkovich* was with Malkovich himself. No other actor had that same impossible-to-define Malkovichness. "We never came up with anyone," Jonze said. "We'd always go back to, 'We gotta get John.'" The actor received the script before a long plane ride from California to Europe. He loved Kaufman's writing, he said, but "it never occurred to me that anyone would be goofy enough to actually make that movie." It would take a phone call from Francis Ford Coppola to convince Malkovich to take a chance on Jonze, Coppola's soon-to-be son-in-law. "Francis said, 'In 10 years we'll all be working for him,'" the actor remembered.

To Malkovich, Kaufman's script was partly about "the need we have through television, through the mass media, through magazines, through the internet, to lead sort of virtual lives," he said. "The idea of how interesting and informative and creative and just plain fun it can be to be someone else." That notion was being explored throughout popular culture in 1999, as artists eagerly abandoned who they were—even if just for a little while—to see what they could get away with while faux-incognito. The rapper Eminem popularized his brutal goofball alter ego Slim Shady, a character through which he filtered some of his darkest rhymes. The paunchy country star Garth Brooks, meanwhile, donned an am-I-goth-or-not wig, sucked in his cheeks, and became Chris Gaines, a slender soul popper whose fake discography included such albums as *Fornucopia*. And Jim Carrey's *Man on the Moon* on-set outbursts were the result of the actor dialing too deeply into the squelchy frequencies of the late comic Andy Kaufman—whose own personality played like a multilayered put-on.

Those were extreme examples, of course. For most people looking to escape themselves, the easiest way to start a new life was via computer. Desktops had become twenty-four-hour reincarnation machines with online avatars, fake email addresses, and anonymity-granting message

boards. "I always thought it would be better to be a fake somebody than a real nobody," notes Tom Ripley, the identity-stealing 1950s con-artist killer—played by a scrawny, nerdy Matt Damon—in 1999's *The Talented Mr. Ripley*. The internet offered those in the real world the opportunity to do exactly that: construct a version of yourself that was a smarter, better-looking, much cooler somebody.

As computers grew more advanced, so did the possibilities for exploration. In 1999, gamers got their first look at the soon-to-be-released *The Sims*. Just about anything was possible in this virtual world: love, success, even death. It was "this alternate reality, this game about me and my life," *Sims* inventor Will Wright said. "And I can spin it off in really weird directions that I might not try in real life."

In *Being John Malkovich*, nearly everyone who slides into Malkovich's brain winds up spun off in a new direction. "It's the thrill of seeing through somebody else's eyes," says Craig, the schlubby puppeteer who leads eager buyers into the actor's head. Craig would be played by the ponytailed, unpleasantly stubbly John Cusack, who'd recently starred in the explosion-clogged action hit *Con Air*. "I called my agent and told him he had to get me something to read that wasn't crap," Cusack said. In a whispered voice, Cusack's rep told him, "You've got to read *Being John Malkovich*." "He sounded like it was some kind of drug deal," the actor recalled. "So I read it and thought 'the only way this will ever get made is if some kid maxes out his dad's credit card and shoots it out of a van.'" Cusack also told his agency that if by chance the movie did get made and he wasn't in it, he would hire new representatives.

Meanwhile, the role of Maxine—the acerbic, pragmatic partner who rebuffs Craig's advances—went to Catherine Keener, who'd spent the decade appearing in sharply written indies such as 1996's *Walking and Talking*. "It took Spike's imagination to cast me," Keener said. "I wasn't who I saw for the part of Maxine. She was sexy and bold, and I didn't really like her."

For Jonze, the toughest *Malkovich* role to fill was that of Lotte, Craig's frizzy-haired, animal-loving wife, who spends more time with her pet chimp than her spouse. Keener suggested one of her friends:

Cameron Diaz, who'd starred in Jim Carrey's *The Mask* and was about to have her first leading-role smash hit with the release of *There's Something About Mary*. She arrived a few minutes later to her first meeting with the director, at a restaurant in Los Angeles. "There was Spike, in one of those big, high-backed chairs, nodding off," Diaz said. "All I could think was, 'Gosh, who is this guy?'" She added, semi-jokingly: "Then I realized he looked like Robert De Niro. That's another of his hidden talents, one of his endearing qualities: he can look like anybody. Sometimes he can look like Matthew McConaughey and, every once in a while, he looks like Kareem Abdul-Jabbar. That really impressed me."

Jonze initially didn't think Diaz made sense for the passive, glam-free Lotte until the actor read for the part. "She came in and she was sort of being cute, and she was, like, being Cameron," he said. "I just started asking her to do things that weren't as cute and sort of stripping down the sexuality and femininity."

No character is as liberated during her time inside Malkovich as Lotte. After her first trip into the portal—which coincides with Malkovich taking a shower—the for-once excitable Lotte tells Craig she's come to a realization: "I've decided that I'm a transsexual," she says, adding, "For the first time, everything felt just right." Later on, when Craig tries to become more controling of Lotte's life, she gives him a brush-off that would have been unimaginable before she started being John Malkovich: "Suck my dick!"

Jonze, true to form, promoted his debut film by not promoting it at all. He canceled a New York Film Festival press conference for *Malkovich*. When he did show up for a subsequent junket, he stayed for just a few minutes, answering a straightforward question such as "When did you change your name?" with "1933." He also made an appearance on *The Late Late Show with Craig Kilborn*, where he was preceded by a fake *Behind the Music*–type minidocumentary detailing his friendship with Secretary of State Madeleine Albright; Jonze and the host sat in silence for several minutes as their awkward banter played out in a voice-over.

The few print articles for which Jonze granted an interview often forced their writers to desperately try to stitch together a few usable quotes.

But moviegoers didn't need Jonze to sell them on *Being John Malkovich*. In a year that saw critics split on nearly every audacious new release—from *The Matrix* to *Eyes Wide Shut* to *Fight Club*—the odd and oddly sweet-natured *Being John Malkovich* pulled everyone's strings. Roger Ebert's four-star review contained multiple exclamation points ("What an endlessly inventive movie this is!" "Whoa!"). A few months later, he'd name it his favorite movie of 1999, calling it "so bountiful you feel not just admiration but gratitude." When *The Village Voice* polled nearly sixty critics about the best movies of that year, *Malkovich* topped the list.

Despite all the critical goodwill directed toward *Malkovich*, its director remained in the background. In fact, there was only one moment in which Jonze seemed seemingly at peace with his increasing infamy. In September, just days after *Malkovich*'s world premiere, he took center stage at New York City's Metropolitan Opera House as part of the MTV Video Music Awards (Jonze would win several statues that night—including a Best Direction award, which would be presented to him by the *Blair Witch* cast members). Under a lone spotlight, he kicked and flailed in front of an audience of nearly 12 million viewers—dressed as dance leader Richard Koufey. It was hard to get a portal into Spike Jonze's brain when he was so happy being someone else.

14

"ARE WE SHOOTIN' PEOPLE OR WHAT?"

THREE KINGS
THE LIMEY

George W. Bush might as well have been stepping onto foreign soil. It was a late-June day in 1999, and the presidential hopeful was meeting the locals at the Bel Air home of Warner Bros. cochairman Terry Semel. Bush was desperate to make friends in California, which hadn't favored a Republican president since 1988, when it had helped elect his father, George H. W. Bush. But his Hollywood drop-in couldn't have been worse timed. In the months following the shootings at Columbine High School, the entertainment industry had been harangued by members of Congress and lectured by Bill Clinton, traditionally a showbiz ally. Bush himself had just recently told reporters of his belief in "a correlation between violence in movies and youth violence." That line likely wouldn't play too well with the execs and performers gathered at Semel's home.

So the fifty-two-year-old Texas governor struck a delicate note while addressing the crowd in Bel Air. Surrounded by longtime Democrats such as Warren Beatty and Quincy Jones, Bush told the gatherers he

wanted to "usher in the responsibility era" as blamelessly as he could. "My job," he said, "is not to hold anybody up for score."

Bush likely didn't recognize one of the lesser-known guests at Semel's home, the guy who'd shown up dressed in camouflage-print T-shirt and shorts. "I went out of curiosity, thinking I was a renegade," says David O. Russell. "I thought, 'I'm going to be irreverent.'" That approach wouldn't have surprised anyone familiar with *Three Kings*, the movie Russell was currently putting together. It held the entire country up for score. Set in early 1991, right at the end of the Persian Gulf War—which had been overseen by Bush's father—the movie follows a group of army soldiers stuck in postcombat Iraq, where oppressive president Saddam Hussein still reigns. As the men attempt to steal a trove of ill-gotten Kuwaiti gold, they come to understand that the war wasn't as virtuously gung ho as they'd been promised. Once they head home, they realize, things will only get worse for the Iraqis they're leaving behind.

By the time George H. W. Bush's eldest son began his campaign for president, the Gulf War was already fading from view for many Americans. But Russell had spent part of the early eighties in postrevolt Nicaragua and had worked as a community activist when he returned to the United States. To him, the events in the Persian Gulf "felt like an unfinished sentence," he says. "It just seemed too weird that we put a half million men in Saudi Arabia, waged this war, and walked away."

Russell wasn't quite finished with the past. Neither was the soon-to-be forty-third president of the United States. "He comes to shake my hand," says Russell. "And I say, 'I'm editing a movie right now that's going to question your father's legacy in Iraq.'"

Bush smiled widely, still gripping the director's hand. "Well," he said, "I guess I'm going to have to go back there and finish the job."

While many filmmakers spent 1999 contemplating the future, others opted to take one last look backward—as if trying to freeze-frame and figure out the twentieth century before it powered down for good. Spike Lee made *Summer of Sam*, a sweaty itemization of the events of 1977,

when New York City was paralyzed by serial killer David Berkowitz. (From behind bars, Berkowitz denounced the movie and implied in the *New York Times* that he was keeping tabs on the director's wife and children.) And writer-director Terrence Malick, who'd seemingly left Hollywood after 1978's haunting romance *Days of Heaven*, returned with *The Thin Red Line*, a near-mystical depiction of a violent Pacific battle during World War II. Both movies resisted snug nostalgia or uplift, instead hinting that the troubles of their times weren't limited to a fixed era. "We're living in a world that's blowing itself to hell as fast as everybody can arrange it," summarizes one of *The Thin Red Line*'s grunts—a sentiment that could likely have been uttered at any point in the last hundred years or so.

Three Kings, however, reached back less than a decade. The Persian Gulf conflict had begun in August 1990, when Iraqi forces, led by Hussein, invaded the oil-rich country of Kuwait. Months later, in January 1991, the United States and its allies launched Operation Desert Storm, bombarding the occupying Iraqis with missiles and later augmenting the attack with ground troops. Victory was quickly declared, and by June, George H. W. Bush—who was gearing up for a tough reelection campaign—was presiding over a $12 million celebratory parade in Washington, DC. Never mind the fact that Saddam was still in power: to millions of Americans, the perceived triumph in the Gulf was a cure for the still painful hangover of Vietnam. At long last, here was a US-led war that hadn't gone over time or over budget. It felt like a win.

But as Desert Storm wound down, parts of the region were in disarray, and millions of dollars' worth of stolen Kuwaiti valuables and gold remained hidden in Iraq. That residual chaos was of great interest to John Ridley, a novelist, stand-up comedian, and writer on such sitcoms as *The Fresh Prince of Bel-Air*. A few years after the end of the war, Ridley—who'd been inspired by the 1948 Humphrey Bogart caper *The Treasure of the Sierra Madre*—began work on a story about soldiers looking for gold in postwar Iraq. "I wanted to see how fast I could write and sell a screenplay," he said. "So I came up with the most commercial and visually interesting story I could think of." He wrote *The Spoils of*

War in a week and sold it less than a month later to Warner Bros., where it went through various stages of development before stalling out.

Not long afterward, the studio extended an invitation to Russell, based on the success of the writer-director's first two films: the shocking but strangely earnest 1994 mother-son incest tale *Spanking the Monkey*—which had won an audience award at Sundance—and 1996's screwball family drama *Flirting with Disaster*, about a young father trying to find his biological parents. Russell's tales of defective families were at once outré and accessible, and after *Flirting* became a modest box-office hit, Warner Bros. encouraged him to dig through its reserves of unmade properties. Russell was intrigued by the description of *The Spoils of War*. The director had been working as a ticket taker at Sundance when the United States began hurling missiles into the desert. The war was a television event, with networks such as CNN broadcasting the sights of night vision firefights and grainy missile attacks. "I was watching the rockets and thinking 'Why are we going into this war for a country I'd never heard of?'" says Russell, who was thirty-two at the time and had been making short films. "It made no sense to me."

A Desert Storm drama such as *The Spoils of War* was an unexpected choice for a director known for low-budget, existentially agitated comedies. But Russell "wanted to make something big and muscular," he says. He spent eighteen months turning Ridley's *Spoils of War* screenplay—which he claims he "didn't even really read"—into *Three Kings*. In doing so, he jettisoned much of Ridley's original script, which would lead to a public feud between the two writers: Ridley, who'd found out his script was in production via the internet, once described Russell as "a guy who every step of the way has tried to grab credit." He eventually received a "story by" credit on the film. (Russell says the two have since made peace; in 2014, when Ridley's script for *12 Years a Slave* won an Oscar, he hugged Russell on the way to the stage.)

Even with a completed screenplay, convincing Warner Bros. to make a film about Middle Eastern politics would be tough. The studio had recently survived a small-scale dustup that had been waged over *Executive Decision*, a Kurt Russell thriller whose main villains were

Koran-carrying hijackers. Before the film's release in early 1996, Muslim activists had faxed letters of protest to the studio and complained to the press, with one Los Angeles imam describing *Executive Decision* as "intellectual terrorism." A last-minute conference between religious leaders and studio executives cooled tempers a bit. But the experience rattled some at Warner Bros. "After *Executive Decision*, we had a taste of fear," says Warner Bros. executive Lorenzo di Bonaventura.

As a preemptive measure, the studio sought out approval of *Three Kings*, sending Russell to the apartment of a prominent Muslim leader near Los Angeles, where the two sat on a rug together for hours, eating fruit and discussing the script. With the exception of a few moments set in the United States, nearly all of *Three Kings* would take place in Iraq, meaning that every detail about Muslim life and culture had to be accurate. "I answered all of his questions," says Russell. "And there was a negotiation about what could stay, and what could go."

That still wasn't enough to satisfy some Warner Bros. execs, who bristled at the American characters' use of epithets such as "camel jockey" and "towelhead" early in the movie. "I'd meet these division heads on the studio lot, and they'd say, 'Oh, you're making that racist film,'" recalls Russell. According to di Bonaventura, there were also reservations about *Three Kings* at Time Warner's corporate headquarters in New York City, which was pressuring the studio executives in Los Angeles. "They felt the movie was going to cause two problems: the Muslim American and Arab American communities were going to boycott us, and the government was going to get pissed at us for a not-entirely-flattering point of view of what we were doing in Iraq."

Russell's caustic take on the Gulf War was evident from *Three Kings'* opening scene, which takes place in March 1991—the same month a cease-fire was announced. A young army sergeant named Troy Barlow spots an Iraqi with a machine gun. He's unclear on the new rules of engagement—"Are we shootin' people or what?" he asks—and, after debating with another soldier, shoots the Iraqi in the neck, causing blood to gurgle noisily from his throat. The scene starts out flippantly comic, then turns horrific. It was based in part on Russell's conversations with

veterans who'd returned from the Gulf, not quite sure what they'd been doing there. "They said it was a very strange and confusing period," says Russell. "They didn't know if they were supposed to be shooting people. They didn't know if they were supposed to be eliminating Saddam Hussein. Many Special Forces guys I interviewed said they cried about having to walk away and let Hussein's brutality take over the country again."

Despite internal anxieties over Russell's script, Warner Bros. finally committed to *Three Kings*, partly for the same reason it had decided to make *The Matrix*: after years of creaky output, the studio had no choice but to try something new. Russell would receive a budget of nearly $50 million to make his big-screen rebuttal to the Bush era. But he wasn't the only director taking a cold look at the recent past.

In the years following the galvanizing debut of *sex, lies, and videotape* at Sundance in 1989, the film's young writer-director, Steven Soderbergh, had maintained a career that was somehow both prolific and obscure. Soderbergh had spent part of the nineties as a for-hire screenplay writer, while pursuing a series of directing projects that, for one reason or another, didn't go his way. "There were years when I wasn't sure how I was going to navigate the film business," says Soderbergh. "I wasn't sure what kind of films I wanted to make."

The movies he did make in those years were fascinating, varied, and totally unsuccessful—at least commercially. They included 1991's *Kafka*, an impenetrable mystery shot mostly in black and white, and 1997's excitingly baffling *Schizopolis*, a low-budget id-scratcher comedy for which Soderbergh served as writer, director, cinematographer, and costar. Barely anyone saw *Schizopolis*, but the movie "freed me up," says Soderbergh. "I let go of a lot of ideas about how I should be doing things."

Newly revived, he was hired by Universal to direct 1998's *Out of Sight*, an adaptation of an Elmore Leonard caper that was Soderbergh's best chance at a commercial comeback. "I did a Jedi mind trick on

myself to forget my career was at stake," says Soderbergh. "I made creative decisions the same way I did on *Schizopolis*, taking the attitude of 'It's 1971. I can do whatever I want.'" Soderbergh cast two sorta-proven actors—*ER* doc George Clooney and *Selena*'s Jennifer Lopez—and tempered down their movie star tics just enough to make their bank-robber-meets-marshal romance seem relatably, painfully human. *Out of Sight* had all of the intimacy and moxie of *sex, lies, and videotape* but within a pulpy, dreamy big-studio film.

After *Out of Sight*, Soderbergh's creative metabolism quickened. By October 1998, he was already shooting his next movie: *The Limey*, a bracing crime drama about an English criminal named Wilson, who's left prison and is now on a revenge junket to Los Angeles to solve the death of a daughter he barely got to know. His search brings him within the ego-fueled orbit of Terry Valentine, a charismatic music producer who got rich in the sixties and is now caught up with a bunch of violent goons. Valentine is a thorough sellout, a former counterculture hero who now poses for credit card advertisements.

The Limey had been written nearly two decades earlier by Lem Dobbs, an English-born screenwriter who'd spent much of his youth in London before finding himself in Los Angeles in the late seventies. "I was very much under the influence of all the tough-guy movies I'd grown up with," says Dobbs, citing hardboiled essentials such as *The Getaway* and *Get Carter*. His *Limey* screenplay sat unproduced for years until Soderbergh directed Dobbs's *Kafka* script. "Somehow, he really liked that dumb old *Limey* script of mine," says Dobbs.

For Soderbergh, one of the draws of *The Limey* was the way it rebuked the sixties revivalism that had infected pop culture throughout the eighties and nineties. It wasn't just *The Limey*'s Terry Valentine pining for the glory days. It was the entire baby-boom generation, whose now-in-power members were picking and choosing whichever parts of the past made them look good. The boomers were constantly reminding everyone how much better things used to be, whether by reviving the VW Beetle, erecting the Rock & Roll Hall of Fame, or championing an Oliver Stone movie about the glory of the Doors. In early 1999, the Second

Age of Aquarius reached its apex with NBC's *The '60s*, a two-night mini series that was billed as "the movie event of a generation," with a plot that incorporated Vietnam, the Black Panthers, and Woodstock. "I'm allergic to a specific brand of nostalgia—the kind of 'Everything was so awesome in the sixties' mentality," says Soderbergh. "When I think about that period, I think about how quickly it became commodified." Like *Three Kings*, Soderbergh's *The Limey* was a reminder that for some Americans the past was a work in progress—an object to be smoothed over and reshaped until it looked nothing like the original.

To star as Wilson—the gruffly stoic, Cockney-accented seeker out to avenge his daughter's death—Soderbergh cast Terence Stamp, the pin-eyed sixties British character actor who'd received an Oscar nomination for playing a saintly but doomed sailor in 1962's *Billy Budd*. Stamp had been a fixture of the Swinging London era of the sixties, famed for his romances with stars such as Julie Christie. Stamp's adversary, Terry Valentine, would be played by Peter Fonda, cowriter and costar of *Easy Rider*, the bleak 1969 road trip tale in which he had traveled America atop a chopper nicknamed "Captain America." "By casting us, Steven's plugged in to a whole collective memory," said Stamp. "Fonda and I bring so much baggage."

The two sixties darlings had dropped out of sight at times during the last two decades, but they'd never lost their cool, and *The Limey* took full advantage of their iconic stature. During filming in Los Angeles, Soderbergh spotted Fonda on a billboard for a credit card company—he'd gone from riding Captain America to shilling for American Express— and incorporated it into the film. It played as a tweak to the actor's own ascent into respectability, as well as a dig at the corporation trying to co-opt Fonda's boomer cool. The director also employed footage of the twentysomething Stamp from the 1967 crime drama *Poor Cow*, using it during Wilson's flashback sequences. The contrast between the ethereal-looking young Stamp and his dignified, silver-haired modern self reinforced the movie's unsentimental stance. In *The Limey*, time is an inevitability: there's no sense trying to revise the past in the hopes it

won't catch up with you. The best you can do is tie up loose ends before the clock runs out.

The Limey was one of the speediest productions of Soderbergh's career, but assembling the movie sometimes felt endless. "It was the most scared I've ever been," he says. Soderbergh had originally intended *The Limey* to be told in a straightforward, cleanly linear style. But when he screened a rough cut for a few friends, "it was painfully obvious that it didn't work at all," he says. "I was terrified that the second act of my career was going to be over before it even started." After that first screening, remembers *Limey* editor Sarah Flack, "Steven came in the next morning with a legal pad with very detailed notes and said, 'Okay, we're going to completely fracture the narrative.' He'd made this big decision overnight."

The Limey would be entirely reassembled, as Wilson's trip to Los Angeles becomes jumbled together and hazy in his mind, full of flashforwards and flashbacks. He'd played with a few time-shifting moments in *Out of Sight*, but the scrambling of *The Limey* was closer in spirit to the kind of kudzu narratives of *Following* or *Run Lola Run*—only in this case the viewer was plugged directly into the characters' semirewritten recollections. "In a memory film, there are no rules," says Soderbergh. Like many of her contemporaries, Flack was editing *The Limey* using Avid, a relatively young high-end software program that had been introduced in the nineties. With digital editing, a character's past, present, or future could all be reordered, or deleted altogether, quicker than ever. "It's the equivalent of a poet or novelist typing on a typewriter and then being given a word processor," says Flack. "It's very freeing."

So was *The Limey*. The low-key but propulsive thriller caught many of Soderbergh's fans by surprise—even the ones who were *in* the movie. When Luis Guzmán, who had a brief role as Wilson's LA tour guide, finally caught the film in theaters, he'd had no idea that the movie's entire structure had changed. "I was like, 'Oh, my God, this son of a bitch is a genius,'" says Guzmán. "He repuzzled that movie. I could have gone to his living room ten times and watched ten different versions, and

each would have been compelling." *The Limey* was confirmation that the merry brazenness of *Out of Sight* hadn't been a fluke. "I remember people feeling like 'He's made two good movies in a row. Good for him,'" says Soderbergh, who'd linked the two films together onscreen. At the end of *The Limey*, Terry Valentine watches a news report about *Out of Sight*'s European premiere, where the paparazzi were following around one of the biggest stars of the decade: George Clooney.

David O. Russell had spent the summer of 1998 desperately trying to recruit the right actor for *Three Kings*. The director considered nearly every late-nineties leading man available for the film, including Clint Eastwood and Jack Nicholson. Many actors and agents simply didn't know what to make of Russell's astringent script. "I couldn't get some people's attention at all," says Russell.

There was one actor, however, who was desperate to be in *Three Kings*. He'd even sent Russell a handwritten note signed, "George Clooney, TV actor." The *ER* star, then in his late thirties, had been disappointed with many of the roles being offered to him: *Out of Sight* had been a rare highlight in a filmography that also included 1997's dreadfully pun-plundering *Batman & Robin*. A movie like *Three Kings*, he said, "was really worth fighting for."

Russell had been skeptical about casting the *ER* star as *Three Kings*' grizzled, disillusioned Major Archie Gates, who leads the hunt for the stolen Kuwaiti gold. The director changed his mind after catching an early screening of *Out of Sight*. "That had a big impact," says Russell. "It showed a new dimension of George." Warner Bros. was also keen on Clooney, in part because the company produced *ER* and could arrange for the show's lead actor—who'd soon be shooting his last season—to shuttle between Los Angeles and Arizona, where *Three Kings* would be filmed.

Joining Clooney in the desert would be Mark Wahlberg as Troy Barlow, the naive family-man grunt who's unquestioning of authority and deeply uncurious about the country he's invading. To play the film's

spiritual, quietly wise Chief Elgin, Russell hired Ice Cube, who'd impressed the director in *Boyz N the Hood*. Ice Cube had grown up on films such as *Apocalypse Now* and *Platoon*. But *Three Kings* would be far less combat-heavy than other recent war films. "The first thing David said to me," remembered Ice Cube, "was, 'Every bullet will count.'"

Russell had written *Three Kings* partly as a reaction to the "gun lust" he'd seen take hold of the culture, and the country, in the nineties. As a kid, he says, "I'd played army, I'd had G.I. Joes—I did all of that stuff. But because of the Vietnam protests, I'd ended up really, really hating war." To remind viewers of the consequences of real-life combat, Russell devised a *Three Kings* shot in which the camera follows a bullet into a body, tracing its path as it slices up flesh and fills the organs with bile. The scene was gruesome in its physiological details, which Russell had gleaned from a friend of his, an emergency room doctor. And it was a reminder that all of the crackerjack action sequences that followed—helicopters giving chase, cars exploding, an out-of-control van skidding toward a minefield—had potentially lethal results. Russell was reacting, in part, to the consequence-free bloodshed he'd seen in nineties films and video games. "They were normalizing violence by bringing it into people's homes and children's rooms," he says.

That craving for chaos was personified by *Three Kings'* Conrad Vig, a dim-witted southern soldier who's anxious to kill somebody, *anybody*. Russell had battled with the studio to give the role to Spike Jonze, whom he'd befriended while working on adapting *Harold and the Purple Crayon*. Jonze was hardly the kind of tested onscreen talent Warner Bros. wanted for its pricey heist film. "I was like, 'Are you serious?'" says di Bonaventura. He made Russell audition such actors as Jared Leto and Christian Bale before approving of Jonze after watching his screen test.

In late 1998, Jonze—who'd recently finished directing *Being John Malkovich*—joined Russell and the *Three Kings* team at an abandoned copper mine outside Tucson, Arizona. The location was just a short flight from Clooney's *ER* set—and, more important, the area was dead enough to double for the harsh terrain of Iraq. "The landscape in Arizona was destroyed," says production designer Catherine Hardwicke,

who'd go on to direct such dramas as *Thirteen* and *Lords of Dogtown*. "It was a toxic location: all the plants were dead, and there was arsenic in the air." As if that weren't bad enough, "The nicest restaurant nearby was an Applebee's or whatever."

In Arizona, Hardwicke constructed an entire Iraqi village, despite not being able to visit the country herself. She'd had difficulty obtaining recent pictures of the region, so she'd asked a Christian preacher who'd been traveling the world carrying a giant cross—and who was heading to Iraq—to take some photos for her. She also contacted Iraqi refugees who'd relocated to the United States and went through their family photos, looking for details. The *Three Kings* producers had recruited Iraqi refugees to appear in the film as extras, and some wound up helping Hardwicke decorate the set. Unlike many Americans, they hadn't forgotten about the events of the early nineties. "I hired them to do the graffiti on the walls," says Hardwicke. "They would get so upset when they saw a huge mural of Saddam Hussein that they would get rocks and start throwing them."

The look of *Three Kings* was influenced in part by Kenneth Jarecke's 1992 photo collection *Just Another War*, which captured the flat landscape of the land and the day-in, day-out tedium of the Desert Storm effort. Russell and Hardwicke also drew from supersaturated color war photos that were appearing on the front pages of *USA Today*. And Russell lobbied Warner Bros. to let him use a specialized film that would yield grainy, high-contrast images—as long as it was developed in the lab properly. "The first week of shooting, you couldn't see George Clooney or Mark Wahlberg's eyes," says Russell. "They looked like raccoons. Warner Bros. was having a hemorrhage."

The troubles for the studio—and for some members of the *Three Kings* team—would only get worse as filming continued. A thick green dust covered parts of the Arizona location, which was blamed for a rash of strange illnesses. There were also unexpected snow, oppressive heat, and a fast-moving production that required numerous extras, military vehicles, and an exploding oil tanker full of fake milk. Russell sometimes dressed for work in an orange-and-yellow camouflage T-shirt, as

if readying for combat himself. (Sofia Coppola, visiting her then boy-friend, Jonze, saw Russell's shirt and later dressed Bill Murray in a sim-ilar one for *Lost in Translation*.)

Not long into filming, it was clear that the director and his leading-man star were not finding peace in the desert. Clooney described the *Three Kings* shoot as "insanity." It "was not well-coordinated, to say the least," he said. "It was absolute confusion." The actor was commut-ing back and forth for days at a time, sometimes leaving the *ER* set at 4:30 a.m. and flying straight to Arizona for *Three Kings*, only to find that Russell had rewritten the day's script. The constant dialogue adjust-ments were one of many sources of tension between Clooney and the director. "He was so specific about everything—down to the movement of a finger," said Clooney. "David's feeling was, 'What am I supposed to do? Shoot it the way I don't like it written?' And my feeling was, 'What am *I* supposed to do? I don't know my lines.'"

The two clashed repeatedly throughout *Three Kings*, spurred on by the heat, the chaotic surroundings, and their differing work philoso-phies. "David will get an idea in the middle of rolling," says Hardwicke, "and will yell out to the cameraman, 'Let's shoot this!' He's just sponta-neously creative. That can rattle some people." Adds di Bonaventura, "George is a big believer in a benign environment. David is a big believer in getting everything you can get for the movie. Those two things are going to collide."

In March 1998, with filming almost completed, di Bonaventura got a call from a producer on the Arizona set of *Three Kings*. "He goes, 'We've got a problem. George is trying to pound David, and David is choking George.' I'm like, 'Are you fucking kidding me?'" The executive was already nervous about the movie, which had gone from sixty-eight shooting days to seventy-eight. "It was one of the few times I was told, 'This is on *you* if it doesn't work,'" he says.

The spat between Clooney and Russell—not their first confronta-tion on the set—occurred during the filming of the movie's climax, as the soldiers abandon their quest for gold and escort a group of refu-gees to safety. It was a hectic scene to film, involving a helicopter and

numerous extras, as the crew worked under the blistering Arizona sun. And because there were so many onlookers, the exact accounts of what happened between Clooney and Russell vary. The director defers to an account Ice Cube gave several years later: "There was this one extra that was kind of out of position," Ice Cube said. "David is running across the desert telling the guy, 'Hey, you're not supposed to be here, you're supposed to be over there.' And David's an intense guy. So he grabbed the guy and moved him where he was supposed to be. And I think George just took exception of David actually putting his hands on the guy." Recalls *Fight Club*'s Holt McCallany, who starred as a gruff military honcho in *Three Kings*: "David said, 'Don't tell me what to do on my set,' and George said, 'This is not your set.' And it just went off from there. I literally wrapped David up in my arms and pulled him away, because they were coming to blows."

However the fight went down didn't matter to di Bonaventura, who quickly got on the phone with Clooney and Russell. "Guys," he told them, "you've got a week and a half to go. You've just got to figure out a way to stay apart."

Not long afterward, shooting on *Three Kings* wrapped. For the next several years, Clooney and Russell would trade occasional jabs in the press before reuniting at a party around the time of the release of *The Descendants*, the 2011 drama directed by Alexander Payne. "We resolved to be friends," says Russell. "We were laughing and talking, like, 'Let's just put this behind us.'" As Ice Cube noted, their tension during the making of *Three Kings* was inevitable, given Clooney and Russell's commitment to making the film in the first place. "They showed that they were both interested in making the best movie they could," he said. "That's all I want to do. I don't want to be in no bullshit. Movies last forever."

In the fall of 1999, David O. Russell and Spike Jonze were giving themselves a tour of the White House: ducking into the Lincoln Bedroom, taking photos in the historic Yellow Oval Room, and occasionally rolling around on the ground. "We were young and rascally," says Russell.

"We were saying 'This is hilarious. We can wrestle in the White House.' Then we realized there were probably cameras."

Russell had come to DC to screen *Three Kings* for President Clinton, bringing with him several of the film's producers, as well as Jonze and Sofia Coppola. Russell showed up for the night in a suit; Clinton wore jeans, a large belt, and cowboy boots. "He said, 'Y'all are my cheap thrill for today—you and the Purdue Women's Basketball Team. And let me tell you: their coach is *stunning*,'" remembers Russell. "And we were all thinking 'You almost got impeached. Not really what you should be talking about.'"

Clinton sat in the front row during the film as the audience—which included several Arab American guests—took in *Three Kings* while hardly making a sound. "It was like being in court," says Russell, who sneaked out as the film was playing to explore the premises. He was back in time to see the crowd applaud and watch Clinton give an hours-long impromptu lecture on the history of the Middle East. "He talked us right under the table, until we finally left at midnight."

Three Kings would become a hit with critics, who praised Russell's talent for hot-wiring together dark comedy, breakneck action, and preach-free political commentary. It would make $60 million in the United States, but the real rewards would come with the movie's home video release: according to di Bonaventura, it made a $30 million profit in DVD sales alone. The movie also earned Russell an accolade from a Los Angeles Arab American group, which gifted him a crystal statuette. "It was shaped like a building, and it was beautiful," says Russell. "It probably weighed at least twenty pounds."

When he got home from the awards ceremony, Russell accidentally dropped the statuette, breaking it into pieces. Russell called the imam who'd given it to him, so he could apologize and asked if he could pay for a new one. "He was very superstitious," says Russell. "Somehow the fact that it broke that night had significance for him." The imam hung up, and the two never spoke again. "It was so strange, like a Hitchcock movie," he says. "It was ominous."

A few years later, in 2003, George W. Bush would follow through

on the bragging pledge he'd made to Russell back in Bel Air, sending military forces to Iraq to "finish the job" his father had started. Operation Iraqi Freedom would last eight years, cost more than $2 trillion, and dismantle the region even further. Russell had made *Three Kings* in part out of his hatred for violence and his fascination with a war that he could never quite understand. Decades later, that war seemed more unresolved and inscrutable than ever. It would sometimes make him think of that night the crystal trophy had shattered on the ground in front of him. "To me, it couldn't help but be linked," he says. "The Gulf War was an incomplete sentence. When that thing slipped out of my arm, it was the beginning of the rest of the sentence."

15

"I'M RUNNING OUT OF HEROES, MAN."

THE INSIDER

One morning in early 1998, Michael Mann kissed his wife goodbye, exited their rented Upper West Side apartment, and crammed himself into the building's tiny elevator. He had a long day of work ahead of him. Mann, then in his midfifties, had recently directed one of the decade's most maxed-out action dramas: 1995's *Heat*, starring Al Pacino as a fastidious Los Angeles cop and Robert De Niro as an equally single-minded master thief. Like all of Mann's movies, *Heat* was cerebral, bombastic, and executed with military-grade exactitude. To film a bank robbery shoot-out in *Heat*, he had commandeered a large swath of downtown LA for multiple weekends, gunshots filling the air as his actors unloaded as many as 1,000 rounds per take. Nothing about the Chicago-raised Mann, from his on-set disposition to his filmmaking style, was relaxed.

Mann was leaving his temporary Manhattan home that day to scout locations for his next film, *The Insider*. The movie included zero

explosions or robberies, but its production had been no less intense than Mann's previous efforts. Based on true events, *The Insider* charted the cautious alliance between Dr. Jeffrey Wigand—a scientist and former tobacco executive with damning intel about his own industry—and Lowell Bergman, a producer for CBS's *60 Minutes*. After spending months trying to convince Wigand to blow the whistle on his former employers, Bergman watched his story become defanged by fearful CBS executives. Bergman felt abandoned by his colleagues, who included two of the most respected journalists in the country: *60 Minutes* creator Don Hewitt and star correspondent Mike Wallace.

Because the incidents that inspired *The Insider* were only a few years old—and because they dealt with a potentially litigious billion-dollar tobacco company—the movie's production had been closely scrutinized from the start. Disney, the studio releasing the film, had lawyers vetting every line of the script. And even before shooting began, there were grumblings from Hewitt and Wallace, who were unhappy that an embarrassing chapter from their decades-long careers was being rehashed in a big-studio movie.

So Mann wasn't sure how to react when, on that morning in New York, his elevator stopped to receive a new passenger: Don Hewitt. Mann had had no idea that the *60 Minutes* executive producer lived in the building, and for a moment, the two men descended in silence. "As those milliseconds are ticking by," Mann remembers, "I'm thinking 'He doesn't know who I am. I don't have to say anything. We can walk out of this elevator together.'" But Mann couldn't stay quiet. "I said, 'Mr. Hewitt, I want to introduce myself: I'm Michael Mann.'" The producer was stunned for a moment, then quickly recovered. "He put his arm around me like I was his best buddy and said, 'That fucking Lowell Bergman. . . ,' like the two of us were pals." Mann and Hewitt walked out of the building together, Hewitt's arm still around the filmmaker, as Mann's waiting crew members looked on in surprise. A year later, the famed TV producer would be publicly raging against *The Insider*. But for a brief moment, he and Mann were just two chatty neighbors.

Throughout the making and release of *The Insider*, the cast and filmmakers frequently found themselves bumping up against the real-world drama they were trying to re-create—often uncomfortably so. Much of *The Insider* was based on "The Man Who Knew Too Much," a 1996 *Vanity Fair* article by Marie Brenner that chronicled Wigand's decision to detail unscrupulous practices he'd witnessed at Brown & Williamson, the producer of such cigarette lines as Kool and Viceroy. Wigand's outspokenness would have harmful side effects: lawsuits, intimidation, financial duress, and the disintegration of his family. At one point, Wigand opened the mailbox at his upper-class suburban home in Louisville, Kentucky, and found a lone bullet inside. By agreeing to go public, he had entered "a particular American nightmare where his life will no longer be his to control," Brenner wrote.

It was that slow slipping away of Wigand's existence—the sight of a man being atomized by a megacorporation—that had drawn Mann to *The Insider*. But in making the film, Mann and his cast were meddling with two primal forces of nature: Big Tobacco and Big Media. With a movie like *The Insider*, noted star Al Pacino, "You're in a bit of a minefield. And you sense it."

On March 14, 1998, *Saturday Night Live* aired an animated parody of the beloved seventies educational cartoon *Schoolhouse Rock!* Written by longtime *SNL* contributor Robert Smigel and titled "Conspiracy Theory Rock," the short took cheery aim at titanic companies such as Disney, Fox, and GE—all of which oversaw their own broadcast television miniempires. In a sardonic sing-along number, Smigel bemoans the monoliths' increasing powers:

They own networks from CBS to CNBC
They can use them to say whatever they please
And put down the opinions
Of anyone who disagrees.

The acidic *SNL* spoof—which disappeared from the episode upon future airings—came at the end of a decade that had seen nearly every major television and film studio, music label, and publishing company gobbled up in a series of billion-dollar mergers. It had begun in 1989, when Time Inc. had merged with Warner Communications, effectively creating the biggest media company in the world, one that owned everything from HBO to *People* magazine to Warner Bros. Over the next few years, the deals continued at a brisk clip: Sony purchased Columbia Pictures; Viacom, which owned networks such as MTV and VH1, acquired Paramount; Disney bought ABC. By the time the decade was over, the major entertainment companies were fatter than ever before.

They'd also become mindful of making too many problems for their new owners. In 1995, the Disney-owned Miramax—which had already irked the Catholic League with its controversial drama *Priest*—had released the NC-17 *Kids* through Shining Excalibur, a newly created independent studio, sparing Disney further headaches. The next year, the formerly indie Fine Line Features delayed *Crash*, writer-director David Cronenberg's tale of car crash fetishists, after objections from Time Warner vice chairman Ted Turner, whom *Crash* star Holly Hunter accused of "moral fascism."

Yet the movie studios were minimal headaches compared to the broadcast networks' news divisions. In 1994, an investigation on ABC's *Day One* program—which alleged that some tobacco companies had added extra nicotine to their cigarettes—led to a potentially annihilating lawsuit from Philip Morris. ABC settled, agreeing to read an apology to Philip Morris on the highly rated *Monday Night Football*, and to pay the company a reported $15 million.

The same month ABC and Philip Morris resolved their dispute, Westinghouse—a company best known for making washers and dryers—announced the latest tremor-triggering media deal: for more than $5 billion, the manufacturer was buying up the country's last independent TV network, one that had long prided itself on its sterling news

programming. After more than fifty years on its own, CBS was finally being sold.

Lowell Bergman picked up a copy of the November 9, 1995 edition of the *New York Times* from a Manhattan newsstand and scanned the front page. Just below the fold was a headline that read "'60 Minutes' Ordered to Pull Interview in Tobacco Report." The accompanying story detailed a behind-the-scenes dustup at the newsmagazine, one with which Bergman was intimately familiar. The *60 Minutes* producer—who'd covered everything from the Persian Gulf War to the CIA—had recently convinced Wigand, the former Brown & Williamson executive, to talk on camera. During the interview, Wigand revealed that B&W had enhanced nicotine levels to make its cigarettes more addictive. It was a bombshell revelation about what had become a national health crisis.

But as Bergman's piece was about to air, lawyers for CBS expressed fears that Big Tobacco might hit the network with a costly and ill-timed lawsuit, especially with the lucrative Westinghouse deal in the works. The network decided to obscure Wigand's statements from the *60 Minutes* report. Bergman hoped his bosses, Don Hewitt and Mike Wallace, would be as outraged by the move as he was. Instead the *New York Times* piece revealed that both Hewitt and Wallace publicly supported the CBS lawyers. (Wallace would later claim that he quickly changed his mind about the network's decision.)

By then, "I figured I was going to get fired," says Bergman. He spoke with Mann, whom he'd known since the two had attended the University of Wisconsin in the sixties. "I told Mike I was probably going to have to look for another job and that maybe I should do a movie. And he said, 'You know, the real story here is *your* story.'"

Mann's hunches had usually proved to be correct. The writer-director's career included the crime caper *Thief* and the skin-burrowing *Silence of the Lambs* forerunner *Manhunter*, and Mann spent much of the second half of the eighties overseeing the neon-lit cop series *Miami*

Vice. Around the time he was talking to Bergman, Mann had just landed an extensive deal with Disney, and was looking for his next movie. His films often found intelligent, innately at-odds men thrown into the same room and forced to work together. And Bergman and Wigand had little in common, save for their own headstrongness: "It's very unlikely that Jeffrey and I would have ever have become friends in the real world if journalism hadn't been involved," Bergman says. As Mann learned of their relationship, he says, he became fascinated that Bergman was "putting everything on the line for a guy he personally didn't feel any affinity to."

After the rights to Brenner's *Vanity Fair* piece were secured, Mann partnered with writer Eric Roth, who'd won an Oscar for Best Adapted Screenplay for *Forrest Gump* and who'd recently adapted such novels as *The Horse Whisperer* and *The Postman.* "I was skeptical about whether I was the right guy," Roth says. "I had never done this docudrama kind of writing. It was all so research-based and fact-based. You couldn't dick around with that." The writers—who knew that the tobacco company would challenge any factual error—relied largely on public records. Over the course of making *The Insider*, Mann would compile volumes of research, which he would keep in three-ring black binders that covered his office shelves.

Beginning in early 1997, Mann and Roth set up shop at the Broadway Deli in Santa Monica, where they'd meet three days a week, sitting at the bar as they wrote and smoked. "Both of us went to a hypnotist during the making of the movie," says Roth. "Michael kicked smoking; it took me a couple more years."

Mann and Roth had an unlikely aide as they crafted their *Insider* script: Mike Wallace. Throughout the film's production, the *60 Minutes* stalwart, then in his late seventies, would occasionally call the two writers to discuss the movie and the circumstances that had inspired it. "He had some apprehensions," says Mann. "By that point he and Lowell were pretty much at odds with each other. He said something to the effect of 'What would I have done without Lowell Bergman to shine a light on the path of moral rectitude?' I said, 'Michael, that's really fantastic

language. Do you mind if I record it and use it?' He said, 'By all means.' "
A few lines from their conversations wound up in the finished film, as
did excerpts from Wallace's talks with Roth. "He was trying to sort of
massage things to go his way," says Roth. "He was very charming."

By the summer of 1997, as Mann and Roth were writing, Wigand
reached a settlement with Brown & Williamson, allowing him to speak
openly with the filmmakers. By then, Wigand was teaching Japanese
and science at a high school in Louisville, Kentucky, not far from
Brown & Williamson headquarters. Though he was a fan of the 1980
TV miniseries *Shōgun*—partly because he'd lived in Japan for several
years—Wigand "didn't know Michael Mann from Adam," he says. "I
had no choice but to trust him, because I had already become a public
figure. But Michael came across as a very honest, trustworthy person."
Wigand's approval came with a few conditions, including a request that
no one be depicted smoking onscreen.

By the time Mann delivered what was then called *The Untitled To-
bacco Project* to Joe Roth, the head of Disney, the script had already
stoked interest—and some concern—within media circles on both
coasts. "There's this unwritten rule that broadcasters and Hollywood
studios don't make movies or documentaries that attack one another,"
says Bergman. "In the old days, you never saw Paramount make a movie
that makes 20th Century Fox look bad." There was a chance that some
people would interpret *The Insider* as ABC/Disney taking a shot at CBS/
Westinghouse. But Mann and Eric Roth insisted that their script—which
would be heavily vetted by Disney's lawyers—stood up to scrutiny.

The decision came down to Joe Roth (no relation to Eric). He loved
The Insider, but Roth made a point of asking the director if the movie
would make any money. "I said, 'Probably not,' " recalls Mann. "Joe said,
'Fuck it, let's make it anyway.' "

Russell Crowe couldn't quite understand why he was sitting across from
Michael Mann. It was a Sunday in 1998, and the thirty-three-year-old
actor was in the director's offices in Los Angeles. He was reading for the

role of Wigand, who was several years older than Crowe. It wasn't just the age difference that made Crowe such an unlikely candidate: the Bronx-born Wigand was paunchy and gray-haired, and the Australian-raised Crowe—who'd been introduced to American audiences in the sharp 1997 noir *L.A. Confidential*—was in prime physical shape, as he was in the middle of filming the hockey comedy *Mystery, Alaska*. "I wanted to meet Mann, and I wanted to tell him he should hire a fifty-two-year-old," said Crowe.

As their read-through began, Mann was also wondering if the meeting had been a mistake. "Russell didn't have that much time to prepare," the director says. "I'm saying to myself, 'This is not going anywhere.' Then we hit one speech, and Russell hit four lines, and that was it. I knew he was the guy." Playing Wigand would require Crowe to gain more than thirty-five pounds, a task he planned to accomplish by eating cheeseburgers, drinking bourbon, and parking himself in front of a TV for a month and a half, watching footage of Wigand.

To play Bergman, Mann's first choice was *Heat* star Al Pacino, who'd enjoyed a career-turnaround in the nineties, having won an Oscar for his role as a blind colonel in 1992's *Scent of a Woman*. But it was *Heat* that had given the actor his most truly *hoo-hah*-worthy role of the decade. Whereas other directors had a tendency to indulge Pacino's hammy tendencies, Mann managed to keep him sharp on the edge—where he needed to be. Before filming, Mann arranged for the actor to meet with a top counterintelligence official at the FBI. "Al's job," says Mann, "was to ask questions: 'This guy doesn't want to tell you anything, but you need to find out this and that.' Just to get some of those skills."

As a kid, Pacino had known who Mike Wallace was—everyone did. "The first time I ever saw him," said Pacino, "I was passing Rockefeller Plaza, and he was in a window there doing something on the radio. I remember looking at him, and he waved at me. And I thought, 'Nice guy, huh?'" Wallace had been a TV fixture since the fifties, having worked as a game show host (and cigarette pitchman) before getting into news. *60 Minutes* had launched in 1968, and on that Sunday-night staple, Wallace had become famous for his contentious interviews with politicians

and business leaders. The chain-smoking correspondent would turn from smarmy to snarling within seconds, sometimes prefacing his toughest inquiries with the phrase "Forgive me." "As soon as you hear that," Wallace said, "you realize the nasty question's about to come."

The actor Mann chose to play Wallace, Christopher Plummer, had experienced the journalist's cozy cruelty firsthand. "Mike Wallace was interviewing me once," remembers Plummer, "and when I sat down, the first question he asked was 'What does it feel like *not* to be a household name?' I could have killed him! He was so ghastly. But then the interview got a little warmer."

Plummer can't recall the exact year of that interview or what show it was for. It must have been early in his career, as Plummer had been a well-known name since 1965, when he had played the all-singing, all-dancing von Trapp patriarch in *The Sound of Music*. In the years before *The Insider* came along, he says, "I was doing movies that I wasn't particularly proud of. They were just money films, really." But after he won a Tony in the midnineties for his role in the play *Barrymore*, "I was getting terrific scripts of a much higher quality. And miles above any of them was *The Insider*."

After being cast as Wallace, Plummer heard that the newsman wanted to meet with him. "I said no," the actor says. "I didn't want to be influenced by anything he said. If you were playing King Lear and he walked in, you'd be slightly thrown: 'Jesus, who is that? Take off your crown and sit down.'"

During Wigand's initial conversations with Mann about *The Insider*, he asked the director to alter the identity of his ex-wife (the couple had divorced in the midnineties, and not amicably). In her place was a fictionalized character, Liane Wigand—a refined but resolute southerner, one who fears losing her upscale suburban lifestyle because of her husband's public troubles. The role required some field research for Diane Venora, a Juilliard-trained performer and self-described "scrapper from New York" who'd starred as Pacino's neglected wife in *Heat*. Mann sent the actor to Louisville, where she spent time in character, even making a stop at a country club so she could befriend some of the

local women. While there, Venora asked one of her new acquaintances what she'd do if she learned her husband was cheating on her. Her response: "I'd never raise my voice. I'd find the thing he loves the most in the world, and I'd destroy it." Says Venora, "What I love about southern women is that they have this glasslike exterior, but they also have these steel backbones. You don't cross them."

By the spring of 1998, other members of the *Insider* team had relocated to Kentucky, including Crowe. He and Venora went out for dinner in their Wigand getups, and went on an excursion to Louisville's famed Churchill Downs racetrack ("Russell was terrific at reading the racing forms," says Venora, "he won like $3,000"). But Crowe spent much of his time with Mann, talking about Wigand. By then the actor had bulked up considerably for the role thanks to his bourbon-and-burger diet. He'd complete the transformation by shaving back his hairline, dying his hair multiple times, and applying liver spots to his skin. "I looked like Brando on a bad day around *Apocalypse Now*," he said.

At one point Crowe showed up at a Kentucky Derby party being held by movie producer Jerry Bruckheimer. While there, he ran into a confused Sylvester Stallone. "He was really enthusiastic about meeting me, because he enjoyed *L.A. Confidential*," Crowe said. "And he kind of turned around, saw me, and you could just see it in his face: 'Who the hell is *that*?'"

After filming in Kentucky, the *Insider* production traveled for several months, with stops in Alabama, Mississippi, California, New York City, and the Bahamas. There was also a brief stint in Israel, where "Pacino's presence created a near riot," says Mann. "When they found out that he was there, we had two thousand kids racing around. We had to smuggle him out of town."

Disney had allotted around $68 million for *The Insider*—and that was *after* Mann had made some cuts to the script. It was a remarkable figure for a film with no extensive special effects, no obvious commercial allure, and certainly no sequel potential. "It was my first exposure

to a director who had a virtually unlimited budget," says Philip Baker Hall, who was cast as Hewitt. "And therefore the ability to do as many takes as he wanted—including takes that appeared to be exactly what he wanted. The cast was all kind of looking at each other, like, 'What does he want? What is he after?'"

What Mann wanted with *The Insider*, he says, was to "bring you into the internal zone of these people. I have to make *you* be Jeffrey Wigand." Some of that was achieved via performance: Mann wanted Crowe to learn how to be a clumsy, arrhythmic golfer and to be constantly adjusting his glasses, in order to capture Wigand's innate awkwardness. And because Wigand was a former martial arts expert, Mann had set up Crowe up with a judo expert before filming. "I wanted Russell to feel in command," says Mann. "Then, as soon as he started feeling in command, I wanted the guy who trained him to throw Russell on his ass." It seemed to have worked. As portrayed by Crowe, Wigand himself seems thrown—a man slowly coming undone.

The Insider was intended to make viewers see the world as Wigand and Bergman do. "The lighting, the shooting, the editing, all the music—everything is designed to bring you inside," says Mann. He placed a large camera lens over the actors' shoulders, and close to their faces, so that the viewer was seeing what they were seeing. And he used bright arc lamps in the bright Manhattan sun to illuminate motes of dust, and "to make everything have a heightened reality," says the director.

The effect was unsettlingly up-close and personal, particularly during a scene that takes place late in the film, after Wigand learns of CBS's objections to airing his interview. His wife has left him, and the interview that was supposed to redeem him looks as though it will never go on air. He removes his glasses and looks at a pastoral mural on his hotel room wall; it soon melts away, morphing into a moving image of his two young daughters—whom he's barely been able to see—as they play in a garden.

Finally he gets a call from Bergman, who's a thousand miles away, wading deep into the waters of the Bahamas, trying to maintain cell phone reception. Wigand picks up the phone and erupts.

JEFFREY WIGAND: You manipulated me into where I am now: staring at the Brown & Williamson building. It's all dark, except the tenth floor. That's the legal department. That's where they fuck with my life!

LOWELL BERGMAN: Jeffrey, where you going with this? [Pause] So, where you going? You are important to a lot of people, Jeffrey. You think about that—and you think about them. I'm running out of heroes, man. Guys like you are in short supply.

JEFFREY WIGAND: Yeah. Guys like you, too.

Though the scene implies that Wigand—alone, frustrated, and seemingly silenced for good—was in dire straits at the time, "I never, ever, ever thought of doing any harm to myself," says Wigand. "That never came to my mind. I believed that I had a job to do, and I needed to be around to do it. But were there rough times? Sure."

Reliving the pressure and strain of Wigand's life clearly had an impact on Crowe, who'd spent months modifying himself to play the pressed-upon scientist. It wasn't just the weight Crowe had put on or the nervous mannerisms he'd adopted. The actor had become so emotionally wrapped up in Wigand that after months of intensive work, he had to escape from *The Insider* altogether. On his last day of filming, the actor recalled, "Michael was talking to me about this next shot, and I said, 'I've never felt like this before, but I'm over this character. I've had enough.' He gave me a hug and let me go. I went to New Orleans and got drunk and sang karaoke. Then I went to a health retreat."

Wearing an overcoat and a baseball cap, Mike Wallace headed to a movie theater on Manhattan's Upper West Side, bought a pair of $5 senior discount tickets—one for him, one for his wife—and took a seat right before the lights went down. It was the fall of 1999, nearly four years since he'd sided, however briefly, with CBS management about the decision to pull Wigand's testimony off the air. Now he was finally going to see the movie that relived one of the darkest moments of his

decades-long career. By then he'd already read the *Insider* script. And he wasn't happy. "What's a nice way of saying it?" Wallace asked. "[Bergman] pissed all over us."

The Insider already had at least one supporter in Wigand, who'd screened the film months earlier. The tobacco whistle-blower, of course, already knew how the movie ended: in February 1996, following months of controversy about CBS's decision, *60 Minutes*—having been scooped by the *Wall Street Journal*—finally ran Wigand's interview. Toward the end of *The Insider*, Wigand looks on as his two daughters watch his *60 Minutes* interview on live TV. It's one of the few times he smiles in the film.

Though the movie ends on a heroic note, for Wigand seeing *The Insider* for the first time—with his daughters by his side—"was quite disturbing for us," he says. "It captured the psychology of what happened. It brought back a lot of painful memories. There were periods when I got emotional."

The same could be said of Hewitt and Wallace—and that was before they saw the movie. When Mann and Bergman had first discussed making *The Insider*, the *60 Minutes* producer had told Mann, "If you think people in your business have a thin skin, you haven't met my guys. They have *no* skin." In one interview, Hewitt railed against what he saw as a vindictive attack by one network on another. "ABC News is in a life-and-death struggle with *60 Minutes*," he told the *Washington Post*. "Who owns ABC News? Disney. Who made the movie? Disney."

The Insider team had tried to preemptively fend off such attacks, screening the movie several months early for *New York Times* columnist Frank Rich, who interviewed the principals involved and (mostly) praised the movie, though he noted that it "fudges chronology and makes Mr. Pacino's Bergman into a superman." He also noted the movie's kinship to *All the President's Men*, the paranoia-laced 1976 account of Bob Woodward and Carl Bernstein's uncovering of Watergate. One of *The Insider*'s most anxious sequences finds Bergman sending a series of faxes to Wigand, trying to convince him to confide in him. It's a genuinely suspenseful back-and-forth with no real dialogue—just the sight

of paper slipping through a machine. Though Mann never intended for his movie to be parked in the same garage as *All the President's Men*, it's hard not to think of *The Insider* as a companion piece—a journalism thriller, this time told through the eyes of Deep Throat.

Which was why Eric Roth was so outraged when, around the time of the film's November 1999 release, he started seeing anti-*Insider* stories in the press. "It was the biggest shock of my life," says Roth. "We'd written a love letter to journalists, and they attacked us." Wallace himself dismissed the film in a lengthy *Los Angeles Times* piece that had followed him as he watched *The Insider* with his wife in that Manhattan theater. He groaned at one of Plummer's most memorable lines, in which he said he didn't want to end his career in "the wilderness of National Public Radio." "I wouldn't say that in a million years," Wallace told the newspaper. "How would you like to have words put in your mouth that you never said?"

Wallace wasn't alone in griping over what he saw as *The Insider*'s taking liberty with the truth. Though the film's credits note that no one was identified as the source of the various threats against Wigand—including the bullet in his mailbox—Brown & Williamson had a different interpretation. The company hinted that it would sue and took out a full-page ad in the *Wall Street Journal* addressed to Disney shareholders: "You are entitled to an explanation from your company as to why they should go to this extreme to sell more tickets."

For Mann, the controversies over the film—especially its treatment of Hewitt and Wallace—were an unwanted distraction. "I wanted to contest Big Tobacco," he says. "I wanted to contest issues of corporate malfeasance with CBS and Brown & Williamson. I didn't want to contest whether or not we were being mean to octogenarians, because number one, it's not worthy; number two, it's not what the movie's about; and number three, who cares?"

Within a few weeks of *The Insider*'s release, the fuss over the movie began to fade, for a simple reason: not enough people were seeing it. In the film's first weekend of release, it earned less than $7 million. "We never got a giant audience," says Eric Roth. "I think people thought it

was about smoking being bad for you—a 'take your medicine' kind of movie."

Soon the counterattack from Hewitt and Wallace ended as both men turned their full-time attention to *60 Minutes*. They were about to get a new boss: in September 1999, just a few months before the release of *The Insider*, CBS was bought by Viacom for nearly $40 billion. A few months later, in January 2000, AOL and Time Warner were brought together for $165 billion—at the time, the biggest merger ever. The media-opoly that *The Insider* had warned about kept growing, as the number of independent companies kept shrinking.

By the time of *The Insider*'s release, Bergman was teaching journalism and working for PBS's *Frontline*; he never returned to *60 Minutes*. Wallace stayed with the show for several more years before retiring at the age of eighty-eight in 2006. At one point, Plummer ran into the veteran newsman at a party. "I was terrified he was going to hate what I had done, because he hated a lot of the picture," says Plummer. "But he was very complimentary. And actually, he used it on lecture tours. He would open his speech by saying 'By the way, I'm not Christopher Plummer.' So it ended nicely."

As for Wigand, he stayed in close contact with Wallace until the anchor's death in 2012, occasionally dining with him and his wife in New York City. "I truly miss him," Wigand says. "He became a very, very good friend." Wigand also kept in touch with Crowe, writing a letter to a judge on the actor's behalf when he was arrested for hitting a hotel clerk with a phone in 2005. By then Wigand had spent years touring the world, discussing the health hazards of cigarettes. "When I go out speaking, people want to talk about the movie," he says. "I want to talk about how to hold the tobacco industry accountable." And though he often plays a clip from *The Insider* when he talks, it's been a long time since he revisited the film: "It ain't my type of movie to watch for fun."

16

"THE BLUEST EYES IN TEXAS."

BOYS DON'T CRY

She kept the routine up for more than a month, hoping it would make her disappear. To start, she'd bind her breasts tightly against her chest. Then she'd put on her husband's clothes, placing a rolled-up sock down the front of his pants. Daily hours-long workouts had already begun to thin her face and sharpen her jaw, and a barber had recently chopped off much of her hair. Even her voice was changing: she spoke in a low register and was listening to audiotapes recorded by a cousin in Iowa to help perfect a flat midwestern accent. If all went well, by the time Hilary Swank headed out the door to run her errands for the day, even some of her own neighbors wouldn't recognize her. As the twenty-five-year-old walked around Santa Monica, people would stare, unsure what to think: Is that a man or a woman? "If people couldn't define what I was," Swank said, "they didn't want to have anything to do with me."

It was late 1998, and Swank was in training for *Take It Like a Man*, a tightly budgeted indie drama. The film's director and cowriter, Kimberly

Peirce, had spent years researching the short life and horrific death of a transgender man, Brandon Teena, who'd been murdered at the age of twenty-one. The project had begun in 1994, when Peirce, a graduate film student at Columbia University, had read about Brandon in a *Village Voice* story, "Love Hurts." Written by Donna Minkowitz, the article outlined the young man's final months, after he had relocated to a small Nebraska town and began wooing a nineteen-year-old named Lana Tisdel. When locals discovered that Brandon had been assigned female at birth, two friends of Lana—John Lotter and Tom Nissen—tracked him down and raped him. Later, they shot and stabbed him. She eventually showed the piece to Andy Bienen, a fellow student at Columbia, and her eventual *Boys Don't Cry* cowriter. "Kim had already annotated the article heavily, underlined passages, circled photographs," remembers Bienen. "And she said something like, 'This is going to be my first movie.' We were still in film school, had no money, knew nobody in the business." Still, he says, "I didn't doubt for an instant that Kim would make this movie."

For Pierce, Brandon's story felt deeply familiar: As soon as she read Minkowitz's article, she thought, *I know this person.* "A lot of my friends were passing as boys—that's not a term you use now, but it's what you used then," she says. "And some of them were starting on the transition from boys to girls. I thought, 'I may not be good enough to tell the story, but I have to learn how.' "

She'd wind up making Brandon the subject of a student-thesis short film, but when Peirce couldn't afford to develop some of the footage, the short was held up in a lab. In need of money, she approached Killer Films cofounder Christine Vachon, who'd recently produced such downtown indie staples as *Poison* and *Go Fish*, both part of what was hailed at the time as the New Queer Cinema movement: audacious, often deeply personal tales of genderqueer life. Vachon agreed to pay $2,000 to liberate Peirce's short film, which the young writer-director wanted to turn into a feature. "The student film was okay," says Vachon. "It wasn't like you looked at it and thought, 'Oh, this is a born filmmaker.' But Kim was supersmart and very articulate about why this story was important."

Peirce and Vachon weren't alone in believing that Brandon Teena's life should be a movie. Both Drew Barrymore and *Scream* star Neve Campbell were interested in portraying him on screen, and production companies were buying up rights to books and documentaries about his death. But Peirce had already been on the ground in Nebraska, armed with a video camera. "I knew that to tell the story of Brandon Teena, I needed to be completely open minded to who this person was and how they saw themselves," she says. Peirce pored over depositions and legal documents and visited the spots where Brandon and his friends had hung out. She even traveled to the farmhouse where he'd been murdered, observing the blood still visible on the walls. It was the same level of obsessiveness she had applied to her pursuit of film. "I played Celebrity with her once," says *Boys* coproducer Brad Simpson, who in later years would work on such hits as *Crazy Rich Asians* and *The People v. O.J. Simpson.* "And we had to say, 'Kim, you can't put Kenji Mizoguchi in there!' She's like, 'But he's one of the famous Japanese directors!'"

Peirce would meet with people who'd known Brandon and, using the terminology of the time, would ask, "What do you think Brandon was? Do you think Brandon was a transsexual, a lesbian, or a butch, or ...?" Such questions were "running through the political landscape" at the time, says coproducer Eva Kolodner. "The lesbian and the trans communities were in this battle over who owned Brandon. Was Brandon a lesbian who was lying to this community? Was Brandon trans? We wanted to get to the truth of this person and his experience."

In July 1996, Peirce found herself face-to-face with someone she hoped would provide some answers, when she showed up at the Nebraska home of Lana Tisdel. Their meeting started out strangely, with Tisdel telling the young director that for a moment she had thought that Peirce—who had short hair at the time—actually *was* Brandon. Once inside Tisdel's home, Peirce assured Tisdel that she wanted to tell the "emotional truth" of what had happened. Peirce pulled out a camera and began asking her questions, including one that several people were

wondering at the time: "When did you know Brandon was a girl?"* Lana's answer kept changing. "She was all over the place," says Peirce. The hard truths about her time with Brandon would be impossible to divine. The meeting did, however, produce at least one crucial bit of intel: "She said, 'Well, Brandon used to see me at karaoke. Do you want to see it?' She puts in this video of her singing karaoke to Brandon. I nearly had a heart attack."

The song Lana performed on that tape was "The Bluest Eyes in Texas," a late-eighties ballad about a lovelorn drifter, performed by the country band Restless Heart. Peirce and Bienen eventually headed to a Tower Records store in Manhattan, where they found a cassette of the song, and listened to its love-woozy chorus: "The bluest eyes in Texas/ are haunting me tonight." Immediately they knew it would be in their screenplay. "It seemed to contain Brandon's whole journey within its verses," says Bienen, "and all of his hopes for a life with Lana in its chorus."

Peirce would bring an early draft of what would become *Boys Don't Cry* to a Sundance lab, where one her advisors was Frank Pierson, the the writer of such anithero staples as *Cool Hand Luke* and *Dog Day Afternoon*. It was Pierson who encouraged her to hinge the script on a single, simple idea: "Brandon Teena wants to be loved."

As they continued to refine their story, Peirce and Bienen would wake up early and go for long strolls through Manhattan. "We would start at Columbia," says Peirce, "and he'd say, 'We're going to walk all the way downtown, and you're going to tell me the story of Brandon. And if you mess up, we have to go back to the beginning." During their long walks, and their subsequent phone-call sessions, the two writers

* In order to accurately reconstruct the events of *Boys Don't Cry*'s late-nineties production, Peirce employs words or concepts that were commonly used in that era—while acknowledging that, decades later, they're no longer part of the LGBTQ vernacular. "The language I use will be from how I came of age," Peirce says, noting that such terms are "part of our social history."

would develop the film's structure—while also making sure *Boys Don't Cry* didn't become sensationalistic. "It couldn't be a tabloid story," says Bienen. "We didn't want the audience to be on the outside looking in."

When the film's producers set out to raise money for the film, however, they found that few financiers were interested in a romantic drama featuring a transgender man. "A lot of people who were not queer did not know about Brandon," says Peirce. "There was a disconnect between queer and mainstream in that moment." Adds coproducer Simpson, who worked at Killer Films at the time: "You almost felt like you were getting humored in these meetings—that they were snickering when you left. Like, 'Yeah, we're not going to make this weird movie.'"

For decades, mainstream Hollywood tended to depict transgender men and women as scorn-worthy oddities, violent lunatics, or both. Hit films such as *Dressed to Kill*, *The Silence of the Lambs*, *The Crying Game*, and *Ace Ventura: Pet Detective* employed transgender characters as murderers or manipulators. The notion of treating them with empathy "has been slow to reach big studio movies," says writer-director Pedro Almodóvar. "But it has always been present in the indie scene."

In 1999, the Spanish writer-director—who'd made such fizzy and impassioned hits as *Women on the Verge of a Nervous Breakdown*—released *All About My Mother* (*Todo sobre mi madre*), at the time the most successful film of his career. *All About My Mother* followed a woman who loses her son and becomes wrapped up in the lives of several kindhearted eccentrics. One of them is a long-lost friend, a transgender woman named Agrado who is forthright about her approach to life: "You are more authentic," she says, "the more you resemble what you've dreamed of being."

Agrado was the latest of several transgender characters Almodóvar had incorporated into his films. "I always made sure the fictions I tell reflect life," he says, "and transexuality is part of human nature." But in the eighties and nineties, the director knew that if he wanted to tell those fictions to the world, he wouldn't be able to do so in Hollywood. The major studios weren't interested in stories of transgender life.

"Our natural circuit was the art house," he says. "That gave us a lot of freedom."

The *Boys Don't Cry* filmmakers, though, were finding that even some indie film investors weren't interested in Brandon's story. "They'd say, 'He's just so unlikable. He lies to everybody, he cheats, he steals—and after these people have opened up their homes to him,'" remembers Vachon. "And I was getting nervous, because of all these competing projects." Vachon wound up securing $1.7 million from Hart Sharp Entertainment, a distribution and production company whose offices, conveniently enough, were across the hall from Killer Films' Manhattan headquarters.

Peirce finally had some money. She also had a signed release from Tisdel, giving the filmmaker consent to incorporate her into the film. But she still needed to find someone to play Brandon Teena—a task she'd actually begun years prior, before she knew for sure that *Boys* would get made. "My assumption was to start queer," she says. "That was my whole world, so the idea of finding a straight person to do it never made sense to me. Not that I didn't think they were great actors. But gender is very immutable." For three years, Peirce says, she accumulated countless audition tapes, but couldn't find the right actor. Both Peirce and *Boys* casting director Kerry Barden say their options for transgender performers were limited in the late nineties. "We put out notices around the country, and we had several transgender artists come in and audition," says Barden. "At that point, though, there didn't seem to be as many actors in the transgender community. We couldn't find a professional transgender actor who could carry this role."

After a 1997 episode of *Ellen* in which the show's titular character came out, Peirce was suddenly inundated with female actors who wanted to audition. Peirce tried them out, "but their inherent femininity was undroppable," she says. "So we have these two camps: the straight girls who weren't able to transform the gender and the people who were genderqueer, but we couldn't get to perform. I'm not saying anybody wasn't talented—it just wasn't happening. And there was a ticking clock."

Not long before filming was due to begin, Barden was in Los Angeles to cast a studio project and decided to work in some *Boys Don't Cry* auditions during his lunch break. That's when Hilary Swank walked in. "She had this long, luxurious Julia Roberts hair, which she had tucked underneath a cowboy hat," Barden remembers. "She had the sexiness that a guy had. She'd figured out that Brandon knew what girls liked."

Barden sent a tape featuring Swank's audition to Peirce and her producers. They were just months away from filming and were growing despondent. "Kimberly and I watched it at like ten o'clock at night in the office," says coproducer Kolodner. "We sat there as we fast-forwarded through these people, like, 'No . . . no . . . no . . .' Then Hilary came up. I remember Kimberly freeze-framing the video, like, 'Oh, my God. That's him.'" On that tape, "she smiled," says Peirce. "She opened her heart. And I just fell in love with these eyes, these lips, with this human who was warm and playful. That was the character. You were like, 'That's how Brandon got into people's homes.' He opened his heart to you."

Neither Peirce nor Kolodner had heard of Swank—who, like Brandon, had been born in Lincoln, Nebraska. Her career-making movie role, 1994's *The Next Karate Kid,* had been quickly forgotten, and a recent turn on *Beverly Hills, 90210* had ended after just one season. But Swank's low visibility was an asset. "They didn't want to hire someone famous," Swank said. "They didn't want someone where people would say, 'Oh, there's so-and-so playing a boy.'"

Swank flew to New York City to audition in person, dressed in her husband's clothes. She'd disguised her hair by pulling it up into a ponytail and putting it under the $1 cowboy hat she'd bought at a secondhand store. When she asked the doorman if she could go up, he rang the filmmakers: "There's this guy here. He says he has a reading." ("That was the first time I passed as a boy," Swank said. "It was fantastic.")

After a successful reading with the film's producers, Peirce took Swank out to Manhattan's East Village to get her a haircut. She showed the barber pictures of Matt Damon and Leonardo DiCaprio and asked for a similar look. Then Swank's blond hair was darkened. Once the stylists were finished, Swank resembled Brandon so much that "I started

crying," says Peirce. "'Cause for so many years, I'd been loving this person and inventing them and living with the real and the unreal."

In October 1998, Peirce and her cast headed to a suburb in Dallas, which would substitute for rural Nebraska. They'd spend the next five weeks there, often working late hours. Swank, whose *Beverly Hills, 90210* stint had only recently ended, had to quickly adjust from the amenities of a network TV show to the realities of an on-the-cheap indie, for which she'd be paid just $75 a day. "During the costume fitting at the hotel, Hilary asked sweetly, 'So can I have my dog stay with me in the trailer?'" recalled Vachon. "There *were* no trailers. Her dressing room was a shower curtain propped up on two metal C-stands."

The other cast members were a bit more familiar with the world of frills-free moviemaking. To play Lana, the quietly enticing object of Brandon's affection, Peirce first pursued future *Go* star Sarah Polley, who turned her down. The director eventually landed on Chloë Sevigny, the downtown doyenne who'd made her acting debut in the nihilistic *Kids*. Peirce hired Sevigny after watching the actor shimmy her way through *The Last Days of Disco*, a flirtatious 1998 drama about early-eighties Manhattan nightlife. "I only got the part because Sarah Polley passed," Sevigny said. "That happened to me a lot in the nineties."

To play the icy-eyed, scuzzily charming John Lotter, Peirce recruited Peter Sarsgaard, who'd starred in such late-nineties indies as the junkie drama *Another Day in Paradise*. The role of Lotter's snarly partner, Tom Nissen, went to Brendan Sexton III, who'd starred as a tormenting junior high schooler in 1995's *Welcome to the Dollhouse*. Sexton, eighteen, was hesitant to play such an amoral character in *Boys*—so much so that he'd pulled out of the movie just days before filming began. Feeling guilty for letting Peirce down, he soon changed his mind. Later, "I wound up reading court transcripts and watching documentaries and testimony," says Sexton. "It was one of the most immersive roles I've ever had."

Many of the early scenes of *Boys Don't Cry* take place at night, as Brandon tries to win over Lana and her friends; at one point he drives

them across an abandoned stretch of dust and dirt as the police give chase. The film's depiction of Nebraska in the dusk-till-dawn hours— the desolation, the eerie silences, the warehouses illuminated only by the stars—gave the movie an alien pallor. "Our thought was that you never saw the moonlight," says cinematographer Jim Denault, who was influenced by the look of such movies as David Lynch's *Blue Velvet*. "It was all artificial light—nothing natural."

Because of the moody setting, work on *Boys Don't Cry* sometimes began late in the evening. "There was a long period where I didn't see the sun," says Sexton. Once shooting was completed for the night, the cast and crew members would rush to get a drink before last call, after which they'd head back to their hotel to grab a few hours' sleep. "We joked that Jameson was the official sports drink of the movie," says Denault.

Stuck in a strip mall town with little to do, the actors playing the local kids—including Sevigny, Sarsgaard, and Sexton—began spending time together when they weren't filming. "We had more downtime than Hilary," says Sexton. "She was kind of an interloper, which paralleled nicely with the film: this outsider comes into town and ruins the chemistry of the clique. That bonding was a happy accident, because it meant we were willing to take risks and improvise and do all the things that Kim is fond of. Her thing was always emotional truth, not factual truth."

Peirce, who'd been readying herself for *Boys Don't Cry* for nearly five years, had little time to hang, as she was racing to complete the script. "Kim knew every moment, every detail, of every scene," says Denault. "You could say, 'Why is this character doing this?' and she'd boil it down to its essence, so you could figure out what was important to shoot." But Peirce's steadfastness didn't always please the rest of the crew. "Kim was very intense, and she demanded a lot, and not everybody was into it," says Vachon, who spent time on set. "In her defense, female directors were very few and far between, and I think there were some guys who didn't want to be spoken to that way by a woman."

Peirce's own recollection differs: "I felt they bent over backward for me," she says. "Maybe there were certain feelings, but man, did they

deliver." However her crew viewed Peirce, there's no doubt she was a rarity: a female writer-director who'd been granted a (barely) workable budget and relative autonomy. Even though the indie-movie boom of the eighties and early nineties had introduced several new women filmmakers—including Susan Seidelman, Leslie Harris, and Penelope Spheeris—at the end of the century, it was still uncommon for them to lead a set. The success of films such as *sex, lies, and videotape* and *Pulp Fiction* may have spurred the formation of numerous minimajors and incited seven-figure bidding wars, but the directors who benefited from those developments were almost exclusively white and male.

"I'm sure for all of those guys, 1999 was fucking awesome," says *Sugar Town* cowriter and codirector Allison Anders. "But for us girls, it was like, 'You don't get to create a body of work.' I'd started to see that we weren't getting ahead." (In response, that fall saw Anders organizing the "Women Filmmakers' Summit," a gathering of more than one hundred female actors and moviemakers that would take place in Santa Barbara in the spring of 2000.)

At the time of *Boys Don't Cry*, Peirce didn't feel out of place in Hollywood. "If you'd asked me back then if there was sexism in the industry," says Peirce, "I would have said, 'No, look at me—if I made it, there must be no sexism.' That was the worst answer in the whole world. Just because one woman breaks through or one queer person breaks through doesn't mean that it's systemically not impossible."

Whatever animosity toward Peirce might have existed among the crew during *Boys Don't Cry*, her biggest challenge was guiding her actors through a series of emotionally trying sequences. One especially tough night came a few weeks into production, during the filming of a scene in which Lotter and Nissen take Brandon to an abandoned area, beat him, and rape him. On the evening the sequence was shot, an unexpected fog rolled over the farmhouse—making the on-set mood all the more gloomy for what would be one of the movie's most devastating moments. "I went into it knowing that it was going to stir up a lot in my actors," says Peirce. That included Sexton, who disappeared right as shooting was set to begin, shaken by the scene's brutality. "I

just broke down and cried hysterically for an hour," he says. "Poor Kim was a first-time director, and she has to come over and talk to this eighteen-year-old man-boy." Recalls Peirce, "I said, 'Can you hold on to your cry inside? That's your humanity. But can you be the character? Because that character may be crying on the inside while doing this.'"

Decades later, says Sexton, "I still get goose bumps from that scene. I was like, 'Never again.' I don't think I worked for a year after that." He wasn't alone in feeling overwhelmed during *Boys Don't Cry*. The strain of playing Brandon would deeply affect Swank, who was in character for as long as eighteen hours a day, and sometimes spent her downtime listening to audio recordings of Brandon describing his rape to police. On Sundays, when the cast members had their day off, "I would put on makeup and try to be Hilary," Swank said. "But I just looked androgynous. I thought I was never going to be me again."

Toward the end of filming, she asked that her then husband, the actor Chad Lowe, come down to Texas to accompany her. "I told him I was having a really hard time getting through this," Swank said. "I had to keep a little bit of distance from the fact that this actually happened to someone." Peirce, however, worried that Lowe's presence might take Swank out of character. "I wanted everybody to live the part," she says. "And I was scared, rightly or not, of her going back to being this straight woman who was going to be with this man in this configuration."

Lowe wound up staying. But the conflict was emblematic of the disputes that sometimes flared between Peirce and Swank during shooting. "They both felt so deeply about the character in a proprietary way," says Vachon. "Kim had been living with this for years and felt she knew Brandon inside and out. And Hilary had to live it—Hilary had to *be* Brandon. So sometimes the fights were like, 'He would *never* . . . ' 'Oh, he *would*.' It was the tension that makes something grueling even more grueling."

Late in the shoot, however, there was a devestating reminder of why they'd decided to struggle through *Boys Don't Cry* together in the first place. On October 6, 1998, a twenty-one-year-old gay college student

named Matthew Shepard was kidnapped, pistol-whipped, and tied to a fence in rural Wyoming. He died several days later, igniting renewed discussion over rampant hate crimes in America, and inspiring a grim headline in *Time*: "The War Over Gays." The news about Shepard, says Peirce, "cast a pall over the set the next day. We all felt terrible, because history was repeating itself. It helped fuel the idea of, 'Could this movie open up the understanding of other human beings so that this didn't happen again?' But we were in great despair."

In January 1999, Vachon had shown footage from *Boys* to potential distributors at Sundance, leading to a $5 million deal from Fox Searchlight. Peirce was still editing the movie, a process that would be slowed by a drawn-out back-and-forth about the film's rating.

When *Boys Don't Cry* was submitted to the Motion Picture Association of America, the committee of parents who determine a film's rating came back with the dreaded NC-17. Coproducer Brad Simpson was tasked with giving Peirce the news. "Kim lives in a world of films and books, so she had no idea what the rating system meant," Simpson remembers. "She said, 'Is that the good rating or the bad one?' And I was like, 'That's the bad one, Kim.'" Few theaters would play a film with an NC-17 rating. If Peirce wanted an R, she was told, she'd have to deliver a less intense cut of the film. "I'm generally considered very intense," Peirce says. "I've been told that my whole life: 'Make it less intense.' I can't make it less intense."

Peirce, a former debating champion, decided that she and Simpson would contest the rating in front of an MPAA board to see if the decision could be overturned. As per MPAA policy, she wasn't told the exact reasons why *Boys Don't Cry* had been given the NC-17. But Peirce figured the movie's brutal rape scene, which had already been edited down, had likely been a major factor. The filmmakers would have to defend that sequence—and the movie as a whole—in front of an MPAA board. And they'd have to do so without invoking any other film as a precedent. That meant Peirce and Simpson couldn't point to a movie such as

The General's Daughter—the 1999 John Travolta thriller that included a horrific extended rape scene—and note the hypocrisy of awarding it an R, while *Boys* had received an NC-17.

In the summer of 1999, Peirce and Simpson showed up at a screening room in Beverly Hills to plead their case. The two downtown filmmakers, who normally dressed a bit too punk rock for the conservative committee, had gone on shopping trips beforehand: Simpson to Banana Republic, Peirce to agnès b. Walking into the room was like heading into "a star chamber," Simpson says. "There are rows of people. No one is sitting together, and they're all faceless. There's literally a fucking priest there with a collar." Peirce spoke first, presenting her arguments for overruling the original decision: "I said, 'If you diffuse the anal rape, you're encouraging rape. Because it's like saying "Why don't we all just get anally raped? It's not painful."'"

The response, she says, seemed positive—even the priest seemed to be on her side. But according to Simpson, after Peirce was finished, an MPAA rep decided to address the committee members directly. "He says, 'It's pretty evident why the movie got an NC-17. We don't want to overrule the parents.'" The rep also mentioned that the MPAA had been under a lot of pressure lately. Simpson immediately knew what the guy was talking about: the *South Park* movie.

Earlier in the year, memos had leaked to the press detailing conversations between MPAA officials and producers of the soon-to-be-released *South Park: Bigger, Longer & Uncut*. The movie was a profoundly foul-mouthed musical, one that was submitted numerous times to the MPAA, which originally gave the film an NC-17. In the memos, it was clear that the MPAA had focused on the film's language and sex jokes, ignoring its moments of animated violence, such as a scene in which Bill Gates is shot in the head.

At the *Boys Don't Cry* hearing, Simpson was shocked to hear an MPAA member allude to the *South Park* controversy; he and Peirce had been told that no other movie could be invoked in the discussion. "The fix was in," says Simpson. After the panel deliberated, Simpson and Peirce were informed that *Boys Don't Cry* would remain NC-17. When

Peirce heard the news, "I hit a cement wall and almost broke my hand," she says. "I knew that, emotionally, I had won in the room."

Peirce had no choice but to recut the movie and resubmit it. By then she'd been tipped off that the MPAA was concerned primarily about two scenes: the rape of Brandon and a sex scene between him and Lana Tisdel, during which Sevigny's character experiences a prolonged onscreen orgasm. Both moments were trimmed, and Peirce also cut a moment in which Brandon wipes his mouth after going down on Lana. After the newly edited version of *Boys Don't Cry* was sent to the MPAA, the movie finally earned an R rating. The MPAA seemingly didn't care about Brandon's blood-spattered murder. Instead, the group dwelled on the film's sex. To Simpson, the ratings ordeal over *Boys* seemed "incredibly unfair," he says. "I felt it was homophobic and transphobic."

Even with the MPAA matter settled, Peirce still had one last obstacle to face as *Boys* rolled into theaters in the fall of 1999: that October, Lana Tisdel sued Peirce, Vachon, Fox Searchlight, and several others in a US District Court in Los Angeles, claiming defamation and invasion of privacy. In the suit, Tisdel claimed that the movie had depicted her as "a skanky snake" and that she'd be "scorned and/or abandoned by her friends and family, some of whom will now believe she is a lesbian."

Tisdel's accompanying statement to the press was even more damning. *Boys Don't Cry*, she said, "destroys the memory of Brandon as badly as the two killers destroyed his body. It is the second murder of Brandon Teena." Reading that statement, Peirce says, "broke my heart. Because that movie is full of love for Brandon and for her."

Tisdel's suit was one of several potential lawsuits facing *Boys Don't Cry*, which was also being threatened by various parties involved with the competing Brandon Teena movies. Peirce was spooked by the possibility of her film being held up by costly court battles. "I was just a kid in the East Village, and I've got this movie that I love, that I'll die for," she says. "I was terrified."

By then, *Boys* had played at numerous festivals, and Academy Award nominations for the film seemed inevitable, thanks in part to

early champions like Roger Ebert, who'd sought out Peirce, Swank, and Sevigny at the Toronto Film Festival—and was so excited about their movie, he asked to take their picture. With Ebert, notes Bienen, "Kim understood that the film suddenly had a powerful and influential protector. But she thought his name was *Robert* Ebert. We'd been living in a world very far from the mainstream." Peirce, meanwhile, was doing so many interviews about the film that at one point she had to wrap a phone around her head with a towel just to relieve the strain on her arm. "One day I woke up, and my mouth wouldn't open," says Peirce. "I thought, 'Is this a heart attack?' My girlfriend at the time was like, 'You strapped the phone to your face and hurt your jaw.'"

The legal problems, Peirce says, threatened to slow all of that momentum—particularly the suit from Tisdel. In the midst of her publicity run, the director got a call from Fox, informing her that Tisdel was giving a deposition against the movie. "They said, 'She's saying that you don't have her life rights. And if you lied to us about that, you're in a lot of trouble,'" says Peirce. Luckily, Peirce remembered that she'd had her camera running during her meeting with Tisdel back in 1996. "We panned down as she signed, and we panned back up," she says.

After it became clear that Tisdel had given her consent to be depicted in *Boys Don't Cry*, Peirce arranged for Fox Searchlight to pay her an out-of-court settlement, to end the matter quickly. "I said to her, 'If you let me release the movie, you can get some money. If you shut the movie down, we all get nothing,'" says Peirce. Eventually Tisdel agreed, with a condition: She wanted to screen *Boys Don't Cry* with Peirce.

That fall, the two met at a private theater on the 20th Century Fox lot in Los Angeles. They'd had little contact since the day Peirce showed up at Tisdel's house in Nebraska to talk about Brandon, and the now twenty-four-year-old Tisdel was sporting orange dyed hair. "She says, 'Why don't you sit a few rows back? I don't how I'm going to react,'" remembers Peirce. "I sat where I could see her expressions, but not invade her space."

After the film ended, Peirce says, "We had a great talk. She told me

she was thrilled with the script and the performance." But what stood out to the director two decades later was the strange sensation of looking at Tisdel as she watched the big-screen story of her time with Brandon. For a moment, it was just the two of them sitting together quietly in the theater, living with the real and the unreal.

17

"THE GODDAMN REGRET."

MAGNOLIA

Not long after the release of his porno opus *Boogie Nights*, Paul Thomas Anderson received a dinner invitation from Warren Beatty. The young filmmaker agreed to meet, on one condition: "I told him, 'We're going somewhere public,'" Anderson said, "'a really brightly lit place where everyone will see I'm having dinner with Warren Beatty.'"

The charm-oozing, socially promiscuous Beatty, who had decades' worth of film business seniority over Anderson, was likely unaccustomed to such a demand. But even he had to acquiesce to the young writer-director. Though only in his late twenties, Anderson was perhaps the most desirable dining companion in Hollywood thanks to *Boogie Nights*, the story of an ad hoc family of adult-film stars and hangers-on in California's San Fernando Valley. First unzipped in the fall of 1997, *Boogie Nights* put the late twentieth century under a coke-dusted microscope, its numerous characters lost in their lust for money, fame, and companionship. The movie was deeply affecting and unexpectedly hilarious: in

one especially keyed-uped sequence, the film's sweat-sheened hero—a dim stud named Dirk Diggler, played by Mark Wahlberg—finds himself in the home of a drug dealer during a chaotic robbery, as firecrackers and Rick Springfield's "Jessie's Girl" pop off in the background.

Released by New Line Cinema, *Boogie Nights* was only a modest box-office hit, but Anderson's screenplay earned an Oscar nomination, as did the performances of costars Julianne Moore and Burt Reynolds, who'd played the role Beatty had turned down: that of a charm-oozing, socially promiscuous porn patriarch. Three years after Quentin Tarantino became a film school pinup with *Pulp Fiction*, Anderson was now the hottest-shit young filmmaker in the country. He had a famous girlfriend (the singer Fiona Apple), and he was becoming chummy with the likes of Tarantino. He'd even been noticed by such filmmakers as Stanley Kubrick and Steven Spielberg. "He told me a story about getting a phone call from Spielberg, asking him how he got *Boogie Nights'* [famously lengthy] opening sequence," says *Boogie* costar Alfred Molina. "He said he started getting all tongue-tied and dry-mouthed, like he was being called to the principal's office and asked, 'What exactly happened behind the bike shed?'" Everyone was curious to see what Anderson would do next—including Anderson himself. By the late nineties, he said, he wasn't sure "if I'm the type of guy who'd want to run the world like Spielberg, or retreat to a mansion in London like Kubrick."

While editing *Boogie Nights*, Anderson had started thinking about his follow-up, which he'd initially envisioned as "small and intimate," something he could shoot in about a month. He'd soon readjust his ambitions. During his meal with Beatty—held at an intimate yet very public Chinese restaurant in Beverly Hills—he was approached by a fellow diner: Francis Ford Coppola. The famed writer-director hadn't been much older than Anderson when he had directed 1972's *The Godfather*, the film that had earned him worldwide attention and, for a while, considerable industry power. "This is the one moment when you have it, when you can do whatever you want to do," he told Anderson. "It's the one moment when you have a clean slate, with no stigma attached. And even if your next movie makes $400 million and gets eight Oscars,

you'll still have to fight battles that you'll never have to fight right now. So whatever you want to do, do it now."

He wasn't alone in encouraging Anderson to think big picture. New Line, the thirty-year-old studio behind the *Nightmare on Elm Street* series, had watched competitor Miramax dominate the decade. Anderson was one of the few cool-kid directors to sit at their table and the studio's best shot at a long-coveted Best Picture nomination. New Line told Anderson they'd give him everything—even the elusive final-cut power—if he stuck with the studio. "I was in a position I will never ever be in again," Anderson said at the time.

That once-in-a-career clout would result in *Magnolia*, a multi-character, hyperconnected drama set in the same suburban LA wonderland Anderson had celebrated in *Boogie Nights*. The movie would find Anderson working with a $35 million budget, a nearly 190-page script, and a cast that ranged from barely known character actors to a name-brand superstar. Anderson could get away with whatever he wanted on *Magnolia*. It was a film in which characters delivered page-gobbling monologues, broke into song en masse, and endured a never-explained third-act plague of frogs falling from the sky. No filmmaker in 1999 would be given a permission slip as big as the one Anderson received to make *Magnolia*.

But Anderson, though showy, wasn't a show-off. He'd use his new-found powers to tell a story of ruinous relationships—the eternal discord between parents and children, husbands and wives, yesterday and today. *Magnolia*, like so many other films of 1999, found its characters locked in an end-of-the-century existential showdown in which they confronted a force more strange and unknowable than a sky full of amphibians: family.

When Anderson was seven years old, he wrote down a few life goals in a notebook: "I want to be a writer, producer, director, special effects man. I know how to do everything and I know everything. Please hire me." The son of Ernie Anderson, an on-air announcer for ABC—and a

former late-night horror movie host in Cleveland—Paul Thomas Anderson grew up in Studio City, California, where he was surrounded by movie and TV culture, often accompanying his father to work. Anderson started making movies when he was a kid, first with a super 8 camera, then with video.

In both *Boogie Nights* and his first feature, *Sydney*—a neo-noir eventually retitled *Hard Eight* and starring Gwyneth Paltrow, Samuel L. Jackson, John C. Reilly, and Philip Baker Hall—Anderson showcased his interest in the tribes we're born into and the ones we invent. Each film finds its lonesome hero seeking the guidance of a father figure and the comfort of an ad hoc clan. "Families are just endless, juicy ammunition for great stories," Anderson said. "They're never going to let you down for good drama or good comedy."

Magnolia would allow Anderson to unload multiple family stories at once. He took his initial inspiration from the LA singer-songwriter Aimee Mann, zeroing in on a heartbreaking lyric from her song "Deathly": "Now that I've met you/Would you object to/Never seeing each other again?" Anderson spent eight months writing the script, with much of the usable material coming together in the last few weeks. At the time he wrote *Magnolia*, he was recovering from the loss of his father, who'd died in early 1997 of lung cancer, just months before the release of *Boogie Nights* (the film was dedicated to his memory). His follow-up, he said, was about "parent-children relationships and how that informs who you are." As Anderson worked, he'd sometimes check in with the actors from *Boogie Nights* or *Sydney*—including Julianne Moore and Philip Seymour Hoffman—who were becoming part of his troupe. "He told me he was working on a script that sounded Robert Altman-ish, with lots of primary actors, each living their story," says Hall, who'd played Richard Nixon in Altman's 1984 one-man drama *Secret History*.

Eventually Anderson invited Hall over to his home to watch old game show episodes as research for Hall's character: Jimmy Gator, the adulterous, decades-long host of a hit TV series called *What Do Kids Know?* Jimmy's dying from cancer, and he's become mysteriously

estranged from his daughter—just one of several distant, demand-
ing, or all-around absentee dads and husbands in *Magnolia*, a movie
that would follow at least five story lines at once. "What's inside me,"
Anderson said, "is someone who is twenty-nine years old, who has
grown up on movies and television. That's there on display—a sort of
channel-changing mentality. I think that's why there are so many dif-
ferent stories trying to, in a way, reflect TV's information overload in a
movie."

Many of *Magnolia*'s stories are linked, no matter how indirectly, to
Earl Partridge, a TV mogul who's now ensconced in his deathbed, rid-
den with cancer. Heavily medicated, he confesses his sins to his nurse:
not only did he fool around on his devoted wife of nearly a quarter cen-
tury, but when she was dying of cancer, he left his teenage son to take
care of her and watch her die; the father and son haven't spoken for
years. "The goddamn regret," Earl says. "The biggest regret of my life: I
let my love go."

To play Earl, Anderson cast Jason Robards, the stage and screen
actor who'd won back-to-back Oscars in the midseventies, first for
his role as the gruffly inspiring newspaper editor Ben Bradlee in *All
The President's Men*, then for his turn as the writer Dashiell Hammett
in *Julia*. Robards, then in his late seventies, had recently been diag-
nosed with lung cancer. Curious about the young writer-director—and,
perhaps, wary of committing to a script that would require doing a
pages-long monologue—Robards called *Boogie Nights*' Alfred Molina,
whom he knew from their time together on Broadway. "I said, 'What do
you have to do?'" remembers Molina. "He said, 'I've just got to lie there.
I'm playing an old guy who's dying.' I said, 'You're going to be treated
like royalty. Paul loves actors.'"

One of Anderson's favorite performers was Tom Cruise, who'd in-
vited the director to the London set of *Eyes Wide Shut*. "He called me
after he had seen *Boogie Nights*," Anderson said. "That's the phone
call from the president of the United States of Movieland." Months
after their meeting, Anderson told the actor he'd written a *Magnolia*
role just for him: Earl Partridge's long-estranged son, a slick-haired,

slicker-talking professional pickup artist named Frank T. J. Mackey. The character was a skeeveball creep, a sort of toxic twin of the winning, put-upon charmers Cruise had played throughout the nineties. Mackey opens his how-to-meet-women seminar—entitled "Seduce and Destroy"—by blaring the thundering fanfare from Cruise's beloved *2001: A Space Odyssey*. He then imparts the following wisdom to his rabid all-male audience: "*Respect* the cock. *Tame* the cunt." Thanks in part to Mackey's coarseness, Cruise needed some cajoling before agreeing to the part; he did so only after being assured that *Magnolia* wouldn't be sold as a Tom Cruise movie. (His face wound up being so obscured on the film's poster that even his agent couldn't find it.) "Someone said, 'How come you haven't played a character like this before?' " said Cruise. "I said, 'Please tell me in the last fifteen years where this character has been.' I mean, Paul was barely born when I was making *Top Gun*."

There were also, Cruise noticed, unmistakable similarities between Earl and Frank's relationship and the one the actor had had with his own father, Thomas Cruise Mapother III. Cruise once described his dad as "a bully and a coward" and lopped off his father's last name before starting his acting career. The two men kept their distance for several years, with Cruise's dad once telling an interviewer he'd "made a personal decision to respect my son's wishes—which was for me to stay the hell out of everything." They had finally reunited in the early eighties, when Cruise had gotten word that his father was dying of cancer. "He would only meet me on the basis that I didn't ask him anything about the past," Cruise said. It was a turn not unlike the one at the end of *Magnolia*, in which Frank visits his father at his bedside, alternating between cursing and crying as he watches the older man slip away. "I asked Paul, 'Come on, man—did you know this about my father and I?' " Cruise remembered. "And he said, 'No, no, no. I didn't know.' "

Anderson had been on decidedly better terms with his father when he passed—but the rest of *Magnolia* was unmistakably drawn from the writer-director's experience. So much of his young life was right there in the script, from the cancer-stricken showbiz dads to the

dense-but-disparte Valley setting to the kid-friendly game show. (Anderson had worked on an early-nineties series called *The Quiz Kids Challenge*.) Having been given the biggest opportunity of his career, he couldn't help "vomiting out onto the page all of the stuff that was around me," he said. "I put my heart—every embarrassing thing I wanted to say—in *Magnolia*."

Things were already running a bit behind schedule when the motorcycle pulled up to the spacious Los Angeles home that was doubling as *Magnolia*'s headquarters. Inside the house were many of the actors who'd become part of Paul Thomas Anderson's movie family, including William H. Macy, Philip Seymour Hoffman, and Luis Guzmán. Some were wrestling with Anderson's bulky screenplay. "He sent me the script, and I was like, 'Oh, my fucking Lord. This guy. Where does he get this from?' remembers Guzmán. "But his writing is quite impeccable."

Among the actors waiting for the reading to begin was April Grace, a character actor who'd appeared on such TV series as *Star Trek: The Next Generation* and *Chicago Hope*. A few years earlier, Grace had come close to landing a role as an adult-film performer in *Boogie Nights*. "My mother basically prayed me out of that movie," Grace says. "She was like, 'Oh, no. You don't need to be in any of kind of movie like that.'" But Anderson liked and remembered Grace and had offered her a part in *Magnolia* without an audition. She'd be starring as Gwenovier, a TV journalist who conducts an intense one-on-one interview with Mackey that slowly unfurls throughout the movie. But *Magnolia* was so secretive that even as Grace arrived at Anderson's house, "I still didn't know who's playing opposite me," she says. "Fiona Apple—God bless her—she could sense I was trying to be cool in the room, because she leaned down and whispered, 'You don't need to worry about anything. All Paul has talked about is how fucking awesome you are.' Then she walked away."

All of a sudden the doorbell rang, and Tom Cruise—who'd traveled

to the gathering on his motorcycle—walked into the house. Grace had had no idea she'd be spending the next several hours reading opposite the actor. Afterward, she says, "Tom took my hands and gave me a kiss and went on his way." Everyone got their water and refreshments, and April Grace decided she needed to leave on a high note, "like George Costanza—'I'm out of here.' And I drove home as high as I've ever been."

Cruise and Grace would spend more time at the *Magnolia* house, sitting in a dining room as Anderson delivered the actors new pages of dialogue. Frank T. J. Mackey was based on audio recordings Anderson had heard featuring several self-professed how-to-meet-women whizzes. Mackey "thinks of himself as one of these superhero guys," Cruise said. "The first wardrobe [suggestion] was golf pants and golf shirts, and I said, 'I always saw him wearing an armband.'" By the time he'd begun filming the scenes for Mackey's "Seduce and Destroy" seminar, Cruise was sporting a samurai-style ponytail, a leather vest, and wrist bracelets—a look partly inspired, he said, by Roy Scheider's machismo style in *All That Jazz*. The clothes give Mackey a synthetically oily sheen as he struts around the stage, barking out the sort of misogynist male empowerment claptrap that, years later, would become part of the lingua franca of the internet. "I will not apologize for who I am," he tells his fans. "I will not apologize for what I need. I will not apologize for what I *want*!"

But all of Mackey's alpha-male armor is stripped away when he appears before Gwenovier and her TV cameras. She slowly puts the squeeze on the coy, elusive Mackey, acting flirty and cajoling before finally dismantling him. She tells Mackey she knows all his family's secrets: that his mother died of cancer when he was a teen and that he's changed his name to cut off all ties with his father. Mackey angrily storms off and, after learning of his dad's illness, finds himself in a car outside the old man's house. There, as the rain falls on the Valley, he starts to sing: "No, it's not going to stop/Till you wise up."

It's a line from Aimee Mann's "Wise Up," a song that, more than two hours into *Magnolia*, nearly all of the film's lead characters begin

singing in unison. They may be physically distant from one another, yet as "Wise Up" plays, they're suddenly connected—by their grief, their loneliness, their goddamn regret (more than a half-dozen Mann compositions would appear in *Magnolia*, including the Oscar-nominated "Save Me"). The castwide sing-along made for such an unguarded moment, both on and offscreen, that Anderson asked Julianne Moore—who starred as Earl Partridge's young wife—to record her vocals first, in order to reassure her castmates that the scene would work. But many of the actors who'd worked with Anderson in the past had no trouble putting their trust in him for *Magnolia*. "Paul's right there for you, even in between takes,'" says Melora Walters, a *Boogie Nights* alum who played Jimmy Gator's estranged daughter in *Magnolia*. "He's not going up to the monitor while everybody's whispering. He's right next to the camera. For me that was a safety net—his gentle way of saying 'I'm here for you to become this person.'"

Like the plastic bag scene in *American Beauty*, the "Wise Up" sequence would split critics and moviegoers—some saw it as an indulgence, others as a moment of uneasy harmony among discombobulated souls. But the sing-along was nowhere as divisive as what followed. Toward the end of *Magnolia*, as its various characters are reaching their various messy catharses—including Frank Mackey, now begging his father not to die—a massive army of frogs begins to tumble from the sky, splatting down onto the pavement and pools of the San Fernando Valley. The downpour is sudden, inexplicable, violent—much like life itself. "I remember talking to an oncologist on the phone who was essentially telling me that there was no way that my dad was going to make it," Anderson said. "And one of the first things that popped into my mind was 'You're telling me frogs are falling from the sky' . . . hearing that your dad is gonna die is as bizarre as hearing frogs are falling from the sky."

For years afterward, *Magnolia*'s detractors would point to the frog plague as the moment when the film's ambitions ran amok—a pivot that found the director's "grandiosity taking over, elbowing everything else aside," as former *Entertainment Weekly* critic Owen Gleiberman

noted. To others, the downpour of amphibians was simply baffling: *Is this really happening?*

Todd Field was wondering the same thing. In late 1999, he and Sydney Pollack found themselves at the Pacific Palisades home of Cruise, their *Eyes Wide Shut* costar. The actor had invited them over to eat dinner and screen an as-yet-unannounced movie. As they dined, a shy young couple came into and went out of the room; Field assumed they were kitchen staff. Afterward, everyone went upstairs to a theater in Cruise's home and watched *Magnolia*. "188 minutes later," Field says, "the lights came up, and you could have heard a pin drop. Sydney looked uncomfortable, as if he wasn't sure what just happened. I knew something had shifted in our universe. Here was something made with such fervor, such single-minded, obsessively committed intensity, that all I could think about was immediately seeing it again." When Field asked, "Who the fuck dared to make *that*?," Cruise pointed to the unassuming guy from the kitchen: Paul Thomas Anderson, who'd been accompanied that evening by Fiona Apple.

At the time, few people outside Anderson's immediate circle had seen *Magnolia*. A trailer for the film wouldn't appear in theaters until shortly before the movie's December release date, as Anderson battled with New Line over how it should be marketed. And while Cruise was eager for his peers to see the movie, the megastar—perhaps still reeling from the suffocating hype around *Eyes Wide Shut*—granted a slim number of prerelease interviews. *Magnolia* stayed largely out of view until a surprise screening appearance at Harry Knowles's brand-new movie marathon in Austin, Texas, which the web gossip had nicknamed Butt-Numb-a-Thon.

It was an apt description, given *Magnolia*'s three-hour-plus running time. Anderson had insisted to New Line that he wouldn't cut it further, and the studio obliged. But asking theater owners and audiences to be patient with a more than three-hours-long tale of cancer and familial rot—no matter how gorgeous and touching *Magnolia* could

be—was another matter. Decades later, when Anderson was asked what he'd change about the film, his answer was brief and exacting: "Chill the fuck out and cut twenty minutes," Anderson said. "It's unmerciful, how long it is."

That running time likely helped keep audiences away. *Magnolia* made less than its production costs in the United States. "We were all disappointed and a little surprised," says Hall. "We thought this was going to be the movie that makes Paul a filmmaker who's not only a visionary and a critical success but who's able to attract people to the box office. I mean, we had Tom Cruise. How could you miss?"

As for critics, their collective response was part admiration, part exasperation. There was overwhelming love for the film's unflagging chutzpah, its intricate story threading, and its use of Cruise, whose seduce-and-destroy movie star skills had never seemed sharper. There was also a deep weariness about the singing—it's "as if they are rehearsing for the latest installment of *Ally McBeal*," wrote Andrew Sarris in the *New York Observer*—and a strong disdain for the plague of falling amphibians. "Even in the Bible, that kind of maneuver was a last resort," noted Janet Maslin in the *New York Times*. Many years later, even some of those involved with the movie cop to having been confused about *Magnolia*'s frogs. "I scratched my head so much from that scene that I probably still have a mark on my head," says Guzmán, who played one of *Magnolia*'s game show contestants. "I was truly trying to figure that out."

Yet the unsettling conclusion of *Magnolia* captured the mood that had taken hold by the end of 1999—a feeling that some grand, impossible-to-explain epoch might arrive at any moment. That blood-splattering plague of frogs may have seemed to have come from out of nowhere. But these strange things happen all the time. "I'll vouch for the frogs," says *Magnolia*'s Philip Baker Hall. In the mid-1950s, Hall was in the army, serving as a translator in postwar Germany. He'd just purchased a new VW and was driving his wife and young daughters across Europe. One night, as he was on a high mountain pass, Hall found himself in the middle of a rainstorm. "It was dark and foggy, and we were

terrified," Hall says. "We were afraid if we pulled over, we'd be pulled off the mountain. I'm driving with the door open, looking down at the road, trying to keep the white line in view. And I'm seeing these splotches of things hit the road and the windshield. And these are frogs."

Anderson hadn't known about Hall's mountain trek when he began working on *Magnolia*. Yet it echoed a line that the writer-director had inserted multiple times into his film—a sentiment expressed by various characters in the film. It's the maxim of *Magnolia*, as well as several other films that fell from the sky that year: "We may be through with the past, but the past isn't through with us."

EPILOGUE

"WE ARE THE MIDDLE CHILDREN OF HISTORY."

MARCH 26, 2000

The place was falling apart. That's what Haley Joel Osment noticed as he sat in Los Angeles' storied Shrine Auditorium during the 72nd Annual Academy Awards. At one point during the four-hour ceremony, the *Sixth Sense* star—who'd been nominated for Best Supporting Actor—watched as Warren Beatty, rushing to the stage for a lifetime achievement award, accidentally broke off part of an old chair, sending a piece of wood flying in the direction of Clint Eastwood. The venue, which had hosted the awards on and off since the late eighties, had been converted into a one-night-only high-tech TV studio. But it was also in desperate need of a makeover. It was stuck between centuries—much like the Oscars themselves.

Some of 1999's most potent films had wound up receiving multiple nominations that year: *The Sixth Sense, Boys Don't Cry, American Beauty, The Insider, Being John Malkovich, The Matrix,* and *Magnolia.* But the Academy had ignored *Fight Club.* And *Three Kings.* And *Run*

Lola Run. And *The Blair Witch Project.* Even *Eyes Wide Shut* was shut out, meaning that Stanley Kubrick—one of the twentieth century's most revered filmmakers—would miss out on a last chance to win an Oscar for Best Director. Meanwhile, the unanimously beloved *Election* received only a single nod, for Payne and Taylor's screenplay. (They'd lose to Miramax's tasteful, traditional, utterly forgettable *The Cider House Rules*—an Oscar-friendly mawkbuster along the lines of past honorees *Life Is Beautiful* and *Driving Miss Daisy.*)

Thanks in part to blockbuster contenders such as *The Sixth Sense* and *The Phantom Menace*, more than 45 million people in the United States were tuned in to the Oscar telecast—one of the biggest audiences ever. They'd watch Best Foreign Language Film winner Pedro Almodóvar—who's deaf in one ear—failing to hear the orchestra's exit music before finally being pulled from the stage by his friend Antonio Banderas. ("I had no idea what was going on," says the director. "When I found out, I felt very silly.") Meanwhile, *South Park: Bigger, Longer & Uncut*'s Matt Stone and Trey Parker showed up dressed as Gwyneth Paltrow and Jennifer Lopez, respectively. "We'd all arrived together, and Matt and Trey said, 'Oh yeah, by the way—we just dropped some acid,'" recalls songwriter Marc Shaiman, who was nominated with Parker for the film's jingoistic anthem "Blame Canada." After the team lost to *Tarzan*'s Phil Collins, "Trey said something that never dawned on me before: 'Fuck that. Let's get out of here.' That was glorious to realize: 'I don't have to sit here in my disappointment. I can change into my street clothes and enjoy the rest of the night."

The unstated main attraction of said endless show—which ran for more than four hours—was watching the decades-old Academy trying to make sense of a radical movie year. The awards opened with host Billy Crystal performing a song-and-dance number spoofing the five Best Picture nominees: *American Beauty*, *The Insider*, *The Sixth Sense*, *The Cider House Rules*, and the pokey Tom Hanks prison drama *The Green Mile*. Crystal paused midway to praise Osment, who'd soon lose one of the night's first acting awards, bested by *Cider House Rules* star

Michael Caine (it was a semi-surprising upset over Tom Cruise, who'd recently landed a Golden Globe for his *Magnolia* turn, and who'd been given 3–1 odds of winning by *Entertainment Weekly*). Osment, for his part, wasn't fazed by the loss. The prospect of giving a huge speech was daunting for an eleven-year-old, who was nervous about forgetting the names of people to thank. "It was almost a relief," he says, of not being called to the stage. Osment had an early bedtime, so he didn't stay out too late after the show ended; his final memory of the night was watching an Oscar party reveler vomit onto a street-side curb as a Fatboy Slim song played somewhere nearby.

The Sixth Sense wouldn't earn any trophies that night; neither would *The Insider*, *Magnolia*, or *Being John Malkovich*. Instead voters went for *American Beauty*, the dark suburban fantasy about a sex-obsessed middle-aged man and a next-door Nazi. The film won Best Picture, Best Director (for Sam Mendes), Best Original Screenplay (for Alan Ball), Best Cinematography (for Conrad Hall), and Best Actor. "I hope it is not all downhill from here," Kevin Spacey joked before dedicating his award "to my friends, for pointing out my worst qualities. I know you do it because you love me." The night's other acting awards went to *Girl, Interrupted*'s Angelina Jolie for Best Supporting Actress and *Boys Don't Cry* star Hilary Swank for Best Actress. "To think that this movie wouldn't have been made three and a half years ago," Swank said from the stage. "We made it now for under two million dollars. And now this. It's quite remarkable."

Boys Don't Cry producer Brad Simpson was also struck by the importance of the night. He was sitting in the third row of the Shrine, right near *Boys* director Kimberly Peirce and not far from some of the year's other young nominees: Alexander Payne, Sam Mendes, M. Night Shyamalan, Spike Jonze. "It didn't feel like you were surrounded by the establishment," says Simpson. "It wasn't like *Braveheart* was nominated—we were up against all of these other weird movies." He'd been galvanized by Peter Biskind's recent book *Easy Riders, Raging Bulls*—and by the way Martin Scorsese, Francis Ford Coppola, and other filmmakers had

taken over the studio system. As Simpson watched, "I thought, 'This is the next revolution,'" he says. "'This new generation of auteur-driven filmmakers is going to take over, and we're going to enter a period as fertile as the 1970s.'"

"I thought it was the beginning," he says, "but it was actually the peak."

It took a while for the filmmakers of 1999 to realize that the year wasn't going to last forever. They'd been granted so much freedom and audience goodwill during those twelve months, it was impossible to imagine an era in which some of it would disappear. At the time, movies were pop culture's paramount concern. How could things possibly change? "That was a special year," says Shyamalan. "We took it for granted."

So had moviegoers. There'd been so many dynamic films in 1999 that viewers would need time to fully absorb what had happened, and many of the year's commercial letdowns enjoyed remarkable afterlives. The exploding DVD and cable TV markets that revived *Office Space* and *Fight Club* would resuscitate many of the year's commercial failures. They'd also ensure that hits such as *The Matrix* and *The Sixth Sense* would appear on late-night TV for years on end, their various body bends and plot twists becoming familiar to even the most casual film viewers.

As a result, many of the year's movies lingered long into the twenty-first century. Decades after *Office Space*, it's impossible to look at the sterile corporate cubicles that populate so many sitcoms and TV ads—with their gray desks and grave-looking inhabitants—and not see the influence of Judge's white-collar comedy. The towering frame of *The Iron Giant* became so recognizable, and so beloved, that one of the film's biggest fans, Steven Spielberg, gave the robot an extended cameo in his pop-culture-cornucopia hit *Ready Player One*. And when a *Rushmore* poster appeared on the bedroom wall of the restless, self-assured titular hero of *Lady Bird*, it was an acknowledgment that Max Fischer

was still beloved by the kids trying to make their mark in the world, instead of simply making time.

But the films of 1999 aren't just constantly being rewatched. They're being forever reinterpreted, their themes still chewed over and fought over to this day. "Without getting too maudlin or fanciful," says Todd Field, "at that time, we were ardent in seeing film as a way to enlarge our collective consciousness."

And when moviegoers wanted to further expand their minds, they turned to the internet. Films such as *The Matrix*, *Fight Club*, and *Election* have become part of the web's visual lingo, their respective heroes immortalized in GIFs, memes, Instagram posts, and lengthy online digressions. In the twenty years since their release, they've come to mean something different to everyone who watches them. Maybe you see the anticonsumerism rants of *Fight Club* as portenders of the big-brand big-brotherness to come—a time when we would willingly turned over the contents of our wallets, and our lives, to the technology companies that keep us sated. Maybe you view its angry, decentralized male space monkeys as forefathers of the angry, decentralized men who dominate the modern internet. Or maybe you employ one of Palahniuk's most cited *Fight Club* lines—"You are not a beautiful or unique snowflake"—as a putdown for anyone you perceive to be overly sensitive foes, which is how several right-wing nationalists used the term during the 2016 presidential election. (One of that year's key agitators, Steve Bannon, referenced the movie while running the conservative news site Breitbart News, referring to his staff as "the Fight Club.")

A movie as dense and self-inquisitive as *Fight Club* could be spun a million ways, because it was filled with a million ideas: about the lives we have, the lives we want, and the systems that shape both beliefs. The same went for *The Matrix*. From the moment it opened, the film inspired countless conversations about theology, technology, and philosophy—threads that would be continued online for years, if not decades. Some of those discussions went down their own unexpected rabbit holes: when the Wachowskis introduced *The Matrix*'s

reality-revealing red pill, they likely didn't imagine that "red pilling" would become web shorthand for experiencing one's own political or personal awakening—no matter how extreme they might be. In 2012, a Reddit scrum entitled r/TheRedPill became a hangout for what's loosely known as the men's rights movement, whose adherents believe that women have become too powerful over men. For a bunch of self-aggrandizing, self-impressed "freethinkers" to draw such interpretations from *The Matrix* requires *whoa*-inducing levels of willful obliviousness: it's a corporate-funded fantasy with a racially integrated and gender-balanced cast, created by a pair of transgender woman creators. But, to paraphrase Morpheus, everyone's a prisoner of their own mind.

The posthumous victory of *Election*, however, would take a while longer to be declared. In 2008, Hillary Clinton—who'd endured the grueling 1992 race that had inspired Tom Perrotta's book—began the first of two historic US presidential runs. Clinton was savvy and ambitious, as were her male opponents. But only she earned comparisons to Tracy Flick, with mash-up videos and web debates noting the two candidates' shared determination, often with derision. During the 2016 campaign, *Election* was invoked yet again, with Clinton running against a rich-kid candidate who seemed baldly unqualified—much like the film's Paul Metzler. On the eve of the vote, the *New York Times* noted that the qualities that made Flick and Clinton so off-putting to some in the nineties—their doggedness, their drive—were more and more seen as positives. Both women had become "a kind of a test for American attitudes toward women who dared to aim high," noted the *Times*, adding "You go, Tracy Flick." After nearly two decades, Tracy Flick had finally won some respect, fair and square.

Still, not every 1999 movie had to capture the culture to earn a following in the years after. Talk to the filmmakers and actors about their favorites from that year, and they'll name lesser-known breakthroughs—*Rosetta, Ratcatcher, eXistenZ*—that got lost. One of the most oft-lionzed 1999 films is *American Movie*, a documentary about a down-on-his-luck indie horror-director, Mark Borchardt, desperate to make his opus before going broke. "Kick fuckin' ass!," Borchardt

exclaims when he gets a much-needed credit card. "Life is kinda cool sometimes." Directed by Chris Smith, *American Movie* was a hit at Sundance. But like many smaller films of 1999, it struggled in theaters, having been released as moviegoers were still catching up on *Being John Malkovich* and *Boys Don't Cry*. Remembers Smith: "Richard Linklater said to me, 'The problem isn't that people don't want to see your film. It's that there's such an incredible amount of films right now.'" Over the years, thanks to DVD, the casually inspirational *American Movie* would finally find its audience, even landing a spot in a 2004 *New York Times* list of the one thousand greatest films ever made—right alongside *The Insider* and *All About My Mother*.

That same decades-long distance, however, also means that some of the movies of 1999 now resonate in uncomfortable ways. The numerous accusations of rape and sexual assault levied against Harvey Weinstein—which led to his exile from the industry in late 2017—have killed the freewheeling, rules-breaking image that Miramax boastfully projected throughout the nineties. When the company's famed logo appears before such 1999 films as *She's All That*, *The Talented Mr. Ripley*, or *The Cider House Rules*, it's hard not to wince now.

That same year, Harry Knowles stepped away from Ain't It Cool News after more than two decades, following multiple online accusations of harassing and groping women. By then his influence over movie fans and studio execs had been long been diminished, his voice drowned out by the fan culture he had helped create—and by the same social media platforms that would eventually lead to his downfall. His site remains active, its rudimentary design looking much as it did in 1999. But Knowles's reign as King Geek is over.

And nearly two decades after Kevin Spacey's Oscar speech for *American Beauty*—the one in which he obliquely called out his "own worst qualities"—the movie that dominated the final months of 1999 has taken on a new, unwanted timeliness. In the fall of 2017, sexual assault allegations were levied against Spacey, prompting many to recall

his *American Beauty* turn as a middle-aged aspiring sex predator. The sight of Lester Burnham leering at a high schooler may have seemed naughtily outré in 1999; two decades later, the moment feels unsavory in countless ways.

In early 2018, Spacey's *American Beauty* performance was even left out of an Academy Awards montage celebrating past Best Actor winners. By then *American Beauty* had become a perpetual target for critics, who questioned the film's Best Picture bona fides: How could a movie about a bored suburban creep win in a year of *Election* and *Being John Malkovich*? But the elements that made *American Beauty* seem so fantastical back in 1999 make it all the more relevant in 2019: its self-entitled pervert; its angry, screen-addicted teen; its fuming Nazi-lover next door. Like many of the movies of that year, *American Beauty* plays like an accidental warning of what was to come. You just had to look closer.

It isn't just the ongoing relevance of the 1999 films that has kept them alive. The connections they have with audience members remain deeply personal. In the prestreaming, presmartphone era, movie theaters were destinations, not diversions. People remember where they first saw *The Phantom Menace*, *The Blair Witch Project*, or *American Pie*—and who they were with—because they were major social or cultural moments. The movies of 1999 aren't mere nostalgia trips; they're a part of people's lives. To the teens and preteens who came of age in the late nineties, films such as *10 Things I Hate About You* and *She's All That* are as beloved as *The Breakfast Club* and *The Karate Kid* were to the generation before. The affection toward *The Best Man* was so sustained that nearly fifteen years after the original film's release, *The Best Man Holiday* would more than double the box office take of its predecessor.

Even Jar Jar Binks eventually found his people. The younger *Star Wars* fans who'd seen the character maligned in 1999 would redefine the character's legacy, using the same force that had initially brought him down: the internet. In the years after *The Phantom Menace*'s release, the

movie was constantly relitigated. Eventually, several "In Defense of Jar Jar Binks" essays were posted online, their authors eager for others to finally take the character seriously. "There are so many layers to Jar Jar that people did not look at," Best says, "because everyone was ready to be angry."

At last, *The Phantom Menace* had its revenge—partly because it had never gone away. Like so many of the films of 1999, it was always playing *somewhere*, even if just in the background.

"What happened to the movies?" asks Kirsten Dunst. Looking at a list of the films of 1999, she says, "I was like, 'How is this even possible?' It showed me how poor movies are these days."

Two decades after the culture rupture that was 1999, movies have somehow managed to simultaneously expand and shrink. Major studio films have never been more expensive, with budgets of $150 million to $200 million becoming so normal, they're barely worth marveling at anymore (by comparison, one of 1999's pricier films, *The Phantom Menace*, cost a then-risky $115 million). And because of those costs, the megamovies need to reach as many people as possible—which sometimes means they have to say as little as possible. In *Fight Club*, the space monkeys are tasked with destroying a piece of corporate art; they respond by pushing a giant sculpture down some stairs. Nowadays, "corporate art" consists of comic book adaptations, sci-fi sequels, and various other CGI-riddled franchise installments that are designed to never quite conclude. Sometimes, the resulting films are remarkable: *Mad Max: Fury Road. Black Panther. Star Wars: The Last Jedi. Blade Runner 2049. Mission: Impossible—Fallout.* But many big-studio sequels have become interchangeable, with screen-swallowing digital effects and dialogue so rote and expository, it feels as though it was written by committee (or perhaps George Lucas).

Yet few viewers seem to be pushing back against them or even questioning their dominance. The mainstream audiences that were willing to be confronted in 1999 now largely want to sit in their seats

undisturbed. "You don't really go to movies for ideas anymore or to get challenged in the way that you used to," says *American Pie's* John Cho. "They're more like bedtime stories: you know what you're going to get, and you use it to get a particular feeling."

That impulse to be comforted isn't hard to understand, given the perpetual turmoil of the twenty-first century. Y2K may not have gone off as expected, but look at what *did* arrive not long after 1999 ended: the country-splitting court battle of Bush versus Gore; the terrorist attacks of 9/11; the subsequent wars in Iraq and Afghanistan; the economic implosion of 2008; years of caught-on-camera police violence against minorities; and an endless procession of hacking scandals and big-tech misbehavior. The resulting turmoil would help yield such tough, direct hits as *There Will Be Blood, Children of Men, Get Out, The Social Network, Michael Clayton, The Hurt Locker, The Wolf of Wall Street, Fruitvale Station,* and *No Country for Old Men*—films that provided downbeat diagnoses on our world's condition.

But modern audiences have an appetite for only a handful of such films each year. For the most part, they want the blue-pill version of the world. "I think 9/11, in a very subconscious way, changed the reasons people go to the movies," says Steven Soderbergh. "It's an event the country still hasn't processed or healed from, and without anyone saying it out loud, this sense of 'Well, you go to the movies to escape' really increased. People have always gone to the movies to escape—but after 9/11, that feeling really took hold."

During that same period, Soderbergh notes, the demands of the industry started to change. Overseas markets such as China—which for decades had been a secondary concern for studios—were opening up, prompting executives to seek out movies that could connect with worldwide audiences. That often means grabbier, noisier, often nuance-free films that look and feel less crafted than fully automated. A few new indie companies, such as A24 and Annapurna, have found ways to yield personal, financially viable hits such as *Moonlight, Lady Bird, Sorry to Bother You,* and Spike Jonze's Oscar-winning *Her.* And when bigger

studios *do* bankroll original stories, the results can be grown-up essentials like *Bridesmaids*, *Phantom Thread*, or *BlacKkKlansman*.

In recent years, the changing mood and the changing economics "started to squeeze on the kinds of movies that I sometimes like to make and that my friends sometimes like to make," says Soderbergh. "You could feel the studios shifting from 'Hey, let's ride this wave of talent and see where it takes us' to wanting to have the kind of control they had back in the eighties."

And with that control, the studios tend to steer filmmakers and actors toward long-term franchises that eat up years of their schedules, overregulate their creativity, and give them little freedom or time to do anything else—except maybe join a *different* franchise. "Someone said to me, 'Oh, it's kind of your fault,'" says Dunst, whose 2002 film *Spider-Man* launched numerous sequels and helped spur the modern comic movie boom. "Listen: I wanted to be in *Spider-Man*. I loved making those movies. But I'm not someone who will go to the movies to see a comic book movie. It's not my cup of tea."

The sheer number of sequels and reboots doesn't leave much room for big-budget movies with out-there ideas. In 1999, there were fewer than a half-dozen major-studio-released sequels—an almost unthinkably low number decades later, when release schedules often include more than thirty sequels or reboots *per year*. And no matter *what* kind of movie a director wants to make, studios are rarely interested in eking out modest sums on smaller, smarter projects—a model that made many of the films of 1999 possible. *Boys Don't Cry*'s Kimberly Peirce, who developed several features before retuning with 2008's postwar drama *Stop-Loss*, says she's noticed an almost steroidal emphasis on box office. "I had movies that, as soon as I sold them, were talked about in a radically different way: 'Oh my God, we can make $100 million on this!'" Peirce says. "I'm like, 'Whoa. Why don't we just make a *profit*?'"

That lust for high grosses was no less pervasive in 1999, which is partly why that year turned out be such a rarity: There really *were* execs who thought courageous, commercially unorthodox films like *Election*

or *The Insider* could be lucrative. And they were quickly proved wrong. "You go down that list of movies and go, 'Okay, which of these made money?,'" says Fincher, whose own *Fight Club* underperformed during its theatrical release. "The notion that Hollywood is fifty percent for the almighty dollar, and fifty percent for ideas that challenge and take root and bear fruit—that's just fucking rubbish. The almighty dollar drives Hollywood." Twenty years later, with audience members increasingly interested only in expensive big-spectacle movies, the studios need movies they *know* people will show up for. In that environment, Fincher says, "Who wants to take a risk? Anybody? Bueller? Bueller?"

The industry that once saw such movies as *Three Kings* and *Being John Malkovich* as noble undertakings—or at least worthy investments—now relies on sure things. "A lot of the movies that got made in 1999 would have a hard time getting made these days," says Alan Ball. "The budget on *American Beauty* was fifteen million dollars, which everybody thought was cheap at the time. Now it's like, 'God, I'd give anything if somebody would just give me *five* million dollars to make a movie.'"

The film industry has long been prone to seismic ruptures, whether it was the arrival of the talkies or the decline of once-reliable westerns and musicals. Yet it's always managed to evolve, pushed into the future by daring execs, risk-rewarding audiences, and the occasional filmmaking raging bull or two. "I once saw Paul Schrader being interviewed back in the mideighties," remembers *Notting Hill*'s Richard Curtis. "This is when videos were becoming popular, and someone said, 'Do you think the movies are going to come to an end?' He said, 'Look, I don't think they are. But madrigals were huge in the fifteenth century. And I'm sure some people were sorry that they died. But we have to put up with the changes that occur; that is the business we're in.'"

Yet many of the changes Hollywood has seen in the early twenty-first century—from studio megamergers to run-amok budgets to big-brandmania—feel downright epochal. Perhaps even insurmountable. Notes *Fight Club*'s Andrew Kevin Walker, "It's my standard crotchety thing to say to the youngsters of the world, 'You're very lucky there's a

lifetime of really great films behind you, because there's not a lifetime of great films ahead of you.' "

To which some of those youngsters would no doubt respond: Who needs movies when we've got TV?

In early 1998, *Magnolia*'s Alfred Molina was having lunch with screenwriter Marshall Brickman, who'd worked in television in the late sixties and early seventies before sharing an Oscar with Woody Allen for *Annie Hall*. Brickman had been developing a possible series with HBO, the network that had enjoyed a few original hit series in the nineties such as *The Larry Sanders Show* and *Oz*, and was about to launch the tartly funny *Sex and the City*. But for the most part, it was still known mostly for boxing matches and theatrical films. "I said, 'So what's the attraction of working for them?'" remembers Molina. "And he said, 'Because I can say "fuck."'" It sounds like an almost trivial response. But at the root of it, he was talking about something very, very profound—the notion of freedom."

Brickman's HBO series never came to fruition. But about a year later, in January 1999, the network would premiere *The Sopranos*, an hour-long drama created by writer-producer David Chase. Its ten-episode initial season followed Tony Soprano, a frustrated mob honcho—played with affable menace by James Gandolfini—who's in the throes of depression. Tony did, indeed, get to say "fuck" a lot. But *The Sopranos* was a brutal, funny, sometimes utterly heartbreaking drama, one absolutely operatic in size and reach. It made viewers reconsider what an hour of TV could look like and feel like. "With *The Sopranos*," says Molina, "the TV in your house ceased to be the guest and was now the host." Adds Ball, whose funeral home drama *Six Feet Under* would debut on HBO in 2001, "*The Sopranos* was something that made me go 'Whoa—TV can be something completely different.'" Ball, unlike many of his class-of-'99 peers, was already working in television when the small-screen uprising began. He was one of the first to realize that television had been liberated from its decades-long constraints—that it would be the place where you could get away with almost anything.

Without advertisers to answer to, cable TV creators spent the next decade creating intense, immersive long-form stories: *The Wire*, *Breaking Bad*, *Mad Men*. The big TV networks, meanwhile, enjoyed their own renaissance with series such as *The West Wing*, *Lost*, and *Arrested Development*. For both writers and directors, television offered creative opportunities that rivaled, or even surpassed, what they'd done on the big screen. "We can make TV shows now the way we made feature films in 1999," says *Run Lola Run*'s Tom Tykwer. "The freedom we have, the experimental power that is given to us, the crazy open-mindedness of the audience towards new ways of storytelling—it's all massively shifted from cinema to television."

Tykwer's TV work includes *Sense8*, a sci-fi drama cocreated by the Wachowskis that premiered not on TV, not on HBO, but on Netflix. In 1999, the company was sending out DVDs by mail, all but prompting snickers from the mammoth video rental outlets such as Blockbuster. Now those companies are gone, and Netflix streams its own self-produced TV series and movies—as do its competitors Amazon and Hulu. Those services would eventually attract filmmakers such as Peirce, Fincher, and Soderbergh, all of whom would direct or produce original work for streaming services. With film studios and filmgoers more interested in superheroes and *Star Wars*, television has become a place for deeply imaginative, often completely unrestricted ideas—the kind that used to be found mostly at the movies. "If *The Matrix* and *Being John Malkovich* were being pitched today," says Cho, "they'd be pitched as television shows."

Cho, like many actors of his generation, now works in both film and television—a situation that some performers didn't find too satisfying in 1999. "Television used to be the graveyard for filmmakers, actors, and writers," notes Brendan Fraser, who earned some of the best reviews of his career for the small-screen roles he took on starting in the mid-aughts. Like Fraser, many of the actors who started their film careers in the nineties have found that a good TV part can be more rewarding. "Movie budgets are now much, much smaller," says Nia Long, a veteran

of both media. "And television has become much more interesting, with less restraints on the material. So I follow the work that speaks to me."

For some, the instant pleasures of the small screen—whether an HBO show or a watch-at-home Netflix movie—long ago eclipsed the grand promises of the multiplex. To the younger consumers who absorb much of what they watch through a phone or a laptop, going to see a movie is an occasional luxury, not a necessity. Why head to the theater when there are hours of stuff available right here in your home? "You can't stop the rain from falling," says *The Straight Story*'s Mary Sweeney, who teaches at USC Cinematic Arts. "It's happening. Fifteen- to twenty-five-year-olds are going to rule whatever the landscape is, and they don't give a damn about movies."

It's a remarkable about-face from the late nineties, when movies were considered a crucial part of our culture—and our daily lives. Watching them felt like a pleasurable duty; making them felt like a higher calling. In *Bowfinger*, Steve Martin plays the titular Bobby Bowfinger, a big-vision, small-talent movie-loving hack who dreams of nothing more than directing a feature film. Bobby schemes, cajoles, and even breaks the law, all to finish his dream project. That's how important the movies are to him.

If director Frank Oz were making *Bowfinger* today, he says, he wouldn't change much about the movie, save for one thing: "Bobby would know he should go into television."

But then again, maybe this strange phase of the movies is just another sequel itself.

In the midnineties, similar state-of-the-art grumblings had worked their way through backlots, theater lines, and magazine meeting rooms. They shared the same deep concern: the movies were in a spiritual crisis. Studios had become obsessed with pointless remakes and retreads. Young people, meanwhile, were spending more of their time and money on at-home distractions such as video games. And TV was threatening

to siphon all of Hollywood's power: in October 1995, *Entertainment Weekly*'s cover story offered "10 Reasons Why Television Is Better Than the Movies," citing such hits as *Friends* and *ER*. The industry needed something new. As one anonymous studio executive said at the time, "We're making a lot of movies that people don't want to see."

At that exact moment, the Wachowskis were sprucing up *The Matrix*.

Kimberly Peirce was piecing together *Boys Don't Cry*.

And M. Night Shyamalan was staring at the posters on his wall, wondering if he could ever tell a story millions of people would care about.

Two decades ago, just as people were worrying about the movies, multiple generations of filmmakers came along and started a counterinsurgency that would reshape the culture for years to come. It wouldn't last as long as anyone would have liked, and only a few people appreciated it at the time.

But it happened. And it can happen again—even now, at a time when some people have given up hope on the movies altogether.

As a certain madman once said: Losing all hope is freedom.

NOTES

PROLOGUE December 31, 1999

xiii "we were still licking our wounds": Author interview, April 12, 2018.

xiv "Everyone was afraid": Author interview, September 13, 2018.

xiv "What was going to happen?": *Charlie Rose*, December 7, 2007.

xiv "It was *three . . . two . . . one . . .*": Author interview, October 5, 2018.

xiv "All of a sudden": Author interview, September 13, 2018.

xiv "There were three": Author interview, October 5, 2018.

xv "Pitt walks up": Author interview, September 13, 2018.

xv "Brad's saying": Author interview, October 5, 2018.

xv "His fiancée's freaking out": *Charlie Rose*, December 7, 2007.

xv *Oh, my fucking God*: Author interview, September 13, 2018.

xvi "When the new millennium arrived": "Apple HAL Ad Super Bowl 1999," YouTube, January 24, 2018, https://www.youtube.com/watch?v=SoKmoJtZt0k.

xvi "I've seen how fragile": Kevin Poulsen, "The Y2K Solution: Run For Your Life!!," *Wired*, August 1998, https://www.wired.com/1998/08/y2k-2/.

xvi "God's instrument": Caryle Murphy, " 'Millennium Bug' a Matter of Faith," *Washington Post*, November 23, 1998, http://www.washingtonpost.com/wp-srv/business/longterm/y2k/stories/consumer_faith.htm.

xvi "It just seems like": Diana Jean Schemo, "More Christians Believe the Second Coming Is Approaching," *New York Times*, December 31, 1999, https://www.nytimes.com/1999/12/31/nyregion/more-christians-believe-the-second-coming-is-approaching.html.

xvii "The whole concept": Jeff Gordinier, "1999: The Year That Changed Movies," *Entertainment Weekly*, November 26, 1999, https://ew.com/article/1999/11/26/1999-year-changed-movies/.

xviii "It was a new century": Author interview, August 16, 2017.

xviii "One thing I learned": Author interview, November 28, 2017.

xx "There's a soulfulness": Author interview, March 7, 2018.

xxi "I remember looking": Author interview, December 4, 2018.

xxi "It's astonishing": Author interview, June 7, 2017.

xxii "The entire narrative": Author interview, May 11, 2017.

xxii "These are very": Author interview, June 28, 2017.

xxii "We were de facto": Author interview, October 5, 2018.

xxiii "Young and older generations": Author interview, June 2, 2017.

xxiii "There was so much": Author interview, February 29, 2018.

xxiii "People forget how": Author interview, December 4, 2018.

xxiii "Maybe it was": Author interview, July 10, 2017.

xxiv: "looking like a wet cat": Author interview, February 5, 2018.

xxiv "If it was the end": Author interview, October 16, 2017.

xxiv "I'd bought $10,000": Author interview, September 15, 2017.

xxv "There'll be giraffes": Author interview, February 5, 2018.

xxv "We were all terrified": Author interview, October 20, 2017.

xxv "They've all got": Author interview, October 5, 2018.

xxv "after I cleaned": Author interview, September 13, 2018.

WINTER

1 "There won't be any accidental survivors": "Getting Ready for the Millennium," *Time*, January 18, 1999.

1 "The euro, the new currency": "The Euro Is Launched," *New York Times*, January 5, 1999, https://www.nytimes.com/1999/01/05/opinion/the-euro-is-launched.html.

1 "My loneliness is killing me": Max Martin, ". . . Baby One More Time."

1 "MONICA LEWINSKY RETURNS": "Monica Lewinsky Returns to Washington to Give Deposition," CNN.com, January 30, 1999, http://www.cnn.com/ALLPOLITICS/stories/1999/01/30/impeachment.

1 "What happened to Gary Cooper?": "Pilot," *The Sopranos*, HBO, January 1999.

1 "A scrub is a guy": Kevin "She'kspere" Briggs, Kandi Burruss, and Tameka "Tiny" Cottle, "No Scrubs."

1 "So we tell the Americans": John Miller, "'Greetings, America. My Name is Osama Bin Laden,'" *Esquire*, February 1999, https://www.esquire.com/news-politics/a1813/osama-bin-laden-interview/.

1 "I think Ross knows": "The One Where Everybody Finds Out," *Friends*, February 11, 1999.

1 **"CLINTON ACQUITTED DECISIVELY"**: Alison Mitchell, "Clinton Acquitted Decisively: No Majority for Either Charge," *New York Times*, February 13, 1999, https://archive.nytimes.com/www.nytimes.com/library/politics /021399impeach-rdp.html.

1 "Welcome to *The Daily Show*": *The Daily Show with Jon Stewart*, Comedy Central, January 11, 1999, http://www.latimes.com/entertainment/tv /showtracker/la-et-st-first-daily-show-jon-stewart-20150806-htmlstory .html.

1 "In an upset": Bernard Weinraub, "'Shakespeare' Best Picture but Spielberg Best Director,'" *New York Times*, March 22, 1999, https://www.nytimes .com/1999/03/22/movies/shakespeare-best-picture-but-spielberg-best -director.html.

1 **"JOE DIMAGGIO"**: Joseph Durso, "Joe DiMaggio, Yankee Clipper, Dies at 84," *New York Times*, March 9, 1999, https://www.nytimes.com/1999/03/09 /sports/joe-dimaggio-yankee-clipper-dies-at-84.html.

1 "Polls show": "Reinventing Al Gore," *New York Times* (editorial), March 21, 1999, https://www.nytimes.com/1999/03/21/opinion/reinventing-al-gore .html.

1 "Hi! My name is (what?)": Dr. Dre, Eminem, and Labi Siffre, "My Name Is."

1 The Blair Witch Project

3 "It's gotten to be a monster": Todd McCarthy, "Redford Fights Buzz Factor," *Variety*, January 19, 1997, https://variety.com/1997/film/news/redford -fights-buzz-factor-1117433260.

4 "We called them": Author interview, April 25, 2018.

4 "With so many art films": Chris Nashawaty, "The Woes of Independent Films," *Entertainment Weekly*, July 25, 1997, https://ew.com/article /1997/07/25/woes-independent-films.

5 "Earlier in the decade": Author interview, October 23, 2017.

6 "We were film students": Author interview, March 10, 2017.

6 "We were reacting": Author interview, March 24, 2017.

7 "The hackle on the back": Author interview, March 27, 2017.

7 "We'd get ten people": Ibid.

7 "John had a crazy-ass record": Author interview, March 10, 2017.

8 "I *shouldn't* have been": Author interview, July 28, 2017.

8 "It was terrifying": Author interview, March 27, 2017.

9 "As soon as that thing": Author interview, March 16, 2017.

9 "You are about to read": Holly Millea, "Into the Woods," *Premiere*, August 1999.

9 "I walked in": Author interview, March 16, 2017.

10 "hippie-rocker kid": Author interview, March 31, 2017.

10 "I didn't have a laser focus": Author interview, March 31, 2017.

10 "a script without dialogue": Author interview, March 10, 2017.

11 "the area was riddled": Author interview, March 24, 2017.

11 "We'll take care of you": *Afterthought; The Blair Witch Project*, Sundance Channel, https://www.youtube.com/watch?v=xTKL-A5H1Ko.

11 "Nothing sexual happened": Author interview, March 31, 2017.

12 "It was late at night": Author interview, March 10, 2017.

12 "The filmmakers told us": Author interview, March 21, 2017.

13 "The three of us": Author interview, March 16, 2017.

14 "It was supposed to be": Email to author, October 11, 2018.

14 "That's where the mythology": Author interview, March 10, 2017.

15 "For a group of filmmakers": Author interview, April 6, 2017.

15 "We spent the night": Author interview, March 24, 2017.

16 "As I watched": Author interview, March 16, 2017.

16 "I was excited": Author interview, March 21, 2017.

17 "We had to do": Author interview, March 24, 2017.

18 "This was the first time": Author interview, April 12, 2017.

18 "I thought": Author interview, March 16, 2017.

18 "It was a weird reaction": Author interview, March 10, 2017.

18 "At the time": Author interview, March 27, 2017.

18 "We had it all": Author interview, April 12, 2017.

18 "We were all": Author interview, March 10, 2017.

19 "piece of shit": Peter Biskind, *Down and Dirty Pictures: Miramax, Sundance, and the Rise of Independent Film* (New York: Simon & Schuster, 2005), 361.

19 "People felt we should change": Author interview, March 27, 2017.

19 "We noticed three young women": Ibid.

20 "There wasn't much competition": Author interview, April 20, 2017.

20 "I'm kind of in": Author interview, March 21, 2017.

2 Following/Go/Run Lola Run

21 "It felt like": Author interview, August 2, 2017.

21 "When the actors": Author interview, January 18, 2018.

22 "down in the mouth": Author interview, June 8, 2017.

22 "I think Glenn's probably": Author interview, March 20, 2018.

25–26 "I guess they called": Author interview, July 28, 2017.

26 "mad scientist": Author interview, January 18, 2018.

26 "I was only getting sent": Author interview, March 8, 2017.

27 "Remember, it was the Academy": Author interview, July 27, 2017.

27 "They were scared of it": Lynn Hirschberg, "The Two Hollywoods; The Man Who Changed Everything," *New York Times Magazine*, November 16, 1997, https://www.nytimes.com/1997/11/16/magazine/the-two-hollywoods-the-man-who-changed-everything.html.

27 "studios with deeper pockets": Author interview, July 27, 2017.

28 "My sense of my place": Author interview, March 20, 2017.

28 "every day was impossible": Author interview, July 18, 2017.

28 "I could see": Author interview, March 8, 2017.

29 "It was almost": Author interview, July 18, 2017.

30 "We were getting good at it": Author interview, March 9, 2018.

31 "quite stupid": Ibid.

31 "The Wall was still there": Ibid.

32 "We were as bored": Ibid.

32 "I wanted to do a film": Laura Winters, "A Rebel with Red Hair Rumples Stuffed Shirts," *New York Times*, June 13, 1999, https://www.nytimes.com/1999/06/13/movies/film-a-rebel-with-red-hair-rumples-stuffed-shirts.html.

33 "I was a chain smoker": Author interview, June 27, 2018.

34 "We'd been living": Author interview, March 9, 2018.

34 "breaking the chains": Winters, "A Rebel with Red Hair Rumples Stuffed Shirts."

34 "When it was done": Author interview, June 27, 2018.

34 "stupid, boring, old-fashioned": Brian Pendreigh, "The Lolaness of the Long-Distance Runner," *The Guardian*, October 14, 1999, https://www.theguardian.com/film/1999/oct/15/2.

3 Office Space

37 "tight tingly thing": Author interview, February 2006.

38 "When you're doing landscaping": Author interview, May 7, 2018.

38 "I was good at math": Author interview, February 2006.

38 "I got a job": Author interview, May 7, 2018.

38 "I said, 'Hey'": *Office Space: Special Edition (with Flair)* DVD, Twentieth Century Fox Home Entertainment, 2005.

38 "There was this baby-boom": Author interview, May 7, 2018.

39 "the voice of a generation": Charles M. Young, "Beavis and Butt-Head: The Voice of a Generation," *Rolling Stone*, August 19, 1993, https://www.rollingstone.com/culture/culture-news/beavis-and-butt-head-the-voice-of-a-generation-106356/.

39 "Buffcoat and Beaver": A. J. Jacobs, "The End of 'Beavis and Butt-Head,'" *Entertainment Weekly*, August 15, 1997, https://ew.com/article/1997/08/15/end-beavis-and-butt-head/.

39 "I was so stressed out": Author interview, February 2006.

40 "Something was boiling": Author interview, May 7, 2018.

40–41 "I was on the fence": Author interview, May 7, 2018.

41 "there was no better": Author interview, September 25, 2017.

41 "We'd come out of": Author interview, April 15, 2017.

42 "I never liked the show": Author interview, April 17, 2017.

42 "I kept those jobs": Author interview, May 1, 2017.

43 "Mike's not the guy": Author interview, February 15, 2006.

43 "They went through": Author interview, September 19, 2017.

44 "They thought I was just": Author interview, February 2006.

44 "She's a little bit": *Office Space* DVD.

44 "It helped put the studio": *Entertainment Weekly Cast Reunions: Office Space*, February 2018, https://people.com/peopletv/video/bs/00000161-9299-d960-a5e3-d299b5380000/office-space.

45 *"When I'm done writing"*: Author interview, May 7, 2018.

45 "ultraspecific": Author interview, September 25, 2017.

46 "Mike came up to me": Author interview, October 18, 2017.

46 "They didn't like the movie": Author interview, May 7, 2018.

47 "He was put": Author interview, February 15, 2006.

47 "Once the studio realized": Author interview, April 17, 2017.

47 "Apparently, they hated us": Author interview, May 1, 2017.

47 "Someone from the studio": Author interview, April 15, 2017.

Notes | **327**

47 "There were moments": Author interview, May 7, 2018.

47 "They hated the music": Author interview, February 2006.

48 "She was like": Author interview, May 7, 2018.

48 "It looked like": Ibid.

48 "I thought": Author interview, February 2006.

48 "I just wanted": Author interview, May 7, 2018.

48 "It put me in": Author interview, September 19, 2017.

49 "She said, 'You know'": Author interview, May 7, 2018.

49 "One of them said": Ibid.

49 "Mike was down": Author interview, February 15, 2006.

49 "I'm walking around": Author interview, September 25, 2017.

49 "Hey, Lawrence": Author interview, September 19, 2017.

50 "People hate": Author interview, May 1, 2017.

50 "The residuals": Author interview, September 19, 2017.

50 "To me, *Office Space*": Author interview, May 7, 2018.

50 "free you from": "Steve Jobs Introduces WiFi to the Masses with a Hula Hoop!," YouTube, November 6, 2009, https://www.youtube.com/watch?v=HFngngjy4fk.

4 The Matrix

51 "I'd only sold": Author interview, March 22, 2018.

52 "It was funny": Ibid.

52 "schmoes from Chicago": Rebecca Ascher-Walsh, "Reality Bytes," *Entertainment Weekly*, April 9, 1999, http://www.whoaisnotme.net/articles/1999_0409_rea.htm.

52 "We saw every single": "Andy Wachowski and Lana Wachowski," DePaul Visiting Artists Series interview, November 13, 2013, https://www.youtube.com/watch?v=ARoKJ0OcEZ8.

52 "Everyone hated *Blade Runner*": Ibid.

52 "We were inspired": Nat Whilk and Jayson Whitehead, "Glory Bound: An Interview with Larry and Andy Wachowski," *Gadfly*, January 1998, http://www.gadflyonline.com/home/archive-wachowski.html.

53 "Hollywood deals started": Author interview, March 22, 2018.

53 "our abortion": Whilk and Whitehead, "Glory Bound."

53 "This is the sex scene": *The Ultimate Matrix Collection*, Warner Home Video, 2004.

53 "Goddamnit": Author interview, October 12, 2017.

54 "We were interested": Bernard Weinraub, "Brothers Unleash the Comic Book of Ideas," *New York Times*, April 5, 1999, https://www.nytimes.com /1999/04/05/movies/brothers-unleash-the-comic-book-of-ideas.html.

55 "When I first read the script": Author interview, March 22, 2018.

55 "Nobody understood it": Author interview, October 12, 2017.

56 "It was an unusual show": Ibid.

56 "Sequels were faltering": Ibid.

57 "*Oh, my God*": Ascher-Walsh, "Reality Bytes."

57 "It got to the point": Author interview, October 12, 2017.

57 "When I first read that script": Jeff Gordinier, "Keanu Reeves Wants to Read You Some Poetry," *Details*, October 27, 2008, http://www.whoaisnot me.net/articles/2008_1027_kea.htm.

57 "They told me": Reddit AMA, October 13, 2014, https://www.reddit.com/r /IAmA/comments/2j4ce1/keanu_reeves_hello.

57 "We knew it would take": Ascher-Walsh, "Reality Bytes."

57 "One of the great misunderstandings": Author interview, October 12, 2017.

58 "I had a dream": Alberlynne "Abby" Harris, "*The Matrix Revolution*: An Interview with Laurence Fishburne and Keanu Reeves," Blackfilm.com, October 2003, https://www.blackfilm.com/20031031/features/laurence _keanu.shtml.

58 "The Wachowskis had heard": Author interview, October 12, 2017.

58 "Obi-Wan Kenobi": *Charlie Rose*, May 13, 2003.

58 "but Keanu and I": *The Howard Stern Show*, June 3, 2015, https://sound cloud.com/howardstern/jadapinkettsmith_matrix.

59 "I couldn't walk for days": "Interview with Carrie-Anne Moss (Trinity) from The Matrix (1999)," Matrixfans.net, February 7, 2012, https://www .matrixfans.net/interview-with-carrie-anne-moss-trinity-from-1999.

59 "I remember thinking": *The Ultimate Matrix Collection*, Warner Home Video, 2004.

59 "After the first day": Ibid.

59 "I was falling over": Chris Heath, "The Quiet Man: The Riddle of Keanu Reeves," *Rolling Stone*, August 31, 2000, https://www.rollingstone.com /movies/movie-news/the-quiet-man-the-riddle-of-keanu-reeves-97442/.

59 "Keanu's doctor told him": Author interview, September 20, 2017.

59 "stretch and watch": *The Ultimate Matrix Collection*, Warner Home Video, 2004.

60 "none of that Hollywood thing": Ibid.

60 "They wanted me": Author interview, September 15, 2017.

61 [*Jones's*] *gun booms*: The Wachowskis with Geof Darrow, *The Art of the Matrix* (New York: Newmarket Press, 2000), 373.

61 "People would say": Interview, DePaul Visiting Artists Series, November 13, 2013.

61 "push at the boundaries": Ibid.

62 "a weird techno-garden": Author interview, August 8, 2017.

62 "They were trying": Author interview, August 8, 2017.

63 "People were superskeptical": Author interview, August 8, 2017.

63 "Joel Silver got up": Ibid.

63 "They said, 'Are you shooting' ": Author interview, September 25, 2017.

64 "We don't do that": Ibid.

64 "It felt like": Author interview, September 15, 2017.

64 "Warners was worried": Author interview, September 20, 2017.

64 "They shot that morning": Author interview, January 7, 2019.

64 "The studio could see": Author interview, September 20, 2017.

64 "They basically": Author interview, January 18, 2018.

64 "*The Matrix* was made": Author interview, January 7, 2019.

65 "The weekend before": "Interview with Carrie-Anne Moss (Trinity) from *The Matrix* (1999)."

65 "Oh no": *The Ultimate Matrix Collection*, Warner Home Video, 2004.

65 "FUCK": Ibid.

65 "In the script": Author interview, September 15, 2017.

66 "Terry said": Author interview, January 7, 2019.

67 "That decade was so comfortable": Author interview, March 22, 2018.

68 "*The Matrix* was ten years": Author interview, June 2, 2017.

68 "I'm a human being": Bruce Weber, "Swift and Slashing, Computer Topples Kasparov," *New York Times*, May 12, 1997, https://www.nytimes.com/1997/05/12/nyregion/swift-and-slashing-computer-topples-kasparov.html.

69 "This world has the Matrix": Bill Warren, "Masters of The Matrix," *Starlog*, May 1999, https://archive.org/details/starlog_magazine-262/page/n51.

SPRING

71 "If you are just joining": Dan Abrams, "Breaking News: School Shooting in Littleton, Colorado," MSNBC News, April 20, 1999.

71 "Believe when I say": Andreas Carlsson and Max Martin, "I Want It That Way."

71 "**GATESES GIVE RECORD**": "Gateses Give Record $5 Billion Gift to Founda-

tion," *New York Times*, June 3, 1999, https://www.nytimes.com/1999/06/03 /us/gateses-give-record-5-billion-gift-to-foundation.html.

71 "We would like to emphasize": "Two Gunmen Still Inside Littleton, Co. High School." Fox News, April 20, 1999.

71 "The streak is over!": "Daytime Emmy Awards," CBS, May 21, 1999.

71 "In my dreams": Moby, "Porcelain."

71 "By midnight on Thursday": Barry Meier. "'Lost Horizons: The Billboard Prepares to Give Up Smoking," *New York Times*, April 19, 1999, https://www .nytimes.com/1999/04/19/us/lost-horizons-the-billboard-prepares-to -give-up-smoking.html.

71 "We were all under the tables": "Eight Students Shot in Littleton, Colorado," MSNBC News, April 20, 1999.

71 "It took just five weeks": "Dow: Leaps Tall Buildings." CNNMoney. May 3, 1999, https://money.cnn.com/1999/05/03/markets/dow11k_milestones/.

71 "Upside, inside out": Desmond Child, Luis Gómez Escolar, and Robi Rosa, "Livin' la Vida Loca."

71 "Perhaps we may": Bill Clinton, "President Clinton's Remarks to the Columbine High School Community," Clinton Digital Library, May 20, 1999, https://clinton.presidentiallibraries.us/items/show/15882.

71 **"BUSH IOWA TRIP"**: Adam Nagourney, "Bush Iowa Trip Signals Real Start of 2000 Race for the Presidency," *New York Times*, June 13, 1999, https:// www.nytimes.com/1999/06/13/us/bush-iowa-trip-signals-real-start-of -2000-race-for-the-presidency.html.

5 Varsity Blues/She's All That/Cruel Intentions/10 Things I Hate About You/American Pie

74 "It was unthinkable": Marilyn Manson, "Columbine: Whose Fault Is It?," *Rolling Stone*, June 24, 1999, https://www.rollingstone.com/culture/culture -news/columbine-whose-fault-is-it-232759/.

74 "Keanu and an accomplice": Bob Harris, "The Columbine High School Shootings," *Mother Jones*, April 27, 1999, https://www.motherjones.com /politics/1999/04/columbine-high-school-shootings/.

74 "In three weeks": Richard Corliss, "The Littleton Massacre: Bang, You're Dead," *Time*, May 3, 1999, http://content.time.com/time/subscriber/article /0,33009,990878-2,00.html.

74 "Our children are being fed": William J. Clinton, "Remarks by the President and Mrs. Clinton on Children, Violence and Marketing ," June 1,

1999, https://clintonwhitehouse2.archives.gov/WH/New/html/19990601.html.

75 "culture of death and violence": John Cloud, "Taking Aim at Show Biz," *Time,* June 14, 1999, http://www.cnn.com/ALLPOLITICS/time/1999/06/14/showbiz.html.

75 "Columbine upset me": Author interview, May 24, 2018.

76 "Violence is like a movie": John Cloud, "Just a Routine School Shooting," *Time,* May 31, 1999, http://www.cnn.com/ALLPOLITICS/time/1999/05/24/school.shooting.html.

76 "In the early nineties": Author interview, September 21, 2017.

77 "It was the easiest audience": Author interview, September 27, 2017.

77 "It was instantaneous": Author interview, December 20, 2017.

78 "I went from doing": Ibid.

78 "When I was seventeen": Ibid.

78 "This is *this* year's guy": Ibid.

79 "Living in New York": Author interview, October 11, 2017.

79 "It was my first day": Ibid.

80 "Did any of you see": "Courtney Love—MTV Movie Awards 99," June 5, 1999, https://www.dailymotion.com/video/xaalcz.

80 "She was like": Author interview, December 20, 2017.

81 "fucking with the brand name": Peter Biskind, *Down and Dirty Pictures: Miramax, Sundance, and the Rise of Independent Film* (New York: Simon & Schuster, 2005), 364

81 "piece of shit": Ibid.

81 "I really wanted": Author interview, November 2, 2017.

82 "I grew up": Ibid.

82 "The main dress": Ibid.

82 "I sporadically went": Ibid.

83 "If you made": Ibid.

83 "I thought, 'I know'": Ibid.

84 "That movie had": Author interview, April 12, 2017.

84 "I said, 'You don't understand'": Author interview, May 24, 2018.

85 "porny": Margy Rochlin, "Cruel, Cruel World," *Premiere,* April 1999.

85 "I was mad": Author interview, May 24, 2018.

85 "I went to a private school": Ibid.

85 "I grew up": Author interview, October 6, 2017.

85 "the kind of seminal": Ibid.

85–86 "Ryan would come": Author interview, April 12, 2017.

86 "Roger and I really": Author interview, October 6, 2017.

86 "I was always": Author interview, October 20, 2017.

86 "She was like": Author interview, April 12, 2017.

86 "We had been living": Author interview, October 20, 2017.

86 "I was probably": Author interview, October 6, 2017.

86 "I lived in": Author interview, May 16, 2018.

87 "everyone in the universe": Author interview, May 24, 2018.

87 "I'm a genie": David Frank, Steve Kipner, and Pamela Sheyne, "Genie in a Bottle."

88 "launched a thousand": Rochlin, "Cruel, Cruel World."

88 "I was so sexually naive": Author interview, May 16, 2018.

88 "Wherever you looked": Author interview, May 24, 2018.

88 "There were signs": Author interview, April 12, 2017.

88 "Movies like *The Goonies*": Author interview, April 24, 2018.

89 "were going to get in": Ibid.

89 "It had things like": Author interview, March 23, 2018.

89 "was a fusion": Author interview, April 24, 2018.

90 "The market was incredibly robust": Author interview, March 16, 2018.

90 "They said Kat seemed": Author interview, April 24, 2018.

90 "We were supposed": Author interview, March 23, 2018.

90 "became ground zero": Author interview, April 24, 2018.

91 "He corrected me": "Heath Ledger," *Too Young to Die* (German documentary series), aired July 28, 2012.

91 "I haven't sung in years": Ibid.

91 "I saw the trailer": Author interview, March 23, 2018.

92 "My high school wasn't": Chris Nashawaty, "Pie in Your Face," *Entertainment Weekly*, July 16, 1999.

92 "There's a kind of": Author interview, April 5, 2017.

92 "We wanted it to feel": Ibid.

93 "I was like": Author interview, May 16, 2018.

93 "I rounded up carts": Author interview, October 2, 2017.

93 "I've looked forty-five years old": Ibid.

93 "I'd never heard": Author interview, November 5, 2017.

93 "I'd felt very disconnected": Ibid.

94 "it was an important moment": Ibid.

94 "I had made myself": Author interview, September 19, 2017.

94 "My boyfriend at the time": Author interview, November 11, 2017.

95 "Jason's reaction": Author interview, September 18, 2017.

95 "I'm calling my manager": *Larry King Now*, August 3, 2016.

95 "I knew this was funny": Jason Biggs, "Jason Biggs Waxes Poetic About His Pie-F*cking Legacy," *Vulture*, April 5, 2012, http://www.vulture.com /2012/04/jason-biggs-american-pie-essay.html.

95 "We weren't quite": *American Pie Unrated* DVD, Universal Pictures Home Entertainment, 2001.

95 "You'd receive these extraordinary memos": Author interview, April 5, 2017.

95 "In retrospect": Ibid.

96 "The women": Nashawaty, "Pie in Your Face."

96 "pretty much a chick flick": Ibid.

96 "When we were shooting": Author interview, October 2, 2017.

96 "It turned out": Author interview, April 5, 2017.

96 "from trying to figure out": Author interview, March 23, 2018.

6 Election/Rushmore/The Virgin Suicides

99 "The last thing": Author interview, June 26, 2017.

100 "The Republican talking point" Author interview, April 20, 2017.

100 "a situation where *everybody*": Ibid.

100 "We saw it as something": Author interview, April 19, 2017.

100 "Alexander's one of the only": Author interview, October 20, 2017.

100 "Tom Perrotta was a revelation": Author interview, June 26, 2017.

101 "I'd drunk the elixir": Ibid.

101 "The book seemed like something": Author interview, June 7, 2017.

101 "It's kind of like": Author interview, June 26, 2017.

101 "He got scared": Ibid.

102 "There were these incredibly": Author interview, June 26, 2017.

102 "I said to Alexander": Author interview, October 20, 2017.

102 "I wanted that genuine": Author interview, June 26, 2017.

102 "They wanted whoever": Author interview, June 26, 2017.

103 "I didn't really know": Author interview, August 15, 2017.

103 "I kind of read it angry": Ibid.

103 "We were like": Author interview, May 10, 2017.

103 "he hadn't even seen": Author interview, June 7, 2017.

103 "Where I'm from": Author interview, September 19, 2017.

104 "I phoned Alexander": Ibid.

104 "It's difficult to mount that": *Rushmore* DVD, Criterion Collection, 1999.

105 "I was two years": Author interview, October 9, 2017.

105 "What we had going": Ibid.

105 "Whenever we write a script": *Charlie Rose*, January 29, 1999.

106 "I made a number": Ibid.

106 "I was a little terrified": Ibid.

107 "At the end": Ibid.

107 "I kind of imagined": *Rushmore* DVD, Criterion Collection, 1999.

107 "I'd barely been": Author interview, November 14, 2017.

107 "a guy who wants": *Rushmore* DVD, Criterion Collection, 1999.

107 "I think he was thinking": Author interview, November 14, 2017.

108 "There was some trouble": *Late Night with Conan O'Brien*, NBC, February 26, 2009.

108 "Bill took us out": Charles Thorp, "What About Bill?: Wes Anderson on Working with Bill Murray," *Rolling Stone*, March 6, 2014, https://www.rollingstone.com/movies/movie-lists/what-about-bill-wes-anderson-on-working-with-bill-murray-19629/.

108 "was an immediate champion": Author interview, October 9, 2017.

108 "very Method": Author interview, November 14, 2017.

109 "There were so many": Author interview, 2002

109 "None of the students": Author interview, October 20, 2017.

109 "It was quite a big deal": Author interview, November 7, 2017.

109 "If you're from the East": Author interview, August 15, 2017.

110 "I know it's old-fashioned": Ibid.

110 "At lunch, I'd ask": Author interview, September 19, 2017.

110 "fiery female characters": Author interview, October 20, 2017.

110 "allowed me to lampoon": Ibid.

110 "never saw Tracy": Author interview, June 7, 2017.

111 "She's trying to be an adult": Ibid.

111 "I grew up with guys": Author interview, October 16, 2017.

112 "The critics tore me apart": Lynn Hirschberg, "The Coppola Smart Mob," *New York Times*, August 31, 2003, https://www.nytimes.com/2003/08/31/magazine/the-coppola-smart-mob.html.

112 "It brought together": Author interview, October 16, 2017.

112 "He was making it": Ibid.

112 "I said to her": "The Making of *The Virgin Suicides*," *The Virgin Suicides* DVD, Paramount Home Video, 2000.

112 "On my first day": Author interview, October 16, 2017.

113 "When you're a teenager": Ibid.

113 "gave me a connection": Sofia Coppola, "Sofia Coppola on Making *The*

Virgin Suicides: 'When I Saw the Rough Cut I thought: Oh No, What Have I Done?,'" *The Guardian*, January 25, 2018, https://www.theguardian.com/film/2018/jan/25/sofia-coppola-on-the-virgin-suicides-director-debut.

113 "I was terrified": Author interview, October 16, 2017.

113 "I was at the precipice": Author interview, April 10, 2018.

114 "My friend and I": Ibid

114 "everything I could get": Author interview, November 8, 2017.

114 "That's where the money was": Ibid.

114 "my dad loaned": Author interview, October 16, 2017.

115 "You should say 'Action'": Hirschberg, "The Coppola Smart Mob."

115 "I thought, 'Okay'": Ibid.

115 "You're not a teen": Author interview, November 8, 2017.

115 "doing a pseudo–Jim Morrison impression": Ibid.

115 "That was terrifying for me": Author interview, April 10, 2018.

115 "My dad told me": Author interview, October 16, 2017.

116 "There were distributors": Ibid.

116 "It's the only movie": Author interview, June 26, 2017.

116 "The camera pulls back": Author interview, April 19, 2017.

117 "The movie we made": Author interview, June 7, 2017.

117 "It's the first time": Author interview, April 19, 2017.

117 "When I first saw": Author interview, October 20, 2017.

117 "*Election* had terrible test scores": Author interview, May 10, 2017.

117 "I had terrible calls": Ibid.

118 "We'd go into marketing meetings": Author interview, April 19, 2017.

118 "Paramount was considering": Ibid.

118 "a romantic triangle": Peter Travers, "Rushmore," *Rolling Stone*, February 5, 1999, https://www.rollingstone.com/movies/movie-reviews/rushmore-246809/.

118 "I fell in love": Author interview, May 16, 2018.

119 "a huge imagination": Author interview, November 14, 2017.

7 Star Wars: Episode I—The Phantom Menace/The Iron Giant/ Galaxy Quest

121 "the hole": *Star Wars: The Complete Saga* Blu-Ray, 20th Century Fox Home Video, 2011.

121 "It's great to be able": Ibid.

122 "probably the most craved movie ever": David Kamp, "The Force Is Back," *Vanity Fair*, February 1999, https://www.vanityfair.com/news/1999/02/star-wars.

122 "Listen to the fans": Harry J. Knowles, "Listen to the Fans, they are your only hope," post to newsgroup rec.arts.sf.starwars.misc, December 18, 1996.

123 "Texans don't have basements": Author interview, March 18, 2013.

123 "a fat character actor": Ibid.

123 "It was an amazing place": Ibid.

123 "get a following": Ibid.

124 "I'd like to think": "Harry Knowles on Inside Edition 1998," YouTube, January 13, 2008, https://www.youtube.com/watch?v=yLBwr_533XA.

124 "It was extraordinary studio propaganda": Author interview, March 2013.

125 "breathing down my neck": Anne Thompson, "George Lucas," *Premiere*, May 1999.

125 "I purchased my freedom.": Ibid.

126 "Just people spinning fictions": Steve Daly, "A Monster Movie," *Entertainment Weekly*, March 26, 1999.

127 "Jar Jar was one": Author interview, June 15, 2017.

127 "I turned into an asshole": Author interview, June 25, 2017.

127 "I couldn't take": Author interview, June 15, 2017.

127 "I was doing": Jancee Dunn, "Jar Jar Binks: A Digital Star Is Born," *Rolling Stone*, June 24, 1999, https://www.rollingstone.com/movies/movie-news/jar-jar-binks-a-digital-star-is-born-50301/.

128 "We laughed all day long": Author interview, June 25, 2017.

128 "You can destroy these things": *Star Wars: Episode I—The Phantom Menace* DVD, 20th Century Fox Home Video, 2001.

128 "I go into the men's room": Author interview, October 8, 2017.

129 "Before the internet": Ibid.

130 "Alan loved the idea": Ibid.

130 " 'fly across the room' ": *Late Night with Conan O'Brien*, NBC, December 21, 1999.

130 "It's easy to mock": John Horn, "Surely, You 'Quest,' " *Premiere*, January 2000.

130 "That year": Author interview, October 8, 2017.

131 "The fanboy-fangirl audience": Author interview, October 8, 2017.

131 "He waits for about two minutes": Ibid.

131 "Henry Knowles, is it?": *Late Night with Conan O'Brien*, NBC, December 21, 1999.

132 "It's a little disjointed": *Star Wars: Episode I—The Phantom Menace* DVD, 20th Century Fox Home Video, 2001.

132 "as fuzzy as an Ewok": George Rush, Joanna Molloy, Marcus Baram, and K. C. Baker, "Murky Rumors of 'Star Wars' Woes," *The Daily News* [New York], June 22, 1998, http://www.nydailynews.com/archives/gossip/murky-rumors-star-wars-woes-article-1.795325.

132 "cheesy": "Buzz Wars, Episode One: The Backlash Menace," *Newsweek*, January 17, 1999, https://www.newsweek.com/buzz-wars-episode-one-backlash-menace-165478.

132 "We were like": Daniel Fierman, "Burning Questions: 'South Park,'" *Entertainment Weekly*, July 16, 1999.

133 "All I can do now": Laurent Bouzereau and Jody Duncan, *The Making of Star Wars, Episode I—The Phantom Menace* (New York: Ballantine, 1999), 149.

133 "I'd had so many projects": Author interview, October 4, 2017.

134 "everyone was trying": Ibid.

134 "I went into a pitch meeting": Ibid.

134 "I lost a family member": Ibid.

135 "I related to that notion": Author interview, October 12, 2017.

135 "They were literally closing": Author interview, October 4, 2017.

135 "At first I was very upset": Ibid.

135 "*Right now, somewhere in Glendale*": Drew McWeeny, "Moriarty Takes His Microscope and Precision Scales to the Workings of THE IRON GIANT," Ain't It Cool News, February 1, 1999, http://www.aintitcool.com/node/2960.

136 "Warners may not have realized": Robert W. Welkos and Charles Solomon, "A Sleeping 'Giant,'" *Los Angeles Times*, April 26, 1999, http://articles.latimes.com/1999/apr/26/entertainment/ca-31167.

136 "The web guys loved this movie": Author interview, April 10, 2017.

136 "a left-wing fable": Rod Dreher, "One 'Giant' Defect," *New York Post*, August 4, 1999, https://nypost.com/1999/08/04/one-giant-defect/.

136 "I was crushed": Author interview, October 4, 2017.

137 "I loved that movie": Author interview, October 4, 2017.

137 "Technology always presents": Author interview, October 4, 2017.

137 "robust cheers": Richard Corliss, "Cinema: The Phantom Movie," *Time*, May 17, 1999, http://content.time.com/time/subscriber/article/0,33009,990986,00.html.

138 "For whatever reason": Ibid.

138 "I went on opening night": Author interview, April 5, 2017.

138 "They said the dialogue": "George Lucas interview 1999." *Empire*, https://
www.empireonline.com/movies/features/star-wars-archive-george-lucas
-1999-interview.

139 "Guess what? Mesa Luved Him!": "Harry's STAR WARS EPISODE ONE
Review," Ain't It Cool News, May 20, 1999, http://www.aintitcool.com
/node/3624.

139 "Most of the people": *Empire*, "George Lucas interview 1999."

139 "I thought all": Author interview, February 23, 2018.

140 "George and I watched": Author interview, June 25, 2017.

140 "A Rastafarian Stepin Fetchit": Joe Morgenstern, "Our Inner Child Meets
Young Darth Vader," *Wall Street Journal*, May 19, 1999, https://www.wsj
.com/articles/SB927082592439077365.

140 "stereotypical elements": Michael Okwu, "Jar Jar Jarring," CNN, June 14,
1999, http://www.cnn.com/SHOWBIZ/Movies/9906/09/jar.jar/.

140 "There is nothing": Eric Harrison, "A Galaxy Far, Far Off Racial Mark?",
Los Angeles Times, May 26, 1999, http://articles.latimes.com/1999/may/26
/entertainment/ca-40965.

140 "I was shocked": Author interview, June 25, 2017.

141 "It's really difficult": Ibid.

141 "I felt tired": "That Moment I Opened Up About Suicide," January 4, 2019,
https://www.youtube.com/watch?time_continue=385&v=qfNiSkd3HfI.

141 "I had death threats": Author interview, June 25, 2017.

SUMMER

143 "First lady Hillary Rodham Clinton": "Hillary Clinton Confirms Plans for
Exploratory Committee," CNN.com, June 4, 1999, http://www.cnn.com
/ALLPOLITICS/stories/1999/06/04/senate.2000/hrc.senate/.

143 "THE UBIQUITOUS PALMPILOT": Dan Briody, 'The Ubiquitous PalmPilot:
Tool or Toy?," CNN, June 29, 1999, http://www.cnn.com/TECH/computing
/9906/29/palmpilot.idg/.

143 "Lance Armstrong completed": Samuel Abt, "Cycling; Armstrong Wins
Tour and Journey," *New York Times*, July 26, 1999, https://www.nytimes
.com/1999/07/26/sports/cycling-armstrong-wins-tour-and-journey.html.

143 "I did it all": Wes Borland, Fred Durst, John Otto, and Sam Rivers, "Nookie."

143 "JOHN KENNEDY'S PLANE VANISHES": David Barstow, "Kennedy's Plane
Lost: The Overview; John Kennedy's Plane Vanishes off Cape Cod," *New*

York Times, July 18, 1999, https://www.nytimes.com/1999/07/18/nyregion
/kennedy-s-plane-lost-the-overview-john-kennedy-s-plane-vanishes-off
-cape-cod.html.

143　"at Pier 30": David Fischer, "The Pied Piper of Skateboarding," *New York Times*, June 27, 1999, http://archive.nytimes.com/www.nytimes.com/pack ages/html/sports/year_in_sports/06.27.html.

143　"Maybe all I need": Jay Bennett, John Stirratt, and Jeff Tweedy, "A Shot in the Arm."

143　"I know your friends": "The Man, the Myth, the Viagra," *Sex and the City*, July 25, 1999.

143　"Brandi Chastain whipped off": Jere Longman, "Refusing to Wilt, U.S. Wins Soccer Title," *New York Times*, July 11, 1999, https://www.nytimes .com/1999/07/11/sports/refusing-to-wilt-us-wins-soccer-title.html.

143　"INQUIRY ESTIMATES SERB DRIVE": John Kifner, "Inquiry Estimates Serb Drive Killed 10,000 in Kosovo," *New York Times*, July 18, 1999, https:// www.nytimes.com/1999/07/18/world/inquiry-estimates-serb-drive-killed -10000-in-kosovo.html.

143　"It seems that Woodstock '99": Ann Powers, "Critic's Notebook; A Surge of Sexism On the Rock Scene," *New York Times*, August 2, 1999, https://www .nytimes.com/1999/08/02/arts/critic-s-notebook-a-surge-of-sexism-on -the-rock-scene.html.

143　"HUMAN IMPRINT ON CLIMATE CHANGE": William K. Stevens, "Human Imprint on Climate Change Grows Clearer," June 29, 1999, https://www.ny times.com/1999/06/29/health/human-imprint-on-climate-change-grows -clearer.html.

143　"Hey, Dirty!": Chad Hugo, Russell Jones, and Pharrell Williams, "Got Your Money."

8　Eyes Wide Shut/The Mummy

145　"the most perfect man": "Rosie O'Donnell Interviews Tom Cruise 1996," December 1996, https://www.youtube.com/watch?v=QwdV2gkAsYM.

146　"movie stars were rare": Author interview, August 2, 2017.

146　"Julia made me": Author interview, December 14, 2017.

147　"In good times": "The 74th Academy Awards," ABC, March 24, 2002.

147　"I couldn't stop": Ibid.

148　"Part of my problem": Tim Cahill, "The *Rolling Stone* Interview with Stanley Kubrick," *Rolling Stone*, August 27, 1987, https://www.rollingstone

.com/movies/movie-news/the-rolling-stone-interview-stanley-kubrick-in-1987-90904.

148 "I want Tom Cruise": Terry Semel and Tom Cruise, "Stanley Kubrick," *Interview*, October 2012, https://www.interviewmagazine.com/film/stanley-kubrick.

148 "have too many opinions": Ibid.

148 "Tom said something": Ibid.

148 "He was just waiting": *The Stanley Kubrick Masterpiece Collection* Blu-Ray, Warner Home Video, 2014.

149 "I didn't care": Cathy Booth, "Three of a Kind," *Time*, June 27, 1999, http://content.time.com/time/magazine/article/0,9171,27437,00.html.

149 "He said, 'Look'": Semel and Cruise, "Stanley Kubrick."

149 "Kubrick had": Benjamin Svetkey, "Eyes of the Storm," *Entertainment Weekly*, July 23, 1999.

150 "It was just": "Stanley Kubrick *Eyes Wide Shut* Interview Compilation," February 1, 2018, https://www.youtube.com/watch?v=9ERv8klddBY.

150 "By the end": Booth, "Three of a Kind."

150 "It took a while": Written response to author questions, July 27, 2017.

150 "perfect visions": Roger Ebert, "Cruise Opens Up About Working with Kubrick," July 15, 1999, RogerEbert.com, https://www.rogerebert.com/interviews/cruise-opens-up-about-working-with-kubrick.

150 "I was so startled": Written response to author questions, July 27, 2017.

151 "After a few minutes": Ibid.

152 "The guy worshipped Kubrick": Author interview, April 10, 2017.

152 "When you look": Semel and Cruise, "Stanley Kubrick."

153 "Sometimes it was very": *The Stanley Kubrick Masterpiece Collection* Blu-Ray.

153 "There were a lot": Ibid.

153 "People were waiting": Ibid.

154 "They probably don't want": Mark Miller, "Throwing Heat," *Newsweek*, September 12, 1999, https://www.newsweek.com/throwing-heat-166064.

154 "so that people": *Jim & Andy: The Great Beyond*, 2017.

155 "I was being driven": Author interview, February 5, 2018.

155 "There was a notion": Ibid.

156 "you weren't doing": Ibid.

156 "The studio was": Ibid.

156 "was a big production": Ibid.

156 "I'm standing on": Ibid.

157 "It could have been": Ibid.

157 "We had no idea": Ibid.

157 "took the town": Ibid.

158 "a day that I had": Ibid.

158 "You know, I love you too": Ibid.

159 "The first time": Booth, "Three of a Kind."

159 "We were so excited and proud": Roger Ebert, "Cruise Opens Up About Working with Kubrick," July 15, 1999, RogerEbert.com, https://www.roger ebert.com/interviews/cruise-opens-up-about-working-with-kubrick.

159 "Trying to define it": Nancy Collins, "Nicole Kidman: Lust and Trust," *Rolling Stone*, July 8, 1999, https://www.rollingstone.com/movies/movie-fea tures/nicole-kidman-lust-and-trust-181558.

160 "trying to write *War and Peace*": "Stanley Kubrick: Award Acceptance Speech, 1998," August 15, 2016, https://www.youtube.com/watch?v=pB81K MhGpqk.

160 "People think": Collins, "Nicole Kidman: Lust and Trust."

160 "The whole world": "Stanley Kubrick *Eyes Wide Shut* Interview Compilation."

161 "His sense of possessiveness": Written response to author questions, July 27, 2017.

161 "Once people were inside": Author interview, March 23, 2017.

162 "It's a movie": *The Stanley Kubrick Masterpiece Collection* Blu-Ray.

162 "I was happy": Author interview, July 6, 2017.

162 "I was so excited": Author interview, March 20, 2018.

163 "a beauty": "*Eyes Wide Shut*: Roger Ebert at the Movies with Martin Scorsese (2000)," June 20, 2017, https://www.youtube.com/watch?v=pvzNPX98bzw.

163 "What we have": Written response to author questions, July 27, 2017.

163 "Stanley would have": Svetkey, "Eyes of the Storm."

9 The Sixth Sense/The Blair Witch Project

165 "Even in film school": David Ansen and Jeff Giles, "The Envelope, Please," *Newsweek*, February 7, 2000, p. 60.

166 "cunt": Jeff Giles, "Out of This World," *Newsweek*, August 4, 2002, https://www.newsweek.com/out-world-143943.

166 "cultural phenomenons": *The Sixth Sense* DVD, Buena Vista Home Video, 2000.

166 "It was a rip-off": Author interview, August 16, 2017.

167 "I come from": Ibid.

167 "looking like some high school kid": Giles, "Out of This World."

167 "Night was very confident": Author interview, October 9, 2017.

167 "When the money came in": Author interview, August 16, 2017.

168 "period piece": Ansen and Giles, "The Envelope, Please."

168 "I was blown away": Elvis Mitchell, *"Reader's Digest*: The Uncut Interview," *Reader's Digest*, March 2002, https://web.archive.org/web/20140907174834 /http://us.readersdigest.com/images/content/021102/bruce_willis_inter view.pdf.

168 "When I was growing up": Author interview, August 16, 2017.

169 "was an opportunity": Benjamin Svetkey, "M. Night Shyamalan's 'Un- breakable,'" *Entertainment Weekly*, December 1, 2000, https://ew.com/ar ticle/2000/12/01/m-night-shyamalans-unbreakable.

169 "I looked at tons of kids": Author interview, August 16, 2017.

169 "is about people fearing": Author interview, September 11, 2017.

169 "I called the casting director": Author interview, August 16, 2017.

169 "I was watching these movies": Author interview, September 11, 2017.

169 "was deeply in his character": Author interview, August 16, 2017.

170 "With another younger actor": Mitchell, "Reader's Digest: The Uncut In- terview."

170 "I just sat there": Cindy Pearlman, "Each Day a G'Day for Toni Collette," *Chicago Sun-Times*, October 18, 2000, http://www.tonicollette.org/articles /200008thechicagosuntimes/.

170 "I was at a really fragile point": *The Sixth Sense* DVD.

170 "We thought it was": Author interview, October 9, 2017.

171 "In the script": Author interview, November 14, 2017.

171 "I'd recently been": Ibid.

171 "I think we got it": Author interview, August 16, 2017.

171 "I'm like, 'This is it'": Ibid.

171 "I was like, 'Holy shit'": Ibid.

171 "the ultimate vote": Author interview, October 9, 2017.

172 "I thought, 'I just want'": Author interview, August 16, 2017.

172 "We had to get": Author interview, March 10, 2017.

172 "We wanted people": Ibid.

173 "One of them said": Author interview, March 16, 2017.

173 "It was so overwhelming": Author interview, April 12, 2017.

174 "When we made the film": Written response to author questions, June 14, 2018.

174 "We wanted them": Author interview, March 10, 2017.

174 "It was like, 'Ugh'": Author interview, March 21, 2017.

175 "I remember thinking": Ibid.

175 "It's a dynamic": Author interview, August 16, 2017.

175 "Is [he] supposed to be": Ibid.

176 "I went, 'If we can'": Mitchell, "Reader's Digest: The Uncut Interview."

176 "They put it": Author interview, August 16, 2017.

176 "I said, 'I saw this movie today'": Author interview, July 27, 2017.

176 "They didn't know": Author interview, May 11, 2017.

177 "It was a madhouse": Rebecca Ascher-Walsh, "Rhymes with Rich," *Entertainment Weekly*, July 30, 1999, https://ew.com/article/1999/07/30/blair-witch-project-rhymes-rich/.

177 "a rite of passage": Richard Corliss, "Blair Witch Craft," *Time*, August 16, 1999, http://content.time.com/time/subscriber/article/0,33009,991741-5,00.html.

177 "You mean it's not?": Ibid.

178 "We'd sit down": Author interview, April 20, 2017.

178 "Fifty percent": Author interview, March 21, 2017.

178 "The only nice thing": Author interview, March 31, 2017.

178 "Everybody wanted to make": Author interview, March 16, 2017.

179 "'*Blair Witch*' may do": Eugene Hernandez and Mark Rabinowitz, "DECADE: Bingham Ray 'On the Record,' Part 2," IndieWire, December 1, 1999, https://www.indiewire.com/1999/12/decade-bingham-ray-on-the-record-part-2-81948.

179 "Bullllllshit!": Corliss, "Blair Witch Craft."

179 "As it became": Author interview, March 31, 2017.

179 "Some of those moments": Author interview, March 16, 2017.

179 "Heather got a bad rap": Author interview, March 16, 2017.

179 "If it had been": Author interview, March 16, 2017.

180 "They almost did": Author interview, March 24, 2017.

180 "I had these casting agents": Author interview, March 21, 2017.

180 "When the limo": Author interview, March 31, 2017.

180 "The awards show copy": Author interview, March 16, 2017.

181 "He's a great comedian": "The 1999 MTV Video Music Awards," MTV, September 9, 1999.

181 "Too much anxiety": Author interview, August 16, 2017.

181 "I watched people picking movies": Ibid.

181 "Generally, when there's": "Bruce Willis," *Rolling Stone*, December 8, 2000, https://www.rollingstone.com/movies/movie-news/bruce-willis-171842/.

181–182 "I remember reading": Author interview, September 11, 2017.

182 "You're amazingly analytical": "Haley Joel Osment, 1999," November 27, 2014, https://www.youtube.com/watch?v=U-V5aR_EUmI.

182 "She was kind of doing": Author interview, September 11, 2017.

182 "a lot of dough": *Rolling Stone*, "Bruce Willis," https://www.rollingstone .com/movies/movie-news/bruce-willis-171842.

182 "Somebody at one": Author interview, September 11, 2017.

182 "a hair young": Author interview, August 16, 2017.

183 "You see dead people or something?": *The Sixth Sense* DVD.

183 "*Blair Witch* had been": Author interview, March 24, 2017.

183 "a name brand": Noah Robischon, "The Blair Witch Crew," *Entertainment Weekly*, December 24, 1999, https://ew.com/article/1999/12/24/3-blair-witch -crew/.

183 "*Blair Witch* had franchise possibilities": Author interview, April 20, 2017.

183 "Dan and Ed didn't want": Author interview, March 27, 2017.

184 "It wasn't that we were arrogant": Author interview, March 10, 2017.

184 "The stresses of *Blair Witch*": Ibid.

184 "There was creative accounting": Author interview, March 24, 2017.

10 The Best Man/The Wood

187 "We had a joke": Author interview, January 18, 2018.

187 "where you just see": Ibid.

188 "Having a successful": James Greenberg, "In Hollywood, Black Is In," *New York Times*, March 4, 1990, https://www.nytimes.com/1990/03/04/movies /in-hollywood-black-is-in.html.

188 "Hollywood doesn't care": Ibid.

188 "Black film properties": Karen Grigsby Bates, "They've Gotta Have Us," *New York Times*, July 14, 1991, https://www.nytimes.com/1991/08/11 /magazine/l-they-ve-gotta-have-us-212091.html.

189 "Hollywood needed to see": Author interview, December 12, 2017.

189 "something of": Elaine Dutka, "The Money's Where the Action Is," *Los Angeles Times*, December 31, 1996, http://articles.latimes.com/1996-12-31 /entertainment/ca-14282_1_action-films.

189 "Black people wanted": Author interview, December 12, 2017.

190 "I decided": Author interview, June 20, 2017.

190 "There was a hunger": Ibid.

190 "I timed finishing it": Ibid.

190 "I didn't believe": Ruthe Stein, "Malcolm Lee Vows to Do It His Way," *San*

Francisco Chronicle, October 17, 1999, https://www.sfgate.com/entertainment /article/Malcolm-Lee-Vows-To-Do-It-His-Way-Spike-s-2902944.php.

191 "But Spike was": Author interview, June 20, 2017.

191 "These people are just": Ibid.

191 "They're like baseball films": Bernard Weinraub, "'Beloved' Tests Racial Themes at Box Office; Will This Winfrey Film Appeal to White Audiences?," *New York Times,* October 13, 1998, https://www.nytimes.com/1998/10/13 /movies/beloved-tests-racial-themes-box-office-will-this-winfrey-film -appeal-white.html.

191 "There was such a fervor": Author interview, June 20, 2017.

192 "I was the new": Author interview, January 18, 2018.

192 "Around that time": Author interview, December 12, 2017.

192 "I thought Jordan slapping him": Ibid.

192 "Nia slapped the shit": Author interview, January 18, 2018.

193 "Midway through writing": Author interview, June 20, 2017.

193 "We were playing": Author interview, December 12, 2017.

194 "I am not": Ibid.

194 "Spike was like": Author interview, June 20, 2017.

194 "I wasn't one": Author interview, July 10, 2017.

196 "For a first-time filmmaker": Author interview, July 10, 2017.

197 "I wanted to wink": Ibid.

197 "felt indie and intimate": Author interview, January 18, 2018.

197 "I said, 'Wait a minute'": Ibid.

197 "I never put them": Ibid.

197 "I grew up playing": Author interview, July 10, 2017.

197 "I was pissed": Ibid.

198 "It wasn't *Matrix* money": Ibid.

198 "Spike was kind of": Ibid.

199 "When it comes to movies": Ibid.

199 "People say these movies 'overperform'": Ibid.

FALL

201 "The ball is beginning": Dick Clark, "ABC 2000 Today," ABC, December 31, 1999.

201 "Hi. My name is Lynn": Lynn Darling, "Learning from Pokémon," *New York Times,* November 18, 1999, https://www.nytimes.com/1999/11/18/opinion /learning-from-pokemon.html.

201 "Donald J. Trump announced": Francis X. Clines, "Trump Quits Grand Old

Party for New," *New York Times*, October 25, 1999, https://www.nytimes .com/1999/10/25/us/trump-quits-grand-old-party-for-new.html.

201 "I want to get with you": Ed Green, Beck Hansen, John King, and Michael Simpson, "Debra."

201 "You're in Times Square": Dick Clark, "ABC 2000 Today," ABC, December 31, 1999.

201 "RECORDING INDUSTRY GROUP": Don Clark, "Recording Industry Group Sues Napster, Alleging Copyright Infringement on Net," *Wall Street Journal*, December 9, 1999, https://www.wsj.com/articles/SB944711263509 285168.

201 "J. K. Rowling says": "Success of Harry Potter Bowls Author Over," CNN .com, October 21, 1999, http://www.cnn.com/books/news/9910/21/rowling .intvu/index.html.

201 "CURFEW IN EFFECT": "Curfew in Effect as Seattle Struggles to Control WTO Protests," CNN.com, November 30, 1999, http://www.cnn.com /US/9911/30/wto.04/.

201 "We're going for": Regis Philbin, *Who Wants to Be a Millionaire?*, ABC, November 19, 1999.

201 "And we're gonna": Dick Clark, "ABC 2000 Today," ABC, December 31, 1999.

201 "Movie renters": Reed Hastings, "NETFLIX.com Transforms DVD Business Eliminating Late Fees and Due Dates from Movie Rentals," Netflix, December 16, 1999, https://media.netflix.com/en/press-releases/net flixcom-transforms-dvd-business-eliminating-late-fees-and-due-dates -from-movie-rentals-migration-1.

201 "Wazzzzup": Charles Stone III, "Wassup?," Anheuser-Busch Budweiser commercial, first aired December 20, 1999.

201 "Seven, six, five, four": Dick Clark, "ABC 2000 Today," ABC, December 31, 1999.

201 "We be big pimpin'": Chad Butler, Shawn Carter, Bernard Freeman, Baligh Hamdi, and Timothy Mosley, "Big Pimpin'."

201 "YELTSIN RESIGNS": "Yeltsin Resigns," CNNMoney, December 31, 1999, https://money.cnn.com/1999/12/31/emerging_markets/yeltsin/.

201 "Three, two, one": Dick Clark, "ABC 2000 Today," ABC, December 31, 1999.

11 American Beauty

203 "On the cover": Author interview, March 13, 2018.

205 "If I told": Donald Trump with Kate Bohner, *Trump: The Art of the Comeback* (New York: Times Books, 1997), 116.

205 "a hard dog": Duncan Campbell, "Hillary Explains Away Clinton's Infidelity," *The Guardian*, August 1, 1999, https://www.theguardian.com/world/1999/aug/02/clinton.usa.

206 "The politics of the time": Author interview, June 7, 2017.

207 "It was horrible": Author interview, March 13, 2018.

207 "I thought, 'Oh, Spielberg'": Ibid.

208 "A week before": Author interview, June 7, 2017.

208 "I loved that Alan": Ibid.

208 "We were seen": Author interview, March 13, 2018.

209 "Everything about it": Author interview, June 7, 2017.

209 "who see the world": Ibid.

209 "She was the perfect": Author interview, October 11, 2017.

210 "I'd met friends": Author interview, March 13, 2018.

210 "It was comical": Author interview, June 7, 2017.

210 "That speech spoke": Author interview, October 11, 2017.

210 "I was always aware": Author interview, June 7, 2017.

211 "*American Beauty* was not": Ibid.

211 "They didn't put": Ibid.

211 "by far the strongest": David Denby, "Transcending the Suburbs," *The New Yorker*, September 20, 1999.

211 "An amazing film": Roger Ebert, "Q&A: Clinton on Movies," RogerEbert.com, September 10, 2008, https://www.rogerebert.com/interviews/qanda-clinton-on-movies.

212 "He thought *American Beauty*": Author interview, June 8, 2017.

12 Fight Club

213 "Everybody griped about": Author interview, November 13, 2017.

214 "small little snippets": Ibid.

214 "I grew up": Ibid.

214 "My peers were": Ibid.

214 "They wanted to know": Ibid.

215 "deep national malaise": Jerry Adler, "Drums, Sweat and Tears," *Newsweek*, June 23, 1991, https://www.newsweek.com/drums-sweat-and-tears -204220.

215 "We are the middle": Chuck Palahniuk, *Fight Club* (New York: W. W. Norton, 1996), 166.

215 "a volatile, brilliantly creepy satire": Karen Angel, "Fiction," *Washington Post*, December 1, 1996, https://www.washingtonpost.com/archive/enter tainment/books/1996/12/01/fiction/b27ebc7d-1486-4516-afb3-c6fe3367 b78f/?noredirect=on&utm_term=.c6b24eb8e8b2.

215 "He loved it": Author interview, November 13, 2017.

215 "You get to the twist": Author interview, November 6, 2017.

216 "I didn't know": Peter Biskind, "Extreme Norton," *Vanity Fair*, August 1999.

216 "I read it": Author interview, December 1, 2017.

216 "I grew up": Author interview, 2011.

216 "Even at a very": Ibid.

217 "people who worked": Author interview, December 8, 2017.

218 "sodomized ritualistically for two years": "David Fincher: A Life in Pictures Highlights," December 18, 2014, https://www.youtube.com/watch?v=rpHIz Em6058.

218 "I was in": Author interview, June 28, 2017.

218 "I remember him": Author interview, April 12, 2018.

218 "I said, 'Here's'": "David Fincher and Brad Pitt on *Fight Club*," October 25, 2014, https://www.youtube.com/watch?v=5-a36Zk1SjY.

218 "It was a dark": Author interview, October 5, 2017.

218 "I hadn't been": Author interview, November 13, 2017.

219 "we were making": Author interview, 2011.

219 "I don't think": Author interview, June 28, 2017.

219 "getting hired to write": Author interview, October 12, 2017.

219 "I knew": Ibid.

219 "marching orders": Email to author, September 12, 2018.

219 "The book had": Author interview, October 12, 2017.

219 "I said, 'What if'": Author interview, November 6, 2017.

220 "I'm the guy": Chris Heath, "The Unbearable Bradness of Being," *Rolling Stone*, October 28, 1999, http://www.bradpittpress.com/artint_99_rolling stone.php.

220 "I saw him deliver": Author interview, October 5, 2018.

220 "Edward's ultimately": Biskind, "Extreme Norton."

221 "I was lucky": Author interview, December 4, 2018.

221 "It took aim": Ibid.

221 "He made this amazing": Author interview, January 26, 2018.

221 "We were sitting": Author interview, December 4, 2018.

222 "breaking apart every line": Benjamin Svetkey, "Blood, Sweat, & Fears," *Entertainment Weekly*, October 15, 1999, https://ew.com/article/1999/10/15/blood-sweat-fears-fight-club.

222 "as if to aspire": Author interview, January 26, 2018.

222 "I went back to Fox": Taubin, "Twenty-First-Century Boys."

222 "You know when": Author interview, February 1, 2018.

223 "Think about our grandfathers' generation": Ibid.

223 "crisis of masculinity": Susan Faludi, *Stiffed: The Betrayal of the American Man* (New York: HarperCollins, 1999), 7.

223 "something to drape over": Ibid., 35.

223 "budget busters": Author interview, Monday, August 21, 2017.

223 "We'd age them down": Ibid.

224 "It was so raw": *Fight Club* DVD, 20th Century Fox Home Entertainment, 2000.

224 "I was supposed to": Author interview, December 4, 2018.

224 "a hypermasculine environment": Author interview, February 1, 2018.

224 "Courtney totally understood": Author interview, October 5, 2018.

225 "exquisitely emotional": Nev Pierce, "Forget the First Two Rules of *Fight Club*," *Total Film*, April 2006, http://nevpierce.com/portfolio/david-fincher.

225 "Mum put the script": Ibid.

225 "just to ascertain": Svetkey, "Blood, Sweat, & Fears."

225 "I just said": Pierce, "Forget the First Two Rules of *Fight Club*."

225 "Helena is so funny": Author interview, December 4, 2018.

225 "Helena said, 'Who the fuck'": Author interview, November 6, 2017.

225 "David is the prince": Ibid.

226 "I could do anything": Ibid.

226 "No style, really": Ibid.

226 "I think Edward": Author interview, October 5, 2018.

226 "I was doing": Author interview, December 4, 2018.

227 "We had them on": Ibid.

227 "Brad and I": Ibid.

227 "David said": Author interview, January 18, 2018.

227 "We were going retro": Author interview, November 9, 2017.

228 "There's a schizophrenic quality": Author interview, January 18, 2018.

228 "It was this weird": Author interview, December 8, 2017.

228 "I was always wondering": *Fight Club* DVD.

229 "We started to reveal": Author interview, June 28, 2017.

229 "I had two reactions": Author interview, October 5, 2017.

229 "a dirty joke": Author interview, June 28, 2017.

229 "All of a sudden": Ibid.

229 "We had guys shaving": Ibid.

230 "they felt that": Author interview, October 5, 2018.

230 "How many people": "Limp Bizkit - Break Stuff - 7/24/1999 - Woodstock 99 East Stage (Official)," September 16, 2004, https://www.youtube.com /watch?v=nwBjhgC139I.

230 "Holy shit": Brian Hiatt, "Woodstock '99 Report #58: Red Hot Chili Peppers Rock as Fires Pose Threat," MTV News, July 26, 1999, http://www.mtv.com /news/516229/woodstock-99-report-58-red-hot-chili-peppers-rock-as-fires -pose-threat/.

230 "I thought, 'I don't want'": Author interview, October 5, 2017.

231 "There was a lot": Author interview, June 28, 2017.

231 "The people whose job": Ibid.

231 "Men do not want": Ibid.

231 "When I think of 1999": Ibid.

231 "No one has the right": *Fight Club* DVD.

231 "You can't do that": Author interview, October 5, 2017.

231 "I remember thinking": Author interview, June 28, 2017.

231 "The publicity shots": Author interview, November 6, 2017.

231 "It's a pummeling of information": Svetkey, "Blood, Sweat, & Fears."

232 "illicit, pummeling free-for-alls": Ibid.

232 "will become Washington's": "Hollywood abuzz over 'Fight Club' snub," MarketWatch, October 18, 1999, https://www.marketwatch.com/story/holly wood-abuzz-over-fight-club-snub.

232 "is exactly the kind": Ibid.

232 "It gets to": Jeff Giles, "Brad Pitt: The EW Interview," *Entertainment Weekly*, September 16, 2011, https://ew.com/movies/2011/09/16/brad-pitt -ew-interview.

232 "It got booed": Author interview, December 4, 2018.

232 "I said there would be": Author interview, October 5, 2017.

233 "We were thinking": Author interview, June 28, 2017.

233 "The thing about": Author interview, April 12, 2018.

233 "Two years of your life": Author interview, June 28, 2017.

233 "I had close friends": Author interview, October 12, 2017.

233 "I was not somebody": Author interview, February 1, 2018.

233 "It's just unforgivable": *Fight Club* DVD.

233 "an inadmissable assault": Ibid.

234 "reeks with condescension": Joe Morgenstern, "Violent *Fight Club* is a Theater of Cruelty—and Not Just for Actors," *Wall Street Journal*, October 15, 1999, https://www.wsj.com/articles/SB939945066136192163.

234 "dumb and brutal": Lisa Schwarzbaum, "Fight Club," *Entertainment Weekly*, October 22, 1999, https://ew.com/article/1999/10/22/fight-club-8.

234 "witless mishmash": Kenneth Turan, "The Roundhouse Miss," *Los Angeles Times*, October 15, 1999, http://articles.latimes.com/1999/oct/15/entertainment/ca-22382.

234 "One guy wrote": Author interview, August 21, 2017.

234 "I think the establishment": Author interview, December 4, 2018.

234 "That was awful": Drew McWeeny, "Moriarty's Review of *Fight Club*," Ain't It Cool News, February 27, 2007, http://www.aintitcool.com/node/4507.

234 "absolutely indefensible": Bernard Weinraub, "A Strained Relationship Turns Sour," *New York Times*, October 18, 1999, https://www.nytimes.com/1999/10/18/business/media-a-strained-relationship-turns-sourhtml.

235 "You'd have to be": Author interview, October 5, 2017.

235 "was my anti-Murdoch thing": Ibid.

235 "People at Morton's": Author interview, June 28, 2017.

235 "These young guys": Author interview, December 4, 2018.

235 "I loved *Fight Club*": Author interview, August 2, 2017.

236 "quite good": Roger Ebert, "A Seat in the Balcony with Bill Clinton," RogerEbert.com, February 3, 2000, https://www.rogerebert.com/interviews/a-seat-in-the-balcony-with-bill-clinton.

236 "When my daughter": Author interview, June 28, 2017.

13 Being John Malkovich

238 "you don't look": Zev Borow, "Situation Comedy," *Spin*, November 1999.

238 "I wanted the whole article": Ibid.

239 "I didn't really know": Chris Heath, "Spike Jonze Will Eat You Up," *GQ*, September 2009, https://www.gq.com/story/spike-jonze-dave-eggers-where-the-wild-things-are.

239 "It was like saying": Jason Tanz, "Charlie Kaufman: Hollywood's Brainiest Screenwriter Pleases Crowds by Refusing to Please," *Wired*, October 20, 2008, https://www.wired.com/2008/10/ff-kaufman/.

240 "It got a lot": Claudia Eller, "Quirky 'Being John Malkovich' May Have the Last, Best Laugh," *Los Angeles Times*, November 30, 1999, http://articles .latimes.com/1999/nov/30/business/fi-38947.

240 "I thought I'd just read": "Spike Jonze on Being John Malkovich," October 21, 2015, https://www.youtube.com/watch?v=HsZ-6TSzA64.

240 "Everyone said": Tanz, "Charlie Kaufman."

240 "I wasn't in the": Jason Tanz, "The Complete Interview," *Wired*, September 10, 2008, https://www.wired.com/2008/09/the-complete-in/.

240 "Shaye turned to me": Stacie Stukin, "Being Sandy Stern," *The Advocate*, November 9, 1999, https://www.questia.com/magazine/1G1-57155930/be ing-sandy-stern.

241 "We never came up": "Spike Jonze on Being John Malkovich," https://www .youtube.com/watch?v=qMYPPnyNYzc.

241 "it never occurred to me": "John Malkovich on 'Being John Malkovich,'" March 14, 2011, https://www.youtube.com/watch?v=qMYPPnyNYzc.

241 "Francis said": Peter Kobel, "The Fun and Games of Living a Virtual Life," *New York Times*, October 24, 1999, https://www.nytimes.com/1999/10/24 /arts/film-the-fun-and-games-of-living-a-virtual-life.html.

241 "the need we have": *Charlie Rose*, October 14, 1999.

242 "this alternate reality": "The Sims Q&A with Will Wright - 1999 | Game Archives," August 11, 2017, https://www.youtube.com/watch?v=RIWSJH -0_CQ.

242 "I called my agent": Paul Fischer, "Star Talk: John Malkovich and John Cusack," Cranky Critic, 1999, https://web.archive.org/web/20080905153053 /http://www.crankycritic.com/qa/cusack_malkovich2.html.

242 "It took Spike's imagination": Lynn Hirschberg, "Being Catherine Keener," *New York Times*, August 27, 2006.

243 "There was Spike": *Being John Malkovich* official production notes, http:// www.cinemareview.com/production.asp?prodid=819.

243 "She came in": "Spike Jonze on Being John Malkovich".

243 "1933": Scott Timberg, "Being Spike Jonze," *Dallas Observer*, November 4, 1999, https://www.dallasobserver.com/news/being-spike-jonze-6396852.

244 "What an endlessly": Roger Ebert, "Being John Malkovich," RogerEbert .com, October 29, 1999, https://www.rogerebert.com/reviews/being-john -malkovich-1999.

244 "so bountiful": Roger Ebert, "The 10 Best Movies of 1999," RogerEbert.com, December 31, 1999, https://www.rogerebert.com/rogers-journal/the-best- 10-movies-of-1999.

14 Three Kings/The Limey

245 "a correlation between": Christopher Stern, "Running Carefully," *Variety*, July 1, 1999, https://variety.com/1999/biz/news/running-carefully-1117503 643/.

246 "usher in the responsibility era": Ibid.

246 "My job": Dan Balz, "Bush Begins 'Vigorous Fight' for California," *Washington Post*, June 30, 1999, http://www.washingtonpost.com/wp-srv/politics campaigns/wh2000/stories/bush063099.htm.

246 "I went out of curiosity": Author interview, December 1, 2017.

246 "I thought": Author interview, July 11, 2017.

246 "felt like an unfinished sentence": Author interview, December 6, 2017.

246 "He comes to shake": Author interview, October 12, 2017.

246 "Well": Author interview, December 1, 2017.

247 "I wanted to see": Benjamin Svetkey, "Easy Writer," *Entertainment Weekly*, October 8, 1999.

248 "I was watching": Author interview, December 1, 2017.

248 "wanted to make something": Ibid.

248 "a guy who": Svetkey, "Easy Writer."

249 "intellectual terrorism": John Dart, "Muslims Protest Studio's New Film," *Los Angeles Times*, March 12, 1996, http://articles.latimes.com/1996-03-12 /local/me-46076_1_muslim-leaders.

249 "After *Executive Decision*": Author interview, October 12, 2017.

249 "I answered all": Author interview, December 1, 2017.

249 "I'd meet these division heads": Ibid.

249 "They felt the movie": Author interview, October 12, 2017.

250 "They said it was": Author interview, December 1, 2017.

250 "There were years": Author interview, July 6, 2017.

250 "freed me up": Ibid.

250 "I did a Jedi": Ibid.

251 "I was very much": Email to author, July 25, 2017.

251 "Somehow, he really liked": Email to author, July 26, 2017.

252 "I'm allergic": Author interview, July 6, 2017.

252 "By casting us": Jeff Gordinier, "Terence Stamp: The Avenger," *Entertainment Weekly*, October 15, 1999, https://ew.com/article/1999/10/15/terence -stamp-avenger/.

253 "It was the most": Author interview, July 6, 2017.

253 "Steven came in": Author interview, November 1, 2017.

253 "In a memory film": Author interview, July 6, 2017.

253 "It's the equivalent": Author interview, November 1, 2017.

253 "I was like, 'Oh, my God' ": Author interview, November 28, 2017.

254 "I remember people": Author interview, July 6, 2017.

254 "I couldn't get": Author interview, December 6, 2017.

254 "George Clooney, TV actor": Benjamin Svetkey, "Three the Hard Way," *Entertainment Weekly*, October 8, 1998.

254 "was really worth fighting for": Gregg Goldstein, "King's Ransom," *Premiere*, November 1999.

254 "That had a big impact": Author interview, December 6, 2017.

255 "The first thing": "David O. Russell," *Vice Guide to Film*, Viceland, November 27, 2016.

255 "gun lust": Author interview, July 11, 2017.

255 "I'd played army": Author interview, December 6, 2017.

255 "They were normalizing": Ibid.

255 "I was like, 'Are you serious?' ": Author interview, October 12, 2017.

255 "The landscape in Arizona": Author interview, February 28, 2018.

256 "I hired them": Ibid.

256 "The first week": Author interview, December 1, 2017.

257 "insanity": Goldstein, "King's Ransom,"

257 "was not well-coordinated": Ibid.

257 "He was so specific": Ibid.

257 "David will get": Author interview, February 28, 2018.

257 "George is a big believer": Author interview, October 12, 2017.

257 "He goes, 'We've got' ": Ibid.

258 "There was this one": "David O. Russell," *Vice Guide to Film*.

258 "David said": Author interview, February 1, 2018.

258 "Guys": Author interview, October 12, 2017.

258 "We resolved to be friends": Author interview, December 6, 2017.

258 "They showed": Goldstein, "King's Ransom."

258 "We were young": Author interview, December 6, 2017.

259 "He said, 'Y'all' ": Ibid.

259 "It was like being in court": Ibid.

259 "It was shaped": Author interview, December 6, 2017.

259 "He was very superstitious": Ibid.

260 "To me, it couldn't help": Ibid.

15 The Insider

262 "As those milliseconds": Author interview, February 16, 2018.

263 "a particular American nightmare": Marie Brenner, "The Man Who Knew Too Much," *Vanity Fair*, May 1996, https://www.vanityfair.com/magazine /1996/05/wigand199605.

263 "You're in a bit": Rebecca Ascher-Walsh, "Where There's Smoke . . . ," *Entertainment Weekly*, November 12, 1999.

263 *"They own networks"*: "Media Controlled Conspiracy Theory Rock:," *Saturday Night Live*, March 14, 1998, https://vimeo.com/34419805.

264 "moral fascism": Degen Pener, "Overseeing Turner's Empire," *Entertainment Weekly*, November 22, 1996, https://ew.com/article/1996/11/22 /overseeing-turners-empire.

266 "It's very unlikely": Author interview, March 14, 2018.

266 "I was skeptical": Author interview, March 14, 2018.

266 "Both of us": Ibid.

266 "He had some apprehensions": Ibid.

267 "He was trying": Author interview, March 14, 2018.

267 "didn't know Michael Mann": Author interview, February 23, 2018.

267 "There's this unwritten rule": Author interview, February 23, 2018.

267 "I said": Author interview, February 16, 2018.

268 "I wanted to meet Mann": Ascher-Walsh, "Where There's Smoke . . ."

268 "Russell didn't have": Author interview, February 16, 2018.

268 "Al's job": Author interview, February 16, 2018.

268 "The first time": Liane Bonin, "Al Pacino Responds to Mike Wallace's Wrath," *Entertainment Weekly*, November 5, 1999, https://ew.com/article /1999/11/05/al-pacino-responds-mike-wallaces-wrath/.

269 "As soon as you hear that": Tim Weiner, "Mike Wallace, CBS Pioneer of '60 Minutes,' Dies at 93," *New York Times*, April 8, 2012, https://www.nytimes .com/2012/04/09/business/media/mike-wallace-cbs-pioneer-of-60-minu tes-dead-at-93.html.

269 "Mike Wallace was interviewing me": Author interview, April 3, 2018.

269 "I was doing movies": Ibid.

269 "scrapper from New York": Author interview, March 18, 2018.

270 "what I love about": Ibid.

270 "Russell was terrific": Ibid.

270 "I looked like Brando": Ascher-Walsh, "Where There's Smoke . . ."

270 "He was really enthusiastic": Amy Longsdorf, "Blowing Hot and Cold," *The Record*, October 31, 1999.

270 "Pacino's presence created": Author interview, February 16, 2018.

271 "It was my first exposure": Author interview, September 7, 2017.

271 "bring you into": Author interview, February 16, 2018.

271 "I wanted Russell": Ibid.

272 "I never, ever": Author interview, February 23, 2018.

272 "Michael was talking": Ascher-Walsh, "Where There's Smoke . . ."

273 "What's a nice way": D. M. Osborne, "Real to Reel," *Brill's Content*, July–August 1999.

273 "was quite disturbing": Author interview, February 23, 2018.

273 "If you think": Author interview, March 14, 2018.

273 "ABC News is in": Tom Shales, "The Explosive Film That Ticked Off '60 Minutes,'" *Washington Post*, October 15, 1999, https://www.washingtonpost.com/wp-srv/WPcap/1999-10/15/046r-101599-idx.html.

273 "fudges chronology": Frank Rich, "Is Mike Wallace Ready for His Close-up?," *New York Times*, July 17, 1999, https://www.nytimes.com/1999/07/17/opinion/journal-is-mike-wallace-ready-for-his-close-up.html.

274 "It was the biggest shock": Author interview, March 14, 2018.

274 "I wouldn't say that": Paul Lieberman and Myron Levin, "Smoke Lingers as 'The Insider' Does a Slow Burn," *Los Angeles Times*, December 3, 1999, http://articles.latimes.com/1999/dec/03/entertainment/ca-39885.

274 "You are entitled": Jim Rutenberg, "Insider Apology? Michael Eisner Phones Don Hewitt with Regrets," *Observer* [New York], November 22, 1999, https://observer.com/1999/11/insider-apology-michael-eisner-phones-don-hewitt-with-regrets/.

274 "I wanted to contest": Author interview, February 16, 2018.

275 "We never got": Author interview, March 14, 2018.

275 "I was terrified": Author interview, April 3, 2018.

275 "I truly miss him": Author interview, February 23, 2018.

275 "When I go out speaking": Ibid.

16 Boys Don't Cry

277 "If people couldn't define": Ted Loos, "A Role Within a Role: A Girl Who Became a Boy," *New York Times*, October 3, 1999, https://www.nytimes.com/1999/10/03/movies/film-a-role-within-a-role-a-girl-who-became-a-boy.html.

278 "Kim had already": Written statements to author, January 11, 2019.

278 "A lot of my friends": Author interview, June 27, 2017.

278 "The student film was okay": Author interview, June 13, 2017.

279 "I knew that": Author interview, June 27, 2017.

279 "I played Celebrity": Author interview, October 17, 2017.

279 "What do you think": Author interview, June 27, 2017.

279 "running through the political landscape": Author interview, August 18, 2017.

279 "emotional truth": Author interview, June 27, 2017.

280 "When did you know": Ibid.

280 "She was all over the place": Ibid.

280 "It seemed to contain": Written statements to author, January 11, 2019.

280 "Brandon Teena wants to be loved": Ibid.

280 "We would start": Ibid.

281 "It couldn't be": Written statements to author, January 11, 2019.

281 "A lot of people": Author interview, October 5, 2018.

281 "You almost felt": Author interview, October 17, 2017.

281 "has been slow to reach": Written response to author questions, January 15, 2018.

281 "I always made sure": Ibid.

282 "They'd say, 'He's just'": Author interview, June 13, 2017.

282 "My assumption was": Author interview, June 27, 2017.

282 "We put out notices": Author interview, November 7, 2017.

282 "but their inherent femininity": Author interview, June 27, 2017.

283 "She had this long": Author interview, November 7, 2017.

283 "Kimberly and I watched": Author interview, August 18, 2017.

283 "They didn't want": Robin Rauzi, "Actress Got Lost in the Story of Brandon Teena," *Los Angeles Times*, October 22, 1999, http://articles.latimes.com/1999/oct/22/entertainment/ca-24840.

283–284 "I started crying": Ibid.

284 "During the costume fitting": Christine Vachon and Austin Bunn, *A Killer Life: How an Independent Film Producer Survives Deals and Disasters in Hollywood and Beyond* (New York: Simon & Schuster, 2006), 99.

284 "I only got the part": Jude Dry, "Chloë Sevigny and Her Mom Don't Talk About 'The Brown Bunny,' and 7 Other Wild Stories from the Indie Actress' Career," IndieWire, June 22, 2017, https://www.indiewire.com/2017/06/chloe-sevigny-brown-bunny-indie-cinema-piff-kitty-1201845337/.

284 "I wound up reading": Author interview, October 3, 2017.

285 "Our thought was": Author interview, October 10, 2017.

285 "There was a long period": Author interview, October 3, 2017.

285 "We joked that Jameson": Author interview, October 10, 2017.

285 "We had more downtime": Author interview, October 3, 2017.

285 "Kim knew every moment": Author interview, October 10, 2017.

285 "Kim was very intense": Author interview, June 13, 2017.

285 "I felt they bent": Author interview, October 5, 2018.

286 "I'm sure for all": Author interview, October 23, 2017.

286 "If you'd asked me": Author interview, June 27, 2017.

286 "I went into it": Ibid.

287 "I just broke down": Author interview, October 3, 2017.

287 "I said, 'Can you'": Author interview, June 27, 2017.

287 "I still get goose bumps": Author interview, October 3, 2017.

287 "I would put on makeup": Loos, "A Role Within a Role."

287 "I told him": Ibid.

287 "I wanted everybody": Author interview, June 27, 2017.

287 "They both felt": Author interview, June 13, 2017.

288 "cast a pall": Author interview, October 5, 2018.

288 "Kim lives in a world": Author interview, October 17, 2017.

288 "I'm generally considered": Author interview, June 27, 2017.

289 "a star chamber": Author interview, October 17, 2017.

289 "I said, 'If you diffuse'": Author interview, June 27, 2017.

289 "He says, 'It's pretty evident'": Author interview, October 17, 2017.

289 "The fix was in": Ibid.

290 "I hit a cement wall": Author interview, June 27, 2017.

290 "incredibly unfair": Author interview, October 17, 2017.

290 "a skanky snake": Ann W. O'Neill, "Film About a Double Life Engenders Double Lawsuits," *Los Angeles Times*, October 24, 1999, http://articles.latimes.com/1999/oct/24/local/me-25805.

290 "scorned and/or abandoned": Ibid.

290 "destroys the memory": Emily Farache, "Crying Foul over 'Boys Don't Cry,'" E!News, October 21, 1999, https://www.eonline.com/news/3888/crying-foul-over-boys-don-t-cry.

290 "broke my heart": Author interview, June 27, 2017.

290 "I was just a kid": Ibid.

291 "Kim understood": Written statements to author, January 11, 2019.

291 "One day I woke up": Author interview, June 27, 2017.

291 "They said, 'She's saying'": Ibid.

291 "We panned down": Ibid.

291 "I said to her": Ibid.

291 "She says": Author interview, June 27, 2017.

291 "We had a great talk": Written response to author questions, October 6, 2018.

17 Magnolia

293 "I told him, 'We're going'": Patrick Goldstein, "The New New Wave," *Los Angeles Times*, December 12, 1999, http://articles.latimes.com/1999/dec/12 /entertainment/ca-42968.

294 "He told me a story": Author interview, November 22, 2017.

294 "if I'm the type": Goldstein, "The New New Wave."

294 "small and intimate": *Magnolia* production notes, http://cigsandredvines .blogspot.com/p/magnolia.html.

295 "I was in a position": Goldstein, "The New New Wave."

295 "I want to be": Lynn Hirschberg, "His Way," *New York Times*, December 19, 1999, https://www.nytimes.com/1999/12/19/magazine/his-way.html.

296 "Families are just endless": *Charlie Rose*, January 7, 2000.

296 "Now that I've met you": Aimee Mann, "Deathly," *Magnolia: Music from the Motion Picture*, Reprise Records, 1999.

296 "parent-children relationships": *Charlie Rose*, January 7, 2000.

296 "He told me he was": Author interview, September 7, 2017.

297 "What's inside me": *Charlie Rose*, January 7, 2000.

297 "I said, 'What'": Author interview, November 22, 2017.

297 "He called me": *Charlie Rose*, January 7, 2000.

298 "Someone said, 'How come'": Chris Connelly, "How Tom Cruise Keeps His Edge," *Talk*, April 2000.

298 "a bully and a coward": Dotson Rader, "I Can Create Who I Am," *Parade*, April 9, 2006.

298 "made a personal decision": Connelly, "How Tom Cruise Keeps His Edge."

298 "He would only meet me": Rader, "I Can Create Who I Am."

298 "I asked Paul": "Tom Cruise," *Inside the Actors Studio*, January 11, 2004.

299 "vomiting out": *Charlie Rose*, January 7, 2000.

299 "I put my heart": Hirschberg, "His Way."

299 "He sent me the script": Author interview, November 28, 2017.

299 "My mother basically": Author interview, November 3, 2017.

299 "I still didn't know": Ibid.

300 "Tom took my hands": Ibid.

300 "thinks of himself": Connelly, "How Tom Cruise Keeps His Edge."

300 "No, it's not": Aimee Mann, "Wise Up," *Magnolia: Music from the Motion Picture*, Reprise Records, 1999.

301 "Paul's right there": Author interview, November 8, 2017.

301 "I remember talking": *WTF with Marc Maron*, January 5, 2015.

301 "grandiosity taking over": Owen Gleiberman, "Why I Fell Out of Love with the Films of Paul Thomas Anderson," *Entertainment Weekly*, October 3, 2012, https://ew.com/article/2012/10/03/my-problem-with-p-t-andersons-films/.

302 "188 minutes later": Written response to author questions, July 27, 2017.

303 "Chill the fuck out": Reddit AMA, January 16, 2018, https://www.reddit.com/r/IAmA/comments/7quthe/im_paul_thomas_anderson_writer_and_director_of/.

303 "It's unmerciful, how long it is": *WTF with Marc Maron*, January 5, 2015.

303 "We were all disappointed": Author interview, September 7, 2017.

303 "as if they": Andrew Sarris, "A Day in the Life of L.A.: Where's the Rough Stuff?," *New York Observer*, January 23, 2000, http://archive.li/0E3X7.

303 "Even in the Bible": Janet Maslin, "Entangled Lives on the Cusp of the Millennium," *New York Times*, December 17, 1999, https://www.nytimes.com/1999/12/17/movies/film-review-entangled-lives-on-the-cusp-of-the-millennium.html.

303 "I scratched my head": Author interview, September 7, 2017.

303 "I'll vouch for the frogs": Author interview, September 7, 2017.

304 "It was dark": Ibid.

EPILOGUE March 26, 2000

306 "I had no idea": Written response to author questions, January 15, 2018.

306 "We'd all arrived": Author interview, November 22, 2017.

307 "It was almost a relief": Author interview, September 11, 2017.

307 "I hope it is not": "The 72nd Annual Academy Awards," ABC, March 26, 2000.

307 "To think that this movie": Ibid.

307 "It didn't feel like": Author interview, October 17, 2017.

308 "That was a special year": Author interview, August 16, 2017.

309 "Without getting too maudlin": Written response to author questions, July 27, 2017.

310 "a kind of a test": Susan Chira, "The Triumph of Tracy Flick?," *New York*

Times, November 7, 2016, https://www.nytimes.com/2016/11/07/opinion/campaign-stops/the-triumph-of-tracy-flick.html.

311 "Richard Linklater said to me": Author interview, May 12, 2017.

313 "There are so many layers": Author interview, June 25, 2017.

313 "What happened to the movies?": Author interview, April 10, 2018.

314 "You don't really go": Author interview, November 5, 2017.

314 "I think 9/11": Author interview, July 6, 2017.

315 "started to squeeze": Ibid.

315 "Someone said to me": Author interview, April 10, 2018.

315 "I had movies": Author interview, October 5, 2018.

316 "You go down": Author interview, October 5, 2018.

316 "A lot of the movies": Author interview, March 13, 2018.

316 "I once saw": Author interview, December 14, 2017.

316 "It's my standard crotchety thing": Author interview, January 26, 2018.

317 "I said, 'So'": Author interview, November 22, 2017.

317 "With *The Sopranos*": Ibid.

317 "*The Sopranos* was something": Author interview, March 13, 2018.

318 "We can make TV shows": Author interview, June 2, 2017.

318 "If *The Matrix*": Author interview, November 5, 2017.

318 "Television used to be": Author interview, February 5, 2018.

318 "Movie budgets": Author interview, December 12, 2017.

319 "You can't stop the rain": Author interview, March 1, 2018.

319 "Bobby would know": Author interview, February 23, 2018.

320 "We're making a lot": Bernard Weinraub, "Dismay over Big-Budget Flops," *New York Times,* October 17, 1995, https://www.nytimes.com/1995/10/17/movies/dismay-over-big-budget-flops.html.

ACKNOWLEDGMENTS

I owe a great debt to all of this book's interviewees: Pedro Almodóvar, Allison Anders, John August, Diedrich Bader, Alan Ball, Kerry Barden, Kym Barrett, Ross Grayson Bell, Albert Berger, Lowell Bergman, Ahmed Best, Andy Bienen, Thora Birch, Brad Bird, Selma Blair, Mark Borchardt, Matthew Broderick, Don Buckley, Ceán Chaffin, John Cho, Gary Cole, Rachael Leigh Cook, Sofia Coppola, Robin Cowie, Jeff Cronenweth, Richard Curtis, Lorenzo di Bonaventura, Nicholas D'Agosto, Jim Denault, Taye Diggs, Lem Dobbs, Heather Donahue, Kirsten Dunst, Shannon Elizabeth, Rick Famuyiwa, Todd Field, David Fincher, Sarah Flack, Andrew Fleming, Brendan Fraser, John Gaeta, David Gale, Sarah Michelle Gellar, Diana Giorgiutti, April Grace, Robin Gurland, Marc Gurvitz, Luis Guzmán, Gregg Hale, Philip Baker Hall, Catherine Hardwicke, Josh Hartnett, Jim Haygood, John Hegeman, David Herman, Seth Jaret, Willa Clinton Joynes, Mike Judge, Michael Kaplan, Glenn Kenny, John King, Chris Klein, Eva Kolodner, Roger Kumble, Ali Larter, Malcolm D. Lee, Joshua Leonard, Kim Libreri, Doug Liman, Ron Livingston, Nia Long, Sheryl Longin, Alison Maclean, Amir Malin, Michael Mann, Lawrence Mattis, Holt McCallany, Karen McCullah, Bill Mechanic, Barry Mendel, Sam Mendes, Ruth Metzger, Alfred Molina, Michael Monello, Daniel Myrick, Ajay Naidu, Christopher Nolan, Edward Norton, Barrie M. Osborne, Haley Joel Osment, Frank Oz, Chuck Palahniuk, Joe Pantoliano, Dean Parisot, Alexander Payne, Kimberly Peirce, Tom Perrotta, Ryan Phillippe, John Pierson, Greg Pitts, Christopher Plummer,

Franka Potente, Sarah Price, Stephen Root, Eric Roth, David O. Russell, Eduardo Sánchez, Marc Shaiman, Seann William Scott, Ken Segall, Brendan Sexton III, M. Night Shyamalan, Brad Simpson, Mike Simpson, Chris Smith, Kirsten "Kiwi" Smith, Steven Soderbergh, Zach Staenberg, Mary Sweeney, Jim Taylor, Tom Tykwer, Jim Uhls, Christine Vachon, James Van Der Beek, Diane Venora, Andrew Kevin Walker, Jeremy Walker, Melora Walters, Chris Weitz, Dr. Jeffrey Wigand, Michael C. Williams, Olivia Williams, Reese Witherspoon, and Ron Yerxa. In addition to giving me generous amounts of their time, they provided the perspectives and details that made this book possible.

A special thanks to interviewees (and fellow *Entertainment Weekly* alumni) Jill Bernstein, Owen Gleiberman, Mark Harris, and Lisa Schwarzbaum, all of whom were gracious enough to let me do some serious brain-picking about the movies of 1999. Many of them worked at *EW* when I joined the magazine that year, and one of the thrills of my early journalism career was getting to watch my peers put their insight and film-smarts to work. And special credit is due to Jeff Gordinier, who recognized the uniqueness of the 1999 movie movement as it was happening, and wrote *EW*'s amazing cover story on the topic that fall.

I'm also deeply grateful to my colleagues at *Wired*—past and present—for allowing me to pursue such a long-term project, and for providing encouragement along the way: Peter Rubin, Jason Tanz, Nicholas Thompson, Andrea Valdez, and Angela Watercutter. A special thank-you to Robert Capps, my *Wired* editor for nearly a decade.

During the two years I worked on this book, I leaned on numerous pop-culturally astute friends for advice, feedback, and sanity-restoring mealtime conversations. They are kind and brilliant, and I wouldn't have finished this without them: Steve Kandell, Chuck Klosterman, Steven Kurutz, Melissa Maerz, Kerrie Mitchell, Brett Nolan, Phoebe Reilly, Chris Ryan, Mary Kaye Schilling, Dan Snierson, Ken Tucker, and Gwynne Watkins.

I'm especially grateful for all the help from Scott Brown, the Rick McCallum to my Watto (or something like that); Gillian Flynn, a reliable

and movie-loving pal since next Sunday, AD; and the wise and reassuring Josh Wolk, a cultural punned-it of the highest order.

To the many friends who have supported me over the years, and whom I don't have room to name here: I hope you know how much you mean to me.

At Simon & Schuster, Sean Manning oversaw this project with clarity, intelligence, and unwavering enthusiasm. *Best. Movie. Year. Ever.* was his idea, and I hope I did it justice. Emily Simonson graciously answered all of my nagging questions, while Jackie Seow and Chad Malone were responsible for the book's amazing cover. And many thanks to all of those at S&S who helped get this book into the world, especially Lynn Anderson, Stephen Bedford, Annie Craig, Jonathan Evans, Marie Florio, Kimberly Goldstein, Allison Har-zvi, Jonathan Karp, Lewelin Polanco, Caitlyn Reuss, Richard Rhorer, and Elisa Rivlin.

My agent, Jud Laghi, put everything together, and served as an ace idea-consultant along the way, as he has for many years now.

The interviews for this book were the result of countless email-threads, phone calls, and text exchanges. I'm very grateful to the numerous managers, publicists, and—most especially—assistants and interns who helped connect me along the way.

Judith Flic handled translations with precision and speed. The staff at The Muse Rooms in Burbank, California, granted me space and companionship while I was deep in the writing process. The amazing Cinephilia & Beyond (cinephiliabeyond.org) and Internet Archive (archive.org/web) provided invaluable research materials.

My daughters, Tegan and Bridget, gifted me with nonstop good cheer and encouragement, as did my wise and generous in-laws: Claudia and Allen Clark, Rich Williams, Jeff Williams, and Victoria Mechkov.

My mother, Kay Raftery, and my brother, Chris, have served as my biggest support system for decades now, and I look forward to many more years of moviegoing (and post-moviegoing debates) with both of them.

My father, William Raftery, died in early 2018 while I was in the

middle of writing. He loved books and the discussions they could inspire. I'll always be in awe of the kindness and curiosity with which he treated the world and the people who inhabit it. And even though he's gone, I continue my conversations with him to this day.

More than anyone else, this book would not have been possible without the love, support, and sheer smarts of my wife, Jenny Raftery. She served not only as my official fact-checker, but also my reality-checker: Challenging my ideas, pushing me to do better, and letting me know when a punch line didn't work with a boldfaced **enh**. She'll always be my favorite writer.

INDEX

ABOUT THE AUTHOR

Over the course of twenty years, Brian Raftery has written about film, television, music, and internet culture for such publications as *Wired*, *GQ*, *Rolling Stone*, *Esquire*, and *New York* magazine. He lives in Burbank, California, with his wife and daughters.